Foreword by
His Majesty Preah Bat Samdech Preah Baromneath
NORODOM SIHAMONI
King of Cambodia

Much has been written about the famous complexes of temples of Angkor, which cover an area well over 200 square kilometres (77 square miles) in northwest Cambodia. These sacred temples have survived the vicissitudes of history, the collapse of the Khmer Empire in the 15th century and, more recently, foreign invasions and civil strife in our country.

I am delighted that so much attention is being given by publishers around the world to books about Angkor and our heritage and warmly welcome the new issue of **Angkor, Cambodia's Wondrous Khmer Temples**, *which is expertly written and superbly photographed.*

While welcoming this new addition to the literature available on Angkor, I earnestly hope that the people who read this book will learn about our Khmer heritage and temples and also about the importance to preserve them, at a time when materialism and cultural globalisation threatens their existence.

NORODOM SIHAMONI

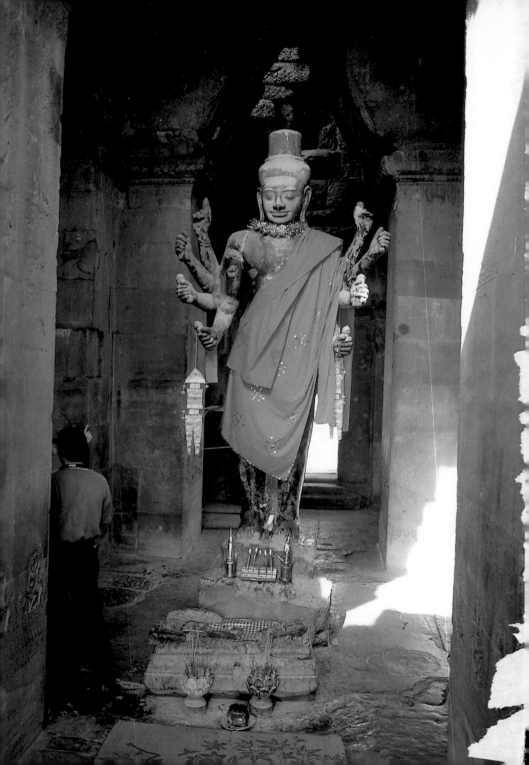

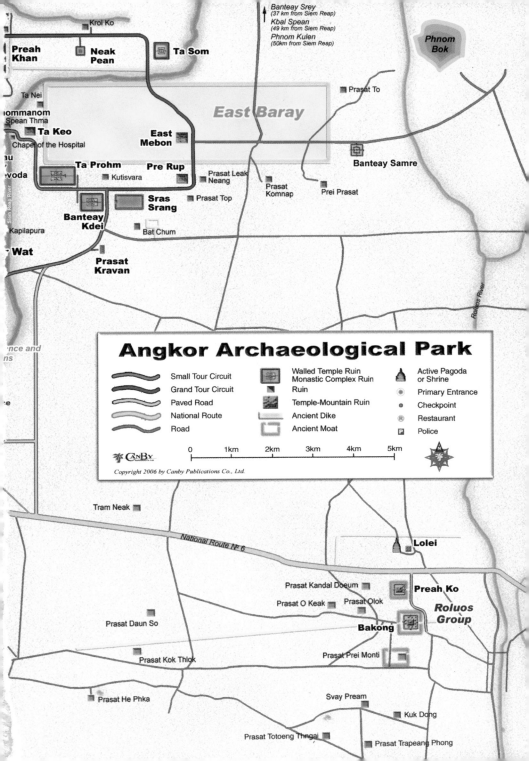

ANGKOR

CAMBODIA'S WONDROUS
KHMER TEMPLES

Dawn F. Rooney

ODYSSEY BOOKS & GUIDES

Odyssey Books and Guides is a division of Airphoto International Ltd.

903 Seaview Commercial Building, 21–24 Connaught Road West, Sheung Wan, Hong Kong
Tel: (852) 2856-3896; Fax: (852) 2565-8004
Email: sales@odysseypublications.com; www.odysseypublications.com

Distribution in the USA by W.W. Norton & Company, Inc., 500 Fifth Avenue, New York, NY 10110, USA
Tel: (800) 233-4830; Fax: (800) 458-6515; www.wwnorton.com

Distribution in the UK and Europe by Cordee Books and Maps, 3a De Montfort Street, Leicester, LE1 7HD, UK
Tel: 0116-254-3579; Fax: 0116-247-1176; www.cordee.co.uk

Distribution in Cambodia by Monument Books, 111 Norodom Boulevard, Phnom Penh
Tel: (855-23) 217-617; Email: info@monument-books.com

Angkor: Cambodia's Wondrous Khmer Temples, Fifth Edition
October 2006
ISBN–13: 978-962-217-727-7
ISBN–10: 962-217-727-1

Grateful acknowledgement is made to the following authors and publishers for permissions granted: Oxford University Press for *The Land of the White Elephant: Sights and Scenes in South-East Asia 1871–1872* by Frank Vincent, ©1988; Thornton Butterworth for *Cambodian Glory The Mystery of the Deserted Khmer Cities and their Vanquished Splendour, and a Description of Life in Cambodia Today* by H W Ponder, ©1936; H F & G Witherby for *Angkor: The Magnificent, the Wonder City of Ancient Cambodia* by H Churchill Candee, ©1925; Oxford University Press for *The Straits of Malacca, Siam and Indo-China Travels and Adventures of a Nineteenth-Century Photographer* by John Thomson, ©1993

Managing Editor: Andrew Dembina
Consultant Editors: John Sanday, Frédéric Goes
Associate Editor: Helen Northey
Design: Au Yeung Chui-kwai
Maps & plans: Professor Bai Yilang, Au Yeung Chui-kwai, Khmer Design Co. or as indicated above
Index: Don Brech, Records Management International, Hong Kong
Photographic research: Khin Po-Thai
Front cover photograph by Magnus Bartlett; back cover photograph by John Sanday
Photography by Peter Danford and Magnus Bartlett, except for those credited individually on images throughout the book. Historical images were provided by the following: Antiques of the Orient, Singapore, from the Garnier Plates collection 50–51, 53, 54–55, 58–59, 78, 120, 122, 126, 180–181; Bibliothèque Nationale, Paris 178; Wattis Fine Art 60–61

Production and printing by Twin Age Limited, Hong Kong. Email: twinage@netvigator.com
Manufactured in China

Page 2: *The Hindu god Vishnu, before its original head was re-attached in March 2004, west gopura, Angkor Wat.*
Right: *Tree takes on temple at Ta Prohm. (Thomas Bauer)*

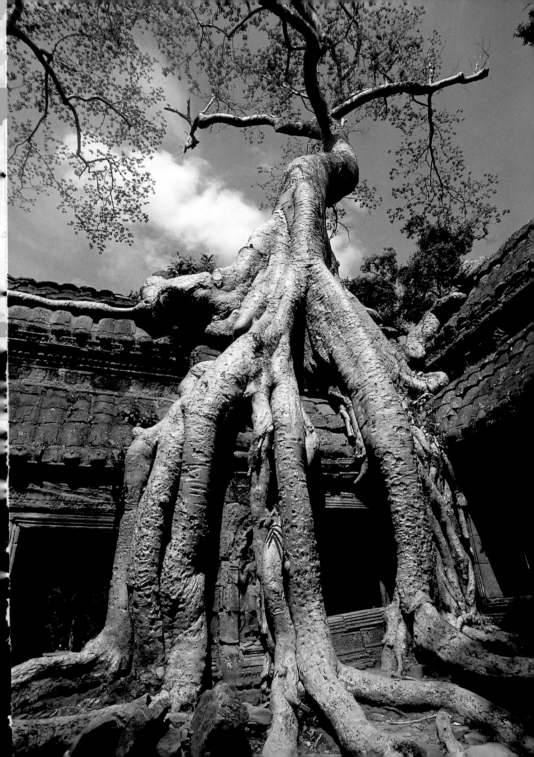

PREFACE

—Go to Angkor, my friend, to its ruins and to its dreams.[1]
This fifth edition of Angkor is significantly revised to reflect the many changes and advances in research that have taken place since the publication of the first edition in 1994. Thirty-three sites have been added, including several beyond the Angkor area and also sites located south of Phnom Penh. Some sites, such as Beng Mealea, are vast complexes; others, such as Prasat Leak Neang, are small, single tower shrines. Regardless of size, each one manifests the extraordinary creativity and artistic skill of the Khmer people.

The most significant recent change for Cambodia was the abdication of the octogenarian king, Norodom Sihanouk, who stepped down for reasons of poor health. A throne council comprising nine members selected a new king. He is Norodom Sihamoni born in 1953 and the son of the former king and his wife, Monineath. He ascended the throne in a stately, yet modest, three-day coronation ceremony presided over by brahmin priests and Buddhist monks. It began on the full moon of October 22, 2004 in the Throne Hall of the Royal Palace in Phnom Penh. His parents conducted a bathing ritual using sacred water from Phnom ('Mount') Kulen in Siem Reap Province. The newly-installed king took possession of replicas of the royal regalia (the original ones are lost) symbolising his rule over Cambodia. Sihamoni vowed to 'devote my body and soul to the services of the people and the nation…' Then, a conch was blown three times to signify magic power or victory; a drum was struck and a brilliant array of fireworks lighted the sky, marking the end of the historic coronation ceremony. The official title of the new king and head of state is: His Majesty Preah Bat Samdech Preah Baromneath Norodom Sihamoni, King of Cambodia.

An auspicious beginning for your Angkor visit is to make merit at the shrine of the so-called 'Big God and Small God', located in the Royal Crusade for Independence Garden in the centre of Siem Reap. According to a 12th-century legend, two monks had a dream that two goddesses told them the Thais would soon invade Cambodia and they asked that the images of 'Big God and Small God' be stored in the great temple of Angkor Wat. The monks ignored the request until they had the same dream again and then they moved the images to the second level in the Gallery of a Thousand Buddhas. As predicted by the goddesses, the Thais invaded Cambodia and pillaged the area but they did not find the images. According to belief, the goddesses are the daughters of an Angkorian king and are known by the local residents of Siem

One of the 54 towers, northeast corner of the upper level, Bayon.

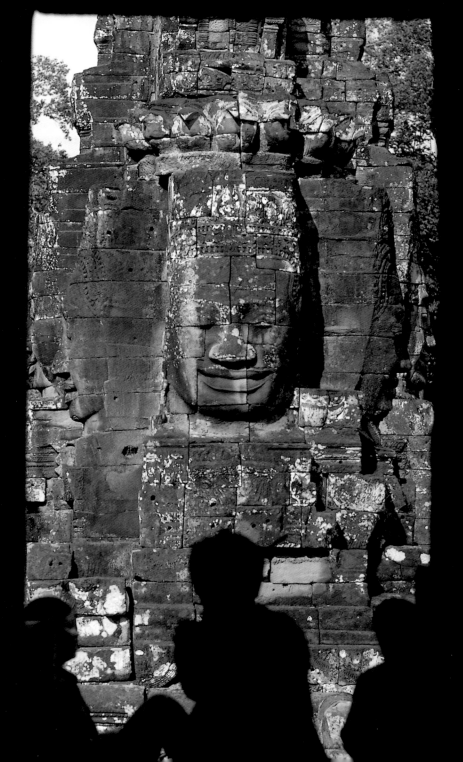

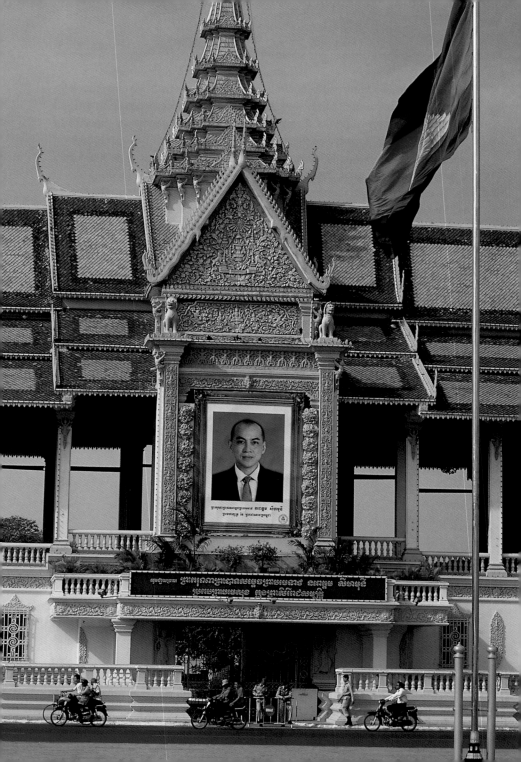

CONTENTS

Recently crowned Norodom Sihamoni's portrait has become highly visible across Cambodia.

Section of Angkor Thom gopura.

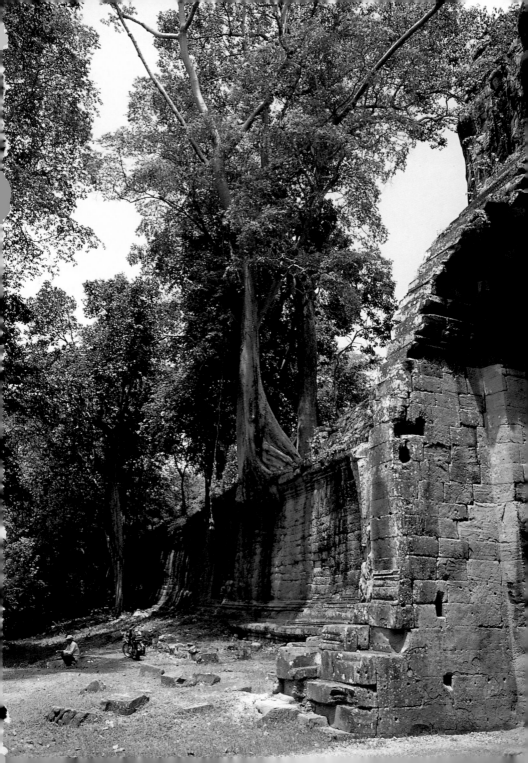

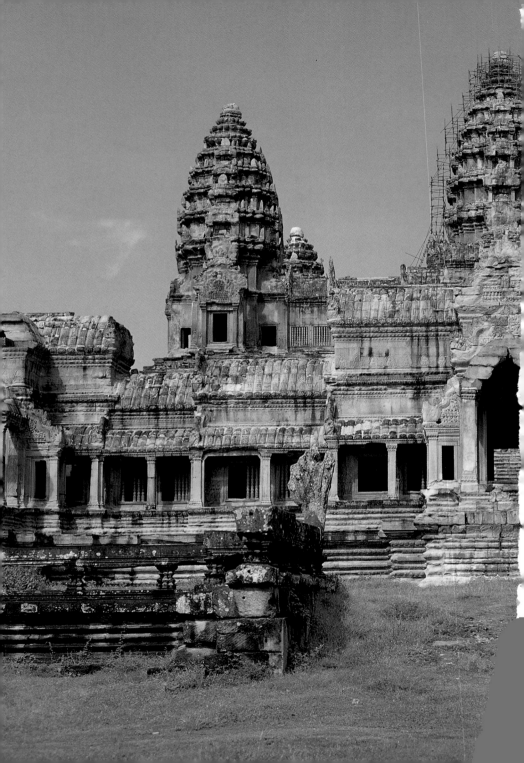

PART I

BACKGROUND

INTRODUCTION

—The tale of it is incredible; the wonder which is Angkor is unmatched in Asia.[2]

The temples startle with their splendour and perfection, but beyond the emotions they evoke lie complex microcosms of a universe steeped in cosmology. While a thorough understanding may be out of reach for many, the monuments' profound beauty touches everyone. Even though there is little doubt the temples of India served as models for Angkor initially, there are features in the structures that are uniquely Khmer. Ideas such as the association of architecture with a capital, the link between the ruler and a divinity, the symbolism of the pyramid temple with Meru, a cosmic mountain, are prevalent throughout the Khmer monuments. The sculpture is equally as individualistic. Sensuous, yet never erotic, male and female forms stand in grandeur and dignity offering universal appeal, past and present.

What is Angkor? Many people who have not been to Angkor think it is only one monument—Angkor Wat. This erroneous idea probably arose because it is the most frequently visited and written about. Angkor, though, covers an area of 200 square kilometres (77 square miles) in North-western Cambodia, and this guide includes descriptions of 74 accessible sites.

This book is both an introduction and a guide to Angkor. It aims to bring together, in a single volume, useful information to help you enjoy and appreciate your visit to Angkor. The text has been compiled from published sources, mainly works by Lawrence P Briggs and Maurice Glaize.[3]

The first part begins with the geography of Cambodia. Historical details follow, tracing the Khmers from early times through the period of Angkor and up to the 19th century. The next section includes preservation efforts at Angkor. A hypothetical chapter follows on what daily life might have been like for the Khmer people. A chapter on religion describes the beliefs and practices of the Khmers, identifies their principal deities and mythical beings and summarises legends frequently depicted in Khmer art. The next chapter, on Khmer art and architecture, describes building materials used in the monuments, the methods of construction, typical architectural and artisitc features, stylistic periods and touches on the cosmological significance of the monuments.

Conservation projects involving international co-operation with the Royal Cambodian Government are described by John Sanday, who heads the World Monuments Fund team's restoration work at Preah Khan and Ta Som. He also

Right: *Relief depicting worshipers, southeast corner pavilion, Bayon.*
Previous pages: *Angkor Wat—the world's largest religious construction in stone.*

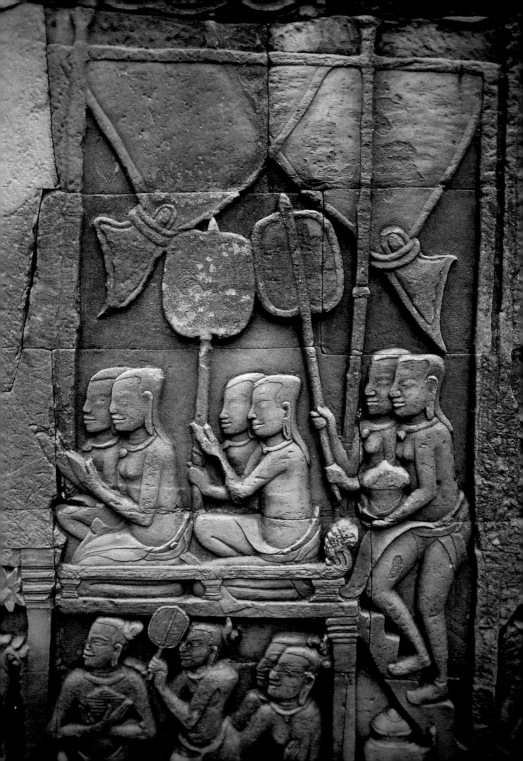

Dawn Rooney

The Hindu god, Shiva.

collaborated on the art, architecture and temple itinerary sections of this guidebook.

The second part of the book presents a series of tours, each one taking between three and four hours to complete. The tours can be taken in any order as can the temples within any one grouping. Each temple is described in detail giving the location, access, date of the monument, name of the king associated with the construction, prevailing religion at the time the site was built, art style, background and layout. A ground plan of the layout accompanies most descriptions.

The third and final part of the book gives practical information on Cambodia, including how to travel between Phnom Penh and Siem Reap and suggestions for accommodation and eating in both places.

Appendices include: a comparative chronology of Khmer and world history, and chronologies of the monuments and the Cambodian kings. There is also a general glossary and a list of books for further reading. Finally, a detailed index allows maximum use of the book.

Measurements are in metric units with imperial units in parenthesis. The abbreviation 'BC' follows all dates before the present era. Dates of the present era have no abbreviation except where its absence would be confusing.

The use of foreign words has been avoided wherever possible and an English equivalent substituted. Technical terms have also been kept to a minimum. The spelling of names derived from Indian languages, such as those of deities, kings and geographical places, are the most commonly found usages and diacritical marks have been omitted. The phonetic system developed by the Royal Institute of Thailand has been followed for the spelling of Thai words.

The Pinyin system has been used for the transliteration of Chinese words except in quotations or captions where the original text has been retained. In those instances, the Pinyin equivalent is provided in parenthesis. Khmer words conform to a phonetic spelling, mainly that followed by the French. The spelling of foreign words is sometimes inconsistent with the conventions adopted for this book because each European country spelt Asian words according to its own interpretation of sound. Foreign words are italicised unless they are proper nouns or have been adopted into the English language.

Two-storey pavilion, Preah Khan.

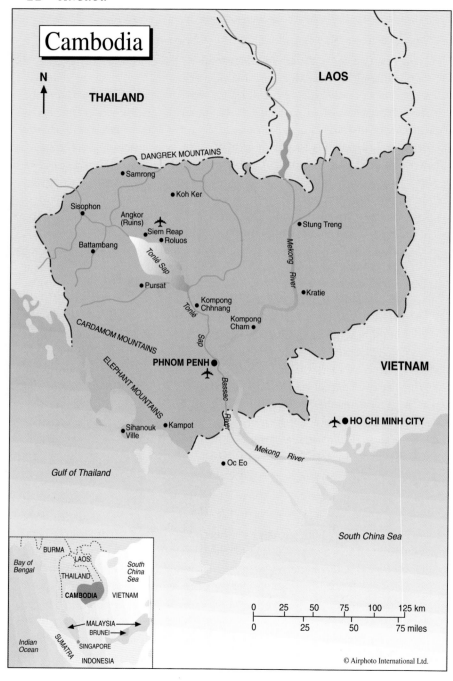

Cambodia

N

THAILAND

LAOS

DANGREK MOUNTAINS

● Samrong

● Koh Ker

Sisophon
●

Angkor
(Ruins)
✈
● Siem Reap
● Roluos

● Stung Treng

Battambang
●

Tonlé Sap

Mekong River

● Pursat

Kompong
Chhnang ●

Tonlé

● Kratie

Kompong
Cham ●

CARDAMOM MOUNTAINS

Sap

ELEPHANT MOUNTAINS

PHNOM PENH ●
✈

VIETNAM

Bassac River

● Sihanouk
Ville

● Kampot

✈ ● HO CHI MINH CITY

● Oc Eo

Mekong River

Gulf of Thailand

South China Sea

BURMA

Bay of
Bengal

LAOS

South
China
Sea

THAILAND

CAMBODIA VIETNAM

← MALAYSIA →
BRUNEI

Indian
Ocean

SUMATRA

SINGAPORE

INDONESIA

0	25	50	75	100	125 km
0		25		50	75 miles

© Airphoto International Ltd.

GEOGRAPHICAL SETTING

Kampuchea, Cambodia, Khmer and Angkor are all names associated with a single Asian civilisation renowned for its art and architecture. Kambujadesa or Kambuja is a Sanskrit name for the modern country of Cambodia. The word derives from a tribe in north India and is associated with Kambu Svayambhuva, the legendary founder of the Khmer civilisation. Kampuchea, a modern version of the name, was part of the official title of the country as recently as 1989. European transliterations of Kambuja became Cambodge in French and Cambodia in English, which is the name of this southeast Asian country today. The modern capital of Cambodia is Phnom Penh, located in the southern part of the country. The inhabitants are Khmers or Cambodians; the national language is Khmer; and in the past the country has also been called Khmer.

The name Angkor derives from the Sanskrit word *nagara* ('holy city') which is *nakhon* in Thai and may have been pronounced *nokor* or *ongkor* in Khmer. Angkor was an ancient political centre situated 320 kilometres (199 miles) north of Phnom Penh in Siem Reap province. The town of Siem Reap ('the defeat of the Siamese'), the provincial capital, is six kilometres (four miles) south of Angkor Wat.

The core of the Khmer empire remained in the vicinity of Angkor for over 500 years, but the area of settlement and political domination fluctuated. At the height of territorial expansion, the Khmers claimed control over major parts of neighbouring areas. Evidence of a former Khmer presence in Thailand exists from as early as the seventh century. Control gradually spread to central and northeastern Thailand and reached a peak in the 11th century under the leadership of Suryavarman I. Archaeological evidence can be seen today at Phimai, in Nakhon Ratchasima province, some 72 kilometres (45 miles) north of Korat. A laterite highway extending for 225 kilometres (140 miles) linked Phimai to Angkor.

TOPOGRAPHY

Angkor is situated in a large basin framed by the Tonle Sap (Great Lake) in the south and the Kulen hills in the north. This plateau is drained by tributaries of the Siem Reap River and intercepted by three hills—Phnom Bok, Phnom Bakheng and Phnom Krom, which became the sites of temples built by King Yasovarman I in the 10th century. Mountain ranges and internal water systems in other parts of Cambodia also formed large valleys where early settlements of the pre-Angkor period flourished.

The Cardamom Mountains (Chuor Phnom Kravanh) in the southwest with an elevation of 1,772 metres (5,814 feet) are the highest in the country. The Elephant Range (Chuor Phnom Damrei) in the south has an elevation of 915 metres (3,002

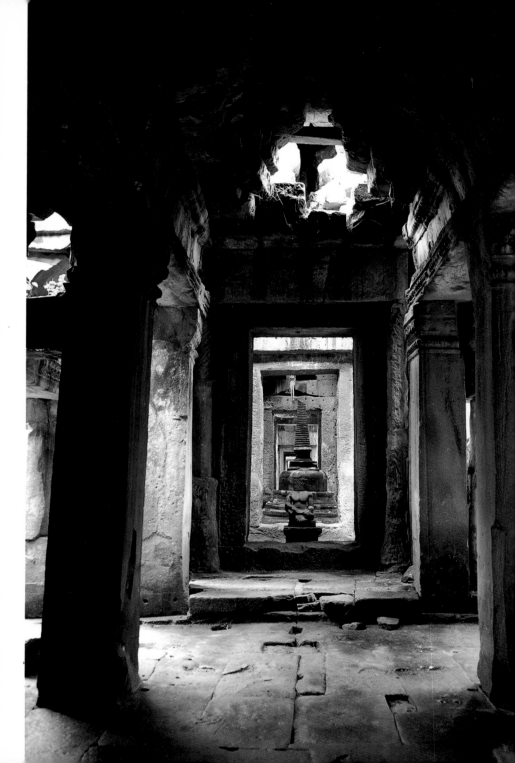

feet). The lowest range is the Dangrek (Chuor Phnom Dangrek) which runs east-west across the north of Cambodia and has an elevation of 488 metres (1,601 feet). Between the western part of the Dangrek and the northern part of the Cardamom mountains, an extension of the delta connects with lowlands in Thailand and forms the southern edge of the Korat Plateau in Thailand. This is one of the few accesses by land between the two areas and, as such, it played an important role in Khmer history, providing a vital communication link to Angkor.

THE MEKONG RIVER

The Mekong River and its tributaries dominate the waterways of Cambodia. From its northern source in the Himalayas, the Mekong flows southward, passing through China, Laos, Thailand, and in a southeastern direction across Cambodia. Finally, the waters of the Mekong discharge into the South China Sea. At Phnom Penh, the Tonle Sap River, a major tributary, joins the Mekong at which an interesting phenomenon occurs. During the rainy season, between May and October, the silted channels of the Mekong River system are insufficient to accommodate the amount of water added to that sent forth by the melting mountain snows, so the river backs up.

The impact of the overflow forces the Tonle Sap River to reverse its course each year between July and October or November and feeds into the Tonle Sap or 'Great Lake', which normally covers an area of approximately 3,000 square kilometres (1,580 square miles). When this action occurs, it increases the size of the lake to 12,000 square kilometres (4,633 square miles) and makes it a natural reservoir. The depth varies from one metre (3.28 feet) to 14 metres (46 feet) over the same period. When the flow reverses at the end of the monsoon the Cambodians traditionally hold a celebratory festival, Bon Om Tuk (see p.27), which coincides with the full moon to give thanks to the spirits for bounteous waters.

Zhou Daguan, a Chinese envoy of the Mongol Empire who lived at Angkor for a year in the late 13th century, gave the earliest recorded account of this feature: 'From the fourth to the ninth moon there is rain every afternoon, and the level of the Great Lake may rise seven to eight fathoms. Large trees go under water, with only the tops showing. People living at the water-side leave for the hills. However, from the tenth moon to the third moon of the following year not a drop of rain falls; the Great Lake is navigable only for the smallest craft, and the depth of the water is only three to five feet'.[4]

The Great Lake was the lifeline of the Khmers. Its pattern of movement provided the structure and rituals of daily life and served as a source of fish and rice to an agrarian society. When the water trebled its volume the lake became an ideal

Preah Khan is a Buddhist monument, but also has several Hindu shrines.

feeding ground for spawning fish and, when it receded, the fish easily fell into the traps laid for them. This movement of the waters enabled the cultivation of floating rice, the earliest known form of Khmer agriculture. It is fast growing and germinates in deep water. The stems can grow up to 10 centimetres (four inches) a day and reach a length of six metres (20 feet). The rice stays on the surface because its growth parallels the rise of the water level. Zhou Daguan recognised the unusual characteristics of floating rice and described 'a certain kind of land where the rice grows naturally, without sowing. When the water is up one fathom, the rice keeps pace in its growth. This, I think, must be a special variety', he noted 700 years ago.[5]

The wet and dry seasons change the landscape of Tonle Sap, Cambodia's Great Lake.

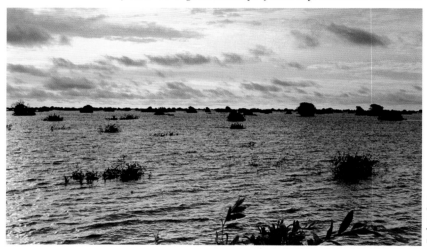

Frederic Goes

Frederic Goes

BON OM TUK WATER FESTIVAL

Water, fish and rice make up the rhythm of life for agrarian Cambodia and at the end of the rainy season people flock to the banks of the Tonle Sap River in Phnom Penh to give thanks to the *Neak Ta* ('Nature Spirit') for the bountiful supply of water that has spread over their land in the past year. The grand, three-day celebration, aptly named the Water Festival (Bon Om Tuk in Khmer), takes place in late October or early November during the full moon with an estimated one million people attending. Boat races on the river highlight the occasion. Over 400 boats, each with 20 to 50 oarsmen, vie for the winning honours.

Every province is represented and villagers spend months of preparation building a boat and training a team of rowers. Each boat is about 12 metres (40 feet) long and painstakingly made from native hardwood—cutting, shaping and then decorating it from prow to stern with brightly painted auspicious designs. When it is time for the annual event, the boat is transported to Phnom Penh accompanied by villagers to cheer for their team.

A joyous, and at times raucous, atmosphere surrounds the festival and the capital is alive with activity centred on the celebration. Flags representing the various teams line the banks of the river along with orchestras and musicians producing cacophonous sounds. Food stalls abound and vendors mill amongst the crowd selling specially prepared dishes, balloons, cotton candy and toys for the children. After the sun sets, candles, incense and offerings of food are made to the spirits. The brilliantly lit Royal Palace glows and a fireworks spectacle illuminates the sky.

While the flamboyant event is a welcome break in the monotony of the agrarian pattern, it is also a poignant reminder of the farmer's dependency on water. The monsoon climate of Cambodia does not release its gift of water evenly and learning how to store the surplus that falls during the rainy season (between May and October) and how to redistribute it during the dry season when there is no rain has challenged the people throughout history. As the rains recede, the river resumes its normal course, flowing from north to south, leaving such an abundance of fish in the lake that villagers scoop them up in baskets. And then it is time to pay respects to the spirits who control the waters and to prepare, once again, for the beginning of the rhythmic cycle that has provided Cambodia and its people with water, fish and rice since the beginning of civilisation.

The central and northwest parts of Cambodia also receive water from another source during the rainy season, triggered by the melting snows of the Himalayas which gush south down the Mekong River (see p.25).

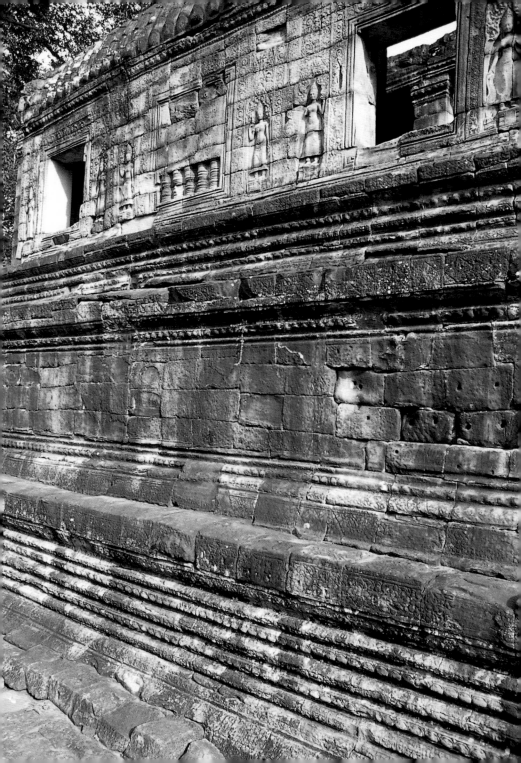

HISTORICAL BACKGROUND

PREHISTORIC PERIOD

Evidence suggests the presence of occupation in Cambodia in the prehistoric period. The earliest inhabitants are unknown. Neither their origins nor the dates they lived in the area can be traced. It is likely, though, that inhabitants throughout mainland southeast Asia—Cambodia, Myanmar, Laos, Thailand and Vietnam—developed basic skills such as the cultivation of rice, the domestication of the ox and buffalo and the use of metals, and practiced animistic worship at about the same time and in a similar way. The earliest settlement found so far at Loang Spean in Battambang province has produced evidence of occupation over 6,000 years ago.[6] The people lived in caves and knew the techniques of polishing stone and decorating pottery with cord-marked, combed and carved designs.

A second prehistoric site, Bas-Plateaux in Kompong Cham province, has yielded radiocarbon dates from the second century BC.[7] The inhabitants of this later site lived in groups resembling villages. Their level of domestication was similar to that of the people of Loang Spean. Samrong Sen in central Cambodia, a third prehistoric site, was occupied about 1500 BC. Opinions differ as to when the prehistoric period ended, but it is generally agreed it occurred sometime between 50 BC and AD 100.

FIRST TO EIGHTH CENTURY

The succeeding period, known as protohistoric, lasted for about 700 years, from the first until the end of the eighth century. From then onwards sufficient historical records have survived to trace a continuous development of the people and places of Cambodia. The patterns of civilisation established in prehistoric societies may have continued to develop in the protohistoric period, although evidence of such a continuity is lacking.

But by the first century AD, the coastal and valley regions comprised settlements whose members grew rice and root crops, had domesticated pigs and water buffalo, made low-fired earthenware for cooking food and storing liquids, and were adept at using metals. They practised animism, worshipping both the spirits of the land and their ancestors.

During the first centuries of the present era, the Chinese travelled by sea to the 'barbarian lands of the southern ocean' searching for new trade routes and commercial outlets to replace the formerly lucrative overland passages to India, which were blocked by nomadic tribes in Central Asia. Concurrently, India also ventured east for commercial purposes to establish trade with China by sea.

Northern library at Bayon.

Trading ships sailed from the eastern coast of India across the Bay of Bengal to the upper western coast of the Malay peninsula. From there, goods were transported by land across the Isthmus of Kra to the western coast of the Gulf of Thailand. Then they followed the coastline around the gulf and on to the southern provinces of China. Mainland Southeast Asia, ideally situated to offer the protection of an inland sea, developed as a mid-way station along this route.

Use of this seaway increased as maritime trade between India and China accelerated through better knowledge of shipbuilding, an understanding of the monsoon patterns, and improvements in navigational skills. It seems likely that religious and social ideas from India reached the shores of Southeast Asia through these Indian-infiltrated areas and were transmitted by brahmin priests over a long period. The phenomenon of elements of the Indian culture being absorbed by the Khmers is known as Indianisation.

As trade developed, groups of settlers emerged at ports along the coast. Archaeological evidence of one of these early habitation sites has been found at Oc-Eo, an ancient centre in the Mekong Delta used by traders in the early centuries of the present era.[8] Finds of Roman coins, Indian jewellery and Buddhist religious objects dating from the second and third centuries at Oc-Eo suggest it was a port along the vast maritime trading network that extended from the Roman empire and the Mediterranean region, eastward to India and the Spice Islands.

Chinese records of the third century name Funan as one of the earliest Indianised settlements in mainland southeast Asia. It was located in the area of the lower Mekong Delta of South Cambodia and South Vietnam. The inhabitants of this historic state are believed to have been a tribe that spoke a tongue from the Mon-Khmer family of languages, which provides a linguistic source for the Cambodians as early as the beginning of the present era. Thus Funan was linked to Cambodia geographically and linguistically and, as such, is the earliest recorded precursor of the Khmer empire. The name Funan may be a Chinese interpretation of *bnam*, an ancient Khmer word meaning 'mountain' and sounding like *phnom* ('hill' in modern Khmer).

Chinese texts describe the mythical founding of Funan, and later a variation of the same story was recounted in Sanskrit and Khmer inscriptions. Versions differ, but the main theme centres around a marriage between a foreigner from India, who was either a brahmin or a king of the Cholas, a dynasty in South India, and a daughter of the *naga* king, who inhabited the waters and ruled over the soil. An inscription from the third century in Champa names Kaudinya as the founder of the new kingdom and he travelled to the land where he met Princess Soma, daughter of the

Reclining Buddha with animistic (Neak Ta) offerings, eastern entrance, Bayon.

naga king, and married her. He carried with him a spear which he planted in the ground of the new land, symbolising his authority.

The Khmer version has been linked to the nation's origins and the genealogy of the kings of Cambodia throughout history. According to the Khmer legend, the race is descended from Kamu, the mythical ancestor of the Khmers. His descendant, Preah Thong, left India and sailed for Cambodia after he was exiled for displeasing the king. One night he saw a beautiful *nagini* on the shore of the water. They fell in love and married. The girl's father, king of the *nagas*, drank the waters that covered the land, built a capital, gave the country to them and named it Kambuja.

Indian ideas were absorbed into the culture of Funan during the early centuries of the present era on an increasing scale. A new influence seems to have arrived in the fifth century, which may have been due to the presence of a Hindu ruler at Funan. The main Indian concepts implanted in Southeast Asia during that time include the introduction of formal religions—both Hinduism and Buddhism—and the adoption of the Sanskrit language at court level, which gave birth to a writing system and the first inscriptions. Other Indian ideas absorbed into the local culture were astronomy, a legal system, literature and universal kingship.

Civil wars undermined the stability of Funan and by the early sixth century the centre of political power had shifted inland. Chinese records mention the emergence of a new state called Zhenla (Chenla) in the latter half of the sixth century, situated on the Mekong in the area of modern-day, southeastern Laos. Zhenla seems to have gained control of Funan and extended its territorial boundaries to the border of today's Vietnam in the northeast and as far as southern China in the north.

Some time in the eighth century, rivalry forced Zhenla to split into two parts, according to Chinese records. Upper Zhenla (of the land), situated on the upper reaches of the Mekong in south Laos and along the northern shore of the Tonle Sap, seems to correspond to the area of the original Zhenla. Lower Zhenla (of the Water) was situated east of the Tonle Sap with its capital at Isanapura (Sambor Prei Kuk). It comprised several small principalities, including the former one of Funan in the Mekong Valley. The time from the fall of Funan to the beginning of the ninth century is known as the pre-Angkor Period of Cambodian history.

Western historians have long held the view that Funan and Zhenla were kingdoms in Southeast Asia and that they were predecessors to the Khmer civilisation. Knowledge of them, though, relies solely on Chinese sources and their existence is not supported by either archaeological or epigraphical evidence. Additionally the names of the two states are not mentioned in any existing inscriptions of the time and

A naga (serpent) balustrade, Preah Khan.

A Sanskrit inscription carved in stone, Banteay Srei.

they are unknown in the Khmer language. A more plausible theory, according to some scholars, such as Claude Jacques, a French epigraphist, is that Cambodia consisted of numerous states and that Funan and Zhenla were only two of several, albeit perhaps the most important ones. They may have called themselves kingdoms for the purpose of offering tribute to China.[9]

NINTH CENTURY TO FIFTEENTH CENTURY

The generally accepted dates for the Angkor Period are 802 to 1432. It began when Jayavarman II conducted a ritual that installed him as universal monarch and ended with the relocation of the Khmers from Angkor, first to Basan on the eastern side of the Mekong and to Phnom Penh in southern Cambodia in 1434. These dates, though, are not absolute as the area was occupied both before and after these years. The dates do, however, designate the period during which the Khmer empire reached its greatest territorial limits and its apogee in cultural and artistic achievements.

The history of this period has been reconstructed from the monuments and their reliefs, statuary, excavated artefacts and inscriptions in Pali, Sanskrit and Khmer— all found within the boundaries of the former empire. The inscriptions provide a genealogy and a chronological framework, describe the merits of the kings, give details about the temples such as the founding and inventories, and about the political organisation. Despite this seemingly large amount of information about the Angkor Period, there are areas such as daily life where information is scarce.

Little is known about Jayavarman II, the founder of Angkor, as no inscriptions from his reign have been found. Evidence of the achievements of this first king comes from the Sdok Kok Thom inscription, dating from the middle of the 11th century, some two hundred years after his reign. Uncovered in north-western Cambodia, this is the most important inscription on the history of the reign of Jayavarman II. It says that he spent some time at the court of the Sailendras dynasty in Indonesia before returning to Cambodia. According to a later account by an Arab merchant, the king of the Sailendras dynasty staged a surprise attack on the Khmers by approaching the capital from the river. The young king, son of Rajendravarman I, was beheaded and the Khmer Empire became a vassal of the Sailendras dynasty.[10] So it could be that Jayavarman II was taken to Indonesia as a prisoner at the time of the attack.

The date that Jayavarman II returned to Cambodia from Indonesia is debated by historians, but most agree that he was back in the country by 790 if not earlier. He asserted his control and power through military campaigns to extend the area of his territorial jurisdiction and to consolidate small principalities before establishing a capital at Indrapura. He then moved his base three more times. The reasons for the

changes are uncertain, but it may have been for a better source of food. One of the locations was Hariharalaya (present-day Roluos), an area that had been occupied in pre-Angkor times.

At the beginning of the ninth century Jayavarman II (reigned 802–850) moved his capital again, this time to another pre-Angkor site, Mount Mahendrapura (today Phnom Kulen), 40 kilometres (25 miles) northeast of Angkor Thom, and it is at this site that the inscriptions say Jayavarman II proclaimed himself universal ruler. This historic event took place in 802 and marked the unification of the Khmer state, the declaration of its independence from Indonesia, and the beginning of the Angkor period. At the same time, Jayavarman II established a new religious belief, the devaraja god-king cult. Soon afterwards he moved the capital back to Roluos where he ruled until his death in 850.

Successive kings after Jayavarman II continued to unify and expand the Khmer Empire. The inscriptions give the names of 39 kings from the Angkor period. Eight of these, selected for worthy achievements and the mark they left on Khmer civilisation, are described in this guidebook.

Indravarman I (reigned 877–889) set a precedent for future kings by building a temple-mountain (Bakong), honouring his ancestors with a temple (Preah Ko), and building a *baray*, the Indratataka, at the capital of Hariharalaya. These elements became *de rigueur* as a means for successive rulers to display their omnipotence.

His son, **Yasovarman I**, (reigned 889–900) built the temple of Lolei at Roluos on an island in the middle of the large *baray* constructed by his father and he dedicated it to his ancestors. Then he moved the capital to Yasodharapura (Angkor) which served as the Khmer centre for the next 500 years, except for a brief time in the first half of the tenth century. Yasovarman I built Bakheng as his temple-mountain on a natural hill and smaller temples on the hills known as Phnom Bok and Phnom Krom. To the east of his temple-mountain he constructed a large *baray*, the Yasodharatataka (East Baray).

Two sons succeeded Yasovarman, then **Jayavarman IV** (reigned 928–944), a usurper, set up another capital at Koh Ker, north-east of Angkor in 928, and ruled for some 20 years. Colossal stone sculptures were produced during his reign and fine examples are on view at the National Museum in Phnom Penh.

His nephew, **Rajendravarman II** (reigned 944–968), brought the capital back to Yashodharapura in 944 and consolidated the empire. He built the two great temple-mountains of East Mebon and Pre Rup and staged a successful military campaign against Champa.

Diptercarpus Elatus, *Ta Prohm*. (*Thomas Bauer*)

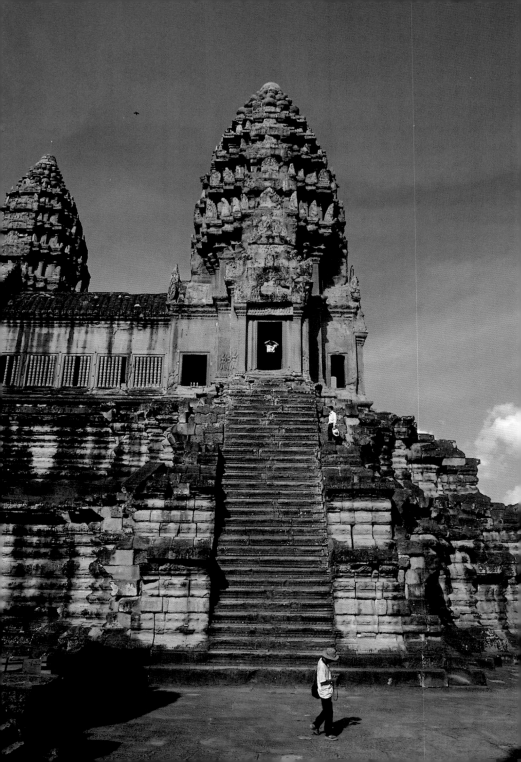

He was succeeded by his son, **Jayavarman V** (reigned 968–1001) who was a child when he ascended the throne. He left two significant architectural legacies: the temple of Banteay Srei, dedicated to him by an official who later became the king's tutor, and the majestic temple-mountain of Ta Keo.

Suryavarman I (reigned 1002–1050) was the next significant king. He claimed dynastic lineage to a family at Nakorn Sri Thammarat in the south of peninsular Thailand, but his origins are obscure. He strengthened the organisation of the government, established internal security, and achieved political acclaim for extending the territorial boundaries southward to the Gulf of Thailand through a series of wars. He conquered the Mon kingdom of central and south Thailand, sometime around 1025, and established a Khmer centre at Louvo (Lopburi), a move that strengthened the empire's economic control and extended it to include Lower Menam. During Suryavarman I's reign, the Khmer empire reached its widest territorial expansion.

After a series of minor kings and short reigns, **Suryavarman II** took the throne around 1113 and reigned until 1150. He was one of the most brilliant of the Khmer rulers and the builder of the great temple of Angkor Wat. He also established relations with China and sent embassies to the Song Emperor. Near the end of his reign he engaged in several wars against the Chams. In 1145, he attacked, defeated the king, and sacked the royal capital. He appears twice in the bas-reliefs of Angkor Wat (South Gallery). At one point he is shown standing on the back of an elephant reviewing his troops and accompanied by his field marshals, and at another he is seated on an elaborately carved throne.

The last major king was **Jayavarman VII** (reigned 1181–1220). He undertook a massive building programme and is accredited for constructing more monuments, roads, bridges, and resthouses than all the other kings put together. He was a devout follower of Mahayana Buddhism and this spiritual dedication permeated every aspect of his reign. He lived outside of Angkor for several years before he became king and then returned, perhaps to prepare to assert his claim to the throne some years later.

Before he took power, the Chams launched a naval battle in 1177 that destroyed the royal capital—the Khmer's worst defeat in history. The Chams launched a brilliantly planned and unexpected attack by sailing their fleet around the coast from central Vietnam and up the Mekong River to the Great Lake, then ravaging the city and setting it on fire. Following the attack, the Chams occupied Cambodia for the next four years until Jayavarman VII staged a war, regained the capital and ascended the throne about the age of 55. He then ruled for about 40 years more.

Southwest corner staircase, top level, Angkor Wat.

During his reign, he invaded Champa and took its king as prisoner to Angkor in 1190, claiming a major military victory. The annexation of Champa to Cambodia followed, and lasted from 1203 to 1220, after which Jayavarman VII died. The victories of the Khmers over the Chams in battles under the direction of Jayavarman VII are depicted on the historic reliefs at the Bayon. Besides being a military leader of excellence, he extended the boundaries of the empire from the coast of Vietnam to the borders of Bagan in Myanmar and from the vicinity of Vientiane in Laos to the Malay Peninsula.

South gallery of bas-reliefs, Angkor Wat.

Thomas Bauer

Documented history for the last two-thirds of the 13th century following Jayavarman VII's death is lacking. We know, though, that no major monuments were built and that the defacement of Buddhist images at the temples during that time was probably due to a revival of Hinduism. We also know that the capital was still prospering at the end of the 13th century because Zhou Daguan described several opulent monuments which he said 'caused merchants from overseas to speak...of "Cambodia the rich and noble"' Theravada Buddhism was one of three religions practiced at Angkor.

In 1350 the Thais established their capital at Ayutthaya and became a great threat to Angkor. The names and dates of the kings who ruled during the remainder of the Angkor Period are obscure and dependent on unreliable chronicles composed at a later date. Angkor remained the capital until 1432, but from then onwards the Khmers moved, by degrees, southward to Phnom Penh.

During the Angkor Period several kingdoms rose to power in the region and threatened the supremacy of the Khmer Empire. Champa, located in the Mekong delta north of Funan in an area corresponding to modern central and south Vietnam, was founded at the end of the second century, according to Chinese records. Indian influences penetrated Champa two or three hundred years later and Hinduism

became the dominant religion. It is possible the Indian influence reached Champa by way of Indonesia as comparative decorative elements are found in the monuments of both cultures dating from the late ninth and early tenth centuries.

Natural geographical barriers restricted the development of Champa into a centralised state. The Chams concentrated on maritime activities and became a strong naval power. Except for the beginning of the 13th century when Champa was ruled by Angkor, it remained an independent state until the last half of the 15th century when it was absorbed by the Vietnamese.

Name	Period of Power (centuries)	Area
Champa	second–15th	central Vietnam
Dvaravati/Mon	sixth/seventh–11th	Thailand
Pyu	sixth–11th	Myanmar
Srivijaya	sixth–13th	Indonesia (Sumatra);
(9th–13th: ruled by Sailendras)		Malay Peninsula; south Thailand
Sailendras	eighth–ninth	Indonesia (central Java)
Pegu/Mon	ninth–11th	Myanmar
Bagan	11th–13th	Myanmar
Sukhothai	13th–14th	Thailand (north-central)
Lan Na	13th–16th	north Thailand
Ayutthaya	mid-14th–mid-18th	Thailand (central plain)

The Mons established several centres in mainland southeast Asia. The kingdom of Dvaravati controlled the Menam Valley, in central Thailand, from the sixth or seventh century to the 11th century. The Pyu established a centre in the sixth century situated in the valleys of the central Irrawaddy and Sittang rivers in Myanmar. Pegu, another Mon site, was founded in the ninth century. The Burmese emerged from the north in the 11th century and took over the Pyus in the central valleys and established a capital at Bagan. The Burmese extended their territorial boundaries southward and conquered the Mons at Pegu.

Two states situated in the Indonesian islands emerged, following the demise of Funan, and grew to become powerful empires in the region. The southeast coast of Sumatra gained importance in the fifth century because of the development of a direct sea route from Indonesia to China and also because it served as a trans-shipment point between India and China. The Srivajayan empire became a centre in

Indonesia of this trade. Its origins probably date to the sixth century and by the late seventh century it was a strong commercial power that had extended its territorial boundaries to the coasts of west Java, Malaysia and Chaiya in southern Thailand.

Although the capital of the Srivijaya dynasty has not yet been found, the southeast coast of Sumatra at Palembang and the Malay peninsula have been suggested as possibilities. Details of the decline of Srivijaya are sketchy. It was besieged by piracy in the Straits of Sunda and Malacca in the 11th century, and, during the Southern Song period (1128–1279) when China allowed its own vessels to conduct trade with southeast Asia, Srivijaya's importance decreased.

A second dynasty, the Sailendras, rose in Indonesia in central Java. Its origins and identity are not clear, but one theory is that survivors of Funan went to Java and, after some time, appeared as the Sailendra dynasty. Both Funan and Sailendra are known as the 'kings of the mountain'. The dynasty was well established in the eighth and ninth centuries when it undertook the construction of the great Buddhist monument Borobudur and others in central Java. Shortly afterwards, the Sailendras lost control of the central area and the capital moved to east Java.

Thailand was a persistent invader of Khmer territory. Sukhothai, the first organised Thai settlement, was established in the 13th century in north-central Thailand. About the same time, the Thai principality of Lan Na was founded with its capital at Chiang Mai. The Thais also controlled the area around the mouth of the Chao Phraya River which became the Ayutthaya kingdom in the middle of the 14th century. Within 100 years, the Thais had gained control of a large part of the area corresponding to modern-day Thailand. Ayutthaya became the dominant power in the region until it was sacked by the Burmese in 1767.

The Thais made repeated raids on Angkor in the 14th century, and battles continued between the two rivals for almost another century until a final siege in 1431 which lasted, according to the Ayutthaya chronicles, for seven months. The Thai invasions, however, did not lead to permanent occupation of Khmer territory. Some time after the brutal attack on the city of Angkor Thom, the Khmers gradually retreated and shifted their capital southward to Phnom Penh, with Lovek and Udong briefly serving as capitals in the 16th and 18th centuries respectively.

Exactly how long this change took is unknown, but it probably occurred over several years and Angkor was never completely abandoned. The temple of Angkor Wat, for example, was maintained by Buddhist monks even in the 15th and 16th centuries. The court returned to Angkor briefly in the late 16th century and again intermittently in the 17th century, but it never regained its former glory.

Northern gopura, Angkor Thom.

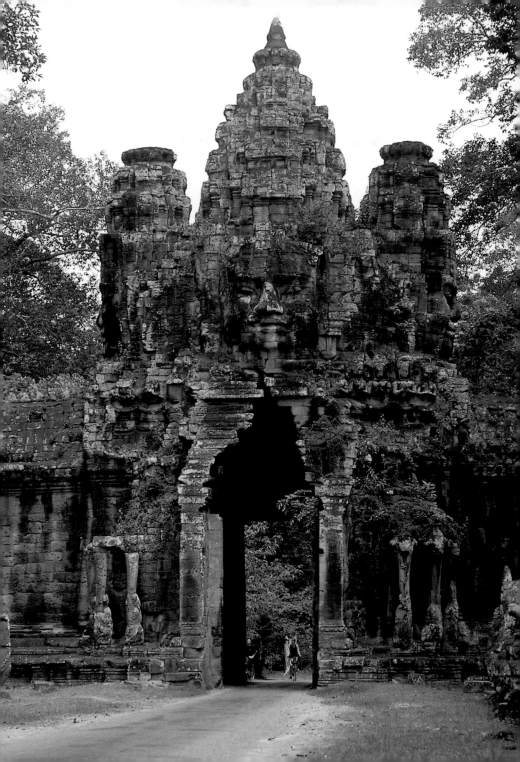

The evidence is inconclusive, but it seems likely that several forces acted as catalysts leading to the decline of the Khmer Empire. The most important reason was the increasing pressure brought about by the encroachment of the Thais, rendering Angkor unsuitable as a capital because of its proximity to the enemy. The loss of manpower through the ensuing wars further meant that maintenance of the irrigation system was neglected. Not surprisingly, the Khmer people also revolted against harsh conditions in the empire, against Jayavarman VII's extravagant building and against his opulent lifestyle which exhausted the kingdom's resources. As central control weakened, the vassal states gradually asserted their independence.

In addition, ecologists point out that by the 13th century forests may well have become depleted. Sustaining the large population probably put pressure on the agricultural system, and drought, or other climatic factors, may well have contributed to the weakening of the state's authority. Increased missions from Cambodia to China in the late 14th and early 15th centuries suggest an interest in developing maritime trade in southeast Asia, and Phnom Penh would have been a more suitable base from which it could be developed.

Another school of Buddhism, Theravada, spread from Sri Lanka across southeast Asia in the 13th century eclipsing former beliefs. In summary, the Khmer rulers probably gradually shifted southeast from the early 15th century onwards and established a base at Phnom Penh and when this shift occurred the character of the kingdom changed.[11] It required new ways of unifying and administering the country and its people.

SIXTEENTH TO NINETEENTH CENTURY

The ruins of Angkor were reported by many foreigners as early as the 16th century. Portuguese refugees forced out of Sumatra by the Dutch in that century sought asylum in Cambodia and were among the earliest Europeans to see Angkor. Numerous overseas traders from China, Japan, Arabia, Spain and Portugal resided in the Cambodian capitals of Phnom Penh and Lovek in the 16th century and were joined briefly by the Dutch and the British in the following century. At about the same time, Portuguese and Spanish missionaries arrived from Malacca.

The earliest and most detailed account of Angkor was by the Portuguese writer Diego do Couto, who described how, in the middle of the 16th century, a king of Cambodia came upon the ruins while hunting elephants. It is believed that Antonio de Magdalena, a Capuchin friar, who visited Angkor about 1585, was his main source of information. He described a Cambodian king who went on an elephant hunt and came upon a 'number of imposing constructions' enshrouded in vegetation.

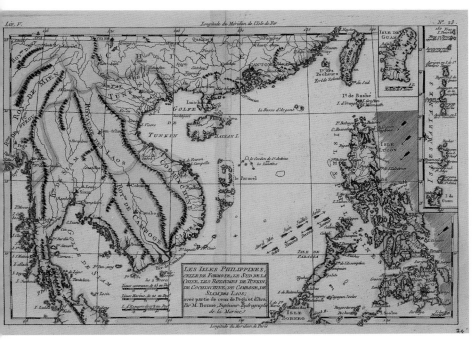

The ruins of Angkor were reported by many foreigners as early as the 16th century but did not appear on this 18th-century European map.

Other published reports by Spanish visitors in the early 17th century seem to have been based on Couto's account. Marcelo de Ribadeneira in a description of Angkor published in 1601 wrote: 'There are in Cambodia the ruins of an ancient city, which some say was constructed by the Romans or by Alexander the Great'.[12] Gabriel Quiroga de San Antonio, a Spanish missionary, wrote in 1603: 'In 1570 a city was brought to light that had never been seen or heard of by the natives'.[13] Christoval de Jaque also mentioned visitors at the ruins in 1570 and, in a book published on his travels in Indo-China in 1606, he called the site 'Anjog' and described the wall surrounding the city of Angkor Thom.[14]

Spanish missionaries in Cambodia in the 1580s heard of a city of ancient ruins and prayed that the ruins 'may be rehabilitated to become an outpost of Christian missions outside the Philippines....'[15] In 1672 Pere Chevruel, a French missionary, wrote: 'There is an ancient and very celebrated temple situated at a distance of eight days from the place where I live. This temple is called Onco, and it is famous among the gentiles as St Peter's in Rome'.[16] Few reports of Dutch visitors have come to light, which is surprising given their strong commercial presence in southeast Asia in the

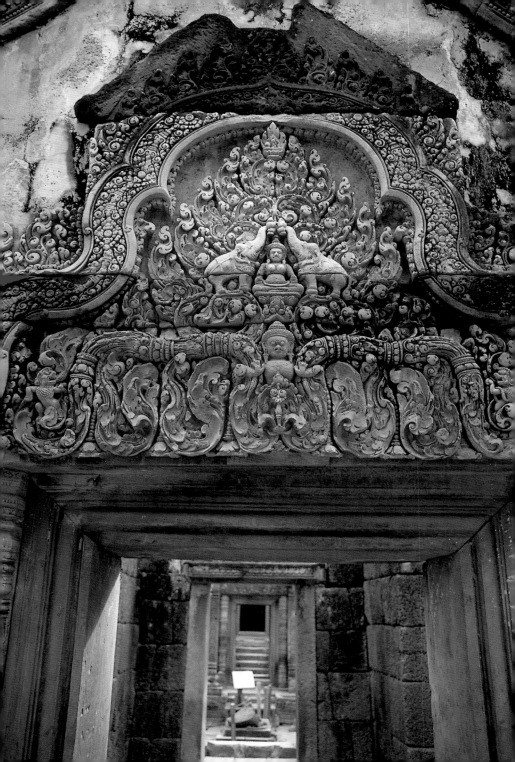

16th and 17th centuries. Gerard van Wusthoff described Angkor in 1641 and 15 years later Hendrick Indjick, a merchant, wrote: 'The king paid a visit to a lovely pleasant place known as Anckoor, which the Portuguese and Castilians call Rome, and which is situated an eight or ten-day journey from here [Phnom Penh]'.[17]

Evidence of the Japanese at Angkor in the 17th century is purportedly carved in sandstone at Angkor Wat in calligraphic characters corresponding to the date of 1632 on a pillar on the second level of Angkor Wat. The oldest known plan of Angkor Wat was drawn by Kenryo Shimano, a Japanese interpreter from Nagasaki, who journeyed to Angkor some time between 1632 and 1636 and drew a remarkably accurate diagram of the temple. Even though he called it Jetavana-vihara, a Buddhist site in India, and Angkor is not named on the diagram, other facts such as the unusual layout and the orientation to the west confirm the identity of Angkor Wat. The most telling reference is a note on the diagram that says 'sculptures in relief...four gods pull the rope', which clearly refers to the Churning of the Ocean of Milk in the gallery of bas-reliefs at Angkor Wat. Shimano's son, Morimoto Ukondayu, who visited the great temple some time later in the 17th century to pay tribute to his father supposedly carved the calligraphic characters.

Other foreigners published accounts of Angkor, but they received little recognition in the West. For example, Dr A. House, an American missionary and long-time resident of Siam, wrote a lively and interesting description of Angkor in 1855. Charles-Emile Bouilleaux, a French missionary, saw Angkor in 1850 and published an account of his travels eight years later. D. O. King, an Englishman who travelled in Indo-China from 1857–1858, detailed his journey in a paper read to the Royal Geographical Society in London in 1859. He pointed out the ruins and the existence of a map of Angkor in a French work. 'The Temple stands solitary and alone in the jungle, in too perfect order to be called a ruin, a relic of a race far ahead of the present in all the arts and sciences', he wrote.[18]

Despite these published accounts by foreigners who saw and wrote about Angkor, they seem to have gone mainly unnoticed in the West. European interest in the ruins was not aroused until Henri Mouhot, a French naturalist, reported on his visit. He was fortunate to gain the support of the Royal Geographical Society in London, departing for Singapore in April 1858 and arriving in Siam in September.

Three months later he set off on a journey that continued until April 1860. During that time he spent two months in Cambodia, including three weeks at Angkor. He surveyed and measured the temple of Angkor Wat and kept detailed notes on his observations of the ruins. His last journey in the region was an exploration of

The Hindu goddess, Lakshmi, flanked by elephants; a pediment at the temple of Banteay Srei.

uncharted territory in north-eastern Thailand and a survey of the Mekong in Laos designed to fill in the blanks on maps made in the 17th century. Mouhot continued his work until November 1861, when he contracted a fever and died at Luang Prabang in Laos at the age of 35. His notes were taken to Bangkok by his faithful servants and later sent to his widow and brother in Jersey where they were published in 1864.

By the time of the publication of Mouhot's diaries, France had a presence in Indo-China. In 1863 a French Protectorate over Cambodia was in place except for Battambang and Siem Reap provinces, which were under the jurisdiction of Thailand. A treaty between Siam and France in 1907 ceded these territories to France where they remained except for a brief period during the Second World War when they were returned to Thailand.

The temple of Preah Vihear (Khao Preah Viharn) on the eastern side of the Dangrek Mountains was an unsettled aftermath of this treaty and both Cambodia and Thailand claimed territorial rights. In 1962 the International Court of Justice at The Hague awarded Preah Vihear to Cambodia. The temple, however, is situated at the apex of a 600-metre (1,968 feet) cliff and its only feasible access is from Thailand.

The temple of Banteay Srei, northeast of Angkor, was disputed because it was located in the territory granted to Thailand. In 1941 the Japanese served as mediators in negotiations between Thailand and France and it was decided the temple should belong to Cambodia.

Base of a pillar decorated with geometric bands, lotus petals and rosettes, illustrated in Voyage au Cambodge, *Delaporte, 1880.*

Dawn Rooney

PILGRIMAGE TO ANGKOR

*F*rank Vincent, Jr, a frail young American who dropped out of university
because of illness at the age of 17, was determined '...to make a
systematic tour of the most interesting parts of the world'. In 1872, he visited
Cambodia and the ancient ruins of Angkor. Vincent describes his journey
overland from Bangkok to Siem Reap, the village closest to the ruins, in vivid
detail. 'The total distance we travelled from Bangkok was 175 miles; of this,
30 miles was by canal in boats, 30 miles on the Bang Pa Kong river in boats,
and the remainder—215 miles—was performed upon horses and elephants,
in bullock-carts, and on foot; the greater part of the journey, however, was
accomplished on horseback. The time consumed in making this trip was
seventeen days.*

*'The governor of Siamrap having provided us with three elephants, on the
13th inst, we started for the ruins of Angkor, three and a half miles distant,
to the north. We took but little baggage with us, being rather impatient now
that we were nearing the main object of the expedition—the ultima Thule
of our desires and hopes—and so we passed quickly and silently along a
narrow but good road cut through the dense, riant forest, until, in about an
hour's time, on suddenly emerging from the woods, we saw a little way off
to the right, across a pond filled with lotus plants, a long row of columned
galleries, and beyond—high above the beautiful cocoa and areca palms—
three or four immense pagodas, built of a dark-grey stone. And my heart
almost bounded into my mouth as the Cambodian driver, turning towards
the howday, said, with a bright flash of the eye and a proud turn of the lip,
"Naghon Wat"; for we were then at the very portals of the famous old "City
of Monasteries", and not far distant was Angkorthom—Angkor the Great.'*

Frank Vincent, Jr, The Land of the White Elephant: Sights and Scenes in
Southeast Asia 1871–1872 (*Oxford University Press, rep, Singapore, 1988*)

Following pages: *The members of the Mekong Exploration Commission.*

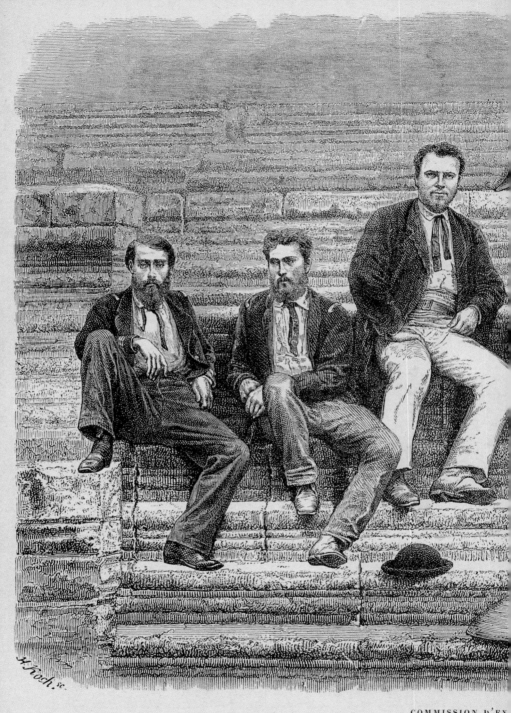

COMMISSION D'EX

M. GARNIER. M. DELAPORTE. M. JOUBERT.

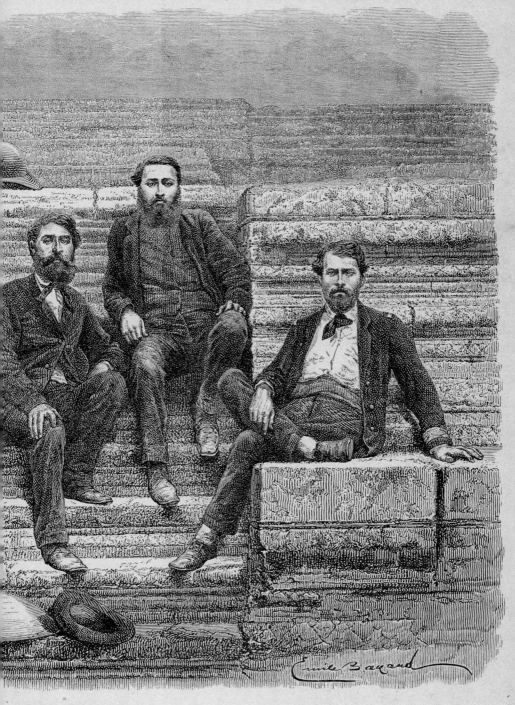

M. THOREL. M. DE CARNÉ M. DE LAGRÉE.

PRESERVING ANGKOR

In June 1866, a French expedition led by Ernest Doudart de Lagrée, who was formerly the French representative to the court of Cambodia, was undertaken to survey the northern reaches of the Mekong River in search of a trade route to China. As only Doudart de Lagrée had visited Angkor before, a side trip was planned which provided the catalyst for a systematic study of the ruins at Angkor.

The Mekong Exploration Commission set out from Saigon, Vietnam, and reached Angkor on June 23, 1866. The team of six Frenchmen spent one week systematically recording their observations and surveying the area. Although Doudart de Lagrée died in 1868 in Yunnan, China, prior to the publication of the expedition's findings, two other members of the team, Francis Garnier and the artist Louis Delaporte completed the work and are recognised today as pioneers in France's research at Angkor. Garnier's findings were published in 1873 in *Voyage d'Exploration en Indo-Chine, Effectué Pendant les Années 1866, 1867 & 1868* and Delaporte's impressions appeared in 1880 in *Voyage au Cambodge: L'Architecture Khmer*. Delaporte's engravings of the ruins of Angkor are well known today and reflect the condition of the monuments in the mid-1860s. His widely published works no doubt perpetuated the idea of 'mysterious Angkor' noted in the writings of many early travellers.

John Thomson, a renowned Scottish photographer, who was travelling extensively in Asia at the same time, happened to meet the Doudart de Lagrée mission at Angkor. Thomson published the first photographic account of the ruins of Angkor. Descriptions of the bas-reliefs at Angkor Wat and at the Bayon, and plans of Angkor Wat based on his own survey, can all be found in his publication *The Straits of Malacca, Siam and Indo China or Ten Years Travels, Adventures and Residence Abroad*.

In 1879, the Dutchman Hendrik Kern was the first to decipher Sanskrit inscriptions found in Cambodia and two Frenchmen, Auguste Barthe and A Bergaigne, are credited with furthering the field of Khmer epigraphy which led to the translation of some 1,200 inscriptions relating to the genealogy of the Khmer kings. Etienne Aymonier, a representative of the French Protectorate, produced the first archaeological inventory of Cambodia at about that time.

THE ÈCOLE FRANÇAISE D'EXTRÊME ORIENT (EFEO)

Even though France made Cambodia a protectorate in 1863, it was only in 1898 that the EFEO, which was founded to study the history, language and archaeology of Indo-China in an effort to protect the ancient sites, was established in Cambodia. Since then, the EFEO has undoubtedly been the most dedicated and influential body

Right: *Drawing of Angkor Wat by Louis Delaporte.*

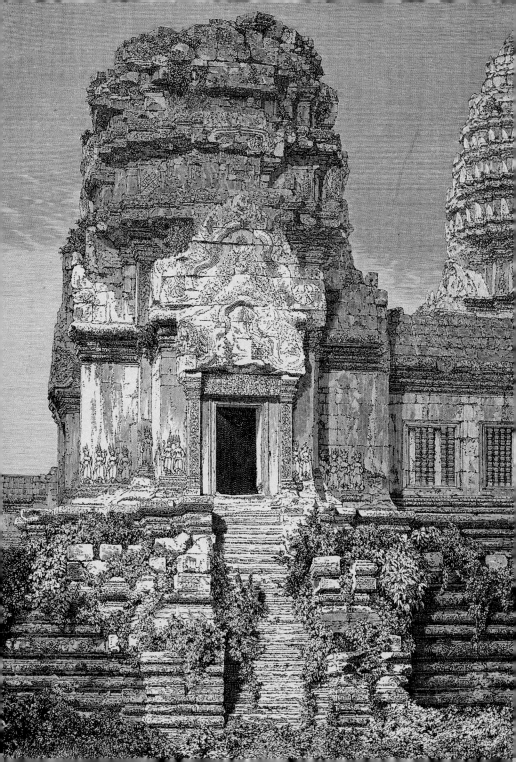

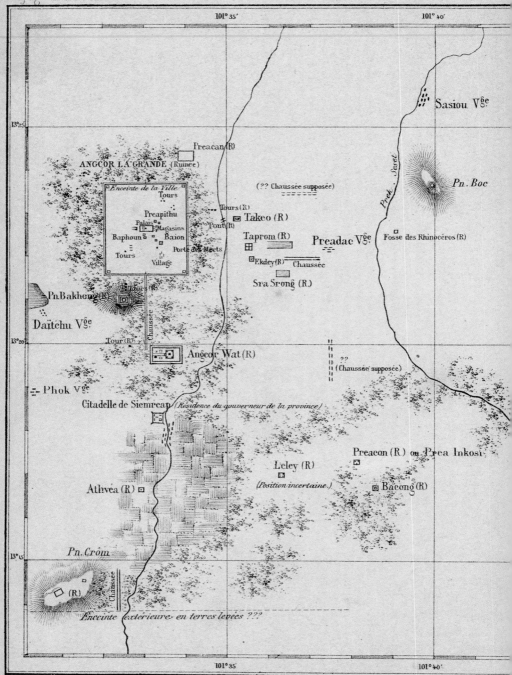

101° 35' 101° 40'

13°25'

Sasiou Vᵍᵉ

Preacan (R)

ANGCOR LA GRANDE (Ruinée)

(?? Chaussée supposée)

Pn. Boc

Enceinte de la Ville
Tours
Tours (R)
Preapithu Tours (R) Takeo (R)
Palais
Magasins Taprom (R) Preadac Vᵍᵉ Fosse des Rhinocéros (R)
Baphoun Baion Pont (R)
Tours Porte des Morts Ekdey (R) Chaussée
Village Sra Srong (R.)

Pn. Bakheng (R)
Tours (R)
Daïtchu Vᵍᵉ
Chaussée
13°20' Tour (R)
Angcor Wat (R) ??
(Chaussée supposée)
Phok Vᵍᵉ
Citadelle de Siemreap (Résidence du gouverneur de la province)

Preacon (R) ou Prea Inkosi

Leley (R)
(Position incertaine.) Bacong (R)

Athvéa (R)

13°15' Pn. Crôm

Chaussée
(R)

Enceinte extérieure en terres levées ???

101° 35' 101° 40'

Pl. I

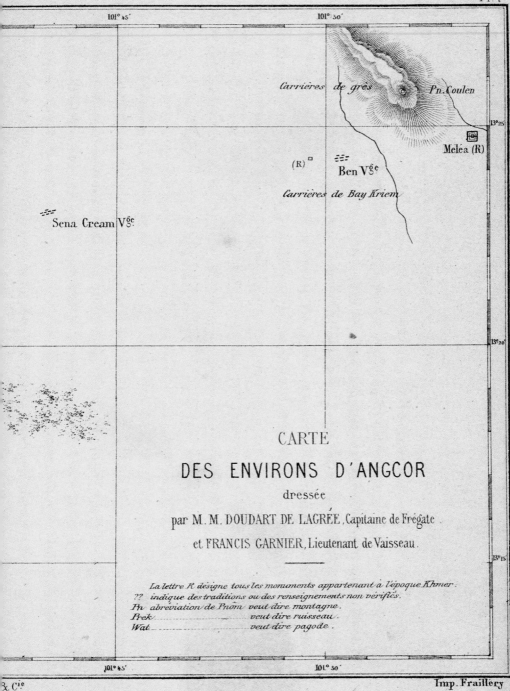

101° 45′ 101° 30′

Carrières de grès Pn. Coulen

13° 25′

Meléa (R)

(R) ⛬⛬ Ben Vᵍᵉ

Carrières de Bay Kriem

Sena Cream Vᵍᵉ

13° 20′

CARTE

DES ENVIRONS D'ANGCOR

dressée

par M. M. DOUDART DE LAGRÉE, Capitaine de Frégate

et FRANCIS GARNIER, Lieutenant de Vaisseau.

13° 15′

La lettre R désigne tous les monuments appartenant à l'époque Khmer.
?? indique des traditions ou des renseignements non vérifiés.
Ph abréviation de Phom veut dire montagne.
Prek................................ veut dire ruisseau.
Wat................................ veut dire pagode.

101° 45′ 101° 30′

to study Angkor. It started to document the Angkor sites by preparing measured surveys and inventories after disengaging them from the jungle. Later the EFEO began a systematic programme of consolidation and restoration of the monuments and the development of plans to present the sites to visitors. The EFEO, for example, created the road network and developed the visitation programme, which is still used by some guides today, following the 'Grand Circuit' or the 'Little Circuit.'

In 1908, the EFEO assisted in the setting up in Siem Reap of the Conservation d'Angkor or Angkor Conservation, the archaeological directorate of the Cambodian Government, which became responsible for the maintenance and protection of the monuments. The Conservation d'Angkor was formerly the nerve centre for all work relating to the conservation and protection of the monuments and sites of Angkor.

Through their involvement, either directly or indirectly, with the Conservation d'Angkor, several Frenchmen have made significant contributions to its direction and programme of research. Its first curator, **Jean Commaille** served from its inception until his untimely death at the hands of bandits in 1916. He started the laborious task of clearing of the sites from the jungle and wrote the first guidebook to Angkor.

Commaille was succeeded by the great **Henri Marchal**, 'the father of Angkor', who spent most of his adult life in Cambodia. He served as curator until his retirement in 1933. He returned to take up the same position twice again. First, between 1935 and 1937, and, second, in 1947 (at the age of 61) to 1953. After serving later in Vietnam and Laos, he returned to Cambodia in 1957, where he remained until his death in Siem Reap in 1970. Marchal undertook an enormous amount of work including the clearance and restoration of large areas of Angkor Thom, Preah Khan and Ta Prohm. He was the first to introduce the system of anastylosis, the method of recording, dismantling, and reconstructing whole structures. It was a system he had learned from the Dutch in Borobudur, Indonesia.

In his book, *Angkor*, Malcolm Macdonald, the then British Commissioner for southeast Asia and a great champion of Angkor, recalls a meeting with Marchal: 'Almost eighty years old, his venerable age did not prevent him from walking with youthful briskness for hours on end as he conducted me on lightning tours through the monuments.... His fund of information about the ancient tombs, his genius as a raconteur of history and his charming, philosophical and witty personality made him a perfect guide amongst his beloved temples. One of my most fortunate experiences at Angkor was my introduction to them by him.'

Previous pages: *The 1866 French expedition was the first to systematically publicise Angkor to the outside world.*

Georges Trouvé, who took over from Marchal as curator between 1933 and 1935, was a 'chubby faced' man who had a knack for locating special treasures at Angkor and he was greatly missed by his colleagues following his sudden and tragic disappearance in 1935.

Another of the great champions of Angkor was **Maurice Glaize** who was curator from 1937 until 1946. Glaize contributed greatly to promoting Angkor with the preparation of his definitive guidebook *Les Monuments Du Groupe D'Angkor*, published in 1943 with three subsequent editions, the last one being in 1963, at which time it required only minimal updating (Glaize's guide has been translated into English and can be downloaded from the Internet at www.theangkorguide.com).

Henri Parmentier, chief of the archaeological services of French Indo-China, also wrote a comprehensive guidebook to Angkor, published in 1959.

Bernard Philippe Groslier, the son of Georges Groslier, Director of Khmer Art at the EFEO, was the last of the French curators at the Conservation d'Angkor. He took over as curator in 1960 and was forced to leave his post with the other French researchers in 1972.

After the EFEO's departure from Angkor in 1972, a noble group of its local staff continued to work on the monuments until 1975 when they were ordered by the Khmer Rouge to work in the fields. Subsequently, the monuments were once more abandoned and for nearly 20 years the jungle gradually reclaimed the structures. It was only in the early 1990s that a concerted effort was made to uncover the monuments and commence once more the never-ending task of repairing, maintaining and presenting the sites to the world.

Fortunately the great archives of the EFEO were copied and kept in Paris and in Phnom Penh. The French copy has survived and recently drawings have been recorded on microfiches and the handwritten site notes and journals have been transcribed on computer disks and are available to those researching or working at Angkor.

Except for a brief period during the Second World War, the French worked continuously at Angkor from the beginning of the last century until 1972 when they were forced to leave due to the civil war in Cambodia. Their presence at Angkor for over seven decades and the contributions of some devoted French archaeologists have earned the country a respected niche in the history of the protection of the monuments of Angkor.

Following pages: A 19th-century engraving of the library at Angkor Wat.

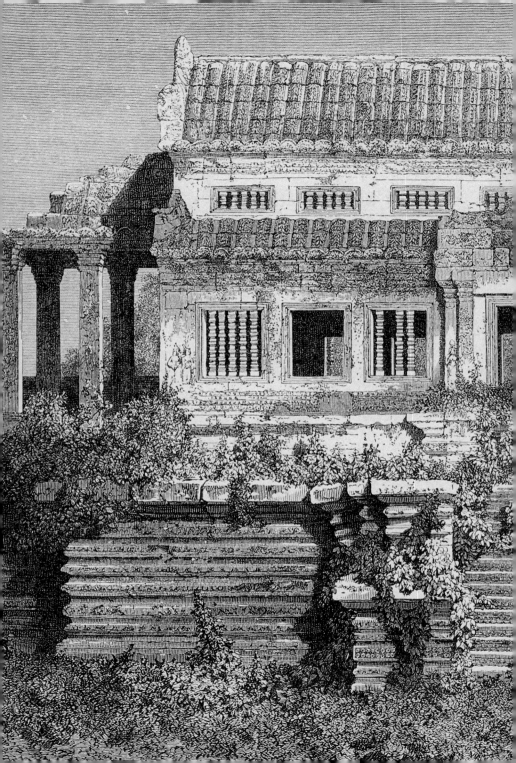

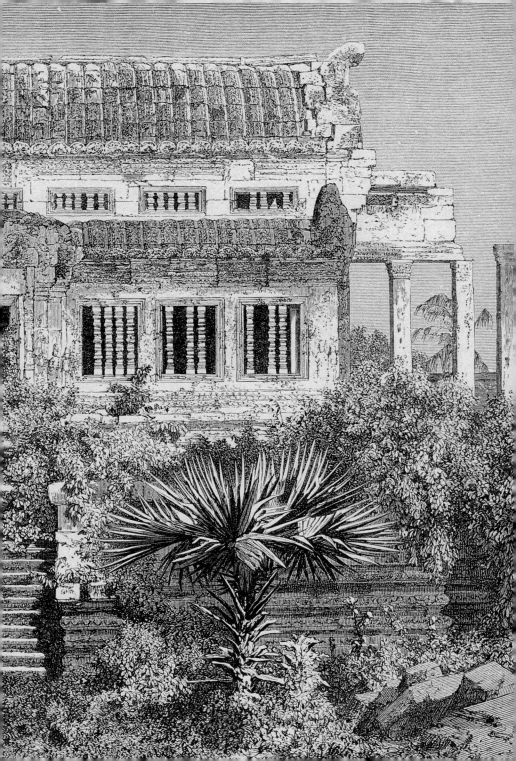

CIVIL WAR AND AFTER

During the period of civil strife, the monuments of Angkor became stores for supplies and occasionally a refuge, but, despite constant turmoil, it has always remained a national symbol. Also, contrary to rumours and erroneous press reports, Angkor was never wantonly attacked for political ends. One stray American bomb is said to have exploded in Angkor Wat and there is evidence of gunfire on the odd sandstone image but, in general, the temples have survived the wars largely unscathed. It was more the people who had carefully tended the monuments that suffered torture, deprivation and death at the hands of the Khmer Rouge. Many among the work force were executed, leaving only a few to recommence the task of repair and maintenance at Angkor.

One exception at this time was the work of the Archaeological Survey of India at Angkor Wat. Following an agreement in the mid-1980s between the Peoples Democratic Republic of Kampuchea and Indira Gandhi, then India's premier, a six-year project to clean and

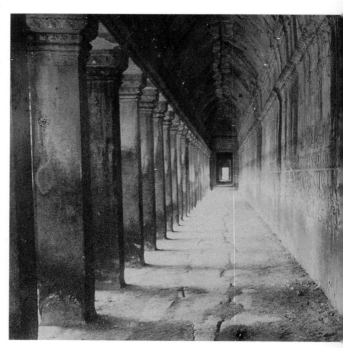

Scenes of Judgement *by Yama, torturers delivering punishments in hell, South Gallery of Bas-reliefs at Angkor Wat.*

restore Angkor Wat using Indian consultants and a Cambodian work force was begun. Their work has been greatly criticised by journalists and foreign experts who have condemned the methods and materials used. The Indian team, though, was working under extreme conditions, with difficulty in obtaining the necessary materials and in using untrained labourers and without the benefit of any past records.

Another project in the 1980s comprised a small team of archaeologists from the Ateliers for the Conservation of Cultural Property of Poland undertaking research and some exploratory excavation at the Bayon complex. Their work was limited and

hampered by lack of funds, as they were also involved in the restoration of early 20th-century murals of the Silver Pagoda in Phnom Penh.

THE ROYAL UNIVERSITY OF FINE ARTS (RUFA)

Fourteen years after the Khmer Rouge forced its closure, Phnom Penh's University of Fine Arts re-opened in 1989. Originally known as L'Ecole des Arts Cambodgiens (the School of Cambodian Arts) it was established as a co-educational institution for

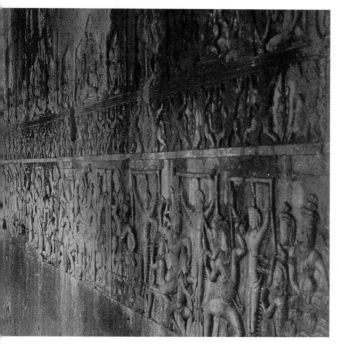

training students in the arts and crafts of Cambodia. Today it offers diploma courses in architecture, archaeology and the plastic arts as well and its students are becoming actively involved in the various international programmes related to the research and conservation of the monuments of Angkor.

THE UNITED NATIONS

Following the United Nation's recognition of the Kingdom of Cambodia, international support and direction was offered to a country that had been devasted by grief and destruction, and had almost lost its will to survive. With the arrival of the United Nations Transitional Authority in Cambodia (UNTAC), UNESCO (United Nations Educational, Scientific and Cultural Organisation) in 1991 established a regional office and assisted the new Royal Cambodian Government in seeking international support to safeguard Angkor.

In an historic declaration during a visit to Angkor Wat in November 1991, Federico Mayor, Director General of UNESCO, declared: 'Angkor, city of the Khmer kings, is waiting to become once more the symbol of its country. Vestiges, which bear witness to a rich and glorious past, reflect all those values that are a source for the

Khmer people of hope reborn and identity recovered. Yet this symbolic city is in peril. The ravages of time, the assaults of nature and the pillaging of man further its decline with every passing day. It must be saved!'

THEFT AT ANGKOR

Many sculptures and reliefs have tragically disappeared from the temples in the past two decades, leaving indelible scars where pieces have been hacked from the source. A known route is to smuggle the stolen art into Thailand where it is acquired by antique dealers in Bangkok and sold on the international art market. Illegal excavation is also a source of theft and deprives the country of archaeological evidence and valuable artefacts.

Efforts at government, local and international levels continue to help strengthen security at the monuments, museums and borders and to establish a greater awareness of the ramifications of theft.

INTERNATIONAL PARTICIPATION

Following peace negotiations which commenced in the latter part of 1989 and the establishment of the coalition government after the national elections in 1993, international participation in saving Angkor became more active. The signing of the political settlement known as the Paris Agreement in 1991 lifted the embargo on international development in Cambodia, and foreign aid and investment started to return, as did an increasing number of foreign visitors curious to experience the mysticism of Angkor.

Interest in assisting with the major challenge of safeguarding and maintaining Angkor came from around the the world. Following the archaeological survey of India's involvement, the World Monuments Fund was the first non-governmental foundation to arrive at Angkor in 1989 with offers of assistance. The EFEO soon returned to re-establish itself, and Japan, initially represented by the Institute of Asian Cultures from Sophia University in Tokyo and later by the Japanese Government, together with France, took a lead in creating international awareness, as well as pledging millions of dollars to support the campaign to safeguard Angkor.

Images obtained by radar and infra-red satellite are being used to give added dimension to the research of Angkor as they yield information that is not visible to the naked eye, and because they reveal details of features below the ground.

WORLD HERITAGE SITE

In December 1992, the historic site of Angkor was included on the UNESCO World Heritage List of over 400 sites; meeting stringent criteria set up by the International

Convention on Monuments and Sites. Inclusion on the list, recognises Angkor as one of mankind's most significant cultural heritage sites and the international symbol of Cambodia and its people. Once on the World Heritage List, a site must comply with conservation principles and undertake the conservation management plan set out in its application. In this way, it is hoped the fate of Angkor and its environs will be adequately protected.

The APSARA Authority (Authorite pour la Protection du Site et l'Amenagement de la Region d'Angkor or "The Authority for the Protection of the Site and the Development of the Region of Angkor"), is a non-governmental organisation set up specifically to administer the conservation and protection of Angkor. International organisations provide the government with technical assistance, and help with the training of professional and local staff and craftsmen to enable them to care for their monuments in the future. Students from the University of Fine Arts are undergoing basic training on many of the sites.

A Buddha image removed from a niche in the late 13th century by vandals, Preah Khan.

THE LOOTING OF ARTEFACTS

Angkor has suffered badly at the hands of looters and this is no recent phenomenon. Perhaps one of the most notorious cases was the theft of several fine sculptures from Banteay Srei in 1923, by none other than Andre Malraux—later to become a famous French politician, who as a young explorer planned a meticulous attack on the then ruinous and unknown temple. The objects were returned to their original place and prompted the EFEO shortly afterwards to undertake a major anastylosis of the temple.

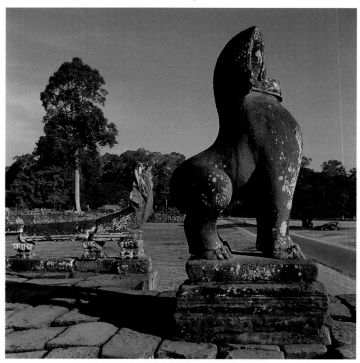

Srah Srang ('the royal bath') with a stately lion
on the majestic platform leading to the bathing pond.

Many fine sculptures have found their way to new destinations partly as a result of the earlier tradition of archaeologists expecting a share in their finds and, more recently, because after the civil war, Angkor was abandoned and unprotected, and prey to the many ruthless post war bounty hunters. Angkorian art soon became famous worldwide and many of the temples were raped by gangs solicited by art thieves from across the borders who tempted local peasants for a few dollars to carry out the looting and transportation of artefacts out of the country. Once abroad, these pieces, if they arrived reasonably intact, were soon to become priceless sculptures demanding tens of thousands of dollars per piece on the open market. At the other end of the scale, military from Vietnam would try to break off heads from bas reliefs and these mutilated pieces would later be found for sale around $10 in the streets of Hanoi leaving behind ugly scars on the buildings they once adorned.

Nearly three decades of civil war and a particularly rich heritage made Cambodia and, in particular Angkor, a great haunt for art traffickers in the 1980s and '90s. However, following the Tokyo Declaration to support the safeguarding of Angkor, and an urgent plea from HRH King Norodom Sihanouk, the Cambodian Government set up a policy to prevent trafficking and legislation was enacted in 1996. Almost immediately, support from the French Government and UNESCO enabled the creation of the Heritage Police Unit in Angkor to monitor the sites and local police units were stationed 24-hours-a-day at each of the sites to deter looting. Although sporadic looting still took place, Angkor was finally protected. Efforts at recovering many of the stolen pieces, especially those with doubtful provenance were very successful following the release by the International Council of Museums (ICOM) of a publication entitled *Missing Objects—Looting in Angkor*. Later many countries, including the USA became party to the Convention on Stolen or Illicitly Exported Cultural Property, which discouraged the sale of Khmer art objects. Such was the success of these measures that in June 1999 the National Museum in Phnom Penh held an exhibition displaying the artefacts that had been retrieved.

It goes without saying that it is illegal to purchase antique art objects, especially those made of stone, whilst in Cambodia. The penalties are severe and the disgrace is undeniable.

—John Sanday, OBE

A CONSERVATION PERSPECTIVE

Research over the last decade has proven that many of the Angkor Monuments remained in use after the capital was abandoned by its royal patrons, who moved south to settle more in the centre of their diminishing empire. The outlying temples were those to be abandoned first, but there is proof that some of the principal temples were remodeled and used as places of worship up until the 17th or even the 18th century. Since the departure of the royal patrons and the time of the Frenchman, Henri Mohout's rediscovery of Angkor in 1860, there were several expeditions to Angkor and there are records of visits by British travellers, by missionaries from Portugal, and by a Japanese mission which is said to have made the first map of Angkor Wat. There are records also, from the mid-16th century, of one of the latter Kings returning to Angkor Wat to restore the temple and complete the bas-reliefs in the northeastern galleries in the middle of the 16th century. However, many of the outlying sites were neglected since the 16th and 17th centuries, until the EFEO began its work at the beginning of the 20th century. During this time, most of the monuments had been engulfed by the jungle and seen little or no maintenance, and it is a wonder that so many structures are still standing. This situation has led to some unusual material and structural failures in the monuments, which are interesting highlights for the visitor.

The Khmers were originally used to building in timber and their skills in working in timber are reflected with many strange joints and details found in the stonework. Also, their engineering concepts were very poor and this is surely one of the main reasons for the present state of collapse of most of the principal structures. The stones cut from the quarries in the Kulen Hills were transported to the site as large blocks varying in size and quality—their understanding of building in stone was negligible and as a result there was little selection in the quality of stone used. The stones were originally laid as large blocks with no mortar or metal fixings to hold them together. Inadequate bonding between stones, even though great trouble was taken to create perfect and tight joints, and a simple system of crude vaulting for the roof structures, are the principle causes for failure.

The quality and strength of the stones differed depending from which part of the quarry they were taken. Stones used in Angkor Wat, for example, have eroded badly, mainly because of the poor quality of the stone and the presence of clays in the stratification of the stone beds. Sandstone is formed by a process of sedimentation causing horizontal layers to be consolidated into a variety of different qualities of

sandstone. During this process layers of clay are mixed with the sand. As clay tends to expand when it becomes wet, stones which have been laid incorrectly—with the strata set vertically—soak up the water and the expansion of the clay causes the thin stratification layers to flake. Stones should be laid on their natural bed but as monolithic columns require lengths of three to four metres, stones intended for columns are cut along the horizontal bed and are upended. Thus the stone, is laid on a vertical bed and moisture can creep, by capillary attraction, between the sedimentation layers. Most damage to the base of columns and walls in Angkor Wat, and elsewhere, is caused by this phenomenon. However, the constant flow of water will cause the laterite stone, often used in foundations to lose its structural integrity and under load it will fail, causing settlement in the foundations.

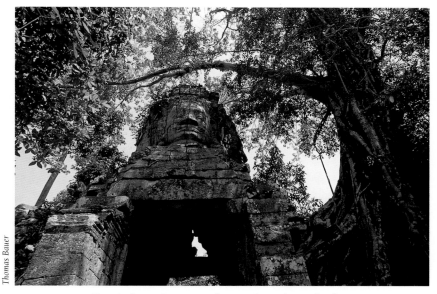

Thomas Bauer

Trees in the tropics are very fast growing and once they have sprouted long overhanging branches, they often become unstable.

Much of the attributed damage has usually resulted from deformation of the structure at the upper levels, in the roofs and vaults, thus allowing monsoon weather to penetrate and weaken the bearing strength of the laterite stone used as a backing or foundation base for the sandstone. This deformation encourages the growth of trees and vegetation in or on the structures.

There is no denying the very drastic damage caused by vegetation. The indigenous tropical forest grows very fast and if left unattended for a period of more than 20 years the forest will quickly take over once more. The EFEO had, prior to the civil unrest worked tirelessly to clear much of the jungle from around the principal temples. On its return in 1992 the temples were once more enmeshed in jungle. The effects of such trees—the *Tetrameles Nudiflora*—nicknamed *fromager* by the French because of its illusion to a ripe brie, flowing off the temple roofs, is very dramatic as can be seen in the temples of Ta Phrom and Preah Khan. These trees are very fast-growing and once their long overhanging branches have developed, they cause instability and falling branches can damage structures beneath them. Some trees that sprout from nearby ground have shallow roots and blow onto structures in strong winds. Strangler vines are parasitic and wrap themselves around the *fromager* slowly killing it and taking over as the dominant growth. In the first instance, the tree is dependent on the stone structure for its moisture and for its support. After a time, the roles are reversed and the structures torn asunder by the tree roots becomes dependent on the tree for support. Today, therefore, control of young vegetation in the monuments is of great importance; but, where the roles have been reversed, preservation of the trees should also be considered, particularly as many of the old and gnarled trees are seen as part of a site's history.

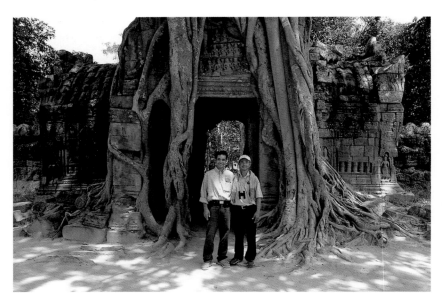

East gopura, *Ta Som*.

The cleaning of the stonework is always a great topic of debate. A typical example that questions the rationale of cleaning can be seen in Angkor Wat. The Archaeological Survey of India worked hard to clean various sections of Angkor Wat, in particular the exteriors of the galleries containing the bas reliefs. Within a few years, the pristine stonework has returned to its darkened colour streaked with a re-growth of the algae that was there before. In a tropical jungle climate and due to the stone's impervious nature, it is unlikely that any application to kill or control biological growths on stone will ever be successful as monsoon rains render any treatment ineffectual. Also the physical process of cleaning stone causes unnecessary surface abrasion and removes the natural protective surface of the stone. In general, biological growths do little to harm undecorated stonework and only in exceptional circumstances should stone exposed to the natural elements be cleaned.

CONSERVATION PROJECTS

Some 70 temples are accessible to visitors—with around 25 major sites—and, today, several of them are benefiting from international assistance. Work on each of these sites is a joint effort between the APSARA Authority, appointed by the Royal Cambodian Government, to administer the safeguarding of the historic city of Angkor. Each year there are two international level meetings when countries contributing to the safeguarding of the historic site of Angkor gather as the International Coordinating Committee (ICC) to monitor progress and to scrutinise new proposals. These proposals range from the physical process of conserving the temples and sites to the approval of commercial enterprises such as the tethered balloon flight over Angkor. A prime objective of the foreign expertise is to help with the training of local, professional staff and craftsmen to enable them to maintain their structural heritage in the future. Students from universities in Phnom Penh, for example, are undergoing basic training on several of the sites.

After several years of training and gaining experience working with the international specialist groups, the APSARA Authority is now well established and is playing an active role in administering the conservation programmes and attending to the growing threats of physical development assailing Angkor following its recognition as a major tourist destination.

There follows a summary of the monuments and sites in Angkor where international organisations are presently working in collaboration with the APSARA Authority. The projects are listed in alphabetical order:

ARCHAEOLOGICAL SURVEY OF INDIA—TA PROHM

The latest team to return to work in Angkor is the Archaeological Survey of India (ASI) subsequent to signing an agreement with the APSARA Authority in 2002. The ASI recently commenced work in Ta Prohm in the first quarter of 2004, tackling, among other issues, the of conserving or removing of trees—a difficult decision which is more often than not affected by romanticism rather than sound building conservation practice.

CHINESE TEAM FOR SAFEGUARDING ANGKOR—CHAU SAY TEVODA

The Chinese team arrived in Angkor in 1998 to work on the restoration of the Chau Say Tevoda, located at the East Gate of Angkor Thom. The extent of their work was to first complete the reconstruction or anastylosis of the southern library. At the same time the team has also been working on the eastern terrace and an interesting raised causeway which leads towards the adjacent Siem Reap River; this project is scheduled for completion in April 2006.

COLLABORATIVE PROGRAMME—ANGKOR WAT

Many different international organisations have, over the years, contributed to the conservation and protection of Angkor Wat, the cultural and religious national symbol of Cambodia.

Prior to the establishment of the APSARA Authority and the ICC, the ASI were involved in major restoration interventions at Angkor Wat between 1986 and 1992, which included the cleaning of the exterior; the reconstruction of several unstable structures including the libraries; the reconstruction of the Gallery of the Churning of the Sea of Milk and several efforts to consolidate the structural movement in the Galleries and towers at level three of the main structure.

France contributed in the early days of the campaign to provide lightning conductors following a strike on the central tower.

The Sophia University, Tokyo pledged funds to complete the restoration of the northern side of the principal west causeway over the moat in 1994. The southern half was restored by the École Française d'Extrême Orient (EFEO) in 1969. In collaboration with the APSARA Authority, repair works got underway in 2000 and are now nearing completion.

The first country to establish a long-term programme in Angkor Wat was the German Apsara Conservation Project (GACP) team which has been working since 1997 on the conservation and consolidation of the decorative stonework, especially the apsaras or devatas that adorn the facades.

Another important contribution is the restoration of Neak Ta, a statue thought to be the original Vishnu image from the central shrine, now found in the shrine on the southwest outer enclosure wall. Its arms were reconstructed and its original head replaced in March 2004, after its discovery at the National Museum.

The Japanese JSA team recently completed the restoration of the northern library, started in 1999.

The World Monuments Fund (WMF) initiated a scientific study of the structural stability of the Churning of the Sea of Milk bas-relief gallery in 2001, in order to begin to understand an endemic problem affecting all the galleries to a greater or lesser extent. More recently, the WMF has augmented its team and the study has been expanded to consider the conservation of the stone fabrication as well. Both studies are undergoing review. This research will go towards the development of suitable interventions to protect the bas relief and further arrest any structural movement, thus preserving one of Cambodia's most significant Khmer artefacts.

Following a major collapse of the embankment to the moat on the southwest side of the west causeway, the Italina Ingeneria Geotecnica Strutturale team took on the restoration of the steps forming this embankment using high-tech fibre fabric to stabilise the ground. This work was co-funded by UNESCO and APSARA Authority.

In June 2003, the APSARA Authority, which has grown into becoming an active participant in Cambodia's quest to safeguard its principal monument, organised a seminar to coordinate research and implementation activities in Angkor Wat. This was a major move towards developing a conservation management plan for one of the most significant religious monuments of mankind.

École Française d'Extrême Orient—Baphuon

The massive 11th-century temple-mountain of Baphuon is one of the sites the French were working on in the 1970s. Prior to the EFEO abandoning this site, it had dismantled much of the remaining structure, in preparation for its restoration. In February 1994, the EFEO resumed work on this temple, following the closure of the site due to the conflict. At the time, dismantled stones were scattered in their hundreds of thousands in the neighbouring jungle and the EFEO had to reconstruct the gargantuan puzzle; disasterously; all records of the carefully referenced documentation had disappeared in their absence. Years have been spent using computers to resolve the original methodology and, together with the skills of a few surviving Khmer stonemasons, the temple now rises from out of a pile of non-descript stones. The EFEO have completed a major part of the restoration of the Baphuon, especially the tricky task of how to present the colossal reclining Buddha that stretches the full length of the 40 metre-long temple platform base. When this section of the temple is finally opened to the public, it will be possible to walk along

a passage within the Buddha to view the unique sculpted vignettes that decorate the western *Gopura*.Since 1992, the EFEO has also worked successfully on the renovation of the Terrace of the Leper King and the northern *perron* (flight of steps) of the Elephant Terrace.

GERMAN APSARA CONSERVATION PROJECT (GACP)

From 1997, a group of scientists from Fachochschule in Cologne have developed a conservation programme known as the German Apsara Conservation Project (GACP)in Angkor Wat. Its focus, like many other organisations working in Angkor, has been to train local Khmers in the process of conserving the delicate decorative stone surfaces in Angkor Wat. Its work initially focused on the graceful stone bas reliefs of over 1,850 female figures, popularly known as *apsaras*, which, among other motifs, adorn the stones of Angkor Wat. GACP's brief has been extended to the exquisite highly ornate frontons over many doorways. More recently, the GACP team has been helping and advising many of the international organisations on how to care for decorative sculpture elsewhere in Angkor.

INDONESIAN GOVERNMENT—GOPURAS TO ORIGINAL PHIMENEAKAS ROYAL ENCLOSURE

The Indonesian Government's reconstruction of the *gopuras* or gateways, giving access through the enclosure wall encircling the 11th century royal temple of Phimaneakas came to an end in 2000 with the completion of three of the four *gopuras*. The system of anastylosis, which was made famous by the Indonesians in the restoration of Borobodur, entails the careful dismantling, recording and accurate reconstruction of a structure avoiding the use of any unsympathetic material.

ITALIAN UNESCO FUNDS IN TRUST—PRASAT PRE RUP

A team of engineers from Engeneria Geotechnica e Strutturale has been studying the structural problems relating to the brick towers of Pre Rup since 1996. With additional funds from the APSARA Authority, the team has undertaken the consolidation of several brick towers on the central mass which were threatening collapse using state-of-the-art engineering techniques.

JAPANESE GOVERNMENT—JSA
—THE BAYON NORTHEAST LIBRARY; ANGKOR THOM, ROYAL PLAZA EAST SIDE; ANGKOR WAT NORTH LIBRARY MAIN CAUSEWAY

The Japanese Government Team for Safeguarding Angkor (JSA) started working in Angkor in 1995. Its main focus at that time was the restoration of the northern library

Some of the temples will only be partially restored, to preserve the full history of Angkor.

of the Bayon, which was successfully completed in 1999. The team is still working on the preparation of a masterplan for the Bayon. JSA has also been working extensively on an archaeological excavation in the Royal Plaza, Angkor Thom where they have recently completed the restoration of one of the 12 laterite towers, known as the Prasat Suor Prat. The JSA team has also extended its work to the restoration of the northern library along the west causeway in Angkor Wat.

SOPHIA UNIVERSITY TOKYO—BANTEAY KDEI

This 12th-century Buddhist monastic complex is the site of a research programme directed by the Institute of Asian Cultures (IAC) of Sophia University, Tokyo. IAC was one of the first international agencies to begin work back in 1991 in Angkor and recently Sophia University has opened its own research centre. Work at Banteay Kdei has included the development of site inventories, archaeological and historical research, and collection of geological and botanical speciments. In 2001 the IAC made a dramatic discovery of 274 Buddhist sculptures that had been buried in Banteay Kdei probably when Hinduism returned in an iconoclastic surge in the

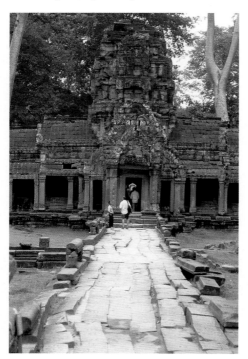

13th century following Jayavarman VII's desire to introduce Buddhism as the principal religion. The IAC continues its programme of architectural research and ethnographic studies of Banteay Kdei as well as two other neighbouring villages Srah Srang and Kutisvra.

SWISS GOVERNMENT— BANTEAY SREI

The Swiss team which arrived in 2001 has taken on the task of the protection and presentation of Banteay Srei and its environs. The team has carried out several key excavation exercises to understand the temple's original layout and its history.

West gopura, *Ta Prohm*.

WORLD MONUMENTS FUND—PREAH KHAN & TA SOM

The World Monuments Fund (WMF), a private non-profit organisation based in New York, has been operating at Angkor since 1992. Over the last 10 years it has been conserving and presenting Preah Khan, an immense Buddhist monastic complex, from the late 12th century, set deep in its own jungle. WMF's plans include developing this aspect so visitors can enjoy these surroundings, with a view to conserve and present Preah Khan as a partial ruin. By clearing paths, opening galleries and corridors, and ensuring structural stability, visitors are able to experience a feeling for the temple's past glory and importance. The success of WMF's programme in Angkor has prompted the construction of a delightful visitor centre which contains a record of WMF's conservation philosophy and drawings and photographs of all their interventions. Preah Khan is being established as an important didactic centre where visitors and Khmer students can learn more about Khmer architecture and tradition as well as how stone temples are repaired.

Following the success of the Preah Khan Project, WMF set up a similar undertaking at 12th-century Ta Som, located at the far eastern end of the Preah Khan Baray. WMF and the APSARA Authority's joint conservation project at Ta Som was set up to be run entirely by WMF's Khmer staff in 2001, when it was the only conservation project in Angkor run entirely by Khmers.

WMF'S latest and probably most diverse project in Angkor is to study the natural and architectural qualities of the temple atop Phnom Bakheng and to translate these attributes into a didactic and exciting experience for the many thousands of visitors who climb the hill to witness a sunset. Sunsets are very unpredictable and it is therefore the hope of this project to provide a new and worthwhile experience for all visitors at all times of day. With funding from the US State department, WMF is hiring specialists to produce a novel approach to protecting this site from the present effects of mass tourism—an invasion of a unique and early culture. —*John Sanday, OBE*

From Terrace of Leper King, looking southeast across parade ground to Prasat Suor Prat.

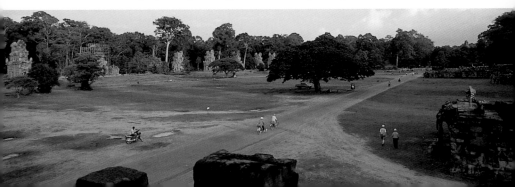

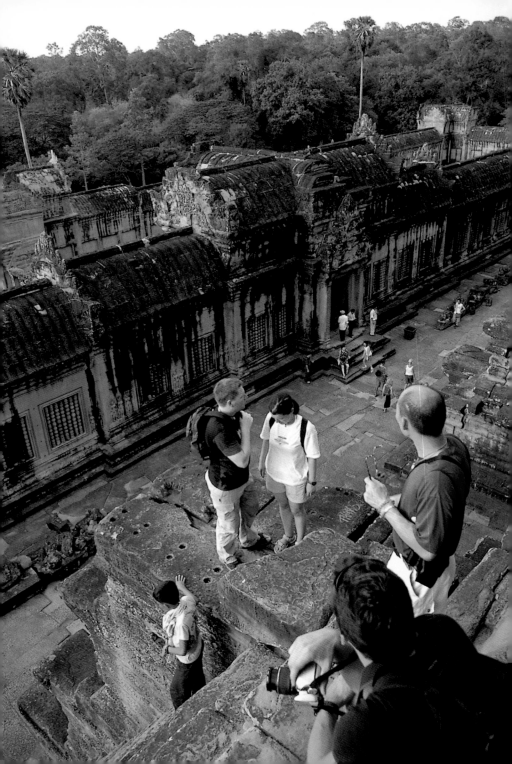

Above: *Remains of a false window at Ta Som.*
Left: *View from the upper level of the southwest tower at Angkor Wat.*

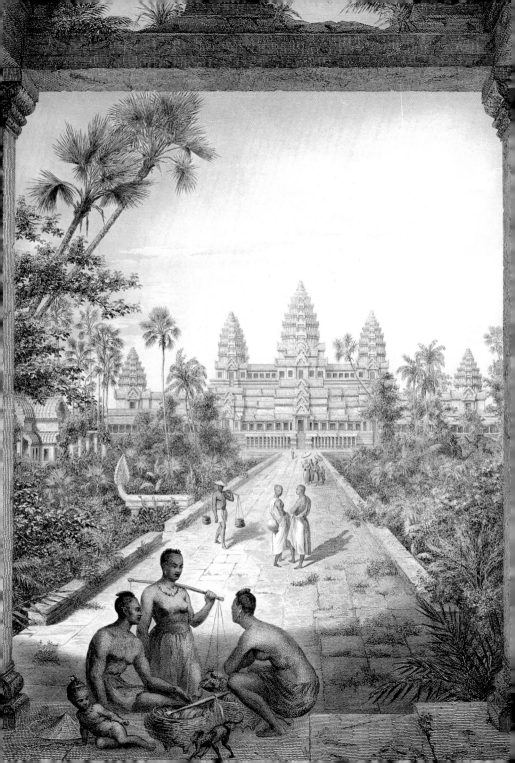

DAILY LIFE DURING THE KHMER EMPIRE

Reliefs carved in stone on the walls of the temples provide a glimpse of daily life at Angkor. From the scenes depicted we know something about what the people ate, what clothes they wore, their domesticated animals, flora and fauna; their means of transport, the games they played, the vessels they used for cooking, and the houses they lived in. There are striking similarities between the activities revealed on the bas-reliefs and those seen in rural Cambodia today. The suffering and devastation of the modern people notwithstanding, life in the countryside is probably quite similar to the past with little change in the basic methods and means of agrarian life.

One first-hand account survives from the 13th century and serves as an invaluable source by someone who actually experienced life at Angkor. The Chinese emissary, Zhou Daguan, gives a detailed description of daily life covering everything from his arduous journey on the Mekong to reach the capital, to childbirth and hygiene practices. This record gives insight on aspects of life for which we have no other information, but it has its limitations as the author was a foreign observer and thus excluded from activities within the palace. Just as many early Western accounts were written from a European perspective, Zhou's journals reveal a distinctly Chinese outlook.

The ancient Khmers had physical characteristics similar to the modern Cambodians. They were of medium height with black, often curly hair and had square-shaped faces with a broad forehead, a long straight nose with wide nostrils, and deep-set eyes: characteristics that can be seen in the faces on the bas-reliefs around the Bayon.

Similarities in dress between the ancient and modern Cambodians are also apparent. A single, rectangular piece of cloth, about two metres in length and one metre wide, is worn by both men and women today in the same manner as is depicted on the reliefs. The practical and versatile garment, a *sampot*, is of woven cotton, although a *sampot* worn by royalty in the Angkor period was made of embroidered silk woven with gold and imported from China, Champa (Central Vietnam), or Thailand. A woman wraps a cloth around her body in a manner that looks like a floor-length skirt and ties it gracefully in front or secures it with a belt at the waist. A man, on the other hand, draws the ends of the cloth up between his legs to form a pant-like garment. Today the male *sampot*

A late 19th-century sketch of Angkor Wat.

is checked or striped whereas a woman wears a patterned one, often in a brightly coloured floral design.

Zhou Daguan noted, however, that only the king could wear an 'all-over pattern,' probably referring to embroidered fabrics. A woman ties her hair back, off the face, and may secure it with fresh jasmine. In ancient times, both sexes wore elaborate jewellery consisting of necklaces, bracelets, and arm and ankle bands. The quantity and material of the jewellery depended on the status of the person wearing it. The ultimate wearers of elaborate jewellery and exotic hairdos were the *apsaras*. Some of the finest examples of these celestial nymphs and all their finery stand beatifically on the interior of the second level of Angkor Wat. Sometimes they are alone, other times in twos or threes, but always richly dressed and bejewelled.

The monsoon and lunar cycles governed daily life in the Khmer Empire. Alternating wet and dry seasons and the waxing and waning of the moon set the pattern for harvesting rice and catching fish, the two staples of the economy. To help nature provide the right balance of rain and to ensure abundant and fruitful harvests, the spirits had to be propitiated. Rites and festivals coinciding with the full moon were held in ancient times just as today. The year begins in April with

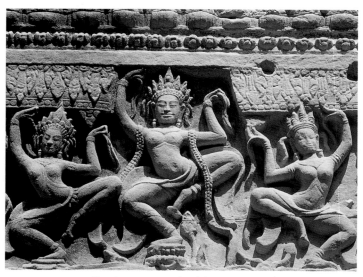

Dancing apsaras—*the ultimate wearers of elaborate jewellery and exotic hairdos, Preah Khan.*

a New Year Festival. This raucous event drives away evil spirits and concurrently invokes good ones with parades, boat races, dances, and, above all, merit-making, offering food, lustral water, and other beneficient things to the spirits, the gods, and the Buddha.

Zhou Daguan described the joyous New Year festivities at Angkor. 'In front of the royal palace a great platform is erected, sufficient to hold more than 1,000 persons, and decorated from end to end with lanterns and flowers. Opposite this, some 120 feet [35.6 metres] rises a lofty scaffold, put together of light pieces of wood, shaped like the scaffolds used in building stupas [temples]. Every night from three to six of these structures rise. Rockets and firecrackers are placed on top of these—all this at great expense to the provinces and the noble families. As night comes on, the king is besought to take part in the spectacle. The rockets are fired, and the crackers touched off. The rockets can be seen at a distance of 13 kilometres (8 miles): the fire-crackers, large as swivel-guns, shake the whole city with their explosions. Mandarins and nobles are put to considerable expense to provide torches and areca-nuts [used for betel chewing]. Foreign ambassadors are also invited by the King to enjoy the spectacle, which comes to an end after a fortnight.'[19]

When the rainy season begins in late May or early June a ceremony takes place to propitiate the spirits of the fields and to bless and sow the seeds before the rice is planted. On the auspicious day and hour the ritual of sowing rice is enacted. A sacred plough, ornately decorated with fresh, fragrant flowers, is drawn by buffaloes to the designated site, sacred rice is sowed, and the soil is ceremoniously furrowed; then the yokes are removed from the buffaloes. They are then free to seek out one of two previously placed bowls filled with water and rice; a third bowl is empty. If the buffaloes go to the bowl with water, then an adequate rainfall will follow. The bowl of rice ensures a bountiful harvest, and, conversely, the empty bowl signifies a poor harvest.

Just as the advent of the rainy season is recognised with fanfare, the end of it is celebrated with a rite to give thanks to the water spirits and offer a tribute to the *naga* king, god of the waters. The festival is a poignant one, even for those of other cultures and religions. Devotees solemnly lower boat-shaped offerings made of banana leaves and filled with candles, incense sticks, and fresh flowers into the water, either a river, canal, or pond. If you watch your boat until the candle extinguishes then all your wishes will be granted. This ceremony was celebrated on the River (*stung*) Siem Reap in November 1994 for the first time in over two decades.

Singing, dancing, music,and games are a spontaneous part of village life and the reliefs at the Bayon show some of this entertainment. You can see musicians play drums, trumpets, cymbals, gongs, bells, conches and flutes; a game of chess; and a cock fight.

From depictions on reliefs, we know that a typical house for a Khmer family of the farmer class at Angkor was much the same as can be seen in rural Cambodia today. It is one-storey, built of wood, and stands on stilts with a stairway leading up to the door. The open space underneath the house on ground level is multi-purpose. It provides room for storing household goods, is an area where the women weave cloth, and at night it serves as a corral for domesticated animals such as water buffalo, chickens, and pigs. Farming implements such as ox carts used for transporting materials and people, ploughs, sickles and hoes are all shown on the reliefs.

Central markets serviced a nucleus of villages and took place only in the morning. Trade was conducted almost entirely by women. Prices were negotiable and, according to inscriptions, barter was the form of payment in Angkorian times. Honey, for example, was exchanged for oil; cloth for syrup, and cotton for ginger conserve.

The inscriptions give some understanding of the organisation of Khmer society and the structure of the state. A large corps of officials administered the nation. Revenue was collected in the form of taxes, usually paid in barter such as grain or other commodities. Various courts existed to hand out justice and the inscriptions suggest that harsh physical penalities were imposed on those found guilty. Flogging and the amputation of hands or feet are among the punishments mentioned.

Although the Khmers never adopted the caste system of India they did have classes of society. The king was at the top of the scale. A successful king ensured the prosperity of the kingdom and passed it on to his ancestors. His protective power was omnipotent and encompassed the people, state, law and soil. This factor was so important that the reign-names of successive kings included the honorary suffix *varman* ('armour') which was later extended to mean 'protection' or 'protector'. Each king built a state temple, other monuments dedicated to his ancestors, a palace, and a *baray*—all as physical expressions of his power and protection over his people and his kingdom.

The territory that the Khmers controlled was divided into areas and districts, each administered by a team of officials, appointed by the king. From time to time, a provincial area increased its local autonomy and halting such threats to

Foot soldiers depicted in some reliefs
can be seen using shields, lances, swords, and spears in battle.

his rule was always a concern of the king. Priests were close to nobility in the class structure and occupied a revered position. Scholars, poets, astrologers and astronomers were privileged members of the intelligentsia, whereas teachers and sacrificers were hereditary appointments.

Warriors and farmers formed the largest classes. Armies were conscripted depending on the need for troops to protect the capital and to wage battles with enemies. Hand-to-hand combat is depicted in the reliefs and massive armies can be seen using shields, lances, swords, and spears in fierce battle. The slave class ranked the lowest in Khmer society and consisted of debtors, prisoners of war, and hill tribesmen. Slaves undoubtedly maintained the temples and comprised the massive work force that would have been required to build the monuments.

Women have held a position of respect and equality in Cambodian society throughout history. Inscriptions recount the hereditary lineage of the ruler often passing matriarchally with the inheritance of property also being transmitted through the female line. Women figured in the government during the Angkor period and were also prominent in the economic structure of the empire.

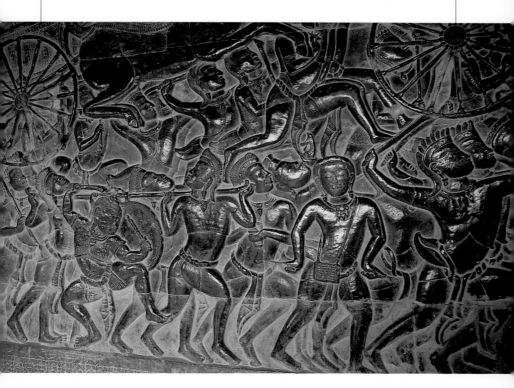

RELIGION

Your appreciation of Angkor will be greater if you have some understanding of the religious traditions of the Khmers which both inspired and governed the concept and execution of all their art and architecture. The earliest form of worship in Cambodia was a widespread primitive belief in animism or spiritual forces. Patronage to it was potent and enduring, and spirits are still worshipped in modern Cambodia. Spirits reside everywhere, it is believed—in the trees, rivers, mountains, stones and the earth. These supernatural forces are both revered and feared as they can be protective or destructive. Because of this duality, widespread superstitions surround them.[20] Rituals are conducted to either invoke or appease the spirits with attention to those who govern the earth such as the *naga*, guardian of the waters, and other forces that have control over man's survival. Ancestral spirits or *neak ta*, are another large and powerful group that resides in nature's habitats such as hills and trees. They require nurturing and pacifying because, according to tradition, when a person dies his soul is reincarnated and his spirit becomes free.

In the early centuries of the Christian era, formal practices from India reached Cambodia and artistic interpretations of India's two religions, Hinduism and Buddhism, became the main themes of Khmer art. The foundations of these religions, though, are based on earlier beliefs of the Indo-Aryans, expressed mainly through the *Vedas*, a text compiled from oral traditions.

While the practices from India were adopted in principle, they were not accepted without modification. Instead, aspects were adapted to suit the ideological and aesthetic ideals of the inhabitants of mainland southeast Asia. Worship of nature's spirits was never abandoned and tenets from animism and the Indian-influenced religions were synthesised. During the Angkor period, even though the religion favoured by the reigning king predominated, worship of local spirits was always part of the prevailing religious practices. Buddhism, for example, absorbed animistic beliefs into its doctrines and borrowed a few of the Hindu deities, while Hinduism embraced gods from several ancient traditions. This amalgamation of beliefs is also reflected in Khmer art, and it is not uncommon to see scenes on bas-reliefs that incorporate aspects of Hinduism and Buddhism.

Legacies of Brahmanism, an earlier tradition, are found in later religious practices. Its principles were formulated between 900 and 500 BC and expressed in the *Brahmanas*, a group of texts used by priests or brahmins to conduct rituals. They also evolved from an earlier text, the *Vedas*, subscribed to by the Indo-Aryans, who settled

Religious monument (stupa) in the central sanctuary of Preah Khan. (John Sanday)

in northern India during the second millennium BC. You can see reflections of this ancient religious practice in dramatic depictions of the Vedic gods, Agni (Fire), Indra (Thunder) and Surya (Sun), at Angkor Wat in the gallery of bas-reliefs (northwest side). Brahmanism retained Vedic rituals and sacrificial practice, and supported the belief in a universal god, but also modified the gods of Vedic times. Besides a series of divine beings, Brahmanism embraced animistic spirits, demons and several other mythical beings that are found later in the Khmer art of the Angkor period. It also adopted the concept of the cosmology of the world with Mount Meru situated at the axis of the universe.

Sometime in the early centuries of the first millennium BC another group of texts, the *Upanishads*, was composed. It reacted against the sacrificial practices of Brahmanism and focused on philosophical thought. An important idea carried over to later religious practices was the relationship between the individual being and the 'Universal Being', a theme that recurs in both Hinduism and Buddhism. It recognised a common belief in rebirth or the idea that one is born again and again in different forms with the ultimate goal being unity and release from the infinite chain of rebirths. This idea was adopted by all the later formal religious practices in Cambodia.

Around the beginning of the present era the early beliefs of the Vedic traditions and Brahmanism fused with ideas from the *Upanishads* and other oral traditions and gave birth to Hinduism, the dominant religion in India today. Hinduism accepts the existence of many sects and schools of thought. Followers believe in a universal principle and they worship, among others, the deities Brahma, Shiva and Vishnu.

Hinduism inspired several religious cults that became dominant forms of worship at Angkor. Shivaism was the earlier of the two and prevailed in the ninth and tenth centuries. Vishnuism supplanted it in the 11th century. The *devaraja*, (meaning 'the king of the gods' in Sanskrit) was yet another cult that developed in Cambodia during the Angkor period. Despite the translation of the term, research by leading modern epigraphists and historians argues that there is no evidence of the ruler's consecration as a god-king.[21] Further debate amongst scholars centres on the importance of the cult in Cambodia during the early Angkor period in a political context, as evidence has shown that the cult was not unique as it existed in the pre-Angkor period at Zhenla. The *devaraja* cult did exist at Angkor, but its importance and function are still being determined.

One of the enigmatic faces, upper level, Bayon.

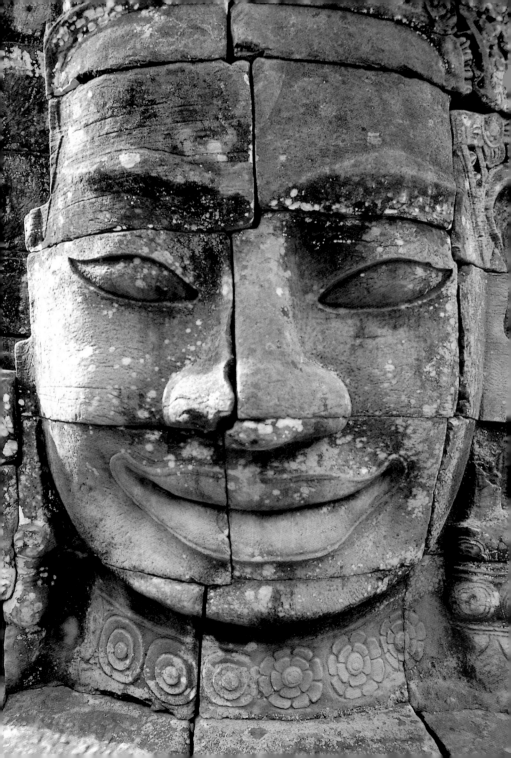

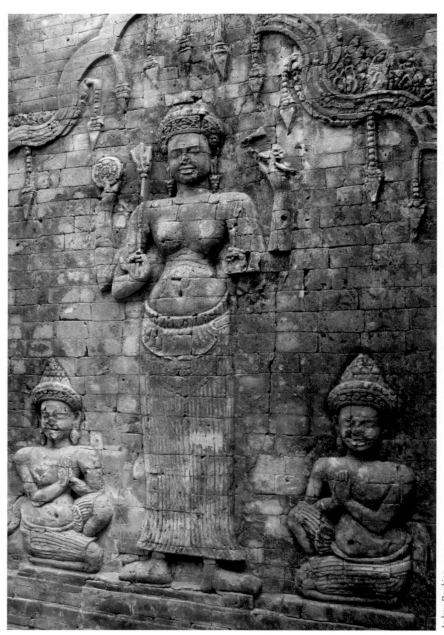

Andrew Dembina

Lakshmi (centre), the consort of Hindu god Vishnu, carved in brick, Prasat Kravan.

The *Puranas*, another religious text, followed the *Upanishads* in chronology, although their present form did not materialise until around the fourth or fifth century AD. It contains mainly legends about the gods, particularly Krishna, the cowherd, who was one of the most popular Hindu deities in early Khmer art. You can see sculptures of Krishna holding up Mount Govardhara in many of the frontons of temples at Angkor.

Buddhism began in India as a reform movement against Hinduism. A main difference is that it centred on a historical figure known as the Buddha (the 'Enlightened One') who was born as Prince Siddhartha in Lumbini, in the lowlands of present-day Nepal, about 623 BC and died around 543 BC, although these dates are regularly disputed by experts. His surname was Gotama. Because he was born into the princely warrior clan of the Sakyas he is often called Sakyamuni. His parents were King Suddhodana and his first wife, Queen Mayadevi. Several key events in the historical life of the Buddha from childhood through his attainment of enlightenment provided themes for Khmer artists and are depicted in several bas-reliefs at Angkor.

By the first centuries of the present era two branches of Buddhism were defined—Mahayana and Theravada. Both of these were transmitted to Cambodia at various times, but it is Mahayana Buddhism that is of the most relevance to the art and architecture at Angkor, as Theravada Buddhism was introduced only in the 13th century, after all the major monuments had been built. Both schools give importance to the act of offering and recognise that giving frees the giver from all attachments.

Mahayana Buddhism, known as the 'Greater Vehicle', may have reached Cambodia by way of the Kingdom of Srivijaya (Indonesia) and Funan where it was practised in the fifth century. Although Mahayana Buddhism had some following during the early Angkor period, it reached a peak of popularity in the late 12th and early 13th centuries during the reign of Jayavarman VII. It is practised today in Nepal, Tibet, Bhutan, Mongolia, China, Korea, Japan and Vietnam. The principles of this sect are expounded through the Sanskrit language. Followers of Mahayana Buddhism believe in the attainment of 'Buddhahood' and the removal of all ignorance. They recognise that there were others before the Buddha who had gained enlightenment and that there would also be others in the future.

The religious ideal of Mahayana Buddhism is a bodhisattva and it was widely portrayed in Khmer art, especially during the late Angkor period. A bodhisattva ('enlightenment being') is one who has performed enough merit to enter Nirvana, but renounces attainment of enlightenment to return to earth and help the sufferings of all humanity. Several bodhisattvas appear in Khmer art, particularly in stone

sculptures, but the one most frequently represented in reliefs is the Avalokiteshvara, 'the Lord who Looks Down from Above', known in Cambodia as Lokeshvara, 'Lord of the World'. This figure in Khmer art is usually a four-armed deity who carries a nectar flask, book, lotus and prayer beads with a small figure of the Buddha seated in meditation in his headdress. If the bodhisattva has eight arms, he holds additional objects—a thunderbolt, an elephant goad, a conch, discus, and sword. The Avalokiteshvara appears in several forms in art during Jayavarman VII's reign. Some believe the faces on the towers of the Bayon represent this being. And the temple of Neak Pean with pools filled with water with curative powers was a place of pilgrimage where the sick could invoke healing from Lokeshvara. In the middle of the central pond, the focal point is a sculpture of the horse Balaha with figures clinging to it which depicts an episode when Lokeshvara changes into a horse to rescue the people who were victims of a shipwreck.

The development of the cults of the bodhisattvas and those of the Hindu gods parallelled each other in the early centuries of the present era, and, thus, it is not surprising to see Hindu features such as hair style or attributes in the Avalokiteshvara. Further merging of the two is seen in the ninth incarnation of the Hindu god Vishnu which is the Buddha.

The **Theravada** School of Buddhism spread gradually from Sri Lanka to mainland southeast Asia by way of Myanmar, Thailand and Cambodia between the 11th and 15th centuries and is practised in those areas today. Theravada Buddhism, ('School of the Elders') adhered to conservative principles preserving the original doctrines and expressed them through the Pali language.

HINDU DEITIES

Gods and goddesses from the Hindu pantheon depicted in Khmer art are eternally youthful, yet have a noble air of elegance. They

One of the few remaining Buddhas in a niche, east processional way, Preah Khan.

Thomas Bauer

appear sitting, standing or reclining without eroticism or nakedness. Identification is not revealed in their faces as they show no emotion except for an expression of serenity.

So how is a Hindu deity recognised in Khmer art? Each deity is associated with specific symbols or attributes, that represent his powers and he often holds these in his hands, which help to identify him. A deity often rides a mount or vehicle, which is another distinguishing feature. The presence of a wife or consort, representing the god's female energy, or *shakti,* who often carries the symbols of her spouse is yet another clue to the identity of a deity.

Keep in mind that many of the Hindu pantheon of gods and goddesses had their origins in ancient Vedic times. When they reappeared later in Hindu iconography they had often changed, and had different identities, characteristics, functions, influence and prominence—all of which were introduced to suit the new concepts of Hinduism. The descriptions that follow are of gods, goddesses and other mythical beings, as they appeared in the Hindu pantheon. References to their earlier forms are only mentioned if needed for identification.

■ GODS

Shiva was one of the earliest and most popular of the Hindu gods represented in Khmer iconography. He appeared in the pre-Angkor period in the form of a composite figure Hari-Hara and in the early Angkor period when several temples— Phnom Bakheng, Baksei Chamkrong, Banteay Srei, and the Roluos group (Bakong, Lolei and Preah Ko)—were dedicated to him.

Early representations of Shiva were in the form of a *linga,* shaped like an erect phallus and usually made of polished stone. The vertical shaft may be divided into three parts symbolising gods that were often worshipped simultaneously. The lower, square portion represents Brahma; an octagonal section in the middle relates to Vishnu; and the upper, cylindrical part with a rounded tip is associated with Shiva. The base of the *linga* is anchored in a square pedestal with a hollow channel on one side, out of which the waters of ablution flow, symbolising a *yoni,* the vulva-shaped female emblem of power.

Although Shiva as a *linga* was widely represented at Angkor, he also appears in some human forms in Khmer art. He is most often depicted as a benevolent god and his fierce aspect, so popular in India, is seldom found at Angkor. Shiva lives on Mount Kailasha in the western Himalayas with his wife Parvati (Uma) and two sons— Skanda (Karttikeya), the God of War, and Ganesha, the God of Knowledge.

A fine relief at Banteay Srei (south library, east face) shows Shiva holding a frightened Parvati on his knee as the demon Ravana tries to topple Mount Kailasha. Shiva's vehicle is the bull, popularly known as Nandi, who is as 'white as the Himalayan peaks'. Images of a crouching Nandi are commonly found facing the entrance of temples dedicated to Shiva such as Preah Ko. Shiva's main attribute is a trident, an indestructible weapon that represents absolute truth. Shiva has a chignon separated into strands of loops in tiers, a brahmin cord over his shoulder, and has a third eye in the middle of his forehead near his brow. It is in a vertical position and is always closed because, according to legend, the universe will be destroyed by a great fire if it opens.

Another human form, depicting Shiva as 'Lord of the Dance', is on a superb pediment at Banteay Srei (east *gopura*) which shows the god in a lively dance with his ten arms fully extended in a joyful rendition. Sometimes in one of his human forms Shiva is shown as an ascetic meditating on a mountain with hermits. Thin with matted hair tied up on top of his head; he carries a water pot and wears a strand of 108 beads around his neck.

Vishnu was a popular Hindu god in Khmer art, widely depicted both in sculpture and reliefs. Vishnu's headdress in pre-Angkor art is cylindrical, whereas, later in the Angkor period, he wears a diadem. In his typical posture, Vishnu is standing with four arms and holds a conch shell, a ball representing the earth (a lotus in Indian iconography) and two weapons—the club and the discus. You can see a dramatic portrayal of this posture of Vishnu at Prasat Kravan (central tower). Vishnu is riding his mount the *garuda*, the mythical king of birds.

Known as the preserver, Vishnu has *avataras*, literally 'descents' and whenever the world is threatened by evil, he assumes the role of saviour and descends to earth in a suitable form. He is reincarnated as a human or animal and guides mankind through the dissemination of his goodness, which eventually triumphs over the forces of evil. Descriptions of Vishnu's ten major *avataras* follow. The sequence of the *avataras* reflects the biological evolution of man according to Hindu mythology. (Rama and Krishna are the most popular ones in Khmer art).

(1) **Matsya,** the fish who saved mankind from a flood.

(2) **Kurma,** the who served as a support for the mountain in the Churning of the Ocean of Milk.

(3) **Varaha,** the boar who held the world above the waters of chaos to prevent its destruction and adorned it with mountains and continents.

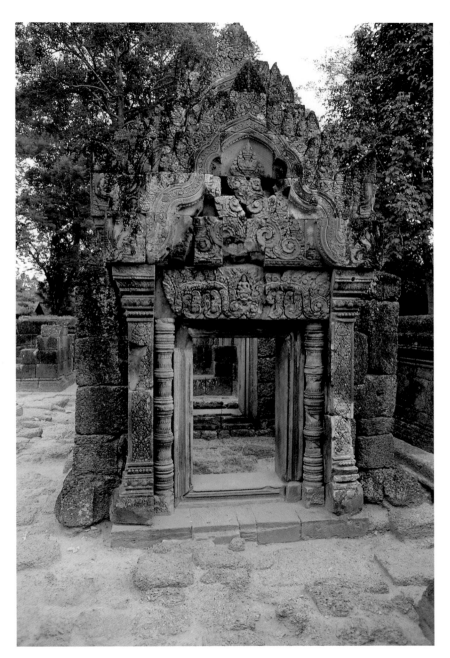

Banteay Srei.

(4) **Narasimha,** the man-lion who overcame the demon, Hiranyakashipu, even though he was invulnerable to man or beast.

(5) **Vamana,** the dwarf who overcame the demon, Bali, and saved the world in three steps. He carries a water pot and an umbrella.

(6) **Parashurama,** known as 'Rama with the Axe'; a martial hero.

(7) **Rama,** the ideal king who performs heroic deeds.

(8) **Krishna,** who is depicted in several stages of his life: childhood, when he performed great feats such as uprooting trees along with a stone he was tied to; youth, when he was a flute-carrying, cow herd and dallied with young girls; manhood; and middle age, when he became a charioteer.

(9) **The Buddha;** according to Hindu belief, this form of Vishnu represents the historical Buddha.

(10) **Kalki,** the horse-human. Vishnu's last incarnation, who is yet to come; he will emerge at the end of our present time-cycle.

Aside from Shiva and Vishnu, there are numerous additional deities:

Agni, god of fire, especially the sacrificial fire, rides a ram.

Brahma, the Creator in the Hindu Trinity with Vishnu the Preserver and Shiva the Destroyer, rides the *hamsa*, a sacred goose. Identifying characteristics: four faces, one looking in each cardinal direction, but only three are visible; his attributes are: prayer beads, a vase, a ladle, and a book. His consort is Sarasvati. According to legend, Brahma was born from a golden lotus that emerged from the navel of Vishnu who was reclining on the serpent, Ananta, on the waves of the ocean during a cosmic sleep.

Ganesha, god of wisdom and remover of obstacles; rides a rat; he is a son of Shiva and Parvati. Identifying characteristics: elephant-shaped head and corpulent, human-shaped body and usually has four arms; his attributes are: an elephant goad, a noose and a bowl of sweetmeats; his fourth arm is held in a gesture of fearlessness. A variation is that he carries a fragment of his broken trunk in his right hand; he removed his tusk to use it as a pen when he was a scribe for the Vyasa when he recited the Mahabharata. One explanation for his form is that Ganesha was actually born with a human head. Shiva was away at the time of his birth and when he returned he encountered an unfamiliar young man guarding Parvati's quarters. Shiva tried to enter but Ganesha forbade him. Shiva was so angry he could not enter his wife's quarters that he beheaded Ganesha, not knowing it was his son. Parvati pleaded with Shiva to save Ganesha's life, so Shiva gave him the head of the next creature he encountered, which was an elephant.

Hari-Hara, a composite deity of Shiva and Vishnu. Identifying characteristics: the plaited locks of an ascetic, representing Shiva and a vertical third eye on his forehead; the cylindrical headdress of Vishnu.

Hevajra, a deity in Tantric Mahayana Buddhism (also known as Heruka). Identifying characteristics: eight heads, 16 arms, and a vertical third eye on his forehead; appears in dancing posture with his left foot crushing a demon.

Indra, god of the sky in Cambodian mythology; his mount is the white elephant Airavata or Erawan. Identifying characteristics: he wears a high tiara or turban, elaborate garments and jewellery; he may carry a thunderbolt, a disc, an elephant goad and an axe. In Vedic times, Indra was the ruler of Tavatimsa Heaven where he controlled the weather. He kept this position in Buddhism and is often seen with Brahma as an attendant of the Buddha.

Kama, god of love, rides a parrot. Identifying characteristics: a sugar-cane bow strung with a line of humming bees and arrows with floral tips. Kama likes to shoot his arrows so as to inspire passion in others, especially in the spring. His consort is Rati. Kama is portrayed in a pediment at Banteay Srei with Shiva and Uma

Kubera, god of wealth; usually rides a dwarf *yaksha*. Identifying characteristics: an ugly dwarf covered with jewels and wears a crown; often surrounded by bags of money. He is guardian of the north and resides high in the Himalayas where he watches over the treasures of the earth.

Skanda (also known as Karttikeya and Kumara), god of war; rides a peacock. Identifying characteristics: multiple heads and arms (often six); carries a double thunderbolt, a sword and a trident. He is considered a son of Shiva and Parvati. Skanda shows his prowess as an archer with an arrow made by Surya from the heat and energy of the sun is a popular theme for reliefs.

Surya, a deity in Vedic times known as god of the sun; rides a golden chariot drawn by seven horses (or one horse with seven heads). Identifying characteristics: a swastika; sometimes he holds a lotus in each hand.

Yama, god of the underworld who judges the dead; he rides a black buffalo. Identifying characteristics: multiple arms carrying a club and a noose. He presides over the gloomy realm of punishment located in the lower regions. All souls must pass by Yama's throne of supreme judgment. As the Lord of Law, Yama keeps a register in which each man's life span is recorded. He allots seats after death in accordance with an individual's performance in the world.

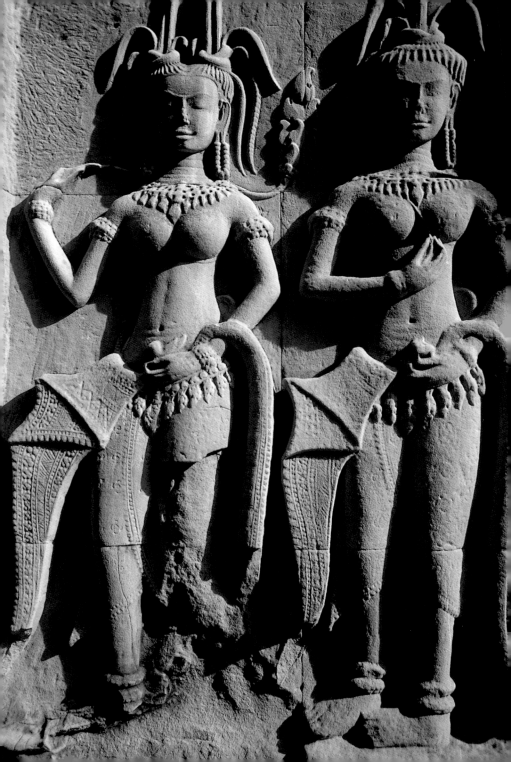

■ GODDESSES

Devi, the 'Great Goddess', is a complex and powerful being. She rides a lion or a tiger; at other times the mount is simply beside her. Identifying characteristics: she carries weapons including a sword, a sacrificial chopper and a trident. In ancient times she was the great mother goddess connected with fertility of the earth and female reproduction. She was also the consort of Shiva. She has several different names, roles, and characteristics. Some forms are fierce, such as Durga ('Inaccessible') and Kali ('Black' or 'Time') and others are mild, such as Guari ('White') or Parvati ('Daughter of the Mountain').

Ganga A goddess associated with the Ganges river and one of Shiva's wives. According to legend, Ganga descends from heaven and Shiva catches her in his hair to break her fall to earth. Thus, she is often depicted as a small figure in the matted hair of Shiva with a river spouting from her mouth.

Lakshmi, goddess of good fortune and abundance from early times. She is also known as Sri. Lakshmi was born with a lotus in her hand from the Churning of the Ocean of Milk. She is often depicted on a lotus (her symbol) pedestal and attended by two elephants sprinkling lustral water on her with their trunks. The number of her arms and attributes vary but they usually include a lotus and a conch.

Parvati ('Daughter of the Mountain') is Shiva's consort and the daughter of the god of the Himalayas. She is also known as Uma. Parvati sometimes carries the trident of Shiva, is often depicted on a lotus pedestal, and rides a lion.

Rati is the spouse of Kama, god of love, and usually associated with sexual desire and passion.

Sarasvati ('The Flowering One') was a river goddess in early times, but in Hinduism she is known as the goddess of learning and the consort of Brahma. She rides a peacock. In Mahayana Buddhism she is the goddess of teaching, music and poetry.

■ MINOR DIVINITIES AND MYTHICAL BEINGS

Ananta ('Infinite') is the name of the serpent on which Vishnu reclines when he is in a cosmic sleep. Also called Shesa ('Remainder') and Vasuki.

Apsara (female divinity) is a heavenly nymph, a courtesan of the sky, who pleases the gods with song and dance.

Asura (demon) is the perpetual adversary of the *devas* or gods in Hinduism; represents the forces of darkness or evil.

Deva (or *devata*), a deity (feminine form is *devi*), is considered a celestial being in Buddhist cosmology.

Apsaras, female divinities, on the interior of the second-level gallery, Angkor Wat.

Dvarapala ('Guardian of the Gate'). This large figure, is also known as the protector of shrines and is often found standing at the entrance to a temple holding a club.

Garuda, king of birds, is the mount of Vishnu and the enemy of the *nagas*. He is a gigantic mythical bird with a human body and bird-like wings, legs and a thick curved beak with bulging eyes; his lower body is covered with feathers and he has the claws of an eagle; he wears a diadem and jewellery. He is one of 72 *garudas* that appear in magnificent form on the outer enclosure wall at Preah Khan (the figures at the west and east entrances are in particularly good condition), with arms stretched above his head, grasping the tails of serpents whose heads curl up at his feet. Another good example of the *garuda* is seen around the base of the royal terrace at Angkor Thom.

Kala is a mask-like creature commonly found in both Hindu and Buddhist temples, who serves as a protector for the temples, and, as such, is found above the doorways. A *kala* has round bulbous eyes, a human or lion's nose, two horns, claw-like hands, and grins. According to legend, the *kala* had a voracious appetite and asked Shiva for a victim to satiate him. Shiva was angered by the request and ordered the *kala* to devour itself. The *kala* consumed its body but not its head. When Shiva heard that the *kala* had followed his order he had its head placed over the doors of temples as a reminder of its 'terrible and beneficient' powers. Fine examples of the *kala* are found on the lintels of the Roluos group.

Makara, a large sea animal with the body of a reptile and a big jaw and snout that is elongated into a trunk, is often depicted spewing another creature or plant motif from its mouth. This mythical creature appears on the lintels of the temples at Roluos.

Naga ('Snake'), a semi-divine being and a serpent-god of the waters, lives in the underworld beneath the earth or in the water. It has a scaly body and multiple heads spread in the shape of a fan. In Khmer art, the *naga* always has an uneven number of heads, usually seven or nine. The *nagas* are ruled by Vasuki and are the enemy of the *garuda*. The *naga* controls the rains and the prosperity of the region where they reside. *Nagas* often marry humans in mythology and the Khmers claim their descent from the union of a foreigner and the daughter of the *naga* king. The Khmer's obsession with the *naga* is reflected in its omnipresence at the temples of Angkor. A typical rendering of this mythical being is a balustrade formed by the body of the serpent that flanks the long causeways leading to the monuments and can be seen at Preah Khan, Bakong, Angkor Wat, and in front of the gates at Angkor Thom.

Nandi (or Nandin, 'Joyful'), a white bull and the vehicle of Shiva.

A powerful garuda spreads its wings on the outer enclosure wall at Preah Khan.

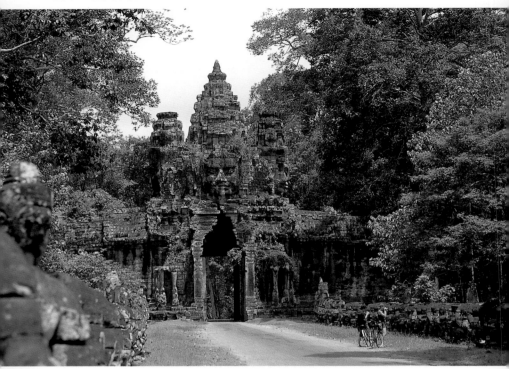

The north causeway, Angkor Thom.

Rahu, a demon who rides through the sky in a silver chariot. According to legend, he causes eclipses by seizing and swallowing the sun and the moon. They eventually reappear from inside his throat, thus ending the eclipse, but he then resumes the task. Like the *kala*, Rahu has no body, just a head, arms and hands. Even today, the Cambodians make tremendous noise before an eclipse to keep Rahu from consuming the moon.

Rishi a Sanskrit term which refers to a sage, an ascetic or a hermit. A *rishi* in Khmer art is seated cross-legged in meditation and has a goatee.

Vasuki (or **Ananta**—see previous page) is the serpent upon which Vishnu reclines or sits and whose body served as a rope when the Ocean of Milk was churned by the gods and demons.

Yaksha is a male semi-divine being who often serves as a guardian. This mythical being has a ferocious appearance and is gigantic in size with bulging eyes, fangs, and a leering grin. In the Ramayana the *yaksha* is a demon giant who lives on the island of Lanka.

LEGENDS IN KHMER ART

The *Mahabharata*, a great Hindu epic, served as the source of inspiration for many narrative scenes depicted in Khmer art. It was put in writing perhaps as early as 400 BC and completed in AD 300. It is written in stanzas and is longer than the *Illiad* and the *Odyssey* combined. The main event of this text is the Battle of Kurukshetra involving the Pandava clan and their cousins, the Kauravas. This event is dramatically depicted in an action-packed scene at Angkor Wat in the gallery of bas-reliefs (west gallery, south side).

Another ancient, Indian epic, the *Ramayana* (*Reamker* is the Cambodian version), has penetrated the art and culture of all south and southeast Asian countries and influenced Khmer art throughout the Angkor period. It was vividly transposed on the bas-reliefs. Later, tales of the *Ramayana* were depicted in mural paintings, shadow plays, theatre, and dance. Episodes from the epic are being revived today in performances by the Cambodian Royal Ballet. It is generally accepted that the composition of the *Ramayana* took place between 200 BC and AD 200.[22] The early date, long evolution, wide distribution and complexities in translations have resulted in numerous changes, additions and variations. Thus the legacy of the *Ramayana* consists of many versions and sources differ. The one written by Valmiki, the first poet, is summarised in this guide as it is the main *Ramayana* source for Khmer art. This lengthy epic is written in grand heroic style and the theme centres on a series of action-packed adventures and ordeals of Rama and the abduction of his wife Sita by the demon Ravana. Laksmana, Rama's brother, and Hanuman, the demi-god who leads the monkey warriors, figure prominently in the story and assist in the rescue of Sita. Violent battles rage. Heroes fight bravely and take on their enemies single-handledly. They go to battle in grand style, magnificently attired and bejewelled. Miracles happen and magical spells are cast. Arrows turn into snakes, then to mythical beings, then to fire. Monkeys lift mountains and gods and demons shrink and expand in size to suit the scene. Even though the episodes are carved in stone, you can detect emotions in the characters—pain, fear, sadness, grief, and tears. The drama of this much-loved story is portrayed in the *Battle of Lanka* at Angkor Wat in the gallery of bas-reliefs (west gallery, north side).

The characters and places that appear in this summary are:

Ayodhya: the capital of Kosala, ruled by Rama's father.

Dasaratha: Emperor of the Kosala Kingdom; father of Rama.

Hanuman: monkey general with exceptional strength, energy and wisdom

Following pages: A scene from the Judgement of Yama, south gallery of bas-reliefs, Angkor Wat.
(Michael Freeman)

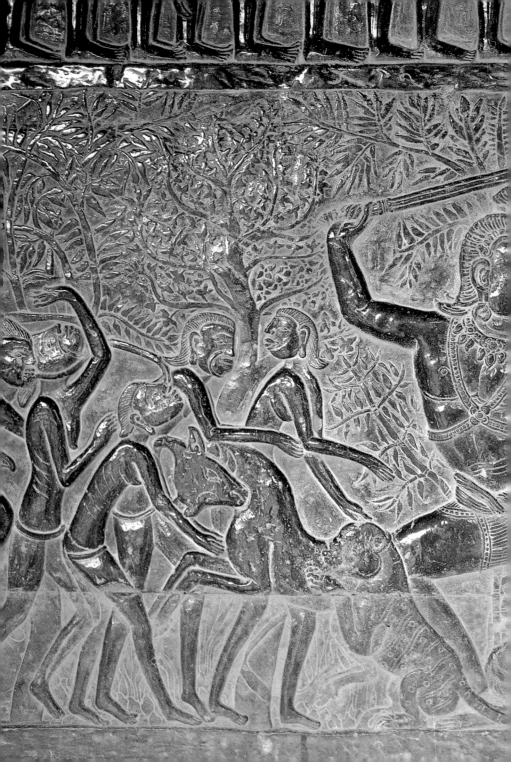

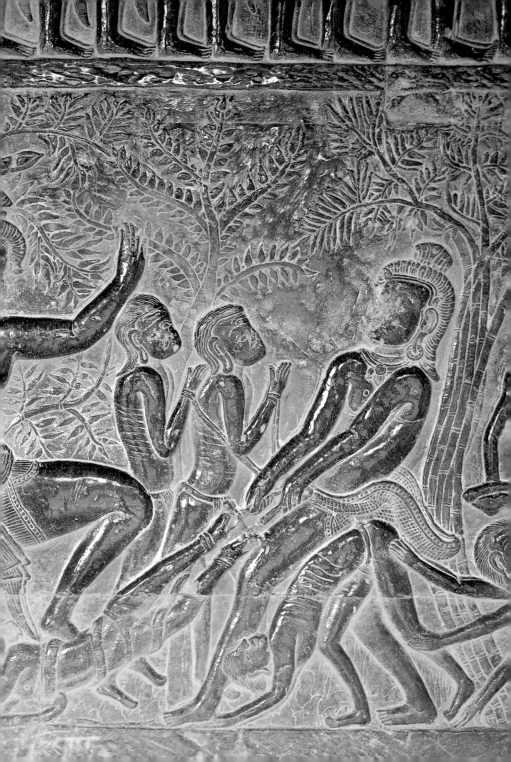

Indrajit: son of Ravana Janaka, King of Mithila, father of Sita.

Lakshmana: brother of Rama.

Lanka: kingdom ruled by Ravana.

Marica: the demon disguised as a golden deer to assist in abducting Sita.

Rakasha: 'Night Wanderer'; a demon.

Rama: the hero of the story; eldest son of Dasaratha.

Ravana: chief of the *rakasas*; demon king; ruler of Lanka.

Sita: the heroine of the story; wife of Rama.

Sugriva: became monkey king after Valin's death.

Valin: brother of Sugriva.

Viradha: a *rakashas*; attempted to abduct Sita.

Vishnu is reclining in a cosmic sleep when the gods approach him and request that he help them rid the world of the terrible demon Ravana, whose acts of injustice are creating an imbalance between the forces of good and evil. Vishnu agrees to help. He divides himself into four parts and descends to earth as the four sons of Dasaratha, Emperor of Kosala Kingdom. Rama, the eldest of four sons, learns the secret lore of divine weapons from a sage and is destined to succeed his father.

Meanwhile in the neighbouring Kingdom of Mithila, King Janaka was presiding over a ploughing ceremony when an infant of extraordinary beauty appears in a furrow in the sacrificial ground. She is 'pure and beautiful, she glows like the full moon'. The maiden captivates the king and he takes her back to his kingdom, adopts her as his daughter and names her Sita 'Furrow'. When it is time for her to marry, the king looks for the finest man in the land. He holds a contest of strength and he puts forth the condition that any man who is strong enough to lift his immensely heavy and powerful bow that was entrusted to him by the god Shiva will be rewarded with Sita's hand in marriage. All the men are eager to win Sita and each one tries to lift the bow but no one succeeds. Then Rama steps forward and with his supreme strength he not only raises the bow easily but he also breaks it and thus wins the hand of Sita. The king rejoices, a wedding feast takes place and Rama and Sita return to live in Ayodhya, the capital of Kosala.

Then, Dasartha prepares to hand the Kingdom of Kosala over to Rama, his beloved son, but his wife, Rama's step-mother, uses her feminine wiles and sexual attraction to persuade him to send Rama into exile so that her own son can be successor to the throne. The decision devastates the king but he owes the queen an unfulfilled boon and so he complies. Rama prepares to depart and his beautiful wife, Sita, pleads to go with him. Soon, Rama, Sita and Lakshmana, Rama's brother, leave for exile in the forest.

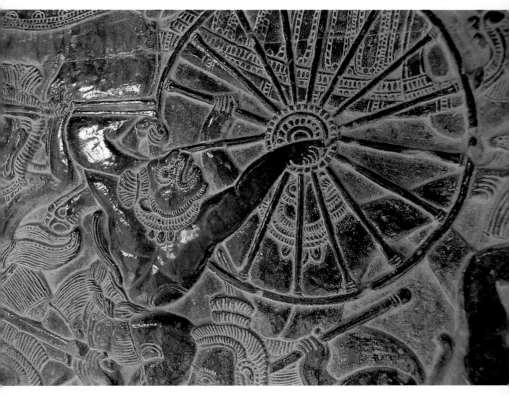

Battle of Lanka, northwest Gallery of Bas-reliefs, Angkor Wat.

When the king dies of grief for his beloved son, Rama refuses to return to Ayodhya and ascend the throne. Instead, he remains with Sita and Lakshmana in the forest where they live as ascetics and encounter many strange adventures. One such episode is depicted at Angkor Wat in the Gallery of Bas-Reliefs (west gallery, north side) where Viradha, a demon, seizes Sita and, just as he is about to devour her, Rama and Lakshmana appear and slay the monster.

Ravana, the demon king (whom Vishnu had taken earthly form to destroy), is the ruler of the *rakshasas* in the neighbouring kingdom of Lanka (Sri Lanka). His terrifying form is easily recognisable by his huge size, 10 heads and 20 arms. Captivated by the beauty of Sita, one day he uses his power to have her abducted. He enlists the demon, Marica, to help him separate Sita from the two brothers. Marica appears before them in the form of a golden deer.

Following pages: *The paved inner courtyard of the third level, Angkor Wat.*

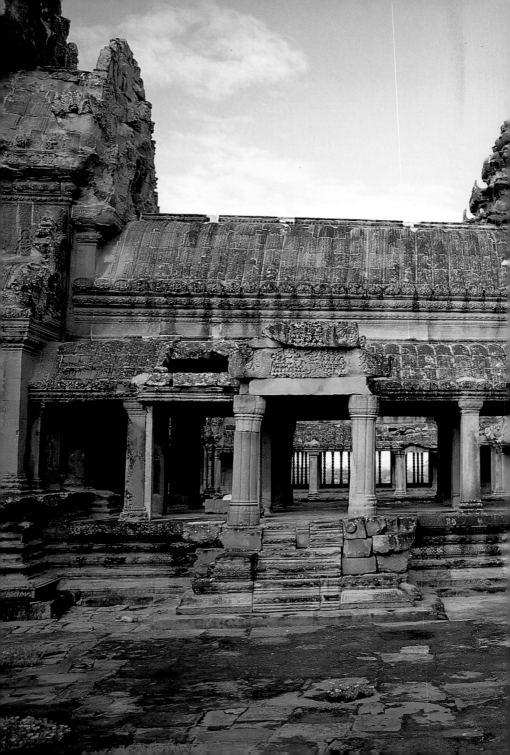

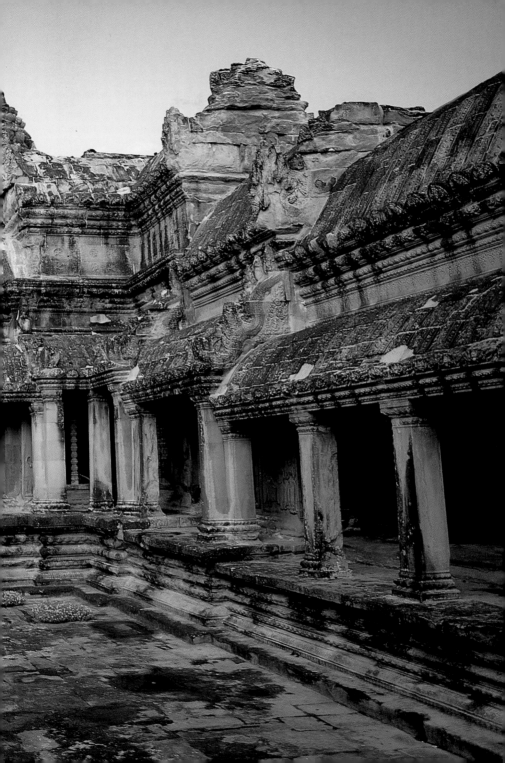

When Sita sees the beautiful illusion she urges Rama to capture the deer for her. Rama follows it and manages to shoot the deer with an arrow, and, as Marica is dying, he takes his true form and imitates the voice of Rama and calls to his brother for help. Lakshmana hesitates, but Sita persuades him to go to Rama's aid. Ravana, disguised as a brahmin, waits for the moment when both brothers have left and Sita is alone, then he approaches and praises her beauty. He returns to his true form and carries her off to his palace on the island of Lanka. This episode is depicted at Angkor Wat in the Gallery of Bas-Reliefs (west gallery, north side). En route, Sita appeals to the vulture king to fly to Rama and plead with him to rescue her. Ravana and Sita arrive at Lanka where she is held captive in a grove of Asoka trees.

Meanwhile, Rama and his brother return home and find Sita gone. When they set out to look for her, they meet the vulture who tells them about Sita's capture. A series of battles and adventures centred on the rescue of Sita follows. Hanuman, the white monkey, and his army of monkeys help in the search. He allies them to Sugriva, the great monkey king, who is battling with his brother Valin. (This fight between the two brothers is portrayed in a powerful stone sculpture in the National Museum in Phnom Penh). Rama intervenes in support of Sugriva and shoots Valin with an arrow.

In return, Sugriva and his army join Rama and Lakshmana and together they prepare to invade Lanka to retrieve Sita. Rama sends Hanuman to Lanka to find where Sita is hidden and he gives him his signet ring to prove his identity. With a mighty bound Hanuman leaps across the ocean to the island of Lanka and when he arrives he magically makes himself smaller so that he can enter the palace and goes to Sita's quarters. He gives Rama's ring to Sita and assures her that she will soon be free. He leaves Sita and begins a rampage of destruction on the palace. He climbs to the top of the Asoka trees, then leaps on to the golden rampart and breaks it before killing many of the demons. When Ravana hears of this he sends his son, Indrajit, who attacks Hanuman with his army.

The battle that ensues is a long one. Hanuman is captured and taken to Ravana who orders his army to parade him through the kingdom with his tail on fire. Hanuman slips free and leaps from rooftop to rooftop setting the entire city on fire, burning the Kingdom of Lanka to the ground. Then he returns to Rama who praises him for his brave deed.

They prepare to take Sita by force and plan how to cross the ocean with armies. Both Sugriva and Hanuman offer to magically turn into a bridge so the army can cross to Lanka. As they move towards the palace they encounter various enemies and fierce battles ensue.

Hanuman and Laksmaṇa fight Indrajit whose powerful magical arrows turn into a web of *nagas* that entangle themselves in Lakhsmana and his army. But eventually Lakshmana kills Indrajit. The armies of Rama and Ravana finally battle each other and good is victorious over evil as Rama finally slays the 10-headed demon Ravana.

Rama, though, questions Sita's fidelity after living in Ravana's kingdom for such a long time. She subjects herself to an Ordeal by Fire to prove her faithfulness. Rama agrees to take her back and they return to Ayodhya where he takes his rightful place on the throne. But all is not well as palace gossip spreads regarding the chastity of the queen when she was in captivity in Ravana's kingdom for 14 years. To retain his power and authority over his people, Rama orders Lakshmana to take Sita, who is pregnant, to the forest and leave her. Sita takes refuge with the sage Valmiki. She gives birth to Rama's twin sons, Lava and Kusa.

Rama continues to rule but there is disharmony in his kingdom and he decides to perform a great horse sacrifice to rectify this imbalance of the forces. The sage Valmiki hears of this plan and orders his sons to go to Ayodhya. During the ritual, the boys sing the *Ramayana* to the amazement and delight of Rama. The boys tell Rama that Sita is their mother and that she is still alive. He sends for Sita.

She reluctantly returns to Ayodhya with Valmiki who testifies to her innocence. Sita calls the Earth Goddess, her mother, to rise from the ground to witness her devotion to her husband and if she has been faithful to receive her. The Earth Goddess emerges, takes her daughter in her arms and they descend into the depths of the earth. Rama is desolate without her. 'From this day onwards I shall never be able to see you, who are so dear to my heart...From now on there will be nothing— only the sound of your name.'[23] He rules his kingdom joylessly for many years before eventually ascending to heaven in his divine form, the supreme divinity Vishnu, where he is reunited with his beloved.

The Buddha is represented in Khmer art with great composure and supreme sensitivity. Artists achieved a sublime balance between the human and spiritual aspects of the Buddha, which resulted in ethereal images. This ideal expression of the Buddha in Khmer art was noted by Georges Groslier: 'My impression is that no country his worship reached, nor even in his own native land, has any image of Gotama embodied the idea of Buddhism more intelligently. No one has so perfectly epitomised his doctrine, his meditation, his renunciation, his profound benevolence.'[24] The most frequently depicted episodes of the Buddha in the reliefs at Angkor centre on his historical life.

The Life of the Buddha: The Buddha-to-be was born into a Hindu family. His father, a warrior, was ruler of the Sakya clan in the Ganges Valley near the border of India. His mother was a beautiful woman named Maya, who gave birth to a baby boy at Lumbini Grove in the presence of the Hindu gods, Brahma and Indra. The newborn was named Siddhartha. His family name was Gotama and his title was Prince. Sages who examined the prince soon after birth identified 32 signs on his body that predicted he was destined to be either a universal ruler or a spiritual leader. His mother died seven days after his birth and he was raised by an aunt. During childhood his father tried to shelter Gotama from seeing the suffering of others by creating pleasure gardens to provide him with everything he needed. And, when Gotama turned 16 years old, his father chose a young maiden named Yasodhara to be his wife. Some years later, she gave birth to their son. Despite all this, Gotama was dissatisfied with palace life. When riding his chariot outside the palace and in four encounters he sees humans in various stages of life he has never before seen—an aging man, a sick one, and a dead one. In his last encounter, he meets an itinerant holy man, who has no material possessions, yet he is content and peaceful. At this point, he decides to pursue the life of an ascetic in a search for the cause of suffering and to find a way to transcend it. Gotama departs secretly from the palace on the night of his 29th birthday, leaving his wife and son behind. He goes on horseback accompanied by his faithful groom Chandaka. The gods help him by making sure everyone is deeply asleep, and by opening the town gates, and muffling the sound of the horse's hooves.

Gotama's 'Great Departure' leads to another major passage in his life that provided a theme for artistic expression—the 'Cutting of the Hair.' The prince and his groom are travelling through a kingdom and they come to a river where they stop. Gotama removes his royal attire and hands it to the groom. Then with one stroke of his sword he cuts off his long hair renouncing his worldly life and bids farewell to his groom and his horse.

After his renunciation the prince assumes the life of an ascetic. He follows the teachings of several masters and then sets out to discover the path of salvation himself. He stays in north India for six years, practising the life of an ascetic and becomes emaciated and weak. Mara ('Death', 'Destroyer', 'Killer') appears to try to thwart Gotama from finding the way to salvation and from achieving enlightenment. This episode is the prelude to the 'Attack of Mara' and another source for artistic interpretation in reliefs at Buddhist temples at Angkor. It begins with Gotama meditating beneath the *bodhi* tree. Mara and his army arrive and harass him and

A female temple caretaker, Bayon.

dispute his right to reign over the world. Gotama replies by telling Mara how much merit he accumulated in previous existences. He says that each time he made merit he poured water over the hands of recipients. The result was that his merit is so great it fills the waters of the earth with his virtues. Mara requests proof of these deeds. Then the Goddess of the Earth appears and vouches for Gotama. As witness to this conversation, she seizes her hair and wrings it, and the waters of ablutions pour forth as offerings from Gotama. The act creates a flood that drowns the army of Mara.

The god Indra appears and convinces Gotama that in order to achieve his goal he must avoid all extremes. So Gotama leaves his life as an ascetic and abandons his austere practices. He assumes the role of an itinerant monk, continues to meditate, and gradually regains his strength. At last, Gotama knows he is ready to attain enlightenment or awakening. At dawn on his 35th birthday he achieved release from the endless round of rebirths and became fully enlightened. Henceforth, Gotama was known as 'the Buddha'. From this time onward, he appears in Khmer iconography wearing a simple monastic robe with the right shoulder bare. In some images this robe is only suggested by a faintly incised line. Other identifying characteristics are: his hair is arranged in tight curls that look like a snail shell, a cranial protuberance on top of the head; elongated ear lobes. Sometimes the Buddha is dressed in princely garments with jewels and a diadem. An example of this can be found on the crowned headdress of images of the Buddha under the *naga* of the 12th and 13th centuries.

Buddha's enlightenment is recorded with skill and beauty in reliefs at Angkor. The Buddha remained meditating at the site of his enlightenment for seven weeks, two depictions of which appear in reliefs at Angkor. The first week he meditates under the *bodhi* tree and Khmer artists captured this scene with fine sensitivity and reflection. The sixth week, as he meditates, a torrential rain descends and the *naga* king, Mucalinda, rises from the underworld in the nearby lake to shelter him. He coils his body and forms a seat to lift the Buddha off the ground and keep him dry. Then he unfurls his multiple heads and forms a hood to protect the Buddha from the rain. Several remarkable stone images in the National Museum in Phnom Penh commemorate this event.

The assaults of Mara and his ultimate defeat by Gotama provide an allegory for the triumph of virtue over evil and are depicted in a scene known as the 'Victory Over Mara.' The Buddha is seen in a posture of meditation, seated with his legs crossed; his left hand rests in his lap and his right hand extends over his knee and points to the ground, in a symbolical gesture of calling the Earth Goddess to witness.

For the next 45 years the Buddha travels through the Ganges basin with his disciples teaching his doctrines. The First Sermon expounding the Four Noble Truths is sometimes called 'Setting the Wheel of the Law in Motion'. You can recognise this episode from deer crouching beside the Buddha with their heads turned back to hear his words.

The last great episode of the Buddha's life seen in Khmer art is his death. He becomes ill in his 80th year and asks his loyal disciple, Ananda, to prepare a bed for him between two trees. He dies on his 80th birthday and, at the moment it happens, the earth shook and trees burst into bloom. The Buddha had drawn his last breath and entered *parinirvana*, the final and perfect state. This moment is depicted on reliefs with the Buddha reclining on his right side with his left hand folded under his head, his right one lying along his side.

Sacred footprints of the Buddha are seen at some temples such as Phnom Bakheng and symbolise Theravada Buddhism and the many years the Buddha wandered through India teaching his doctrine. They are based on an impression of the Buddha's footprints. The soles are sometimes decorated with a grid that is filled with auspicious signs and grouped around a central wheel.

Western shrine, Preah Khan. (Thomas Bauer)

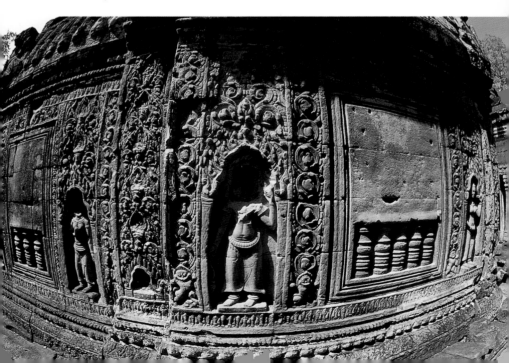

A Day on the Hill of the Gods

*T*his is the most solitary place in all Angkor—and the pleasantest. If it was truly the Mount Meru of the gods, then they chose their habitation well. But if the Khmers had chanced to worship the Greek pantheon instead of that of India, they would surely have built on Phnom Bakheng a temple to Apollo; for it is at sunrise and sunset that you feel its most potent charm. To steal out of the Bungalow an hour before the dawn, and down the road that skirts the faintly glimmering moat of Angkor Wat, before it plunges into the gloom of the forest; and then turn off, feeling your way across the terrace between the guardian lions (who grin amiably at you as you turn the light of your torch upon them); then clamber up the steep buried stairway on the eastern face of the hill, across the plateau and up the five flights of steps, to emerge from the enveloping forest on to the cool high terrace with the stars above you—is a small pilgrimage whose reward is far greater than its cost in effort.

Here at the summit it is very still. The darkness has lost its intensity; and you stand in godlike isolation on the roof of a world that seems to be floating in the sky, among stars peering faintly through wisps of filmy cloud. The dawn comes so unobtrusively that you are unaware of it, until all in a moment you realize that the world is no longer dark. The sanctuaries and altars on the terrace have taken shape about you as if by enchantment; and far below, vaguely as yet, but gathering intensity with every second, the kingdom of the Khmers and the glory thereof spreads out on every side to the very confines of the earth; or so it may well have seemed to the King-God when he visited his sanctuary—how many dawns ago?

Soon, in the east, a faint pale gold light is diffused above a grey bank of cloud, flat-topped as a cliff, that lies across the far horizon; to which, smooth and unbroken as the surface of a calm sea, stretches the dark ocean of forest, awe-inspiring in its tranquil immensity. To the south the view is the same, save where a long low hill, the shape of a couchant cat, lies in the monotonous sea of foliage like an island. Westward, the pearl-grey waters of the great Baray, over which a thin mist seems to be suspended, turn silver in the growing light, and gleam eerily in their frame of overhanging trees; but beyond them, too, the interminable forest flows on to meet the sky. It is only in the north and northeast that a range of mountains –the Dangrengs, 80 miles or so away—breaks the contour of the vast, unvarying expanse; and you see in imagination on its eastern rampart the almost inaccessible temple of Prah Vihear.

Immediately below you there is movement. The morning is windless; but one after the other, the tops of the trees growing on the steep sides of the Phnom sway violently

to and fro, and a fussy chattering announces that the monkeys have awakened to a new day. Near the bottom of the hill on the south side, threadlike wisps of smoke from invisible native hamlets mingle with patches of mist. And then, as the light strengthens, to the southeast, the tremendous towers of Angkor Wat push their black mass above the grey-green monotony of foliage, and there comes a reflected gleam from a corner of the moat not yet overgrown with weeds. But of the huge city whose walls are almost at your feet, and of all the other great piles scattered far and near over the immense plains that surround you, not a vestige is to be seen. There must surely be enchantment in a forest that knows how to keep such enormous secrets from the all-seeing eye of the sun?

In the afternoon the whole scene is altered. The god-like sense of solitude is the same; but the cool, grey melancholy of early morning has been transformed into a glowing splendour painted in a thousand shades of orange and amber, henna and gold. To the west, the Baray, whose silvery waters in the morning had all the inviting freshness of a Thames backwater, seems now, by some occult process to have grown larger; and spreads, gorgeous but sinister, a sheet of burnished copper, reflecting the fiery glow of the westering sun. Beyond it, the forest, a miracle of colour, flows on to be lost in the splendid conflagration; and to the north and east, where the light is less fierce, you can see that the smooth surface of the sea of tree-tops wears here and there all the tints of an English autumn woodland: a whole gamut of glowing crimson, flaring scarlet, chestnut brown, and brilliant yellow; for even these tropic trees must 'winter'.

By this light you can see, too, what was hidden in the morning: that for a few miles towards the south, the sweep of forest is interrupted by occasional patches of cultivation; ricefields, dry and golden at this season of the year, where cattle and buffaloes are grazing.

...As for the Great Wat, which in the morning had showed itself an indeterminate black mass against the dawn; in this light, and from this place, it is unutterably magical. You have not quite an aerial view—the Phnom is not high enough for that; and even if it were, the ever-encroaching growth of trees on its steep sides shuts out the view of the Wat's whole immense plan. But you can see enough to realize something of the superb audacity of the architects who dared to embark upon a single plan measuring nearly a mile square. Your point of view is diagonal; across the northwest corner of the moat to the soaring lotus-tip of the central sanctuary, you can trace the perfect balance of every faultless line. Worshipful for its beauty, bewildering in its stupendous size, there is no other point from which the Wat

appears so inconceivable an undertaking to have been attempted—much less achieved—by human brains and hands.

But however that may be, even while you watch it, the scene is changing under your eyes. The great warm-grey mass in its setting of foliage, turns from grey to gold; then from gold to amber, glowing with ever deeper and deeper warmth as the sun sinks lower. Purple shadows creep upwards from the moat, covering the galleries, blotting out the amber glow; chasing it higher and higher, over the piled up roofs, till it rests for a while on the tiers of carved pinnacles on the highest towers, where an odd one here and there glitters like cut topaz as the level golden rays strike it. The forest takes on colouring that is ever more autumnal; the Baray for ten seconds is a lake of fire; and then, as though the lights had been turned off the pageant is over...and the moon, close to the full, comes into her own, shining down eerily on the scene that has suddenly become so remote and mysterious; while a cool little breeze blows up from the east, and sends the stiff, dry teak-leaves from the trees on the hillside, down through the branches with a metallic rattle.

Above: *Two of the 12 Prasat Suor Prat shrines.*
Right: *The inner causeway of the western entrance to Angkor Wat.* (*John Sanday*)

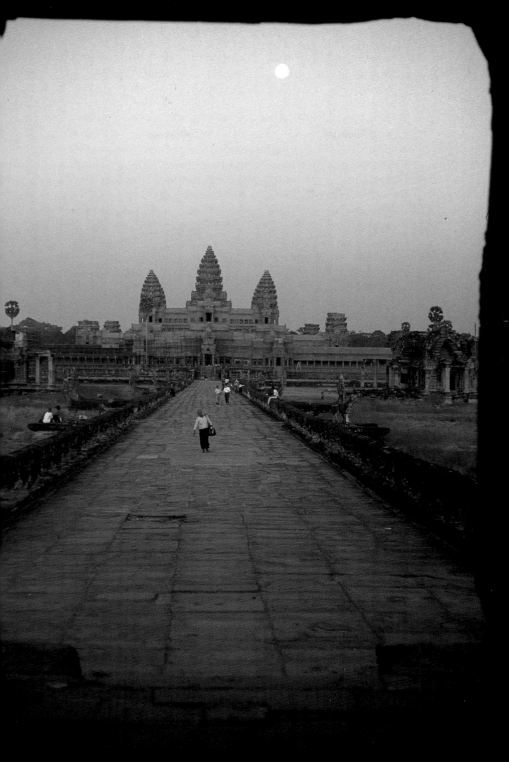

There is one more change before this nightly transformation-scene is over: a sort of anti-climax often to be seen in these regions. Soon after the sun has disappeared, an after-glow lights up the scene again so warmly as almost to create the illusion that the driver of the sun's chariot has turned his horses, and come back again. Here on Bakheng, the warm tones of sunset return for a few minutes, but faintly, mingling weirdly with the moonlight, to bring into being effects even more elusively lovely than any that have gone before. Then, they too fade; and the moon, supreme at last, shines down unchallenged on the airy temple.

It is lonelier now. After the gorgeous living pageantry of the scene that went before it, the moon's white radiance and the silence are almost unbearably deathlike: far more eerie than the deep darkness of morning with dawn not far behind. With sunset, the companionable chatter of birds and monkeys in the trees below has ceased; they have all gone punctually to bed; even the cicadas for a wonder are silent. Decidedly it is time to go. Five almost perpendicular flights of narrow-treaded steps leading down into depths of darkness are still between you and the plateau on the top of the Phnom: the kind of steps on which a moment of sudden, silly panic may easily mean a broken neck—such is the bathos of such mild adventures. And once on the plateau you can take your choice of crossing it among the crumbled ruins, and plunging down the straight precipitous trace that was once a stairway—or the easy, winding path through the forest round the south side of the hill, worn by the elephants of the explorers and excavators. Either will bring you to where the twin lions sit in the darkness—black now, for here the trees are too dense to let the moonlight through; and so home along the straight road between its high dark walls of forest, where all sorts of humble, half-seen figures flit noiselessly by on their bare feet, with only a creak now and again from the bundles of firewood they carry, to warn you of their passing. Little points of light twinkle out from unseen houses as you pass a hamlet; and, emerging from the forest to the moat-side, the figures of men fishing with immensely long bamboo rods, from the outer wall, are just dimly visible in silhouette against the moonlit water.

H W *Ponder,* Cambodian Glory, The Mystery of the Deserted
Khmer Cities and their Vanquished Splendour,
and A Description of Life in Cambodia Today
(*Thornton Butterworth, London, 1936*)

KHMER ART AND ARCHITECTURE

The temples of Angkor are majestic and grand. Their beauty is astonishing and, as you walk through these centuries-old monuments, you are struck by the wonder of the art and architecture. How did the builders manoeuvre such huge blocks of stone? Where did they come from? How was the carving done? The questions that arise are endless as you stare at the wondrous temples. In this chapter we look at the materials and methods the builders used, the architectural features, the profusion of carved decoration that embellishes the walls of the temples, and the symbolism of the forms and motifs.

What is a Khmer temple? It can be one or several structures. Baksei Chamkrong, for example, is a single shrine with one enclosure wall; Preah Khan, on the other hand, is a series of buildings interconnected by passageways with four enclosure walls. The fundamental architectural element of a temple is a shrine in the form of a tower situated at the centre of the plan. The shrine housed the sacred image which embodied the power of the king and represented a symbolic relationship between ruler and divinity. An appropriate temple had to be constructed for the ceremony that consecrated this relationship. Only then was harmony with the order of the universe ensured; without it society could not prosper and proliferate.

The ruler-divinity relationship lasted as long as the king lived, but when he died another ruler started the process anew. He would initiate his own so-called state temple, bigger and grander than his predecessor's, dedicating it to the religion of his preference. It was also common for a king to build a temple dedicated to his parents and other ancestors to ensure the continuation of the royal lineage.

The temple, then, served as a link between man and the gods. It was built according to carefully ordered principles and based on a geometric plan with orientation to the cardinal points. Emphasis was on the east-west axis, which associated the temple with the rising and setting of the sun. Although the cosmological symbolism and astronomical calculations are less understood than other aspects of Khmer architecture, it is clear that the movements of the sun, moon, stars and planets had significant bearing on architectural forms of the Angkor period. Although a temple was never re-used by a succeeding ruler, some, such as Angkor Wat, continued service even after the death of the king and are thought to have functioned as mausoleums containing the ashes of the deceased ruler.

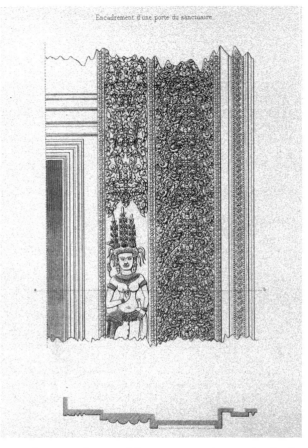

Encadrement d'une porte du sanctuaire

Above: *Line drawing of decoration on a pilaster with a female divinity; below: cross section of a pilaster.*

Other elements of a temple include an open area or courtyard around the main tower and a high wall with one or more entry gates on the axis enclosing the entire area. At larger temples, a moat surrounds the wall and is bisected by a raised causeway extending across the moat and up to the entry gate of the enclosure wall.

As the ground plan developed, it expanded outward in size and complexity and more elements were added to the basic ones already mentioned. Long halls appeared in the courtyard. Later, they became continuous galleries. A narrow passageway with columns or walls and windows surrounding the central buildings were common components of temples from the 11th century onwards. Pavilions in the corners on each level of a tiered base increased the complexity of the temple. Galleries, porches, halls, terraces, bathing pools, more towers and more enclosure walls were other additions. You can perceive the different layouts and components of a temple by studying the ground plans which accompany most of the descriptions in this guide.

In addition to building state and ancestor temples, a king solidified his power by constructing a *baray*, or large reservoir, and naming it after himself. A *baray* is easily

Preah Khan's beauty and symmetry have held up well against the test of time.

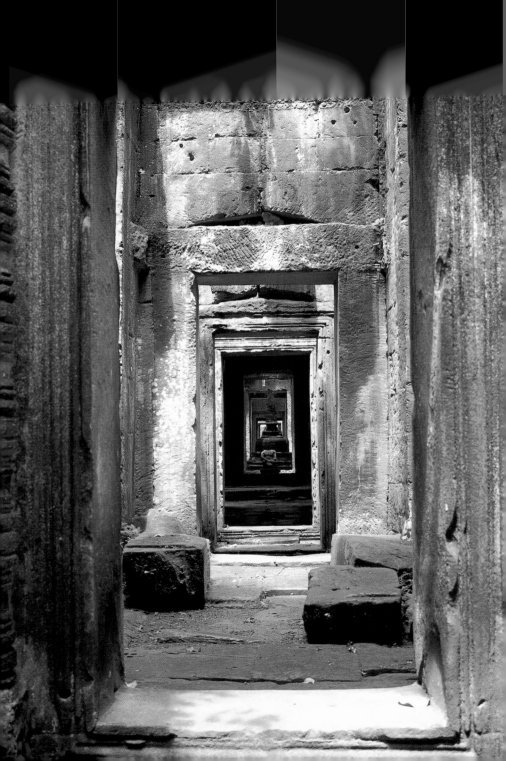

recognisable because of its rectangular shape and east-west orientation. A temple positioned on an artificial island in the centre reinforced the aesthetic and symbolic significance of the *baray*.

The first one, Indratatakata, was built in the ninth century at the ancient capital of Hariharalaya (today Roluos), south of Angkor. This vast *baray* (3,200 by 750 metres; 10,500 by 2,500 feet) was constructed to store rainwater for use during the dry season and to supply water for the surrounding rice fields on the plain of Roluos. It marked the beginning of royal-sponsored irrigation works during the Angkor period.

The next king, Yasovarman I, built an even larger *baray* (7,000 by 1,800 metres; 23,000 by 5,900 feet) during the first year of his reign in the late ninth century. The Yasodharatataka, now known as the East Baray, lies east of the Siem Reap River. An estimated 6,000 workers took three years to build this *baray*.

Yet another vast reservoir, the West Baray (8,000 by 2,100 metres; 26,000 by 6,900 feet), was probably started in the 11th century by Suryavarman I and finished somewhat later by Udayadityavarman II. The only one filled with water today, it was occasionally used as a landing area for seaplanes in the middle of this century. Another, the Jayatataka (3,700 by 900 metres; 12,100 by 2,900 feet), lies west of Preah Khan and is about half the size of the East Baray. It was built by Jayavarman VII in the second half of the 12th century. The small temple of Neak Pean is situated on an island at the centre of this *baray*, which is often referred to as the Preah Khan or Northern Baray.

The function of the *barays* has recently been the subject of debate amongst modern scholars. The symbolic association between a *baray*

Line drawing of a false door with decorative centre panel and a pattern of rosettes; beneath this: cross-section of a door.

and the king, as a divine protector of his people and provider for their welfare, is undisputed. Inscriptions commemorating the consecration of Yasodharatataka, found in the four corners, testify to the religious significance of the *baray*. The original theory as to the practical function held that *barays* and a network of canals, laid out in a rectangular grid, were part of a hydrological system on the scale of those instituted by civilisations at Babylon, Egypt and pre-Columbian Mexico.

Engineers and historians have more recently questioned, however, whether these *barays* were part of a centralised irrigation system. The absence of archaeological and historical evidence supporting a widespread, controlled irrigation system raises questions as to whether the Khmers had the knowledge of advanced irrigation techniques. It also questions whether they ever engineered this kind of system, or were even capable of flood control on a such a large scale.

The original theory presumed that the 'three or four rice harvests a year' noted by Zhou Daguan, the 13th century Chinese emissary who lived at Angkor for a year and wrote an account of his observations, meant that the Khmers engaged in irrigated rice agriculture. Curiously, though, Zhou Daguan did not mention the *barays* that dominated the surrounding areas of the city of Angkor Thom, nor is there any mention of an irrigation system in over 1,200 inscriptions. Further doubt is cast by results of aerial photography, which show that the canals at Angkor connect with the moats surrounding the walls of temples, rather than with a feeder system to carry the water from the *barays* to the rice fields for irrigation.

In light of this evidence it has been suggested that the control of water was on a small scale and just sufficient to support flood retreat rice cultivation. Another idea is that the *barays* were built only for urban use to provide water for bathing, drinking and transportation.

Despite this recent evidence, the original theory should not be discarded until further research is conducted and results are analysed. An understanding of the role of water at Angkor and the Khmers' manipulation of it is crucial to elucidation of the whole complex.

BUILDING MATERIALS USED IN THE MONUMENTS

The Khmers used limited materials to develop a style of architecture renowned for its beauty and creativity. The following is a brief description of those materials commonly found in the monuments.

TIMBER

The earliest structures were built of wood but because of its perishable nature, most of the evidence has disappeared. Wood, as in India, was a revered material and reserved for exclusive use by kings, court officials and priests. As such, it played an important role in the decoration of temple complexes. Domestic timber structures for royalty would have included the superstructure of the king's palace and administrative buildings. A relief in a fronton at Banteay Srei depicts a palace on stilts with a tiered roof and gives a glimpse of what the wooden structures may have looked like. The detail of this relief is so complete that you can get an idea of the furnishings, fabrics and window treatments of the period. Besides buildings, wood was also used for temple furniture, such as altar tables and canopies for images, structural supports and decoration in Khmer architecture.

Evenly spaced, circular indentations or post-holes in the paving of the lower sanctuary at Phnom Bakheng from the east side suggest a canopy supported by wooden posts once stood there. Carved timber double doors would have been placed in all doorways leading to towers or shrines. There are visible remains of timbers used as lintels on the third level of Angkor Wat. A wooden coffered ceiling would have covered the cavernous space created by the corbel vaults; carved and painted with lotus motives and even gilded for added highlights. A modern concrete reconstruction of a timber coffered ceiling has been installed by the EFEO as an example in the southeast gallery at Angkor Wat.

Joining techniques used in carpentry were often transferred to sandstone constructions, leaving a long legacy that lasted throughout the Angkor period. Some common carpentry techniques, recognisable in the stone work, are the mitred joints used to frame window and door openings. Examples of designs borrowed from timber decorations are the turned balusters used in window openings and the octagonal columns on either side of door openings and the elaborately carved colonettes.

BRICK

This was the first durable material used in the construction of Khmer temples. Whereas all wooden structures have disappeared, remains of several brick structures dating to the sixth century have been found at pre-Angkor sites. The earliest from the Angkor period are the three ninth-century temples of the Roluos group, Bakong, Lolei and Preah Ko. Another fine example is the single brick shrine at Baksei Chamkrong—its near-perfect proportions and majestic base give this temple a

Nature and man—a unique and acquired relationship at Angkor.

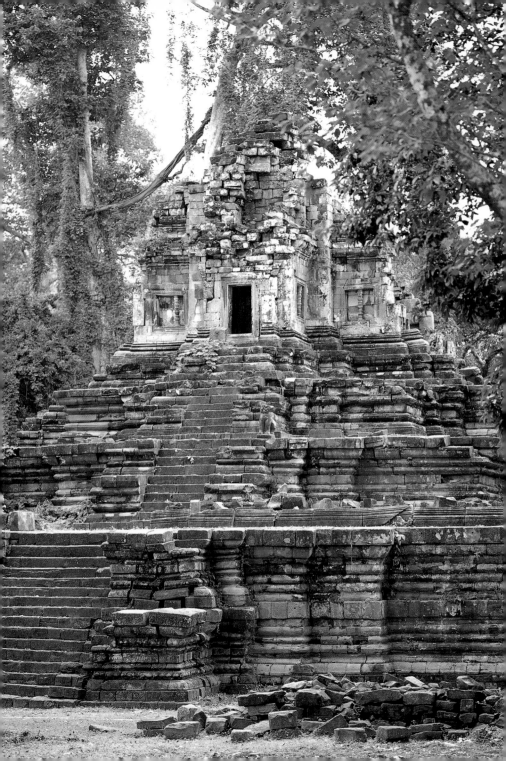

special appeal. The towers at East Mebon and Pre Rup are also built of brick, but have suffered more than others from the effects of weathering. In the central tower of Prasat Kravan, extraordinary, imposing brick carvings of the Hindu god Vishnu and his wife (Lakshmi) decorate the interior. Bricks used for Khmer temples were most likely fired in nearby kilns, as the region has abundant suitable clay. Brick structures were built using rectangular bricks which were bonded with a vegetable-base mortar for strength and solidity.

STUCCO

From the beginning of the Angkor period, stucco was used selectively for fine decoration to disguise the brickwork. The Khmers produced some exquisite and delicate undercut stucco decoration which some believe is unequalled. The composition of the stucco was a mixture of lime, sand, tamarind, sugar palm and clay from termite mounds. Holes were pierced in the brick walls in horizontal and vertical rows or the stone work was roughened to provide a better bonding or key. These holes can be seen at the towers of the East Mebon. The stucco may have been embellished even further with painting or gilding. Over the centuries most of the stucco has disintegrated because of the elements. Remarkably, however, some examples have survived over ten centuries and can be seen at Preah Ko and Bakong. A painstaking programme to conserve the stucco of the former has recently been completed.

SANDSTONE

The earliest use of sandstone as a building material in Khmer architecture was for door jambs, 'false doors', columns, window openings and lintels on brick temples. In the Roluos complex, Preah Ko and Lolei are ninth-century examples of the combination of sandstone and brick. Sandstone is easier to carve,

Elaborately decorated pillar with a band of lotus petals at its top and bottom; beneath this: cross section of pillar base.

enables finer detail and is more valuable than brick. With these advantages and an abundant source on Kulen Mountain, northeast of Angkor, sandstone replaced brick as the main building material for Khmer monuments by the end of the tenth century. It was used for facades, roofs, galleries, halls, pediments and, eventually, entire structures. As the Khmer Empire expanded so did the demand for building materials and the supply of fine sandstone diminished, so inferior grades, in some cases, had to be used.

Although sandstone may appear indestructible, it is a porous material and subject to the natural process of weathering, which results in progressive decay. Carved surfaces are particularly vulnerable. Some 1,000 years after the monuments were built, the effects of weathering are manifested. Conservators working at Angkor Wat have identified several types of damaging factors that are causing the sandstone to deteriorate. Flaking results in a surface layer carrying the reliefs to peel and at an advanced stage to break away from the stone along with the carving. Severe flaking has occurred on some of the *apsara* reliefs at Angkor Wat. Sandstone is also vulnerable to bat deposits, which disseminate salt ions and damage the surface. Climatic stress caused by variations in temperature, monsoons and changes in humidity is yet another source of damage to the surface of the sandstone. Now that the properties of the type of sandstone used in building the monuments of Angkor are known and the causes of damage identified, conservationists are taking measures to stabilise, repair and, hopefully, diminish further deterioration.

LATERITE

Laterite is created as the result of deep tropical weathering of mainly basaltic rocks, composed of high percentages of iron and aluminum oxides, which give it a reddish colour. It is widespread in the Khorat Plateau in Thailand and the northern rolling areas of the Tonle Sap [Lake] in Cambodia. In some areas where the laterite has been exposed on cliff faces it appears as hard, almost lateritic rock or gravel. In situ, laterite is a stiff, reddish and permeable stone, which can easily be cut and shaped with an axe or hoe to the desired size of block. After the blocks are brought to the surface and left to 'cure' for six months the iron and aluminum oxides have oxidised and the blocks have hardened into permanent rocks with a reddish surface. No further weathering occurs and the laterite is a durable material, suitable for building the foundations and the core of temples, road, surfaces, bridges, walls and the like. In the 13th century, laterite was often used in place of sandstone for the construction of walls and roofs, perhaps because the source of sandstone became depleted.

METAL

Sheets of copper or bronze may have lined the walls of important central shrines where the sacred image was housed. Regular holes in the walls of the main approach and the central shrine at Preah Khan suggest this function. Although there is no trace of the metal, its use could explain the plainness of the interiors today. Metal was certainly used to embellish the temples in other areas such as spires on central shrines as noted by the 13th-century Chinese observer, Zhou Daguan. He described the 'Golden Tower (of the Bayon), a golden bridge guarded by two lions of gold, with eight golden Buddhas; and the Tower of Bronze (the Baphuon) that was even higher than the golden ones'.[25]

FIRED CLAY TILES

Zhou Daguan also noted that yellow glazed, clay tiles were used on the roofs of temples. A typical tile is rectangular and curved with a nib on the interior that enabled it to interlock with another. Fragments of unglazed, fired tiles of similar form were found during the clearing of several temples.

Several buildings also suggest that the roofs were pitched and covered with fired clay tiles. The two-storey pavilion at Preah Khan and structures leading to the Bakong clearly show the use of timber rafters which would have supported the tiles.

An intricately carved floral and geometric pattern.

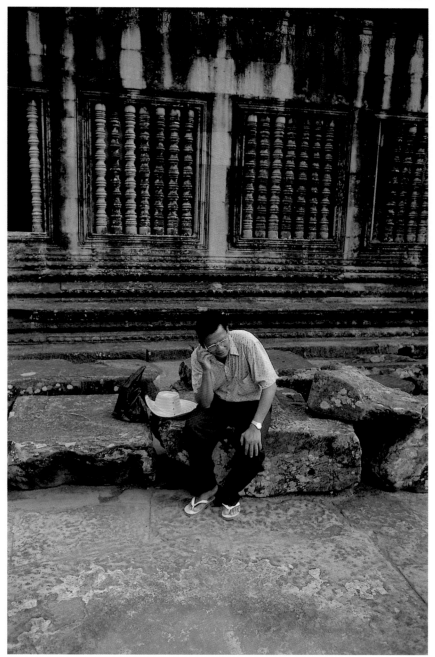

Windows with balusters, carved in stone, are characteristic of Khmer artistry, upper level, Angkor Wat; mobile phones are now a characteristic tour guide accessory.

METHODS OF CONSTRUCTION

As you walk through the temples you will probably wonder where the huge blocks of stone came from and how they were transported and put into place. The accomplishment of these tasks is one of the great technical achievements of the Khmers.

A scene on the west side, south aisle of the inner gallery of the Bayon depicts some of the methods used in handling the stone blocks. The sandstone was cut from the quarry face, shaped into blocks of random size and floated along the Siem Reap River from Phnom Kulen to Angkor. The blocks were then transported to the building site by elephant or ox cart, depending on the sizes. Pairs of bamboo pegs were driven into specially prepared holes—two sets to a block—and linked by ropes. The blocks could then be hoisted into place using tripods, levers and pulleys.

The basic form of construction used for stone structures, such as towers, pavilions and galleries, was a base or platform. In cases of temple-mountains (see p.132), a high platform would be formed using laterite to shape the platform, which would be filled with rammed earth. In most cases the laterite would be covered by sandstone blocks. All structures would be built with blocks of dressed, but uncarved stone, which would be carefully bedded and in many cases matched with very complicated shapes to mirror the joint of the adjacent stone. The joints themselves are remarkably fine and tight, even today, as they were laboriously rubbed to form an exact match. Stones would be ground together with abrasive sand between them, and rocked back and forth until a tight joint was formed.

In the construction of the towers, it is strange that the stones were seldom keyed together. Instead, vertical joints were laid one on top of the other, creating an inherent weakness in the structure and a place where tree and vine roots could easily lodge and prise the structures apart. No mortar was used between the stones and only occasionally would stones be held together with metal clamps. As metal was a valuable commodity, stone joints have been cut open by looters to remove the metal clamps at many temples.

Once in place, and only then, were the structures decorated. No doubt hundreds of stone carvers would have been employed to rough out and finish in situ the designs of the master carvers. There are many examples which clearly indicate that this was the process used. The joints between stones bear no relationship to the figures carved on them. For example joints will often cut through a head or face. In many instances, the actual window opening has been only partly cut with a simple architectural decoration traced around the opening. In the case of the reliefs, several sections show where designs have been 'sketched' by the chisel of the master carver and are still awaiting completion.

Upper level, Bayon.

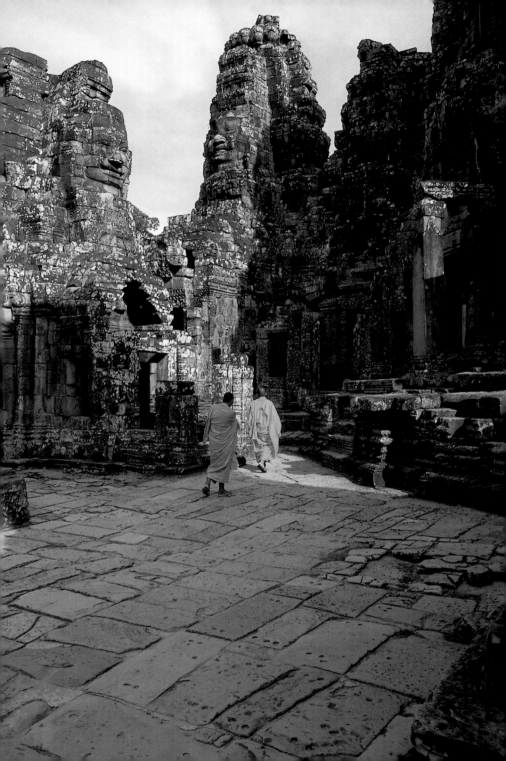

TYPICAL ARCHITECTURAL FEATURES

One of the overriding design features of the Khmer temples is the symmetry with which they were built. Layouts of temples and monasteries are all symmetrical around a central axis. This symmetry provides mirrored images, profiles or silhouettes around a dominant architectural feature such as the central tower on the grand scale or the main porticos on the axial routes.

There are several distinct features common throughout Khmer architecture and typically seen at Angkor. For ease of recognition, these features are described in some detail in the following pages. As the architectural themes were largely imported from south India the original nomenclature has also been retained. A typical example of this is *gopura* meaning 'gateway' or 'entry tower'.

TEMPLE MOUNTAIN

The Khmers adapted the Indian concept of a temple-mountain so successfully and uniquely that today it is synonymous with Khmer architecture. Kings of the early Angkor period established their sovereignty by building a temple-mountain. The temple draws its symbolism from Hindu mythology. It is an earthly facsimile of Mount Meru, the sacred abode of the gods. The temple as a microcosm of a central mountain was an essential concept that had a profound influence on Khmer art.

The physical form is a square-shaped tower elevated on a tiered base. Some temple-mountains, such as Phnom Bakheng, were built on natural hills, but artificial mounds like the one constructed at Pre Rup provided the basis for others. The earliest temple-mountain of the Angkor period is Bakong, a single shrine set on a tiered base. By its height in the 10th century, however, the temple-mountain concept had expanded to a five-tower arrangement, or the quincunx, with a central tower and four smaller towers placed on the corners at the top level of a tiered base. Four axial staircases, often guarded on each tier by pairs of stone lions sculpted in the round, gave access to the top level of the temple-mountain. This formation of five towers symbolises the five peaks of Mount Meru. The central shrine was sometimes given additional height with porches and steps on each side. Pre Rup and Ta Keo are fine examples of this majestic feature.

The symbolism of Mount Meru appears in both Hindu and Buddhist mythology and, although the legends differ somewhat, the general theme remains the same. The world is a central continent divided into regions with heavens above and hells below. Mount Meru separates earth from the heavens and is situated at the exact centre of the continent. Six concentric chains of mountains surround Meru and they are

separated by six oceans. The Ocean of Infinity encloses the entire mass. Symbolically, Meru marks the axis of the world and the chains of mountains represent the successive stages towards knowledge.

It is believed by Hindus that Mount Meru, which is associated with the Himalayas in Central Asia, is ruled by Indra and is the mythical dwelling place of Brahma and other gods. The mountain is surrounded by eight guardians at each cardinal and sub-cardinal point. In Buddhism, a continent shaped liked an island lies beyond the ocean in each of the four cardinal regions of space. Layers of heavens soar above Mount Meru. The four rulers of the cardinal points live at the summit of the mountain. Fantastic animals inhabit the forest at the base of the mountain, which serves as a refuge for ascetics to meditate.

MONASTIC COMPLEX

In strong contrast to the concept of the temple-mountain, the monastic complexes are an intricate but symmetrical plan laid out on a horizontal plane, as opposed to the strong vertical emphasis. However, comparisons are possible in the concentric walls representing the platforms getting smaller in plan as they rise, and an almost indiscernible difference in height between the entrance and the central shrine. The main entrance to the monastery and its

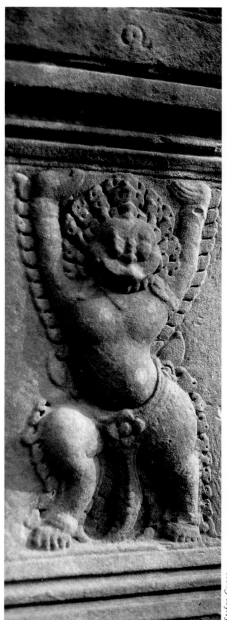

Garuda, mount of the Hindu god, Vishnu.

Stefan Cucos

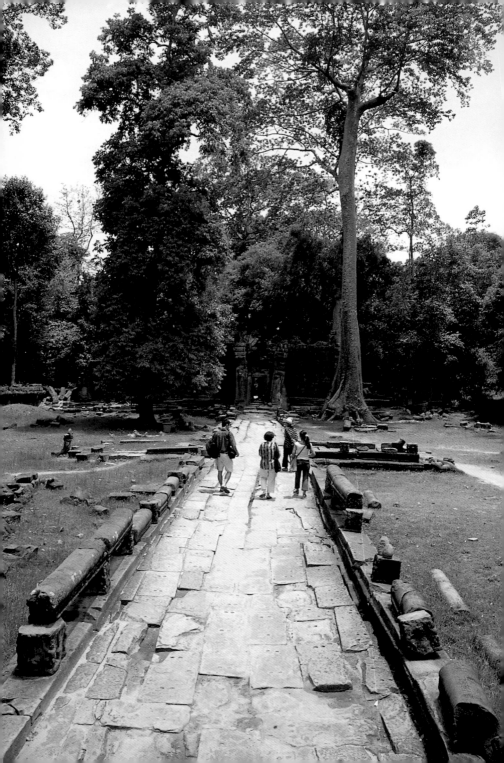

principal temple follows a similar pattern from the east, is lined with guardians and is proportionally grander than other access points.

However, the monastery is like a small town and within the first enclosure wall there was space for the community to live. In Preah Khan, for example, the inscription tells of a community of 97,840 being closely associated with the monastery. The second enclosure wall envelopes the temple proper and from this point the complex gives the appearance of being on a higher level. The temple complex is further divided into a series of different sectors by cloistered arcades and courtyards, but the layout focuses on the central shrine.

It is often difficult to find one's bearings in these monastic complexes especially as many of them have become ruinous. It is worthwhile studying a plan of the complex to get an understanding of its layout. Originally doors would have enclosed each space and would only have been opened to permit worshipping monks to enter the sanctuaries. Therefore, most of the spaces would have been dark, a fact often forgotten as you look along the 100-metre-(320 feet)-long axial corridors.

Gopura

A *gopura* or gateway is the main architectural feature of the wall that surrounds a Khmer temple. The name, which is derived from Sanskrit, originated in the seventh century Pallava architecture of south India. Even in its simplest form, the *gopura* placed on the principal axes stands out in contrast to the simple laterite wall. Early *gopuras* are rectangular in plan, but later, as the form developed in complexity, they became cruciform. Over time, they were built much larger and more elaborately, with extensions such as porches and steps.

By the 12th century, the proportions were such that they took on the appearance of separate buildings. A good example of this is the *gopura* of the outer enclosure wall at the west entrance of Angkor Wat. A new form appeared in the 13th century, and contrasted dramatically with the profile of the earlier *gopura*. The new style which provided access to the Angkor Thom complex soared to a height of over 20 metres (65 feet) and is crowned with four enormous heads, possibly representing the Buddha or the profile of Jayavarman VII, one facing in each cardinal direction.

Causeway

The combination of a causeway and a moat provided a dramatic backdrop for the *naga* or serpent balustrade that made its first appearance at Bakong in the ninth century. In this example, the *naga* was not carried by gods and demons, a theme that

Causeway to the west gopura, *Ta Prohm.*

did not become fully developed until the 12th century. Long rows of giant stone figures sculpted in the round—majestic gods on one side of the causeway and ferocious demons on the other—flank the causeway from end to end and hold the scaly body of the *naga* whose head and tail rise up at each end of the causeway. You can see splendid examples of *naga* balustrades at the entrances to Angkor Thom, although many of the heads are missing as a result of theft. Others have been replaced with copies, and the originals taken to the Conservation Office storage, to prevent further loss.

ENCLOSURE WALL

One of the most striking features following the *gopura* and the causeway are the massive enclosure walls that surround most of the temple complexes. The purpose of these walls was to provide psychological barriers between the communities—they were never intended as fortifications—and to differentiate between the sacred and the profane. In many of the monastic complexes, for example, there are as many as three or four concentric walls defining the usage of space. The walls were built of the coarse, yellow laterite, which contrasted well with the fine sandstone of the *gopura*. In some cases the walls were also embellished with sandstone decoration and were capped with a row of continuous carved images such as the Buddha in flaming niches. A singular example of rather grandiose embellishment is the three-metre (10 feet) high *garudas* that are placed every 40 metres (130 feet) around the outer enclosure wall of Preah Khan.

TOWER

The tower is the predominant architectural feature of Angkor. Its form is derived from the south Indian temple, which has an easily recognisable silhouette. The base stands firm on a platform with symmetrical doorways on each façade. These doorways either open or are false, depending on the use of the tower. Above the cornice level, the tower begins to taper slowly at the base, but more pronounced towards the top creating a rounded effect. The tower is crowned with a lotus, which possibly served as the base for a gilded metal spire—a typical feature in other Asian temples. The tower is constructed with cantilevered stones following the principles of vault corbelled construction with the exposed outer surface being elaborately carved. Often there are added embellishments to the towers such as the flamelike ends of the pediments seen on the towers at Angkor Wat.

PAVILION OR SHRINE

Pavilions and shrines are more often isolated or paired structures that encompass the designs and details of the larger structures only much smaller in size. They are normally constructed in exactly the same way, with vaulted roofs, doors and window openings as well as similar decorative features. They are often located in pairs on either side of the axial route leading to the temple proper.

During the early period of research, the EFEO tended to refer to all single structures as *bibliothèque* or 'library' following its discovery of scenes from the legend of the 'Nine Planets of the Earth' carved on the stones of one such building. In some cases, these structures did serve as libraries where the sacred texts were kept. But more recent research suggests most of them were chapels to house, the sacred flame; or pilgrims' rest houses or family shrines.

CORBELLED VAULT

The Khmers generally used the corbelled vault to form a roof between walls and columns. This reliance on the most primitive type of arch reverts no doubt to the Indian influence on Khmer architecture. Corbelled vaults are constructed by cantilevering rectangular blocks and projecting each stone one third of its length from each side until the span between walls can be capped by a single ridge stone.

Khmer architects carried this method to remarkable heights as can be seen in the constructions of the central shrine at Ta Keo, where enormous blocks of stone were carefully cantilevered, one on top of the other, from each of the walls until they met in the centre. The construction of a corbelled vault obviously limits the spans that can be achieved and its exclusive and continuous use in buildings of the Angkor period accounts for the narrow galleries and passageways that are prominent in Khmer architecture.

TYPICAL ARTISTIC FEATURES

As with the architectural features, much of the artistry was derived from concepts imported from south India. But because of the Khmers' remarkable artistic talents they were able to embellish these concepts in many wonderful ways. It is hard to believe that the artistry found in the decorated lintels and the kilometres of reliefs is often over 900 years old, created centuries before the rococo work of Europe and South America.

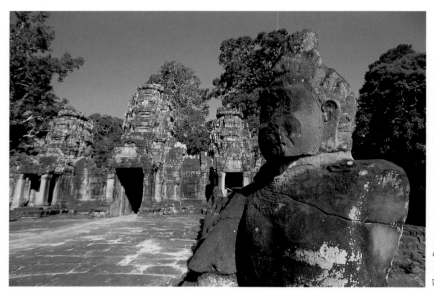

Thomas Bauer

STATUARY

Khmer sculpture is among the finest in the world. Remarkable figures in stone and bronze reflect the skills of Khmer artists. An excellent starting point for visitors to Angkor is the National Museum in Phnom Penh, which has the finest and most extensive collection of Khmer sculpture in the world. Life-size sculptures carved in stone were an integral part of temple architecture. Guardians protecting the temple, lions guarding stairways, elephants adding grandeur to tiered platforms and sensitive renditions of the Buddha and of the gods and goddesses graced all Khmer temples, adding dimension and majesty to their overall appearance. Today, unfortunately, most of the free-standing sculptures have been stolen or removed for safe-keeping.

At several of the sites there are still decorative pieces in the form of freestanding guardian lions, the torsos of *dvarapala*—guardians armed with clubs; the multi-headed *naga*—protective snakes; the *deva* and *asura* or gods and demons, often supporting the *naga* on either side of the causeway and the *garuda* or mythical bird which serves as protector. There are also elements of worship such as the *linga* and *yoni*, symbolic Shivaite images of the male and female, which represent destruction and rebirth, and the *stelae*, beautifully inscribed stones with information on the foundation and function of the temples, are still present in many of the complexes.

Above: *Demon, flanking the causeway, east gopura, Preah Khan.*
Right: *Female divinities in niches. (Stefan Cucos)*

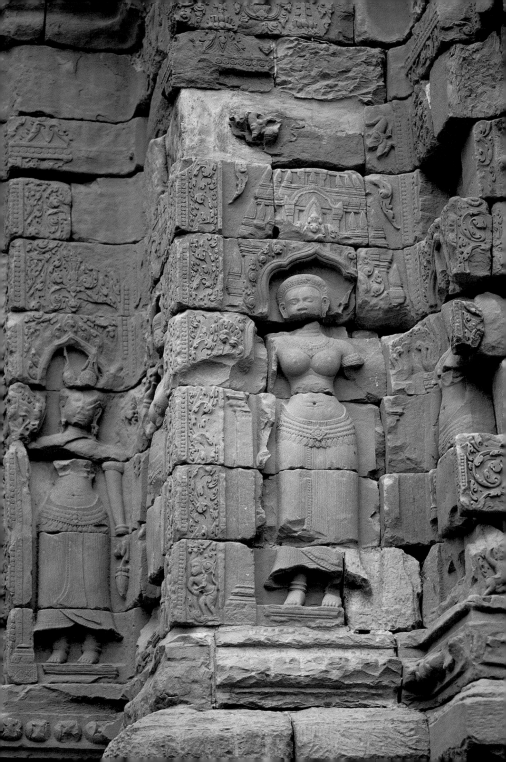

RELIEFS

Reliefs carved in stone are among the greatest artistic achievements of the Khmers. Narrative scenes inspired by the great Hindu epics, the *Ramayana* and the *Mahabarata*, sacred books and military history of the period unfold on the walls of temples conveying sublime beauty, power, majesty, humour and always consummate good taste. Rows of graceful *apsaras* or celestial nymphs line a cornice in perfect unison or dance lithely on a lotus, geometric medallions filled with an intricate floral and leaf motif cover walls like tapestry, fantastic mythical beasts bound across the walls, battle scenes spring to life—the scenarios created in the reliefs provide endless fascination and make you want to return again and again. The reliefs surpass the function of portraying events; they transform the temples into celestial dwellings.

The carved decoration at Angkor Wat is called bas- or low-relief, whereas the deeper carving at the Bayon is haut- or high-relief, depending on the degree of undercutting. Khmer artists struggled with the technique of perspective or the creation of a three-dimensional illusion. To show objects and people in the distance, the Khmers used planes, placed one above the other. The higher up the wall, the further away is the scene. Sometimes seven or eight planes were used to establish the right degree of perspective. Another convention used to show scale was to carve faces peering through gaps or behind the wheels of a chariot.

As in Egyptian art, a person's rank was indicated by size—the higher the ranking the greater the size. Khmer artists incorporated detail with finesse as a means of controlling the composition, and remarkable results were achieved using only shape and texture. Even the crowded, complex scenes which most of them are, have an underlying form. For example, the bas relief of the 'Churning of the Ocean of Milk' in the southeast gallery at Angkor Wat culminates in the centre with the divinity Vishnu, the largest and most important figure, balanced on either side by smaller in scale divinities and demons; the top of the panel depicts an ethereal scene of floating *apsaras* offset at the bottom with the Mighty Ocean of Milk. By deliberately placing important elements in key positions and balancing the components in the distance, middle and background, an ordered composition was achieved.

There is a sheen to be seen on the surface of some of reliefs at Angkor Wat. Some say that the position of the sheen may have resulted from visitors rubbing their hands over them. Others think it was the result of applying a lacquer in former times. There are also traces of gilding and black and red paint are visible too, which are probably the remains of an undercoat or a fixative.

APSARAS

The *apsaras* or celestial nymphs are sensuous, graceful females which adorn the temple walls and they are amongst the most beautiful examples of relief carving. They dance or fly in the heavens or stand in exquisite perfection ready to wait on the gods.

WINDOW OPENINGS

Openings to windows were protected by finely-turned stone balusters. The designs drew inspiration from similar constructions in wood. This window treatment has become a hallmark of Khmer architecture and a variation often seen to simulate a symmetrical facade is a solid window depicting balusters on the lower half and a roller blind on the upper portion.

Detail of a false window with balusters, Ta Prohm.

DOORWAYS

A set of intricately sculpted collonettes flanking doorways and supporting lintels are a regular feature in a Khmer temple. The carving on the octagonal drums which reached a high artistic level varies, but it is always elaborate and divided into registers by rings and decorated with popular motifs, flowers and leaves between them. False

Following pages: The Khmer army battling with the Chams, outer gallery of reliefs, Bayon.

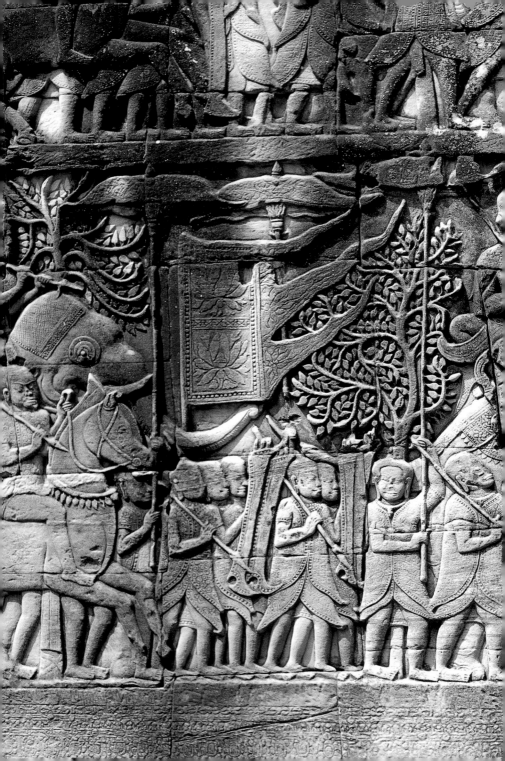

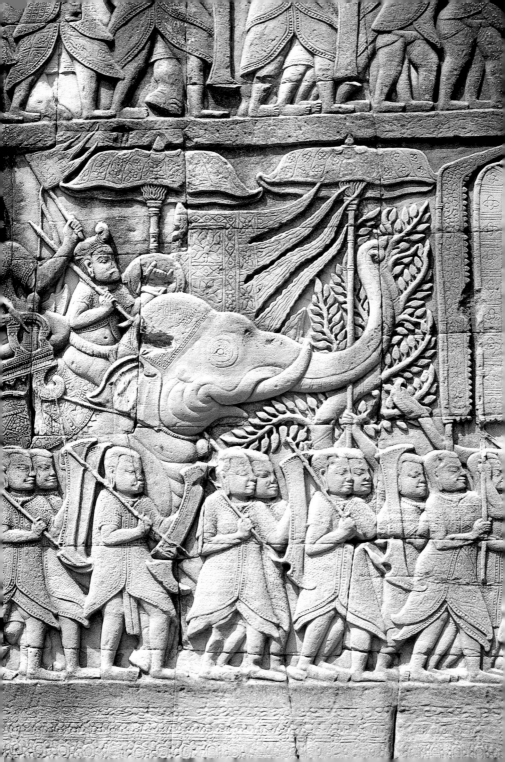

doors are the same size and shape as a true door, but instead of being built of wood they are carved from sandstone.

A typical arrangement in a tower used as a shrine is an opening door on the principal axis, usually facing east, with false doors on the remaining three sides as design features. Sometimes a flight of stairs precedes the false door, adding height and elegance. The stone work framing the false door emulates the decoration that was carved on the surface of the timber, double-leaf door in every detail. The motifs and workmanship on the false doors represent some of the most beautiful elements in Khmer architecture. A lion's face in place of a brass door knocker is a special ninth-century feature found on the towers of Bakong.

LINTELS

Lintels in Khmer architecture are highly decorated rectangular sandstone blocks spanning a doorway, window or any opening, and often support the fronton. The Khmers carved the face of the lintel with superb decoration that filled the entire space with scenes inspired by mythology, as well as intricate floral motifs and fanciful beasts. The fine grain and hardness of the grey sandstone used on the earliest lintels enabled crisp and skilfully undercut sculpting. The decorative lintels of the East

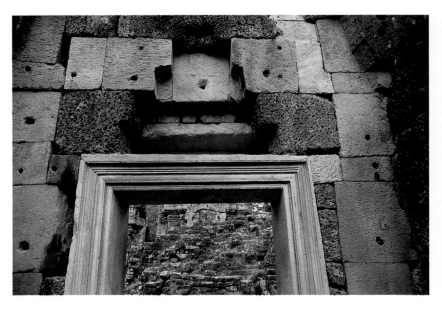

View through doorframe, Banteay Srei.

Mebon temple and those found at the Roluos group exhibit remarkably fine workmanship.

A typical decorative arrangement on an early lintel might include Vishnu on his mount, the *garuda*, surmounting the head of a monster, *kala*, spewing garlands with jewelled tassels; a pattern of foliage surrounds this central scene and fills out the lintel; small personages or fanciful animals sometimes frolic lithely among the flowers and leaves; and the scaly crocodile-like body of the mythical beast, *makara*, borders the entire scene and terminates with heads at the bottom left and right sides of the lintel.

Pediments

The pediment, fronton, or triangular form is above a lintel over a portico or door. Some of the best examples can be found in Khmer art of the tenth century at Banteay Srei. A pediment is the source of rich decoration, especially for narrative scenes for divinities set in abundant foliage. Two undulating *nagas* with multiple heads often frame the interior. At Banteay Srei three frontons have been superimposed, which is an innovation of great beauty. The head of a *kala*, spewing a five-headed serpent is a motif that also made its first appearance at Banteay Srei. This popular theme lasted throughout the Angkor period. The frontons at Angkor Wat are mainly narrative scenes and draw inspiration from Hindu mythology, particularly the *Ramayana*.

Khmer Art Styles

Khmer art and architecture are divided into stylistic periods, each one designated by the name of the principal architectural monument that exhibits the most characteristic elements of the period. The chronology used in this guide follows the one that was developed by Philippe Stern in the 1930s and refined by other French scholars. Research by modern scholars in the past two decades, however, demands a reassessment of the early chronology set out by Stern and others. The validity of classifying art periods and assigning dates based on stylistic aspects of the monuments is questioned. Evidence suggests that art styles may not have parallelled the historical dates assigned to the monuments based on archaeology or the historical dates of the reigns of Khmer kings based on epigraphy. For now, until further research and analyses are conclusive, the summary that follows subscribes to the early chronology put forth by French scholars.

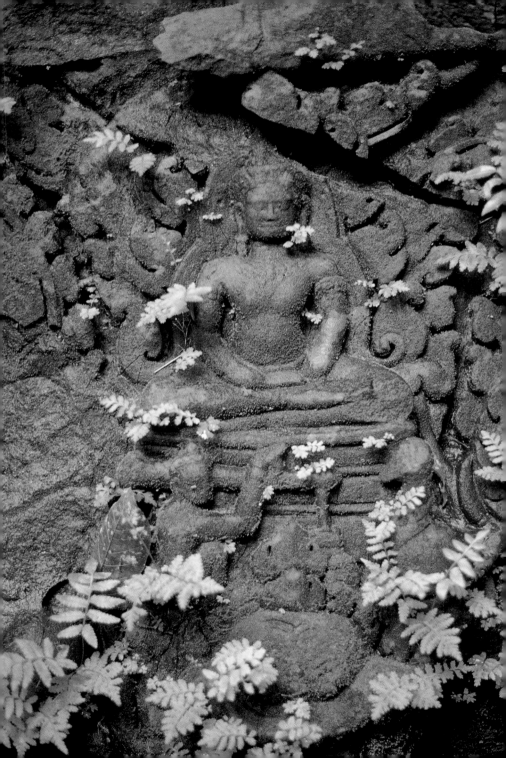

PRE-ANGKOR PERIOD (SIXTH TO LATE-EIGHTH CENTURY)

Indian-inspired elements in the early pre-Angkor temples such as a moulded plinth, a carved lintel, and a corbelled vault set the foundation for the architectural principles of the classical Angkor period. Pre-Angkor sculpture was elegant with refined detail that, like its architecture, drew inspiration from India. The form and anatomy of the sculpture was naturalistic and, in profile, the stance is slightly curved. Garments are diaphanous and cling to the body.

ANGKOR PERIOD (802–1432)

The earliest stylistic period in this group is the **Kulen style**, which derives it name from the Kulen Mountain range, northeast of Angkor Thom. The few remaining temples there are in poor condition and, in some cases, just heaps of stones, which makes it difficult to appreciate the art form and decoration.

The most easily accessed, earliest group of temples is at Roluos, 12 kilometres (seven miles) southeast of Siem Reap, which belong to the **Preah Ko style**, dating from the last quarter of the ninth century. The simplest form of a tower can be seen at Preah Ko. It is a square brick structure built on a low plinth and faces east. The upper part of the sanctuary comprises square brick tiers each of a diminishing size. The tiers on buildings of this period are easily identifiable as each one emulates the façade of the shrine below. Miniature false doors are seen at the axis on each tier.

A natural development of the single tower was to build between three and six towers all similar in size, forming and aligning them in one or two rows at ground level or on a platform. Concurrent with the expansion of more towers at ground level, the temple mountain concept increased in importance. Although it is uncertain when the first temple-mountain form appeared, it is probable that the temple of Bakong in Roluos was the earliest to be constructed at Angkor.

Sculpture of the Preah Ko style is characterised by an architectonic rigidity, and the figures are heavier and more powerful than pre-Angkor examples. Sculptures of standing gods are awesome and large-scale, sometimes over life-size. The Khmers invented a special arch around the sculpture to support these large and heavy images which grew from the base at the back of the sculpture and framed the entire standing figure. Either the hands or attributes and the back of the head were attached to the arch. Several examples of this convention can be seen in the National Museum in Phnom Penh. The form appeared in the seventh century and continued in use until the ninth century at which time sculptures became smaller and they did not require the extra support.

A Buddha image seated on a naga. *(John Sanday)*

The great architectural innovation of the **Bakheng style** was the temple-mountain structure with five towers arranged in a quincunx.

The art and architecture of the **Koh Ker style** reflects the tyranny of that time. In AD 921 Jayavarman IV, a usurper, set up a rival capital about 64 kilometres (40 miles) east of Angkor at Koh Ker that lasted for about 20 years. Little remains of the mainly brick temples, but there are some remarkable examples of free-standing sculpture from this period in the National Museum. They are a departure from previous examples of sculpture as, for the

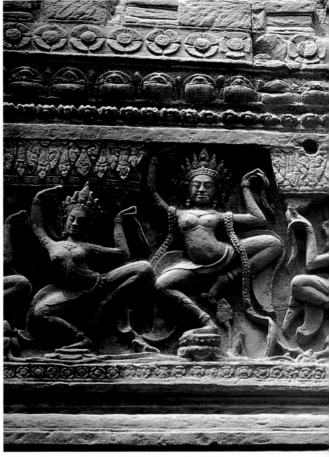

A frieze of apsaras in the Hall of the Dancers, Preah Khan. (Stefan Cucos)

first time in Khmer art, they express movement. The figures are also very large, some say because the king was a megalomaniac. Two outstanding pieces of this style in the National Museum are a pair of wrestlers and Sugriva and Valin, the monkey-headed brothers from the *Ramayana,* locked in hand-to-hand combat.

The architectural achievement of the middle of the tenth century can be found in the **Pre Rup style.** The temple of this name is a remarkable example of the temple-mountain built by Rajendravarman II. It is an impressive site with five towers which were formerly stuccoed, arranged in a quincunx on top of a very high tiered, laterite platform with steep staircases leading up to the top. A neighbouring temple, the East

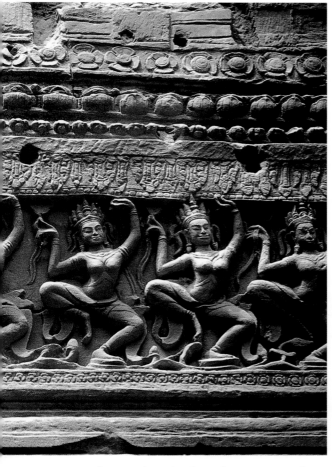

Mebon, is of the same period and design although its platform is not so elevated.

The **Banteay Srei style** has given one of the most endearing legacies to posterity, that is the temple of the same name. Situated 19 kilometres (12 miles) northeast of Angkor, its size and scale are diminutive in comparison to the temple-mountain structures of Angkor. A magnificent sculpture from Banteay Srei, now in the National Museum, which depicts the seated image of the Hindu divinity Shiva with Uma on his knee, typical of the sculptural skills of this period. The head of Uma was unfortunately stolen from the museum in the 1970s.

The **Kleang style** is represented by two long rectangular sandstone structures known as the North and South Kleangs. The function of these buildings is constantly being debated and, although the name means 'storehouse', it has been suggested that they served as halls or for receiving foreign dignitaries. Another key temple of this style is the majestic temple-mountain of Ta Keo with its mighty five towers with no carved decoration. The lack of adornment emphasises the massive stone blocks and the complexity of the temple's construction as well as the remarkable use of space and volume.

When the **Baphuon style** was developed in the middle of the 11th century, temples had reached gigantic proportions. Continuous vaulted and columned galleries, which were constructed off tiered platforms, were common features of this period and they formerly encircled the central tower at Baphuon. The sculpture of the Baphuon style is very distinctive as it moved towards a new form, which was even more naturalistic than previous styles. Gods and goddesses were still idealised, but with more apparent realism, and their lines and volumes flow harmoniously.

The Khmers' artistic genius culminated in the **Angkor Wat style** of the first half of the 12th century, and the temple-mountain reached its apogee at Angkor Wat. Encircling galleries, vaulted passages, elaborate porches leading to towers, grand staircases between terraces and an extensive gallery of bas-reliefs complimented the temple plan. Despite its complexity, the elements blend together with remarkable harmony and balance. Tower pinnacles in the form of a lotus are a distinctive silhouette of Angkor Wat and their profile has become synonymous

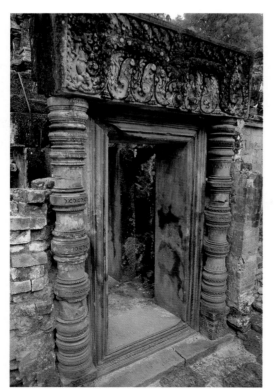

with Cambodia, gracing all five of the recent variations of the national flag. The sculpture of the Angkor Wat style was inspired by forms of the first half of the tenth century. Figures are distinguised by a frontal stance, symmetrical posture and wide shoulders and hips.

The **Bayon style** is a synthesis of the previous styles which is characterised in the Buddhist temples of the late 12th and early 13th centuries. The temples are of a complex architectural layout constructed at ground level and auxiliary structures including interconnected galleries and rooms. Examples of this type of

Left: Doorway at Banteay Srei.
Right: Looking north from the upper west level, Angkor Wat.

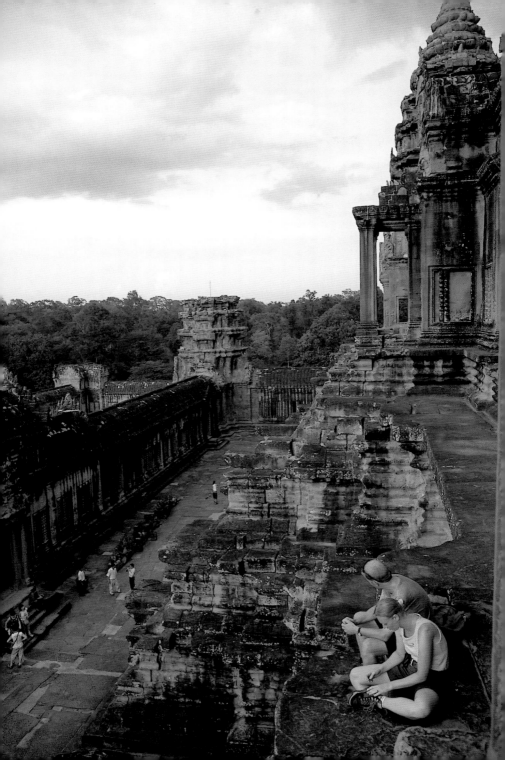

temple style are the Buddhist monastic complexes of Banteay Kdei, Preah Khan and Ta Prohm. The sculpture of the Bayon style reflects the new religious beliefs of that time and is best exemplified in the image of the Avalokiteshvara (Lokeshvara), or 'Lord of the World', which is identified by a small seated Buddha at the base of the crown. Images of the Buddha seated on the coils of the *naga* are associated with sculpture of the Bayon period.

COSMOLOGY IN KHMER ARCHITECTURE

The layout, architecture and decoration of a Khmer temple were modelled according to a series of magical and religious beliefs. Devotees moved from the mundane world to a spiritual one by walking along one of the four axes, each of which has a different astrological value. East, the direction of the rising sun, is auspicious, representing life and the sexual prowess of the male. Most of the Khmer temples were built with the entrance to the east, as this was the formal approach to most Hindu shrines except for Angkor Wat. For example, the main approach to Angkor Wat, which originally housed images of Vishnu, is from the west. In general, however, west is considered inauspicious and represents death, impurity and the setting sun. North is also auspicious and is associated with the elephant because of its strength. South has a neutral value.

Numbers represent universal order and serve as a means of effecting the interplay between man and the gods. Numerous mathematical schemes have been put forth to explain the proportional measurements of specific temples and, in particular, Angkor Wat. The Khmers adhered to the Hindu belief that a temple must be built correctly according to a mathematical system in order for it to function in harmony with the universe. Thus, if the measurements of the temple are perfect then there will be perfection in the universe also.

A study has proposed that when Angkor Wat was laid out by the Khmers, the distances between certain architectural elements of the temple reflect numbers related to Hindu mythology and cosmology. The positions of the bas-reliefs were regulated for example by solar movement. Scenes on the east-west stretches reflect those related to the rising and setting of the sun.

Under the surface of the earth are numerous hells and above it are paradises or heavens. Hell in Khmer cosmology is a place of suffering where the damned expiate their sins and crimes and each hell is more horrific than the last. Afterwards they are reborn to begin a new life. In the south gallery of bas-reliefs at Angkor Wat, the sins and the punishments of its 32 hells are depicted. There are numerous paradises above the earth, and above the last one is *nirvana*. The duration of life in these paradises increases at each higher level with earth representing neutrality.

PART II
THE MONUMENTS

SUGGESTED TEMPLE ITINERARIES

Previous Page: A reflection of the glory of Angkor Wat.

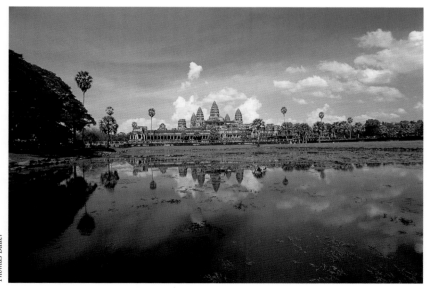

Thomas Bauer

Angkor Wat and its reflection in a pond.

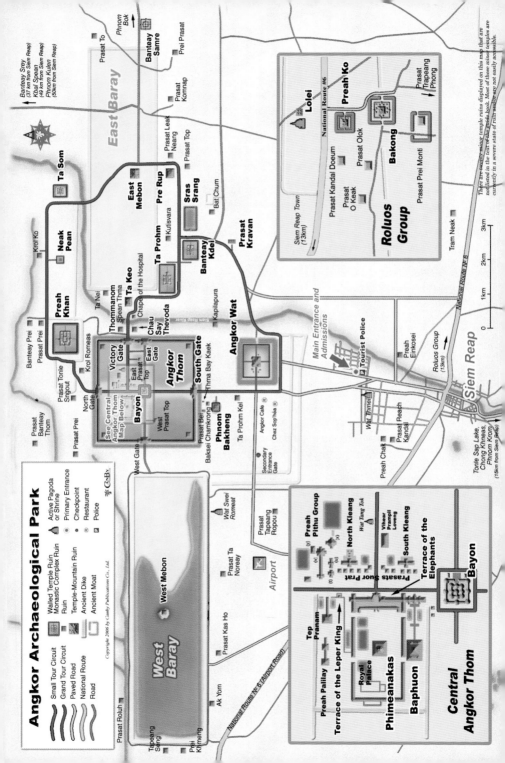

Angkor Archaeological Park

Small Tour Circuit
Grand Tour Circuit
Paved Road
National Route
Road

Walled Temple Ruin
Monastic Complex Ruin
Ruin
Temple-Mountain Ruin
Ancient Dike
Ancient Moat

Active Pagoda or Shrine
Primary Entrance
Checkpoint
Restaurant
Police

Copyright 2006 by Canby Publications Co., Ltd.

There are twenty minor temple ruins displayed on this map that are not listed in the text of this guide book. Most of these minor temples are currently in a severe state of ruin and/or may not be easily accessible.

Roluos Group

Lolei
Preah Ko
Prasat Trapeang Phong
Prasat Kandal Doeum
Prasat Olok
Prasat O Keak
Bakong
Prasat Prei Monti
Siem Reap Town (13km)
Tram Neak

East Baray

Banteay Srey (37 km from Siem Reap)
Kbal Spean (49 km from Siem Reap)
Phnom Kulen (50km from Siem Reap)

Phnom Bok
Phnom To
Prei Prasat
Banteay Samre
Prasat Konnap
Prasat Leak Neang
Prasat Top
Bat Chum
East Mebon
Pre Rup
Sras Srang
Ta Som
Kutisvara
Prasat Kravan
Banteay Kdei
Neak Pean
Krol Ko
Krol Romeas
Preah Khan
Banteay Prei
Prasat Prei
Prasat Tonle Snguot
North Gate
Victory Gate
East Gate
East Prasat Top
Ta Nei
Thommanom
Spean Thma
Ta Keo
Chapel of the Hospital
Chau Say Thevoda
Kapilapura
Siem Reap River
Angkor Thom
West Prasat Top
Bayon
West Gate
South Gate
Thma Bay Kaek
Prasat Bei
Baksei Chamkrong
Phnom Bakheng
Ta Prohm Kel
Angkor Café
Chez Sop'héa
Secondary Entrance Gate
Angkor Wat
Main Entrance and Admissions
Tourist Police
Preah Einkosei
Roluos Group (13km)
Wat Thmei
Preah Chak
Prasat Reach Kandal
Siem Reap
Tonle Sap Lake, Chong Khneas, Phnom Krom (15km from Siem Reap)
National Route Nº 6

West Baray

Prasat Roluh
Tapeang Seng
Prei Khmeng
Ak Yom
Prasat Kas Ho
West Mebon
Prasat Ta Noreay
Airport
Wat Swei Romeal
Prasat Tapeang Ropou
National Route Nº 6 (Airport Road)

Central Angkor Thom

Preah Pithu Group
Wat Tung Tok
North Kleang
Vihear Prampil Loveng
South Kleang
Prasats Suor Prat
Terrace of the Elephants
Preah Palilay
Tep Pranam
Terrace of the Leper King
Royal Palace
Phimeanakas
Baphuon
Bayon

Introduction to Itineraries

This section of the book is intended as a practical guide for visiting the Khmer monuments and is designed for use at the sites, to help you get around the temples, and to enhance your appreciation of the art and architectural features. Points of special interest are indicated and explanations of art and architectural features are given to make your visit enjoyable and memorable. This section can also be read after visits to reinforce the experience. Historical quotes from early visitors and legends told by natives are included to try to capture the spirit of Angkor's past glory.

The names of many of the temples given in this guidebook are modern, as the original names are unknown. The ones given derived from various sources including local names, transliterations by foreigners and from legends transmitted orally.

The nearest temples are about six kilometres (four miles) from Siem Reap, so before setting off for the temples you will need to decide on a means of transport and to purchase a ticket to visit the temples. You can hire a car or van with a driver and you can rent a bicycle or motorcycle (with or without a driver). Some motorcycle drivers also serve as guides. Of course if you are travelling in a group or on a package tour the itinerary will be arranged in advance. Whatever type of transport you choose, it is preferable to hire it for the duration of your stay at Angkor. Permits to visit the temples can be purchased individually for one or several days. Always carry your permit with you and have it available to show guards whenever asked.

An early start is recommended to avoid being at the temples during the hottest part of the day and also so you will not miss the many photographic chances that occur before the sun is directly overhead. Try to be en route by 7am; return to Siem Reap for lunch around 1pm or 1.30pm; then depart for the temples again by 3pm for more sightseeing; climb to one of several vistas for the sunset, returning to Siem Reap just before dark, which is about 6.30pm all year round.

The sunsets are magnificent, and are best seen from the uppermost level of one of the several temples that affords a splendid view. As you sit on the blocks of sandstone, warm at the end of the day from the sun's rays, gaze over the vast plain of Angkor and imagine what it must have looked like 1,000 years ago, think of the people who lived at Angkor, of the battles they fought and the temples they built to sustain their civilisation. The best vistas for sunset are Angkor Wat, Phnom Bakheng, Pre Rup, East Mebon and Ta Keo.

The monuments included in the suggested temple itinerary have been arranged into 14 groups based on proximity. Either the groups or the temples within a given group can be taken in any order. Each one consists of between three and four hours of actual time at the monument plus approximately 30 minutes to reach the site from Siem Reap and another 30 minutes to return, except for Groups 4, 12, 13 and 14 which are further away. For a more leisurely pace allow a half day for each of the groups. Numbers which appear in bold type and in parenthesis throughout the text refer to locations on the relevant temple diagram. *Gopura* is marked up on the corresponding map or plan as entry tower.

Visitors travelling to the more remote sites such as Beng Mealea, Koh Ker and Preah Khan of Kompong Svay, east of Angkor, must not stray from the well-trodden paths and must be vigilant of the markers (wooden stakes painted with with red tips) denoting unsafe zones. DO NOT TRESSPASS!

The most popular monuments with visitors are Angkor Wat, the Bayon, Ta Prohm, Preah Khan and Banteay Srei. If you have time, plan to visit Angkor Wat and the Bayon twice, once in the morning and once in the afternoon, to see these great monuments in different lighting conditions. Ta Prohm is at its best in the early morning when the dew is lifting. The jungle growth entwined around the stones glistens with drops of moisture, and as the night air fades the sun rises, casting haunting shadows in the crevices of fallen stones.

The terraces of the Royal Palace of Angkor Thom and façades of other ruins within the royal city are visible from the road and can, therefore, be seen in just a few minutes

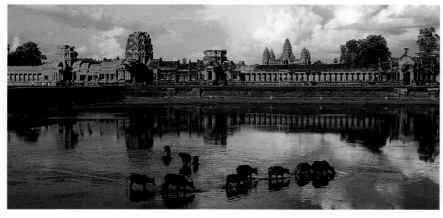

Above: *The tranquil moat surrounding Angkor Wat.*
Right: *Inner courtyard, National Museum, Phnom Penh.*

while passing by, but this neither does justice to the ancient city nor gives you any feel of what it must have been like in its heyday. The jungle behind the terraces and across the road is peaceful and serene with footpaths guiding you to the ruins; it is one of the most undisturbed and least visited parts of central Angkor. Walk around this area leisurely and enjoy the beauty of the Baphuon, Phimeanakas, Preah Palilay, Tep Pranam and the Kleangs, Prasats Suor Prat and Preah Pithu—all in the city of Angkor Thom.

It is not difficult to find your way around Angkor because the temples are linked by a system of roads built by the EFEO earlier in the last century. Most of the roads have been re-surfaced and are in reasonable condition and give convenient access to the vicinity of the ruins. Entrance to some of the actual temples, though, requires walking along a footpath for a few metres. To get to the ruins leave Siem Reap by the paved road at the north of town and continue to the drive-in ticket booth where you can purchase your permit for visiting the temples.

The monuments and surrounding jungle afford unlimited photographic opportunities. Photography is best either early morning or late afternoon. Clouds are common and tend to diffuse light—which is somewhat flat even though it is intense. As most of the temples face east, the best lighting conditions are in the morning, except for Angkor Wat where the best light is in the afternoon because it faces west. The temples surrounded by jungle such as Ta Prohm and Preah Khan can be photographed with good results when the sun is directly overhead and shining through the foliage.

Just as you are never prepared for the immensity and overwhelming beauty of

Angkor, you are never ready to leave it. With photographs and visions etched in memory, 'one never need never say good-bye to Angkor, for its magic will go with you wherever fate and the gods may take you to colour your thoughts and dreams to life's very end.' [26]

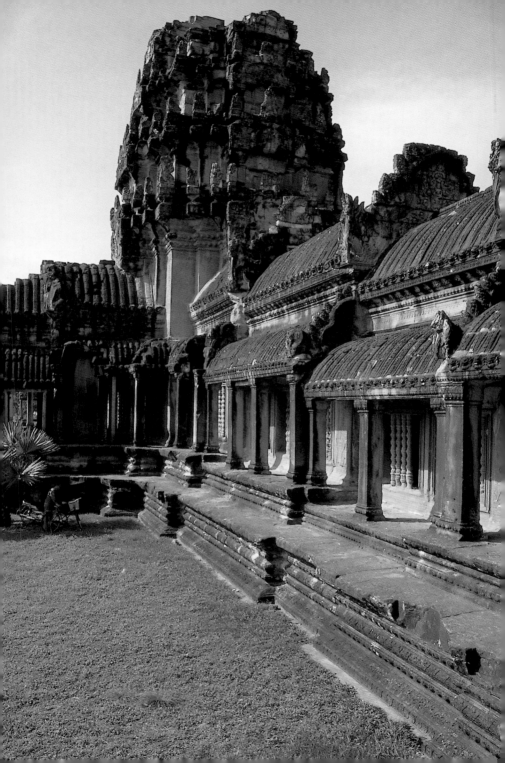

GROUP 1
ANGKOR WAT: 'THE CITY THAT IS A TEMPLE'

Angkor Wat, in its beauty and state of preservation, is unrivaled. Its mightiness and magnificence bespeak a pomp luxury surpassing that of a Pharaoh or a Shah Jahan, an impressiveness greater than that of the Pyramids, an artistic distinctiveness as fine as that of the Taj Mahal.[27]

Location: six kilometres (four miles) north of Siem Reap; one kilometre (two thirds of a mile) south of Angkor Thom
Access: enter and leave Angkor Wat from the west
Date: first half of the 12th century (approximately 1113–1150)
King: Suryavarman II (reigned 1113–circa 1150)
Religion: Hindu (dedicated to Vishnu)
Art style: Angkor Wat

BACKGROUND

Angkor Wat, the largest monument of the Angkor group and one of the most intact, is an architectural masterpiece. Its perfection in composition, balance, proportions, reliefs and sculpture make it one of the finest monuments in the world. This temple is an expression of Khmer art at its highest point of development.

The word *wat*, or *vat*, which means 'temple' was probably added to Angkor when it was a Theravada Buddhist monument, most likely in the 16th century. After the capital gradually shifted to Phnom Penh, Buddhist monks maintained Angkor Wat.

Some believe Angkor Wat was designed by Divakarapandita, the chief adviser and minister of the king, who was a brahmin with divine honours. The Khmers attribute the building of Angkor Wat to the divine architect Visvakarman. Construction probably began early in the reign of Suryavarman II and because his name appears posthumously in the bas-reliefs and inscriptions it is believed that Angkor Wat was completed after his death. The estimated time for construction of the temple is 30 years.

There has been considerable debate amongst scholars as to whether Angkor Wat was built as a temple or a tomb. It is generally accepted that the architecture and decoration identify it as a temple where a god was worshipped and that it was a mausoleum for the king after his death. Its orientation is different from other temples

Left: *A view of the western façade, Angkor Wat.*
Following pages: *A view towards the western entrance of Angkor Wat.*

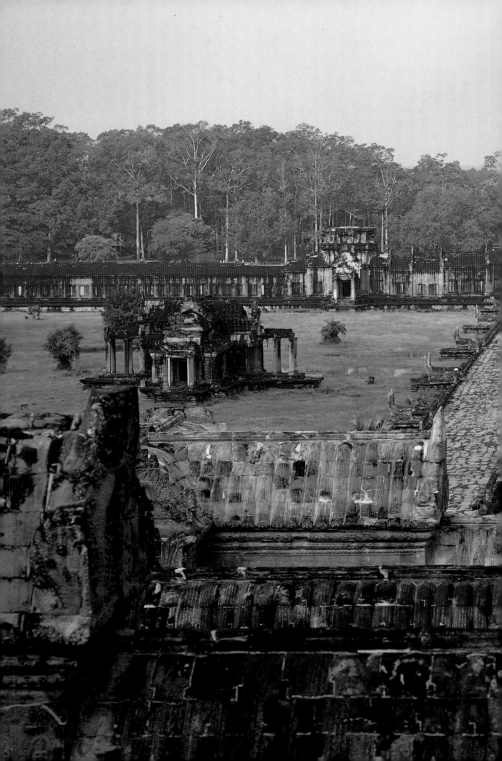

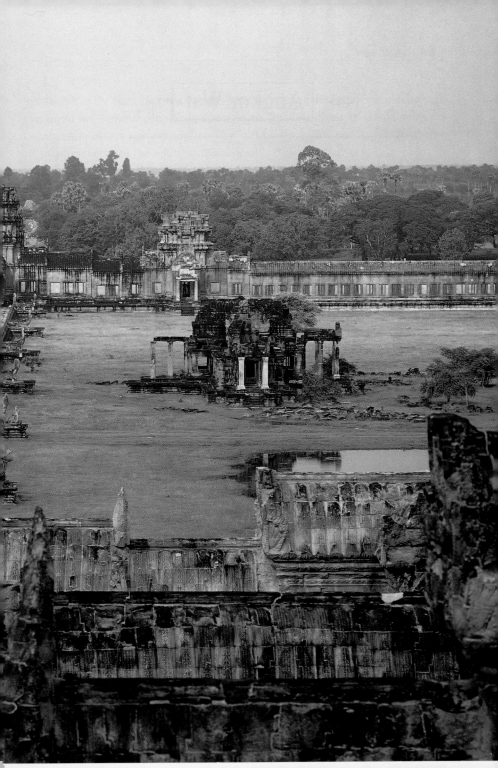

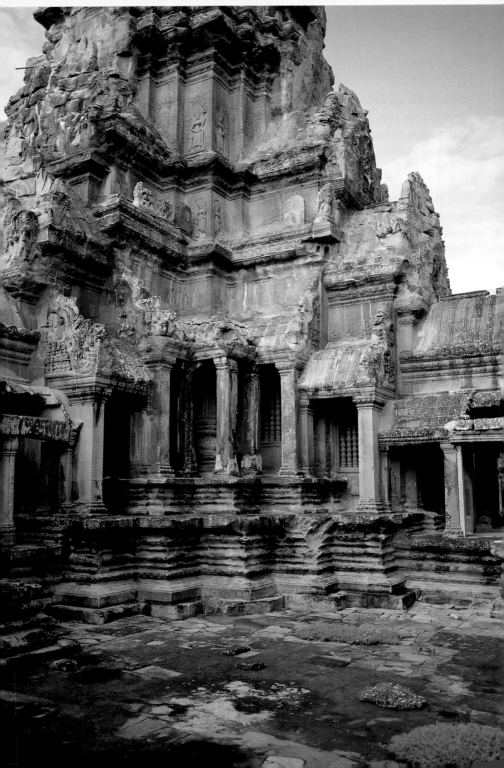

To become familiar with the composition of Angkor Wat it is advisable to learn to recognise the repetitive elements in the architecture. Galleries with columns, towers, vaulted roofs, frontons, steps and the cruciform plan occur again and again. It was by combining two or more of these aspects that a sense of height was achieved. This system was used to link one part of the monument to another. A smaller replica of the central towers was repeated at the limits of two prominent areas—the galleries and the *gopuras*. The long causeway at the west entrance is repeated on the eastern side of the first gallery.

SYMBOLISM

Angkor Wat, according to Coedès, is a replica of the universe in stone and represents an earthly model of the cosmic world. The central tower rises from the centre of the monument symbolising the mythical Mount Meru, situated at the centre of the universe. Its five towers correspond to the peaks of Meru; the outer wall to the mountains at the edge of the world; and the surrounding moat to the oceans beyond.[29]

A study has shown that when Angkor Wat was laid out by the Khmers originally, the distances between certain architectural elements of the temple reflected numbers which were related to Hindu mythology and cosmology. The positions of the bas-reliefs were regulated, for example, by solar movements. Scenes on the east-west sides reflect those relating to the rising and setting of the sun.

LAYOUT

Even though Angkor Wat is the most photographed Khmer monument, nothing approaches the actual experience of seeing this temple. Frank Vincent grasped this sensation over 100 years ago: 'The general appearance of the wonder of the temple is beautiful and romantic as well as impressive and grand...it must be seen to be understood and appreciated.'[30] Churchill Candee experienced a similar reaction some 50 years later: 'One can never look upon the ensemble of the Vat without a thrill, a pause, a feeling of being caught up into the heavens. Perhaps it is the most impressive sight in the world of edifices.'[31]

Angkor Wat is an immense monument occupying a rectangular area of about 210 hectares (500 acres), defined by a laterite enclosure wall (4) which is surrounded by a moat that is 200 metres (660 feet) wide. The perimeter of the enclosure wall measures 5.5 kilometres (3.5 miles). The moat is crossed by a huge causeway built of sandstone blocks 250 metres long (820 feet) and 12 metres (39 feet) wide (5). With

Angkor Wat appears taller than it is because of three progressive levels.

such impressive statistics it is easy to understand why some local inhabitants believe that Angkor Wat was built by the gods.

Start your tour at the west entrance, where you can see the first of many wonders at Angkor Wat. Climb the short flight of steps to the raised sandstone terrace (6) in the shape of a cross. You are standing at the foot of the long causeway leading to the interior. Look at the balance, the proportions and the symmetry, then the beauty of Angkor Wat begins to unfold. Giant stone lions on each side of the terrace guard the monument.

Look straight ahead to the end of the causeway at the *gopura* with three towers of varying heights, of which much of the upper sections have collapsed (7). The form of this *gopura* is so developed and elongated that it looks almost like a separate building. A long, covered gallery with square columns and a vaulted roof extends along the moat to the left and right of the *gopura*. This is the majestic façade of Angkor Wat and a fine example of classical Khmer architecture. It originally had another row of pillars with a roof. You can see evidence of this in a series of round holes set in square bases in front of the standing pillars.

Helen Churchill Candee must have been standing on this terrace almost 70 years ago when she wrote: 'Any architect would thrill at the harmony of the façade, an unbroken stretch of repeated pillars leading from the far angles of the structure to the central opening which is dominated by three imposing towers with broken sum-mits.'[32] **Tip:** before proceeding along the causeway, turn right, go down the steps of the terrace and walk along the path a few metres for a view of all five towers.

Then return to the centre of the terrace and cross the causeway towards the main part of the temple taking in the grandeur that surrounds you. The water in the moat shimmers and sometimes you can see lotus in bloom, birds bathing, buffaloes wallowing and children playing. In the 1920s, when RJ Casey walked on this causeway he noted it was 'an oddity of engineering.... The slabs were cut in irregular shapes, which meant that each had to be chiselled to fit the one adjoining. The effect as seen under the noonday sun...is like that of a long strip of watered silk.'[33]

On the left side, just before the midway point in the causeway, look for two large feet carved in a block of sandstone. It is possible that they belong to a figure at one of the entrances to Angkor Thom and were brought to Angkor Wat last century when the causeway was repaired with reused stones.

The causeway leads to the cruciform *gopura* or entry tower (7) mentioned earlier. The gateways at ground level on each end of the gallery probably served as passages for elephants, horses and carts, whereas the other entrances are accessed by steps and

North stairway to upper level, Angkor Wat.

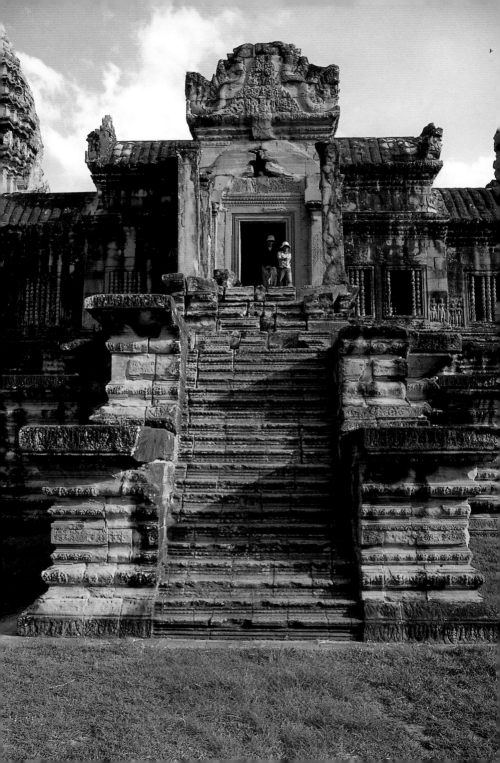

lead onto the central causeway. When Churchill Candee saw these entrances in the 1920s, she remarked that 'architecture made to fit the passage of elephants is an idea most inspiriting'.[34] A standing image of the Hindu god, Vishnu, is inside the west *gopura* (right side). It has been restored several times and is probably not in its original location (see p. 8). Modern Cambodians, though, honour it with offerings of flowers, gold leaf and incense. Traces of original colour can be seen on the ceiling of the *gopura*.

From the central entrance turn right and walk along the columned gallery coming to the end, where the quality of carving and intricacy of decoration on the false door is of exceptional beauty. Walk through the opening at the end of the gallery towards the east. Here you will see the first full view of the splendid five towers of Angkor Wat (but there are even better views of them to come). Take a sharp left turn at the porch and walk along the ledge of the inner side of the gallery, back towards the centre. Along the upper portion of this wall you will see an array of divinities riding fantastic animals framed with an exquisite leaflike motif. The liveliness of these figures, the variety and the crispness of carving is exceptional. As you near the centre of the temple, the female divinities, the *devatas*, on the walls of the porch are some of the most beautiful in all of Angkor Wat.

You are now back to where you entered the gallery and looking towards the main temple complex (which forms the celebrated view of Angkor Wat that appears on the Cambodian flag). Standing at this point you feel compelled to 'get to the wondrous group of the five domes, companions of the sky, sisters of the clouds, and determine whether or not one lives in a world of reality or in a fantastic dream'.[35]

Continue eastward along the raised walkway of equally imposing proportions (length: 350 metres, 1,150 feet; width: nine metres, 30 feet) (8). A low balustrade formed by short columns supporting the scaly body of a *naga* borders each side. As you walk along the causeway notice the ceremonial stairs with platforms, always in pairs (to your left and right). These may have given access to the streets between dwellings. The serpent balustrade also frames the stairs. It terminates with the body of the serpent making a turn at right angles towards the sky and gracefully spreading its many heads to form the shape of a fan. This arrangement is sometimes called a landing platform.

Two buildings, so-called libraries (9), stand in the courtyard on the left and right, just past the middle of the causeway. These 'jewel-boxes of Khmer art' are perfectly formed. A large central area, four porches, columns and steps present a symmetrical plan in the shape of a cross. Some of the columns have been replaced with concrete copies for support.

In front of the libraries are two basins (length: 65 metres, 215 feet; width: 50 metres, 165 feet), ingeniously placed to capture the reflection of the towers in the water (10). The one on the left is filled with water, whereas the other one is usually dry. **Tip**: turn left at the first steps after the library, but before the basin, and follow the path for about 40 metres (131 feet) to a large tree for a superb view of the five towers of Angkor Wat particularly at sunrise, depending on the light, a reflection of the towers appears in the basin.

The architectural triumph on this walkway is the cruciform-shaped Terrace of Honour, just in front of the principal *gopura* of Angkor Wat (11). Supporting columns and horizontal, carved mouldings around the base accentuate the form of the terrace. Steps flanked by lions on pedestals are on three sides of the terrace. Ritual dances were performed here, and it may also have been where the king viewed processions and received foreign dignitaries.

Casey sensed such activity in the 1920s: 'One cannot but feel that only a few hours ago it was palpitating with life. The torches were burning about the altars. Companies of priests were in the galleries chanting the rituals. Dancing-girls were flitting up and down the steps....That was only an hour or two ago, monsieur...it cannot have been more.'[36]

From the top of the terrace there is a fine view of the famous Gallery of Bas-reliefs (215 by 187 metres, 705 by 614 feet) on the first platform level (1). The vaults over the gallery are supported by a row of 60 evenly-space columns providing light to the inner wall decorated with bas-reliefs. **Tip: at this point, you have the choice of continuing straight to the central towers or turning right to see the reliefs.**

The cross-shaped galleries provide the link between the first and second levels (12). This unique architectural design consists of covered cruciform-shaped galleries with square columns forming four courtyards each with paved basins and steps. The corbel vaults are exposed all along the galleries. Several decorative features stand out: windows with stone balusters turned like wood, rosettes on the vaults, a frieze of *apsaras* under the cornices and ascetics at the base of the columns. **Tip**: Many of the pillars in the galleries of this court have inscriptions written in Sanskrit and Khmer. At both ends of the north and south galleries in the courtyard are two libraries of similar form, but smaller than the ones along the entrance causeway (13). There is a good view of the upper level of Angkor Wat from the northern one.

The Gallery of 1,000 Buddhas, on the right, once contained many images dating from the period when Angkor Wat was Buddhist, but only a few of these figures remain today and they are in poor condition (14). The Hall of Echoes, on the left, is

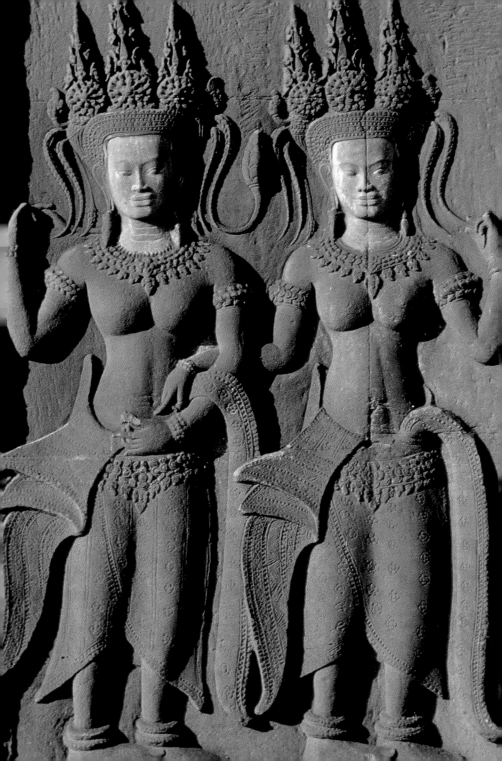

so named because of its unusual acoustics (**15**). **Tip**: to hear the resonance in the Hall of Echoes walk to the end of the gallery and into the alcove, stand with your back to the wall, thump your chest and listen carefully.

Return to the centre of the cruciform-shaped galleries and continue walking eastward toward the central towers. Another set of stairs alerts you to the continuing ascent. The outer wall of the gallery of the second level, closest to you (100 by 115 metres, 330 by 380 feet), is solid and undecorated, probably to create an environment for meditation by the priests and the king (**2**).

The starkness of the exterior of the second level gallery is offset by the decoration of the interior. Nearly 1,850 *apsaras* ('celestial nymphs') adorn the walls of the gallery, offering endless visual and spiritual enchantment. These graceful and beautiful females delight all visitors. They were born from the Churning of the Ocean of Milk. From their ethereal origins to their realistic appearance on the walls of Angkor Wat they offer timeless joy. When you first walk into the courtyard the multitude of these female figures on the walls and in the niches may seem repetitive, but as you move closer and look carefully you become aware of the variations and quickly see that each one of these celestial nymphs is different. The elaborate coiffures, headdresses and jewellery befit, yet never overpower, these 'ethereal inhabitants of the heavens'.

Female divinities appear at Angkor Wat for the first time in twos and threes. These groups break with the traditional formality of decoration in other parts of the temple by standing with arms linked in coquettish postures and always in frontal view except for the feet, which appear in profile. Pang, a Cambodian poet, in a tribute to the Khmer ideal of female beauty wrote of the *apsaras* in the 17th century: 'These millions of gracious figures, filling you with such emotion that the eye is never wearied, the soul is renewed, and the heart never sated! They were never carved by the hands of men! They were created by the Gods—living, lovely, breathing women!'[37]

Only the king and the high priest were allowed on the upper or third level of Angkor Wat (**3**). This level lacks the stately covered galleries of the other two, but as the base of the five central towers, one of which contains the most sacred image of the temple, it has an equally important role in the architectural scheme.

Like all of Angkor Wat, the statistics of this level are imposing. The square base is 60 metres (197 feet) long, 13 metres (43 feet) high, and rises over 40 metres (131 feet) above the second level. Twelve sets of stairs with 40 steps each—one in the centre of each side and two at the corners—ascend at a 70-degree angle giving access to the topmost level. Standing at the bottom on the stairs, looking up, the ascent can

Female divinities on the interior of the second level gallery, AngkorWat. (Michael Freeman)

seem formidable. But persevere and forge ahead for the effect is worth it when you reach the top. **Tip**: the south stairway (centre) has concrete steps and a handrail. The steps on all sides are exceptionally narrow. It is suggested you ascend and descend sideways.

All the elements of repetition that make up the architectural plan of Angkor Wat are manifested on the upper level. The space is divided into a cruciform-shaped area distinguished by covered galleries and four paved courts. A *gopura* with a porch and columns is at the top of each stairway. Passages supported on both sides with double rows of columns link the *gopura* to the central structure. The corners of the upper level are dominated by the four towers. Steps both separate and link the different parts. A narrow outer gallery with a double row of pillars, windows and balusters surrounds this third level. **Tip**: walk along the outer gallery of the upper level and enjoy the view of the surrounding countryside and the western causeway.

The central sanctuary (17) soars 42 metres (137 feet) above the upper level. Its height is enhanced by a tiered plinth. The highest of the five towers, it is equal in height to the cathedral of Notre Dame in Paris. This central sanctuary originally had four porches opening to the cardinal directions and sheltered a statue of Vishnu. Today it houses a Buddha image and it is possible to make an offering and light a candle in this sacred inner sanctum. Sometime around the 15th century when the temple was used by Theravada Buddhists the doorways of the central sanctuary were blocked by walls, forming vestibules for Buddhist worship

Nearly 500 years later archaeologists discovered a vertical shaft 27 metres (89 feet) deep behind the doorway on the south side, which is probably where the sacred objects of the temple were originally buried but were pillaged.

From the summit, the layout of Angkor Wat reveals itself at last. The view is a spectacle of beauty befitting the Khmer's architectural genius for creating harmonious proportions. There it is, the spectacular mass of stone that makes up Angkor Wat, the largest religious monument ever constructed.

GALLERY OF BAS-RELIEFS

'By their beauty they first attract, by their strangeness they hold attention', Helen Churchill Candee wrote of the bas-reliefs in the 1920s.[38] The Gallery of Bas-reliefs, surrounding the first level of Angkor Wat, contains 1,200 square metres (12,900 square feet) of sandstone carvings. The reliefs cover most of the inner wall of all four sides of the gallery and extend for two metres (seven feet) from top to bottom. The detail, quality, composition and execution give them an unequalled status in world

Angkor Wat: Galleries of Bas-reliefs

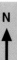

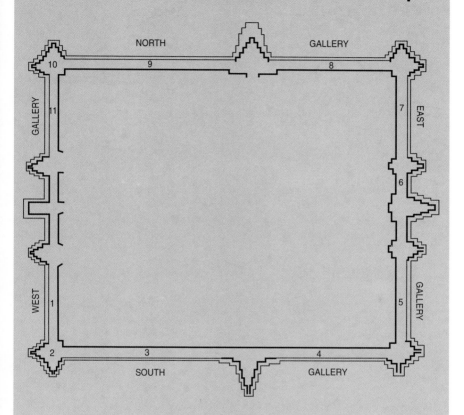

NORTH GALLERY

10 9 8

GALLERY

11 7

EAST

6

WEST 5

1

2 3 4 5

SOUTH GALLERY

WEST GALLERY

1 Battle of Kurukshetra
11 Battle of Lanka

CORNER PAVILION

2 Scene from the *Ramayana*

SOUTH GALLERY

3 Army of King Suryavarman II
4 Judgement by Yama/
 Heaven and Hell

EAST GALLERY

5 Churning of the Ocean of Milk
6 Inscription
7 Victory of Vishnu over the Demons

NORTH GALLERY

8 Victory of Krishna over Bana
9 Battle between the Gods and the Demons

CORNER PAVILION

10 Scene from the *Ramayana*

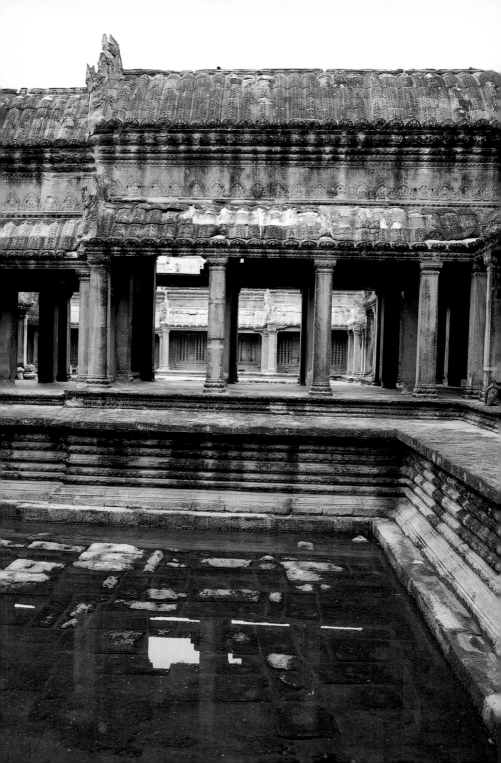

art. Columns along the outer wall of the gallery create an intriguing interplay of light and shadow on the reliefs. The effect is like 'the work of painters rather than sculptors'. The bas-reliefs are of 'dazzling rich decoration—always kept in check, never allowed to run unbridled over wall and ceiling; possess strength and repose, imagination and power of fantasy; wherever one looks [the] main effect is one of "supreme dignity"', wrote a visitor 50 years ago.[39]

The bas-reliefs are divided into eight sections, two panels flanking each of the four central entrances and additional scenes in each pavilion at the north and south corners of the west gallery. The scenes on the bas-reliefs run horizontally, from left to right, in a massive expanse along the walls. Sometimes decorated borders are added. The scenes are arranged in one of two ways: either without any deliberate attempt to separate the scenes; or in registers which are sometimes superimposed on one another. The latter form was probably introduced at a later date.

Each section tells a specific story inspired by one of three main sources—either Indian epics, sacred books or warfare of the Angkor period. Some scholars suggest that the placement of a relief has a relevance to its theme. The bas-reliefs on the east walls, for example, depict creation, birth and a new beginning (all associated with the rising sun), whereas those on the west walls portray war and death and aspects related to the setting sun.

Parts of some of the reliefs have a polished appearance on the surface. There are two theories as to why this occurred. The position of the sheen and its occurrence in important parts of the reliefs suggest it may have resulted from visitors rubbing their hands over them. Some art historians, though, think it was the result of lacquer applied over the reliefs. Traces of gilt and paint, particularly black and red, can also be found on some of the reliefs. They are probably the remains of an undercoat or a fixative.

Tip: as the bas-reliefs at Angkor Wat were designed for viewing from left to right, the visitor should follow this convention for maximum appreciation. Enter the Gallery of Bas-reliefs at the middle of the west side, turn right into the gallery and continue walking counter-clockwise. If you start from another point always keep the monument on your left.

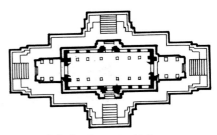

© Airphoto International Ltd

Above right: *Plan of a library at Angkor Wat.*
Left: *Covered galleries with columns define the boundaries of the first and second levels at Angkor Wat.*

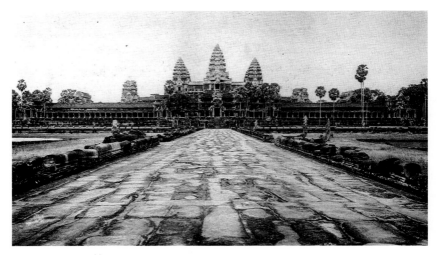

*Early photograph of the five (two are broken) towers of Angkor Wat
from the second causeway at the west entrance.*

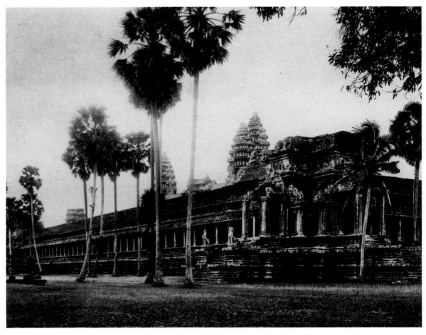

The southwest corner pavilion of the Gallery of Bas-reliefs, c. 1880.

If your time at Angkor is limited, the following bas-reliefs are recommended (the numbers refer to the plan):

Location	Theme
Location	*Theme*
1 West Gallery	Battle of Kurukshetra
3 South Gallery	Army of King Suryavarman II
5 East Gallery	Churning of the Ocean of Milk
11 West Gallery	Battle of Lanka

In view of the vast number of bas-reliefs at Angkor Wat and recognising that only so much art can be absorbed at one time, descriptions in this guide include just the highlights in the main galleries and one or two identifiable scenes in the corner pavilions. For complete details of all the reliefs at Angkor Wat, see *Sacred Angkor* by Vittorio Roveda. Descriptions begin in the middle of the west gallery and continue in a counter-clockwise direction around the square.

■ WEST GALLERY: BATTLE OF KURUKSHETRA

This battle scene (1) is the main subject of the Hindu epic *Mahabharata*, and it unfolds in action-packed drama on the walls of Angkor Wat. It recalls the historic wars in Kurukshetra, a province in India, and depicts the last battle between rival enemies (the Kauravas and the Pandavas, who are cousins). In fierce, hand-to-hand combat the ferocious battle ensues. With commanders (represented on a larger scale) giving instructions from elaborately carved chariots or the backs of elephants, arrows fly in all directions, warriors fight bravely, others march in unison, horses rear in fright and slain bodies are strewn across the battlefield.

The armies of the Kauravas and the Pandavas march into battle from opposite ends towards the centre of the panel where they meet in combat. Headpieces differentiate the warriors of the two armies. Musicians play a rhythmic cadence to keep the soldiers in step. The scene builds up gradually and climaxes in a mêlée in the centre of the panel. Identifiable figures in the panel include: Bisma, one of the heroes of the *Mahabharata* and commander of the Kauravas (at the top, near the centre) is pierced with arrows fired by his arch enemy Arjuna; his men surround him as he lies dying; Arjuna (near the centre holding a shield decorated with the face of the demon Rahu) shoots an arrow at Krishna, his half-brother, and kills him; after death, Krishna (four arms) becomes the charioteer of Arjuna.

■ SOUTHWEST CORNER PAVILION: SCENE FROM THE RAMAYANA

Unfortunately, many of the bas-reliefs in this pavilion have been damaged by water. The scenes (2) are inspired by the Indian epic, the *Ramayana* and the life of Krishna.

One such episode from his life is found on the north branch, east face in a well-known story of Krishna lifting Mount Govardhana. He does this after persuading the pastoral people of India to shift their allegiance from Indra to him. Enraged, Indra sends a deluge of rain and thunder to the land of the shepherds as punishment. Krishna comes forth to provide shelter for them and their flocks by 'lifting up Mount Govardhana from its base in one hand, he holds it in the air as easily as a small child holds a mushroom'. He supports the mountain for seven days before Indra admits defeat; (above the north door) Rama kills Marica, who, disguised as a golden stag, helped in the abduction of Sita; (south branch, east face). A fight between the brothers, Valin and Sugriva (king of the monkeys), who are enemies, duel for possession of Sugriva's kingdom. Rama intervenes and kills Valin by piercing him with an arrow. Below, Valin lies in the arms of his wife and on adjoining panels monkeys cry over Valin's death.

■ SOUTH GALLERY: ARMY OF KING SURYAVARMAN II

This gallery (3) also depicts a battle scene, but it differs from the previous one because it is a historical, rather than mythical, portrayal of a 'splendid triumphal procession' from a battle between the Khmers and their enemies. The reliefs show methods used in warfare, mainly hand-to-hand combat, as they had no machinery and no know-ledge of firearms. The naturalistic depiction of trees and animals in the background of this panel is unusual. The central figure of this gallery is the king, Suryavarman II, the builder of Angkor Wat, who appears twice in the reliefs, once

A drawing of the western façade of Angkor Wat.

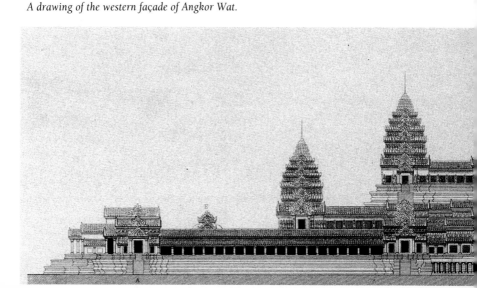

standing and again seated. An inscription on the panel identifies him by his posthumous name. It is uncertain when the rectangular holes randomly cut in this gallery were done or by whom. They may have contained precious objects belonging to the temple.

On the upper tier, the king (seated and with traces of gilt on his body), with a brahmin standing nearby, holds an audience on a mountain, while below a procession of women from the palace carried, in palanquins and accompanied by female servants, descends from a mountain in the forest. The army gathers for inspection and the commanders, mounted on elephants, join their troops who are marching towards the enemy. The commander's rank is identified by a small inscription near the figure. King Suryavarman II stands on an elephant (conical headdress, sword with the blade across his shoulder) and servants around him hold 15 ceremonial parasols, indicating his position and rank.

The lively and loud procession of Sacred Fire (carried in an ark) follows with standard bearers, musicians and jesters. Brahmins chant to the accompaniment of cymbals. The royal sacrificer rides in a palanquin. Towards the end of the panel: the military procession resumes with a troop of Siamese soldiers (pleated skirts with floral patterns; belts with long pendants; plaited hair; headdresses with plumes; short moustaches) led by their commander, who is mounted on an elephant. The Siamese troops were probably either mercenaries or a contingent from the province of Louvo (today called Lopburi) conscripted to the Khmer army. A number of the Khmer warriors wear helmets with horns or animal heads (deer, horse, bird) to frighten the enemy and some of their shields are embellished with monsters for the same purpose.

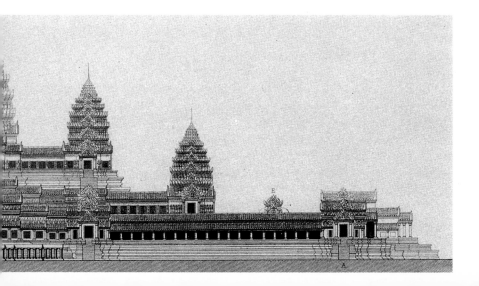

■ **JUDGEMENT BY YAMA/ HEAVEN AND HELL**

This is a fierce scene (4), where brutality and torture abound. Three tiers recount the judgement of mankind by Yama and two tiers depict heaven and hell. Inscriptions have identified 37 heavens, where one sees leisurely pursuits in palaces, and 32 hells, with scenes of punishment and suffering. Draperies and *apsaras* separate the two and a row of *garudas* borders the tier on the bottom. Traces of gilt can be seen on those mounted on horseback at the beginning of the panel. The lower section of the panel was badly damaged and was later repaired with cement plaster.

Lower tier: Yama, the supreme judge (with multiple arms, holding a staff and riding a buffalo), points out to his scribes the upper road representing heaven and the lower one of hell. Departed spirits await judgement. Assistants to Yama shove the wicked through a trap door to the lower regions using a pitchfork, where torturers deliver punishments such as sawing a body in half for those who overeat; law breakers have their bones broken; thieves of rice have their stomachs filled with red-hot irons and some of the punished wear iron shackles or have nails pierced through their heads. Upper tier: the virtuous are rewarded by a life of leisure in a celestial palace. A frieze of *garudas* holding up the celestial palace with *apsaras*, floating in the skies above, separates the two tiers.

■ **EAST GALLERY: CHURNING OF THE OCEAN OF MILK**

This is the most famous panel of bas-reliefs (5) at Angkor Wat and one of the greatest scenes ever sculpted in stone. The myth derives from the Hindu epic *Bhagavata-Purana* and centres on gods and demons who have been churning the ocean of milk for 1,000 years in an effort to produce an elixir that will render them immortal and incorruptible. The figures are carved with such consummate skill that you sense the strength of their muscles as they pull the serpent's body, you see the effort in their expressions and you rejoice at the rewards yielded from their churning that float effortlessly in the celestial heavens above.

The scene is divided into three tiers. The main tier, in the middle, is bordered along its base by various real and mythical aquatic animals in a churning ocean which is framed by a serpent's body; whilst above these are flying *apsaras*. At each end of the panel, soldiers and charioteers stand by, waiting to carry the participants away after the churning is completed.

The story begins with the gods, who are discouraged because they have been unsuccessful in producing the elixir and are exhausted from fighting the demons. They seek help from Vishnu, who tells them to continue churning and to work together, with, rather than against, the demons in helping to extract the *amrita* (elixir of immortality). In the middle tier of the panel, on the side of the head of the serpent

Vasuki, is a row of 92 demons (round bulging eyes, crested helmets) and on the side of his tail, is a row of 88 gods (almond-shaped eyes, conical headdresses). They hold Vasuki's body waist-high; it stretches horizontally across the expanse of the panel.

As Vishnu instructed, the gods and demons are working together and churning with the assistance of Hanuman, the monkey god. But as they churn difficulties develop. Mount Mandara, begins to sink. The churning nauseates Vasuki and he vomits a mortal venom that floats on the waves and threatens to destroy the gods and demons. Brahma intervenes and requests that Shiva drink the venom, but it is so powerful that it burns his throat leaving an indelible trace, an incident that henceforth gives him the name of 'the god with the blue throat'.

In a scene that climaxes in the centre of the panel, Vishnu comes to the rescue in his reincarnation as a tortoise and offers the back of his shell as support for the mountain. The serpent Vasuki serves as the rope and curls himself around it. Fortified with new support, they start again, pulling rhythmically, first in one direction and then in the other, causing the mountain to rotate, churning the water, and trying to generate the elixir. Vishnu appears in this scene again, in yet another reincarnation—as a human being (four arms, holding a disc in his upper left hand)—to preside over the churning which continues for yet another 1,000 years.

Finally, their efforts are rewarded. The churning yields not only the elixir of immortality, but also many treasures including, among others, the three-headed elephant Airavata, the goddess Lakshmi, a milk-white horse, Chanda the moon god, the conch of victory, the cow of plenty, and the wonderful *apsaras*.

■ INSCRIPTION
Continuing towards the north, just past the middle of the east gallery, there is an interesting inscription (6) of the early 18th century when Angkor Wat was a Buddhist monastery. It tells of a provincial governor, who built a small tomb where he deposited the bones of his wife and children. You can see this spire-shaped tomb in its original location (although in poor condition), looking to the east of the inscription in the gallery.

■ VICTORY OF VISHNU OVER THE DEMONS
The stiffness of the figures and the cursory workmanship suggest that the bas-reliefs (7) in this section of the east gallery and the south part of the north gallery may have been carved at a later date, perhaps the 15th or 16th century. Nevertheless, there is plenty of action. The scene begins with an army of demons marching towards the centre of the panel and coming at Vishnu with a vengeance. Centre: Vishnu (four arms), mounted on the shoulders of his vehicle, the *garuda*, fights bravely and

successfully slaughters the enemies on both sides. The leaders of the demons (mounted on animals or riding in chariots drawn by monsters) are surrounded by marching soldiers. Another group of warriors (bows and arrows) with their chiefs (in chariots or mounted on huge peacocks) follows.

■ NORTH GALLERY: VICTORY OF KRISHNA OVER BANA THE DEMON KING

At the beginning of the panel Vishnu (**8**), in his incarnation as Krishna (eight arms, multi-heads, framed by two heroes), is mounted on the shoulders of a *garuda*, and is followed by Agni, the god of fire (multiple arms), riding his vehicle, the rhinoceros. This scene is repeated several times as Krishna advances with his army of gods towards Bana. However, he is stopped by a fire engulfing the wall surrounding the city. The *garuda* extinguishes the fire with water from the sacred river, Ganges. The demon Bana approaches from the opposite direction in a splendidly carved chariot drawn by a pair of fierce lions. On the extreme right, Krishna (1,000 heads, hands across his chest) kneels in front of Shiva, who sits enthroned on Mount Kailasa with his wife, Parvati, and their son, Ganesha, as they demand that Shiva spares the life of Bana.

■ BATTLE BETWEEN THE GODS AND THE DEMONS

This is an epic battle scene (**9**) on a grand scale, engaging 21 gods of the Brahmanic pantheon, who march in procession carrying classic attributes and riding their traditional vehicles. A god battles against a demon, while warriors on both sides fight in the background. A series of adversaries follow; then Kubera, God of Wealth (with bow and arrow), appears on the shoulders of a *yaksha*; followed by Skanda, God of War (multiple heads and arms), mounted on a peacock; Indra stands on his mount the elephant; Vishnu (four arms) rides his vehicle, *garuda*; a demon (tiered heads) shaking swords; Yama, God of Death and justice (sword and shield), stands in a chariot drawn by oxen; Shiva draws a bow; Brahma, the Creator, rides his sacred goose; Surya, God of the Sun, rides in a chariot pulled by horses; and Varuna, God of Water, stands on a five-headed *naga* harnessed like a beast of burden.

■ NORTHWEST CORNER PAVILION: SCENE FROM THE RAMAYANA

As in the northeast pavilion, the *Ramayana* is the main source of inspiration for the bas-reliefs (**10**) in the northwest corner pavilion. A scene worth seeking out is found on the south branch, west face which depicts Vishnu seated (with four arms) surrounded by a bevy of *apsaras* (east branch, north face). At the top of this scene we

Top: *Angkor Wat, view looking east. The south library lies to the right;*
a naga head (foreground, right) guards the causeway.
Bottom: *View to the northwest from the top level.*

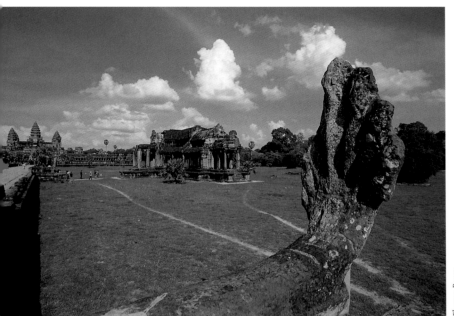

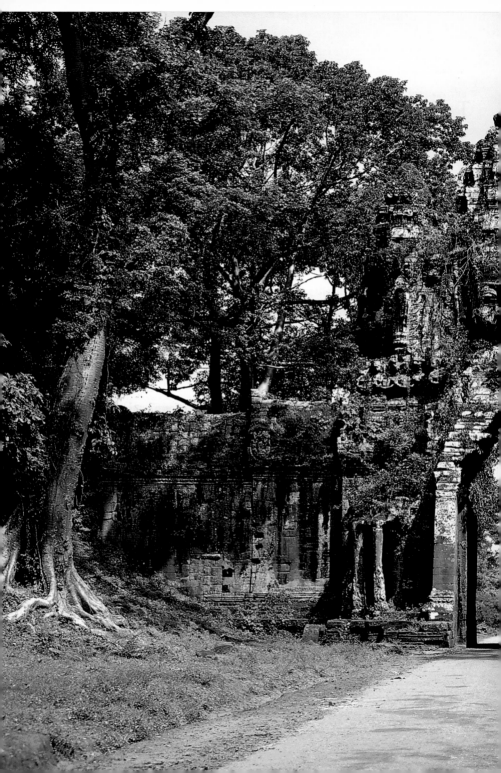

GROUP 2
ANGKOR THOM

Angkor Thom is undeniably an expression of the highest genius. It is, in three dimensions and on a scale worthy of an entire nation, the materialisation of Buddhist cosmology, representing ideas that only great painters would dare to portray....Angkor Thom is not an architectural "miracle"....It is in reality the world of the gods springing up from the heart of ancient Cambodia...[41]

Location: 1.7 km (1.06 miles) north of Angkor Wat
Access: from Siem Reap, enter by the South *Gopura*
Date: late 12th–early 13th century
King: Jayavarman VII (reigned 1181–1220)
Religion: Buddhist
Art style: Bayon

BACKGROUND

Angkor Thom, the last capital, was indeed a 'Great City' as its name implies, and it served as the religious and administrative centre of the vast and powerful Khmer Empire. It was grander than any city in Europe at the time and must have supported a considerable population—which may have been as high as one million. Within the city walls were the residences of the king, his family and officials, military officers and priests while the rest of the people lived outside of the enclosure. The royal structures were built of wood and have all perished, but remains of stone monuments let us glimpse at the past grandeur of this once great capital. You can walk amongst the Bayon, the Terrace of the Elephants, Terrace of the Leper King, the Prasat Suor Prat and others, as well as the earlier monuments of the Baphuon and Phimeanakas—all within the walls of Angkor Thom. Looking at these ruins it is easy to imagine why foreigners referred to Angkor Thom as 'an opulent city'.

Zhou Daguan, the Chinese emissary who provided the only first-hand account of the Khmers, described the splendour of Angkor Thom: 'At the centre of the kingdom rises a Golden Tower [Bayon] flanked by more than 20 lesser towers and several hundred stone chambers. On the eastern side is a golden bridge guarded by two lions

Previous pages: The majestic entrances to Angkor Thom each have four heads—one facing each cardinal direction.

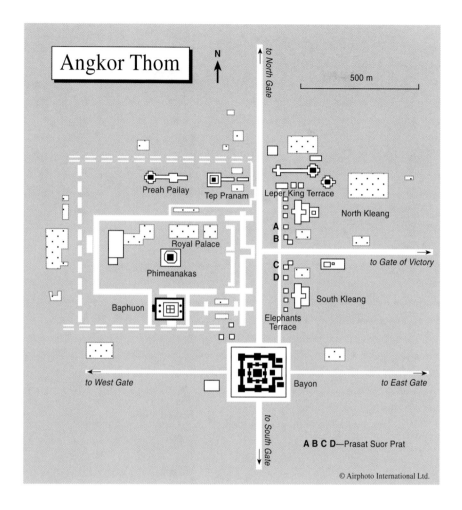

© Airphoto International Ltd.

of gold, one on each side, with eight golden Buddhas spaced along the stone chambers. North of the Golden Tower rises the Tower of Bronze [Baphuon], higher even than the Golden Tower: a truly astonishing spectacle, with more than ten chambers at its base. A quarter of a mile further north is the residence of the King. Rising above his private apartments is another tower of gold. These are the monuments which have caused merchants from overseas to speak so often of 'Cambodia the rich and noble'.[42]

LAYOUT

A laterite wall eight metres (26.24 feet) high encloses the city of Angkor Thom, which is laid out on a square grid. Each side of the wall is about three kilometres (1.9 miles) long and it encloses an area of 145.8 hectares (360 acres). A moat with a width of 100 metres (328 feet) surrounds the outer wall. The city is accessed along five great causeways, one in each cardinal direction, plus an additional Gate of Victory on the east aligned with the Terraces of the Elephants and the Leper King. A tall *gopura,* distinguished by a superstructure of four faces, bisects the wall in the centre of each side. Four small shrines, all called Prasat Chrung, stand at each corner of the wall around the city of Angkor Thom. An earthen embankment runs along the inner side of the wall and serves as a road around the city. The five principal entrances lead to the Bayon, situated at the centre of the capital. This temple, in its present form, was the creation of Jayavarman VII and its architecture reflects the dynamism and expansiveness of his reign. Massive towers rise around a circular central sanctuary, each one with four faces gazing afar, yet near.

CAUSEWAYS

The stone causeways across the broad moat surrounding Angkor Thom with their unique *gopuras,* are one of the great sights at Angkor, never ceasing to fill visitors with wonder. The south gate is the one most frequently photographed, and the lighting is best in the morning. Start at the south side, ask your transport to wait on the north, and walk across the causeway to get a sense of the size and scale of the demons and gods protecting the entrances leading to the royal city.

The causeways leading to the *gopuras* are flanked by a row of 54 stone figures on each side—gods on the left and demons on the right—to make a total of 108 mythical beings guarding each of the five approaches to the city of Angkor Thom. The demons have a grimacing expression and wear a military headdress, whereas the gods look serene with their almond-shaped eyes and conical headdresses. Some of the heads on these figures are copies; the original ones have either been stolen or removed to the Conservation Office for safekeeping. The gods and demons hold the scaly body of a *naga* on their knees. This composition defines the full length of the causeway. At the beginning of the causeway, the *naga* spreads its nine heads in the shape of a fan.

GOPURAS

'Through here all comers to the city had to pass, and in honour of this function it has been built in a style grandiose and elegant, forming a whole, incomparable in its strength and expression.'[43]

Each of the five sandstone *gopuras* rises 23 metres (75 feet) to the sky and is crowned with four heads, one facing each cardinal direction. Three-headed elephants (the mount of the Hindu god, Indra) stand at the base of each *gopura*. The trunks are plucking lotus flowers perhaps out of the moat. Indra sits at the centre of each elephant with his consorts on each side. He holds a thunderbolt in his lower left hand. Stand in the centre of the *gopura* and you will see a sentry box on each side. Inside the entrance of the *gopura* you can see the corbelled arch, a hallmark of Khmer architecture.

SYMBOLISM

Jayavarman VII's capital of Angkor Thom is a microcosm of the universe divided into four parts by the main axes. The temple of the Bayon stands as the symbolic link between heaven and earth. The wall enclosing the city of Angkor Thom represents the stone wall around the universe and the mountain ranges around Meru. The surrounding moat suggests the cosmic ocean. This symbolism is reinforced by the presence of the Hindu god Indra on his mount, the three-headed elephant, on each *gopura*.

What do the dramatic causeways that culminate in *gopuras* of such unusual form with four faces symbolise? Not everyone is in agreement, and the subject has been the source of considerable debate amongst scholars. The long-held and most well-known idea is that the gods and demons holding the body of the *naga* represent the myth of creation as depicted in the *Churning of the Ocean of Milk*, the famous relief on the east gallery (south side) at Angkor Wat. The three-headed white elephants seen at the base of each *gopura* were born from this image.

Another idea is that they represent the rainbow uniting the worlds of man and the gods. As you walk across the causeway you are transgressing from the earthly world to a heavenly one. A more recent theory (put forth by Boisselier) draws on a historical event from Buddhist texts and Khmer inscriptions, which suggest the causeway and *gopura* theme represents Indra's miraculous victory over the demons. The stone figures, which are two families of *yakshas* (guardians) not gods and demons, stand guard at the gates of the city to ward off any future surprise attack. The city itself represents Indra in Tavatimsa heaven, situated at the centre of the kingdom.

PRASAT CHRUNG THE 'CORNER SHRINES'

The four small shrines, each called Prasat Chrung, are of archaeological importance because they originally contained a stele that mentions the foundation of Jayavarman VII and provides historical information about the period. The steles have been removed and placed in the Angkor Conservancy for safety.

The shrine in the southeast corner of Angkor Thom is in good condition and a lovely walk, shaded by trees with nice views of the moat. A laterite enclosure wall (destroyed) and a sandstone door frame mark the entrance at the west. The pediment above is framed by a lobed band that resembles a serpent and terminates in multiple heads at its ends. The narrative scene of the pediment is dominated by a standing Lokeshvara with rows of worshippers around him.

A short causeway and a raised terrace paved in sandstone lead to the entrance of the single sandstone shrine, which stands on a base and is cruciform with a square porch in each cardinal direction. The east and west porches have entrances into the central shrine, whereas the north and south porches are 'false doors'. A blooming lotus crowns the superstructure of the shrine.

The walls are decorated with *devatas* in niches and with false windows with balusters and blinds. The moulding on the shrine is well-defined in places and includes horizontal bands of lotus flowers, petals and buds, floral swags, roundels with foliage and small dancing figures.

ROYAL PALACE

Situated at the heart of the city of Angkor Thom, the Royal Palace area is (around 600 x 300 metres; 1,969 x 984 feet) is distinguished by two terraces that parallel the road. Evidence of the Royal Palace itself is illusive because only the stone substructures remains. It is difficult, therefore, to conceive its original layout or scale. An additional difficulty is that some of the parts which still remain, pre-date Jayavarman VII's rebuilding of the original site of the Royal Palace. Like much of Angkor Thom, the residences of the king, and those who worked in the palace, were built of wood and have disintegrated, leaving no traces.

The recognisable remains of the palace complex start from the main road with two foundations now known as the Terrace of the Elephants and the Terrace of the Leper King. Projections with steps evenly spaced along the terraces lead to an open area that was a Royal Plaza (550 x 200 metres; 1,804 x 656 feet) used by Jayavarman VII for reviewing troops, processions, hosting festivals and ceremonies. These terraces probably supported wooden pavilions from where the king and his court sat and viewed the activities and the people assembled below. Behind the terraces, a rectangular laterite wall with *gopuras* delineates the private areas of a former palace complex. Inside the enclosure is the temple of Phimeanakas and separate rectangular bathing pools for the men and women.

TERRACE OF THE ELEPHANTS

An Imperial hunt in the sombre forests of the realm. There are formidable elephants.... The forest in which they travel is impenetrable to all but tiny creatures, able to squeeze their smallness between the fissures of the undergrowth, and to the biggest animals, which crush chasms for their passage in the virgin vegetation. The elephants are ridden by servants and princes, and tread as quietly as if they were on an excursive promenade. Their steps of even length have no respect for any obstacle.[44]

Location: Royal Plaza of Angkor Thom
Access: from the road at the east
Date: end of the 12th century
King: Jayavarman VII (reigned 1181–1220)
Religion: Buddhist
Art style: Bayon

BACKGROUND

The Terrace of the Elephants shows evidence of having been rebuilt and added to; and it is believed that alterations took place during the reign of Jayavarman VII at the end of the 12th or the beginning of the 13th century. It is located directly in front of the east *gopura* of the Royal Palace enclosure wall.

LAYOUT

The Terrace of the Elephants extends over 300 metres (984 feet) in length from the Baphuon to the Terrace of the Leper King. It has three main platforms and two subsidiary ones. The south stairway is framed with three-headed elephants gathering lotus flowers with their trunks (which form columns). The central stairway is decorated by lions and *garudas* in bas-reliefs in a stance of support for the stairway. Several projections above are marked by lions and *naga* balustrades with *garudas* flanking the dais. The terrace has two levels: one of which is square and another which has a gaggle of sacred geese carved along its base. It is likely that these platforms originally formed the bases for wooden pavilions which were highlighted with gold. One of the main attractions of this terrace is the façade decorated with elephants and their riders depicted in profile. Photograph them from the main road then walk up close to get a sense of scale and proportion. 'All the pachyderms, almost life-size, are magnificent...and the whole effect has an indescribable splendour.'[45] The elephants are using their trunks to hunt and fight while tigers claw at them.

Horses with Five Heads

At the northern end of the platform behind the outer wall, two large horses, each with five heads, sculpted in high relief stand on each side at the base of the inner retaining wall. This wall must have been part of an earlier retaining wall for the terrace. The horses are exceptional pieces of sculpture, lively and remarkably worked (the one on the north side is in the best condition). It is the horse of a king, as indicated by the tiered umbrellas over his head; the horse is surrounded by *apsaras* and menacing demons armed with sticks in pursuit of several people bearing terrified expressions. Some French savants believe this is a representation of Avalokiteshvara in the form of the divine horse Balaha.

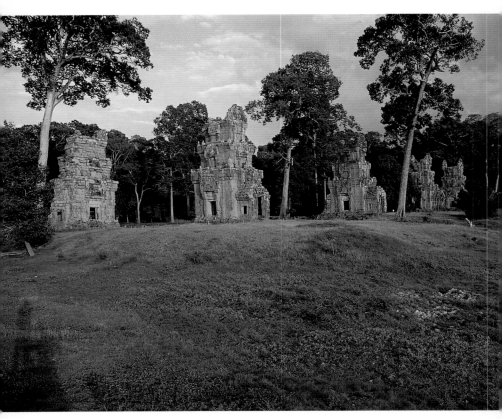

Five of the 12 prasats at Suor Prat, across from the Terrace of the Elephants.

TERRACE OF THE LEPER KING

The stone monarch is absolutely naked, his hair is plaited and he sits in the Javanese fashion. The legs are too short for the torso, and the forms, much too rounded, lack the strong protruberances of manly muscles; but, however glaring are his defects, he has many beauties, and as a study of character he is perhaps the masterpiece of Khmer sculpture. Whilst his body is at rest his soul boils within him.... His features are full of passion, with thick lips, energetic chin, full cheeks, aquiline nose and clear brow...his mouth, slightly open, showing the teeth. This peculiarity of the teeth being shown in a smile is absolutely and strangely unique in Cambodian art.[46]

Location: immediately north of the Terrace of the Elephants
Access: from the main road
Date: end of the 12th century
King: Jayavarman VII (reigned 1181–1220)
Religion: Buddhist
Art style: Bayon

BACKGROUND

The Terrace of the Leper King carries on the theme of grandeur that characterises the building during Jayavarman VII's reign. It is faced with dramatic bas-reliefs, both on the interior and exterior. During clearing, the EFEO found a second wall with bas-reliefs similar in composition to those of the outer wall. Some archaeologists believe that this second wall is evidence of a later addition to extend the terrace.

The original wall was only a metre (3.2 feet) wide of laterite faced with sandstone. It collapsed and a second wall of the same materials, two metres (6.5 feet) wide, was built right in front of it without any of the rubble being cleared. The EFEO has created a false corridor which allows visitors to inspect the reliefs on the first wall.

LEPER KING

The curious name of this terrace refers to a statue of the Leper King that is on the platform of the terrace. The one you see today is a copy. The original is in the courtyard of the National Museum in Phnom Penh. The figure is depicted in a seated position with his right knee raised, a position some art historians consider to be Javanese style. Its nakedness is unusual in Khmer art.

Who was the Leper King? Mystery and uncertainty surround the origin of the name. The long-held theory that Jayavarman VII was a leper and that is why he built so many hospitals throughout the empire has no historical support whatsoever. Some historians think the figure represents Kubera, god of wealth, or Yasovarman I, both of whom were allegedly lepers. Another idea is based on an inscription that appears on the statue in characters of the 14th or 15th century which may be translated as the equivalent of the assessor of Yama, god of death or of judgement. Yet another theory suggests that the Leper King statue got its name because of the lichen which grows on it. The position of the hand, now missing, also suggests it was holding something.

Historian Georges Cœdès wrote that most of the Khmer monuments were funerary temples and that the remains of kings were deposited there after cremation. He thinks, therefore, that the royal crematorium was located on the Terrace of the Leper King. The statue, then, represents the god of death and is properly situated on the terrace to serve this purpose. Yet another theory derives from a legend in a Cambodian chronicle that tells of a minister who refused to prostrate before the king, who hit him with his sword. Venomous spittle fell on the king, who then became a leper and was called the Leper King thereafter.

LAYOUT
The Terrace of the Leper King is supported by a base 25 metres (82 feet) on each side and six metres (20 feet) in height. The sides of the laterite base are faced in sandstone and decorated with bas-reliefs divided into seven horizontal registers.

RELIEFS
Exterior wall: mythical beings—serpents, *garudas* and giants with multiple arms, carriers of swords and clubs, and seated women with naked torsos and triangular coiffures with small flaming discs—adorn the walls of the terrace. Interior wall: The themes are similar to those on the exterior and include a low frieze of fish, elephants and the vertical representation of a river.

A tranquil pond reflects a regal terrace and staircase of the Angkor period.

PHIMEANAKAS: 'AERIAL PALACE'

Location: inside the enclosure wall of the Royal Palace
Access: walk over the Terrace of Elephants and through the east *gopura* of the enclosure wall encircling the enclosure wall of the Royal Palace. You are on the principal access to the temple. Alternatively, follow the pathway between the two terraces, bearing left through a breech in the enclosure wall, close to the northeast *gopura*. The temple's tiered platform will be visible from here to the west
Tip: for those who want to climb to the top, use the west stairway
Date: 10th–early 11th century
King: Rajendravarman II (reigned 941–968)
Religion: Hindu
Art style: Khleang

BACKGROUND

Phimeanakas, located inside the Royal Palace compound, was the temple where the king worshipped. It must originally have been crowned with a golden pinnacle, as Zhou Daguan described it as the 'Tower of Gold'. It is small compared with others, but, even so, it has appeal and is situated in idyllic surroundings. Although its construction seems to have been initiated by Rajendravarman II, subsequent kings made additions, Suryavarman I in the 11th century made the most significant ones.

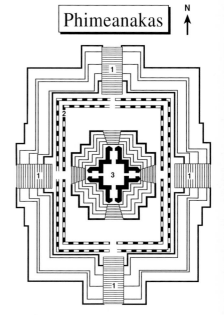

This temple is associated with a legend that tells of a gold tower (Phimeanakas) inside the royal palace of Angkor the Great, where a serpent-spirit with nine heads lived. The spirit appeared to the Khmer king disguised as a woman and the king had to sleep with her every night in the tower before he joined his wives and concubines in another part of the palace. If the king missed even one night it was believed

1 Stairs
2 Gallery
3 Central sanctuary © Airphoto International Ltd.

he would die. In this way the royal lineage of the Khmers was perpetuated.

Ascent to Phimeanakas, a Hindu temple. (Thomas Bauer)

LAYOUT

Your prelude to Phimeanakas is the cruciform east *gopura* of the enclosure wall of the Royal Palace. Its lintels are of Khleang style with a central motif of a *kala* head; an inscription on a door jamb (south side, west face) details an oath of fidelity for dignitaries of the empire. Continue walking west until you reach the temple. The general plan of Phimeanakas is rectangular. The temple, built of laterite and sandstone, originally consisted of a central sanctuary on a tiered platform and an enclosure wall. The grounds around the sanctuary included several courts and ponds that were part of the Royal Palace. A second enclosing wall, surrounded by a moat (now dry) was built at a later date.

■ CENTRAL SANCTUARY

The single sanctuary (3) stands on a base with three laterite tiers and is approached by four steep stairways, one on each side (1). These stairways are framed by walls with six projections—two per step—with sculpted lions. Elephants once stood on sandstone pedestals in the corners of the base, but, today, they are mostly broken.

■ UPPER TERRACE

The upper terrace affords a fine view of the neighbouring temple of the Baphuon. A narrow, covered sandstone gallery (2) with windows and balusters at the edge of the upper terrace is the first appearance of a stone gallery with a central sanctuary. There were small pavilions at the corners, but only vestiges remain.

■ ROYAL BATHS

To the north of Phimeanakas, there are two paved ponds that were part of the Royal Palace compound. The smaller and deeper pond, known as Srah Srei or the women's bath, which is closest to the main road, is identified by moulding and laterite steps. The other larger pond or the men's bath, directly to its west, can be reached by a footpath to the right of Phimeanakas. Follow it until you come to a large pond paved in laterite with sandstone steps. Continue walking for a short distance, then turn back and look at the amazing sculpted borders, in two tiers and carved in high relief, on the southwest edge of the pond. You will see rows of princes and *naga-princesses* in the middle with male and female guardians and winged figures above; and marine life—both real and mythical—below. This entire area was probably crowned by a platform with a *naga* balustrade, and may have served as a gallery for the sovereign and dignitaries of the court.

Srah Srei, the women's bath in the palace compound.

Above: *A royal bath near Phimeanakas.*
Right: *The north gate in the enclosure wall of the Royal Palace.*

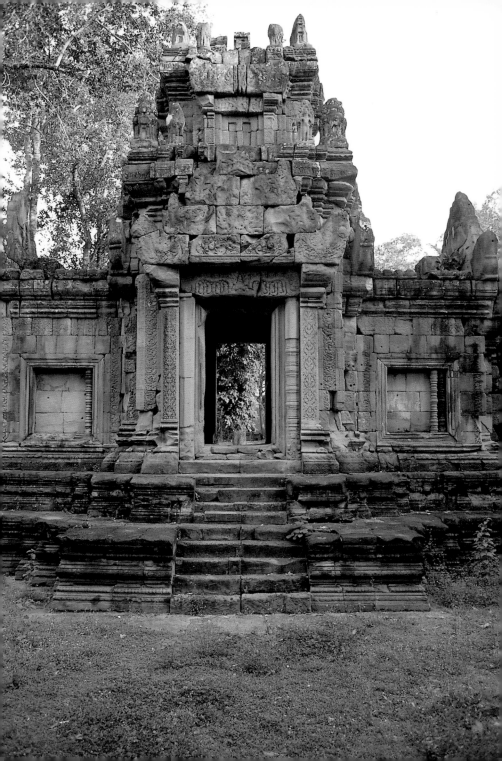

PRASAT TOP EAST

Location: 900 metres (2,952 feet) east of the royal square of Angkor Thom; about 200 metres (656 feet) before the Victory Gate; walk south along a path for about 250 metres (820 feet)

Access: enter and leave from the north

Date: late 13th–early 14th century (perhaps 1295)

King: Jayavarman VIII (reigned 1243–1295)

Religion: Hindu (dedicated to Jayamangalartha, a Brahmin scholar, who was the son of one of the gurus of Jayavarman VII)

Art style: Bayon

BACKGROUND

Prasat Top East, formerly known as Mangalartha (named after the Brahmin to whom the temple was dedicated) and Monument 487 (the reference number in the French inventory), is the last known Hindu temple to be built at Angkor and the last of the monuments with a dated inscription that tells of the period following the death of Jayavarman VII in the early 13th century. Some stones appear to have been recycled.

LAYOUT

A temple's cruxiform sanctuary with four porches built of sandstone opens to the east and is raised on a double base with moulding and four stairways. There are false doors on the three other sides, which have little decoration.

Some tympanums have been reconstructed and are on the ground. (east) Vishnu reclining on the serpent Ananta; (south) the three strides of Vishnu to gain the world; (north) Shiva dancing with four arms surrounded by *apsaras* with Uma seated on his knee; a lintel of the Churning of the Ocean of Milk; (west) a lintel with Krishna lifting Mount Govardhana.

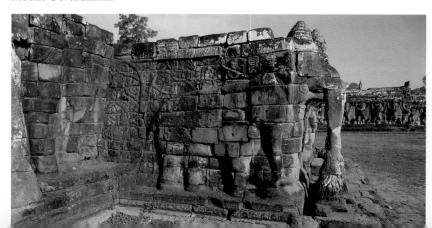

BAPHUON

North of the Golden Tower [Bayon]...rises the Tower of Bronze [Baphuon], higher even than the Golden Tower: a truly astonishing spectacle, with more than ten chambers at its base.[47]

Location: 200 metres (656 feet) northwest of the Bayon, and south of the Terrace of the Elephants

Access: enter and leave at the east

Tip: access to the central complex is restricted, as much of the temple has collapsed and is currently being restored

Date: middle of the 11th century (1060)

King: Udayadityavarman II (reigned 1050–1066)

Religion: Hindu (dedicated to Shiva)

Art style: Baphuon

BACKGROUND

The massive size and grandeur of the Baphuon is unrecognizsable today because much of the temple has either collapsed or been dismantled. The EFEO was restoring this temple when it was forced to abandon work and leave Angkor in 1972 because of war; they have now resumed their work (see p.71). Even though the Baphuon is situated inside the royal city of Angkor Thom it is older and dates from the 11th century. A highlight of the temple is the bas-reliefs, which differ from most others as they are vignettes carved in small stone squares set one above the other on the temple walls, similar to tiling.

LAYOUT

Baphuon is built on a temple-mountain concept with a single sanctuary situated on a high base symbolising Mount Meru. A rectangular sandstone wall measuring 425 by 125 metres (1,394 by 410 feet) encloses the temple (1). Even though it was a later addition, a special feature of the Baphuon is a long elevated eastern approach (200 metres, 656 feet) supported by three rows of short, round columns forming a bridge to the main temple. This arrangement is unusual in Khmer art. The approach is intercepted by a central cruciform pavilion (4) with terraces on its left and right sides. Turn left (south) and walk to the end of the gallery to see a rectangular paved pool (5). You can get some idea of the themes, style and workmanship of the tile-like frames that the Baphuon is renowned for by looking at the walls of this pavilion (the

A section of the terrace shows from where the Terrace of the Elephants derives its name.

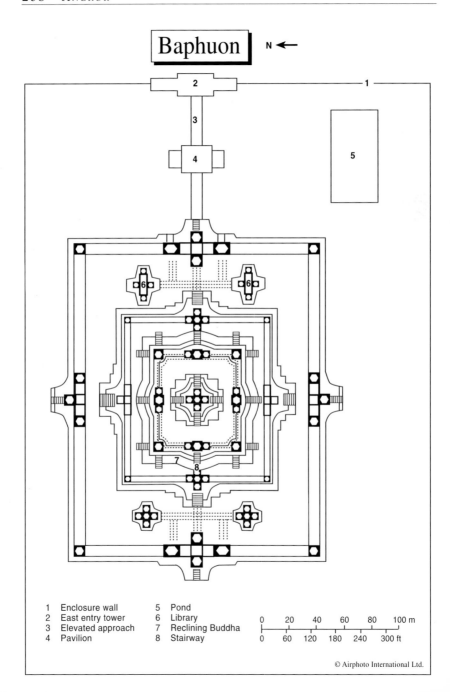

Baphuon

N ←

1 Enclosure wall
2 East entry tower
3 Elevated approach
4 Pavilion
5 Pond
6 Library
7 Reclining Buddha
8 Stairway

0 20 40 60 80 100 m
0 60 120 180 240 300 ft

© Airphoto International Ltd.

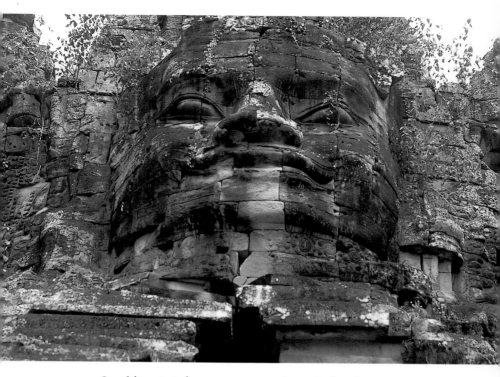

One of the majestic faces on a gopura, north gate, Angkor Thom.

best quality and the greatest quantity are on the northeast exterior walls) where warriors fight with lance and shield, birds and monkeys scale trees and mythical creatures frolic. Themes for these narrative scenes draw on the great Hindu epics, the *Ramayana* and the *Mahabharata* and daily life, particularly hunts in the forest.

Originally, a central tower shrine with four porches crowned the peak of the mountain, but it collapsed long ago. The shrine stood on a rectangular sandstone base of five diminishing platforms, rather than the more common square format. The first, second and third levels were surrounded by concentric sandstone galleries. This massive temple-mountain is an EFEO restoration project. (see page 71).

Following pages: *The Bayon, east entrance. (Thomas Bauer)*

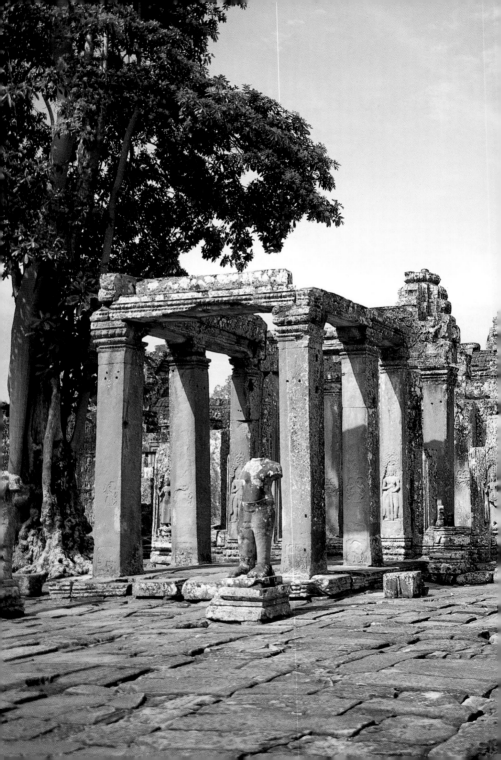

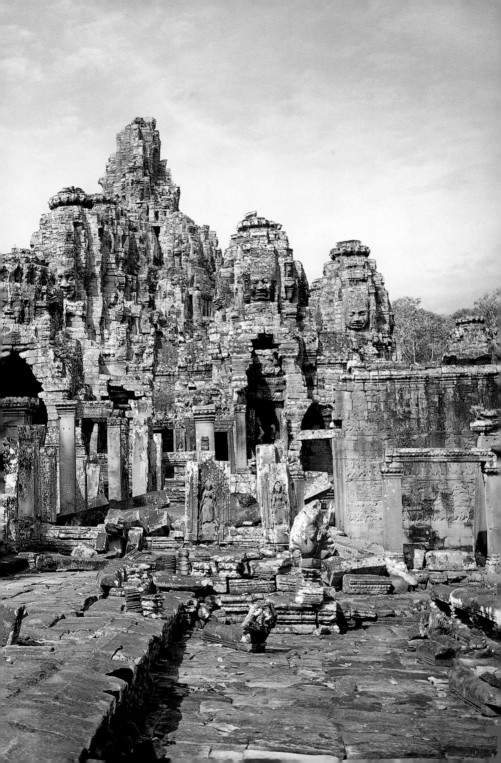

BAYON

We stand before it stunned. It is like nothing else in the land.[48]

Location: in the centre of the city of Angkor Thom, 1.5 kilometres (1 mile) from the south gate
Access: enter from the east
Date: late 12th to early 13th century
King: Jayavarman VII (reigned 1181–1220)
Religion: Buddhist
Art style: Bayon

BACKGROUND

The Bayon vies with Angkor Wat as the favourite monument among visitors. The two temples evoke similar aesthetic responses yet are different in purpose, design, architecture and decoration. The dense jungle surrounding the temple camouflaged its position in relation to other structures at Angkor, so it was not known for some time that the Bayon stands in the exact geographical centre of the city of Angkor Thom. Even after topographical maps finally revealed its correct location, the Bayon was erroneously identified as a Hindu temple connected with the city of Yasovarman I, and, thus, dated to the ninth century.

A fronton found in 1925 depicting an Avalokiteshvara identified the Bayon as a Buddhist temple. Furthermore, in 1933, an image of the Buddha seated on a *naga* and sheltered by his multiple heads spread like a fan (height: 3.6 metres; 11.8 feet) was found beneath the central shrine at a depth of 14 metres (45.9 feet) These discoveries moved the date of the monument ahead some 300 years to the late 12th century. The image of the Buddha was removed from the temple and placed under a shelter that is located 100 metres (328 feet) east of the Bayon on the right side of the road leading to the Gate of the Dead at Angkor Thom. Although the date is firmly implanted and supported by archaeological evidence, the Bayon remains one of the most enigmatic temples of the Angkor group. Its symbolism, original form, subsequent changes and additions are not yet understood. These aspects leave us today with a complicated, crowded plan that challenges both archaeologists and historians.

The Bayon was built nearly 100 years after Angkor Wat. While its basic structure and earliest part of the temple are unknown, it is clear that the Bayon was built on top of an earlier monument, that the temple was not built at one time, and that it underwent a series of changes. The middle portion of the temple was extended

during the second phase of building. The Bayon of today with its huge central mass dates to the 13th century and belongs to the third and last phase of the art style. Jayavarman VII's goal was to rebuild the capital and to bring to the kingdom a new vibrancy, signifying a bright future for the Khmers. To accomplish this, he erected the Bayon and created a structure somewhat like a temple-mountain in its grandiose plan and scale.

The architectural composition of the Bayon exudes grandness in every aspect. Its elements juxtapose each other to create balance and harmony. Over 200 large faces carved on the 54 towers give this temple its majestic character. 'The faces with slightly curving lips, eyes placed in shadow by the lowered lids utter not a word and yet force you to guess much', wrote P Jennerat de Beerski in the 1920s.[49] It is these faces that have such appeal to visitors and reflect the famous 'smile of Angkor'.

The iconography of the four faces has been widely debated by scholars and, although some think they represent the bodhisattva Avalokiteshvara, in keeping with the Buddhist character of the temple, it is generally accepted that the four faces on each of the towers are images of King Jayarvarman VII and signify the omnipresence of the king. Besides the architecture and the smiling faces, the highlight of the Bayon is undoubtedly the bas-reliefs, presented in both the inner and outer galleries. The scenes in the outer gallery are unique as they depict many scenes from daily life.

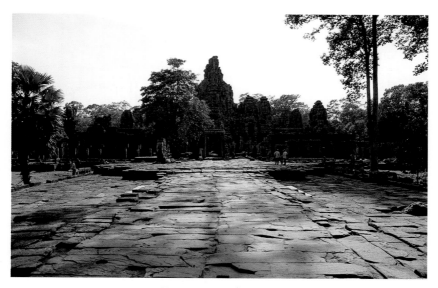

East entrance to the Bayon.

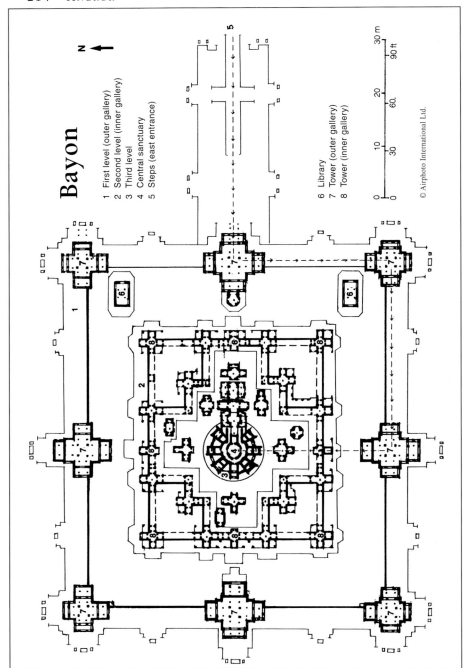

Bayon

1 First level (outer gallery)
2 Second level (inner gallery)
3 Third level
4 Central sanctuary
5 Steps (east entrance)

6 Library
7 Tower (outer gallery)
8 Tower (inner gallery)

© Airphoto International Ltd.

Layout

The plan of the Bayon is presented on three separate levels. The first and second levels contain galleries featuring the bas-reliefs. A circular central sanctuary (4) dominates the third level, which is cruciform in plan. Despite this seemingly simple plan, the layout of the Bayon is complex due to later additions, a maze of galleries, passages and steps, connected in a way that makes the levels practically indistinguishable and creates dim lighting, narrow walkways and low ceilings.

Enter the Bayon from the east (5) at the steps leading to the raised entrance platform. The outer gallery of the Bayon, the first to be encountered, is square in plan and is interspersed with eight cruciform *gopuras* (7)—one in each corner, and four placed on the north-south and east-west axes. The gallery was originally covered.

The decoration on the pillars in front of the east *gopura* is characteristic of the Bayon style and is exceptionally beautiful. A unique motif comprising two or three *apsaras* dancing gracefully on a lotus appears on monuments of the late 12th and early 13th centuries. The depiction of this motif is especially well-executed on the columns of the outer gallery at the Bayon. The dancers are in a frontal stance, rather than in profile as seen at earlier temples such as the Roluos group. They form a triangle and are framed by an intricate and intertwined leaf pattern. The figure in the centre is larger than those on either side. **Tip**: the absence of a roof over these pillars allows sufficient light for the visitor to view and photograph this motif at all times of the day. Direct overhead sunlight at midday provides the most dramatic lighting.

The two galleries of bas-reliefs are distinguished by the degree of elevation. The outer gallery is all on one level, whereas the second or inner gallery is on different levels and access is sometimes difficult due to collapsed areas and the generally poor condition of the temple. The layout of the inner gallery can be misleading, but as long as the reliefs are in view you are still in the second gallery.

On the interior of the first level there are two libraries (6) located in the northeast and southeast courtyards. The second gallery of bas-reliefs has towers in each corner and four *gopuras* on the central axes (8). On the upper level there are a series of interlocking galleries with towers at each corner. This area is confusing and cramped as some passageways are demolished in some parts and walled up in others.

The architectural climax is at the third level (3), with the central sanctuary and the faces of Avalokiteshvara. From this level you can watch the shifting light as the sun moves about the faces producing new shadows and highlights. The multitude of faces at different levels affords endless fascination. 'Godliness in the majesty and the size; mystery in the expression', wrote de Beerski, when he looked at the faces in the 1920s.[50]

The central mass is circular, a shape that is uncommon in Khmer art. Originally, there were eight shrines which were later increased to 16. Small porches with frontons provide the bases for the monumental faces, while windows with balusters keep the diffusion of light to a minimum. The faces on the four sides of the eight towers marking the cardinal directions are exceptionally dramatic depictions. The interior of the central sanctuary is a cell surrounded by a narrow passage.

GALLERY OF BAS-RELIEFS

'They have homely human things to tell and they tell them without affectation', wrote H Churchill Candee of the bas-reliefs in the galleries of the Bayon.[51] The reliefs on the inner gallery are mainly mythical scenes, whereas those on the outer gallery are a marked departure from anything previously seen at Angkor. They contain genre scenes of everyday life—markets, fishing, festivals with cockfights and jugglers and so on—and historical scenes with battles and processions. The reliefs are more deeply carved than at Angkor Wat, but the representation is less stylised. The scenes are presented mostly in two or three horizontal panels. The lower one, with an unawareness of the laws of perspective, shows the foreground, whereas the upper tier presents scenes of the horizon. They both exhibit a wealth of creativity.

Descriptions of the reliefs in this guide follow the normal route for viewing the Bayon. They begin in the middle of the east gallery and continue clockwise. Always keep the monument on your right. **Tip**: do not become so absorbed in the reliefs that you forget to stop at each opening and enjoy the view of the faces on the third level.

THE OUTER OR FIRST GALLERY (See plan p.214)

This is the gallery with the wonderful scenes of daily life. The scenes were probably used as a teaching vehicle to disseminate the tenets of Buddhism. Some of the scenes in this gallery are unfinished. For evidence of this, look at the extremities, such as the corners, particularly near the top of the wall.

■ EAST GALLERY

The workmanship of the reliefs in this gallery is excellent. They are divided into three panels and depict a military procession with banners and a background of tropical trees (1). On the top tier, warriors (short hair and no head covering) are armed with javelins and shields, while those on the lower tier have goatee beards and wear exotic headdresses suggesting they are Chinese. Musicians accompany the warriors. Horsemen riding bareback flank the musicians.

Offerings to an image, east entrance, Bayon.

Bayon: Outer Gallery of Bas-reliefs

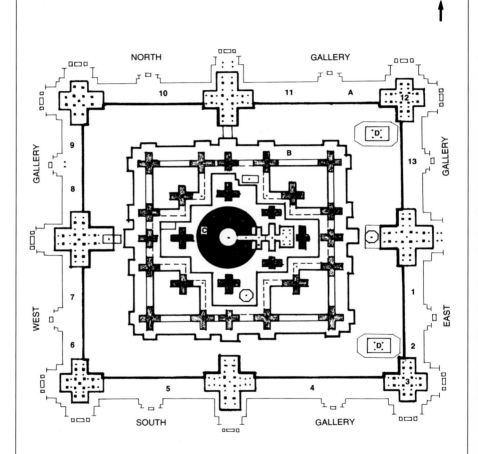

See text for bas-relief reference

A First level C Third level
B Second level D Library

The commanders of the troops, including Jayavarman VII, identified by parasols with tiers and insignias, are mounted on elephants. Cavalry precede, and women of the palace follow the king. Towards the end of the procession, covered wooden carts (on the lower tier) of the same style as are used today, carry provisions of food for the military. A person crouching blows a fire for a cooking pot. Looking through the doorway between (1) and (2) where you can see the south library.

The military procession continues (2). The reliefs follow on with genre scenes of everyday life and include a coconut tree with monkeys. A tiered wooden building may be a food shop. The headdresses, clothing and objects hanging from the ceiling suggest that the people inside the building are Chinese.

■ SOUTHEAST CORNER PAVILION
The carving in this corner (3) of the pavilion is unfinished. Identifiable scenes include a wooden palace with a superb *kendi* (drinking vessel) underneath the stairs of the two storeys. An ingenious depiction of a boat spans a 90-degree turn in the wall.

■ SOUTH GALLERY
The scenes in the first part of this gallery (4) contain some of the finest workmanship of all the reliefs at the Bayon. The panel begins with a historical scene depicting the naval battle of 1177 on the Tonle Sap between the Khmers (with no head covering) and the Chams, their neighbouring enemies of southeast Vietnam. They are readily identifiable by their hats, which resemble upside-down lotuses. The boats are majestically portrayed with richly ornamented prows and a galley with oarsmen and warriors armed with javelins, bows and shields. Helen Churchill Candee must have had these boats in mind when she wrote: 'One wonders if Cleopatra floated in greater elegance'.[52] Action is provided by bodies being thrown overboard, and sometimes being eaten by crocodiles.

On the bottom row, genre scenes of daily life along the shores of the Tonle Sap are depicted with spirit and candour—a woman removing lice from another woman's hair, a mother playing with her children, another woman kneeling with her arms around a figure who is writhing in pain, which may be a scene of childbirth assisted by a midwife, and a patient in a hospital. A hunter prepares his bow to shoot a large animal. A fishing scene follows: people on one of the boats play a board game; a scene of a cockfight; above, fishermen on the Tonle Sap and, below, women fishmongers. Scenes of the palace follow—princesses surrounded by their suitors, wrestlers, sword fighters, chess players and a fight between wild boars. An outline of a giant figure, perhaps the king, surmounts this entire scene.

Following pages: *Nature has encroached deep into the foundations at the Bayon.*

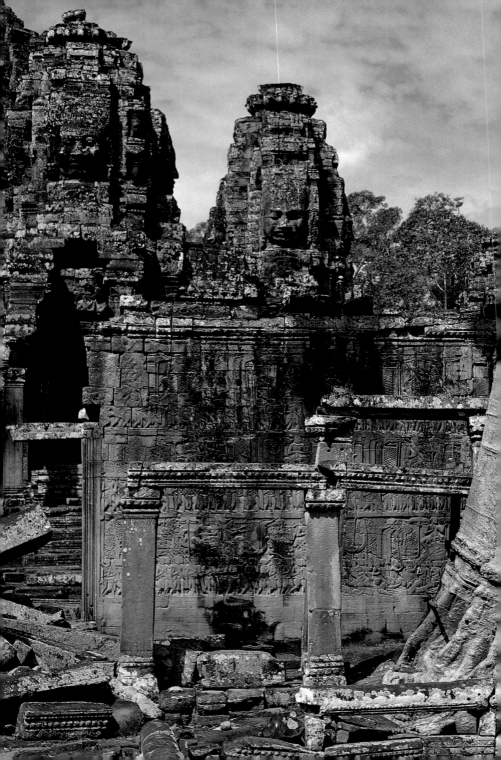

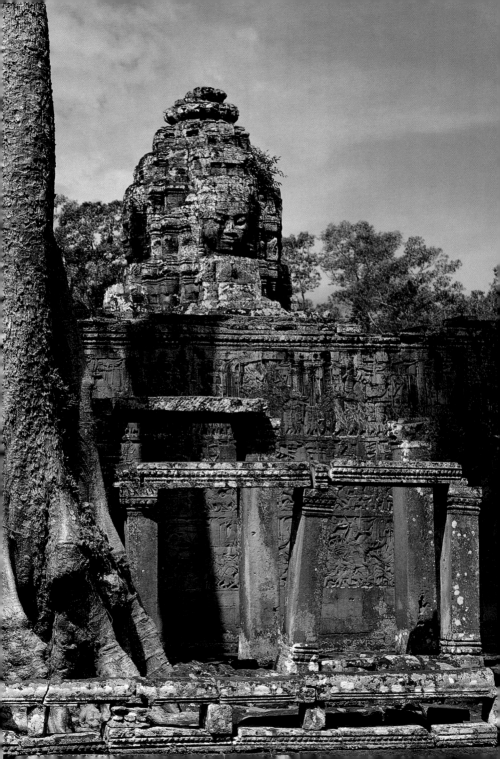

Further along the gallery, the battle resumes. Lower tier: the Chams arrive in boats and disembark. Upper tier: the battle continues on land with the Khmers, disguised as giants (closely-cropped hair and cords around their torsos) winning. Afterwards, the king sits in his palace amidst his subjects celebrating their victory. Masons cut sandstone, blacksmiths pound iron and cooks tend fires in preparation for a celebration.

In the second part of the south gallery (5) only the lower level is finished. The scene is a military procession and the main point of interest is the weapons of war used by the Khmers such as large cross-bows mounted on the back of an elephant manned by archers and a catapult mounted on wheels.

■ WEST GALLERY

Many reliefs in this gallery (6) are unfinished. Lower tier: warriors and their chiefs, mounted on elephants, pass through mountains and forests (identified by small triangles); near the centre: an ascetic scales a tree to escape an attack by a tiger; above: scenes depict the methods used for constructing temples such as grinding and polishing sandstone. Beyond the door: a so-called civil war (7): this appears to be a street scene with crowds of men and women threatening others armed and ready for battle. The mêlée continues with hordes of warriors and elephants participating.

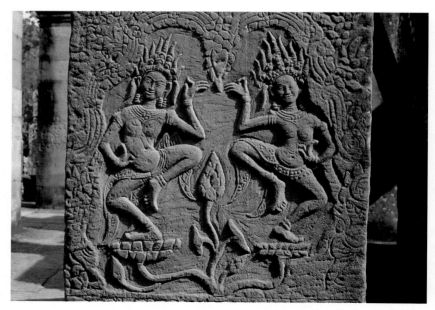

Above: *Dancing* apsaras *on a pillar, Bayon.*
Right: *Extreme wide angle view of the third level, Bayon. (Thomas Bauer)*

In the second part of the west gallery (**8**) is a scene of hand-to-hand combat in which warriors armed with clubs harass others who protect themselves with shields. A fish swallows a deer on the lower register. An inscription, incised under a shrimp, says that 'the king follows those vanquished in hiding'. Beyond the door: (**9**) a peaceful procession against a background of trees depicts the king (carrying a bow) on the way to the forest where he will meditate before celebrating the consecration of the Sacred Rite of Indra.

■ NORTH GALLERY

The highlights of this gallery (**10**) are circus jugglers, acrobats and wrestlers, and an animated procession of various animals including a pig, rhinoceros, rabbit, deer, puffer fish and lobster. At the other end: ascetics meditate in the forest and, on the banks of a river, a group of women receive gifts. Near the door: scenes of combat between the Khmers and the Chams. The wall of the second part of the north gallery (**11**) is almost entirely collapsed. At each end, the battle between the Khmers and Chams continues and the Khmers flee to the mountain.

■ NORTHEAST CORNER PAVILION

Scenes of processions of Khmer warriors and elephants (**12**).

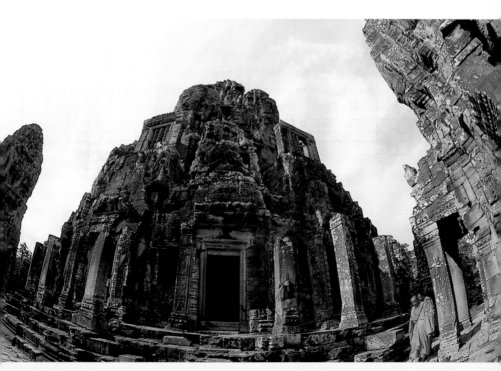

Above, Shiva in his celestial palace surrounded by his followers; ascetics and animals along the banks of a pond. A tiger pursues an ascetic while other devotees converse in the palace and several worshippers prostrate before the god. Centre, Vishnu (four arms) is surrounded by flying *apsaras* and prostrating followers.

■ WEST GALLERY

Vishnu (four arms) is mounted on *garuda* and subduing an army of demons (11).

Small room (12): a palace scene with *apsaras* dancing, accompanied by an orchestra; above, dancers and, above that, a battle scene.

Between two towers; right (13): Vishnu (four arms) superimposed on scenes of the construction of a temple—workers pulling a block of stone, polishing and hoisting blocks of stone into place. A nautical scene follows, with two people playing chess in a boat, and a cockfight. From left, Shiva in a palace with Vishnu on his right; an ascetic meditating in a grotto and swimming amongst lotus flowers; a bird holds a fish in its mouth.

Beyond the centre of the west gallery: a procession of warriors on horseback with two rulers sitting in chariots pulled by horses (14). Small room (15), from the right: a palace scene with people conversing and attendants dressing young princesses.

The most interesting relief in the next area (16) depicts the Churning of the Ocean of Milk; the body of the serpent with demons on the side of the head; the monkey Hanuman assists the gods on the side of the tail. A replica of the serpent crawls along the ocean bed and is represented by a panel of fish; centre, a column resting on the back of a turtle forms the pivot; Vishnu in his human form embraces the shaft. Other items are disks symbolising the sun and the moon and a flask which is destined to contain the elixir of immortality. Left, a god mounted on a bird seems to want to pacify a group of demons who are engaged in a battle; their chief stands in a cart drawn by lions.

■ NORTHWEST CORNER PAVILION

Another procession of warriors is depicted on these reliefs (17).

■ NORTH GALLERY

Palace scenes (18): a procession of servants with offerings; a mountain inhabited by wild animals (elephants, rhinoceros, serpents). One boat carries men with short cropped hair and a chief with a trident and another one bears men wearing the headdress of an inverted flower. Small room (19) facing: Shiva (ten arms) dances, with *apsaras* flying above. Vishnu (right) and Brahma (four faces) (left), with

One of the many towers visible from the northeast corner of the upper level, Bayon.

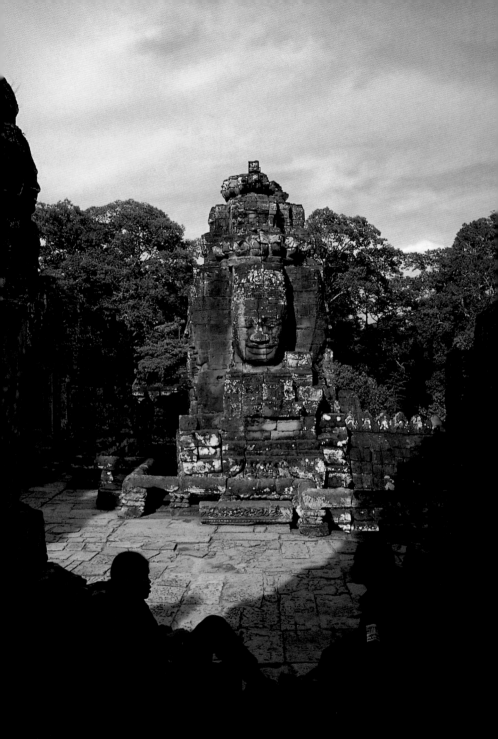

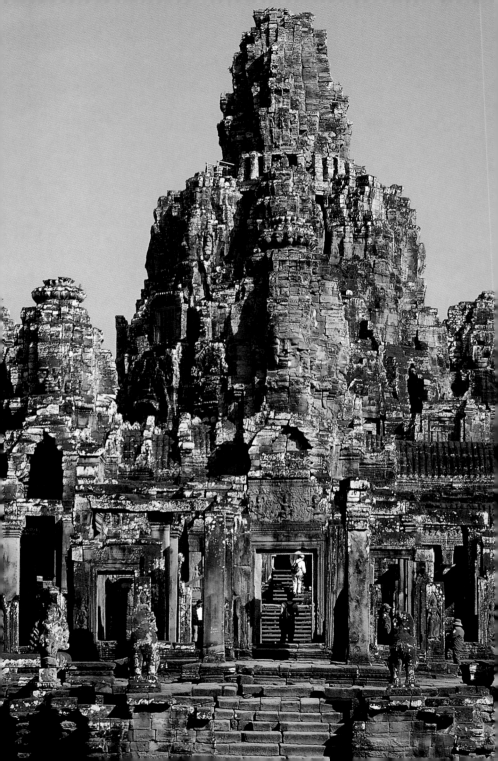

Ganesha; below is Rahu. Side of the wall: Shiva sits between Vishnu and Brahma; a charging boar.

Between two towers (**20**): (right), Shiva is surrounded by ascetics and women, with his mount the bull, Nandi, nearby; (facing), ascetics meditating in the mountains. Kama, the god of love, shoots an arrow at Shiva, who is meditating at the top of a mountain with his wife Parvati at his side. Between two towers (**21**): from the right, Shiva mounted on the bull, Nandi, with his wife Parvati sitting on his thigh. A palace, multiple-headed serpents and, below, *apsaras*. An episode from the *Mahabharata* follows, depicting 'Shiva granting a favour to Arjuna'.

On the left of the door: another scene from the *Mahabharata* of Ravana shaking Mount Kailasa. Two scenes of the palace are superimposed on each other. Servants with offerings (**22**): above, ascetics meditating; Shiva blesses his worshippers, with flying *apsaras* above. A king (short-cropped hair) leads a procession followed by his army, musicians, elephants and horses, princesses in palanquins and a cart pulled by oxen.

■ **NORTHEAST CORNER PAVILION**
Fragments of a procession (**23**).

■ **EAST GALLERY**
A military procession with musicians, foot soldiers framed by horsemen and a chariot drawn by horses, a chariot (six wheels) mounted on sacred geese, the ark of the sacred fire, an empty throne and the king carrying a bow mounted on an elephant (**24**). After the door: someone of rank prostrating at the feet of Shiva before going to battle. Small room (**25**): two large boats surrounded by fish in a pond. *Apsaras* and birds fly above.

Between two towers (**26**): the Legend of the Leper King. From left to right: the king fights against a serpent and a crowd watches. The serpent spews his venom on the king and he contracts leprosy. The king sits in his palace and gives orders to his servants, who descend a staircase to consult with healing ascetics in the forest. Women surround the sick king and examine his hands. The king lies on the ground while an ascetic stands at his side.

The magnificent circular central tower at Bayon.

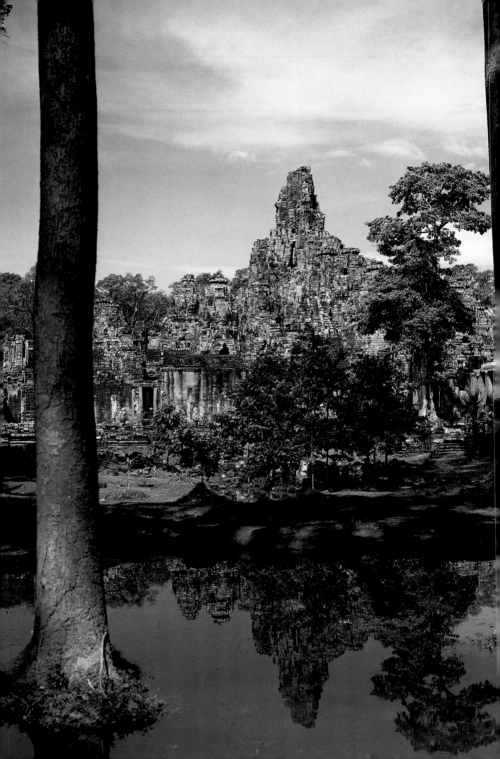

Prasat Top West

Location: from the southwest side of the Bayon follow the path south for 1.5 kilometres (about one mile) that leads to the west gate of Angkor Thom; halfway along you will come to a clearing in the forest on the left; walk 100 metres (328 feet)

Access: enter and leave from the north

Date: tenth century; additions after 13th century until 17th century

Religion: Hindu initially; then Theravada Buddhist

Background

Prasat Top West was formerly known as 'Monument 486' based on the reference number in the French inventory. The temple spans several hundred years and different religions, making it an interesting study both architecturally and historically.

The original central shrine standing on a laterite platform was Hindu and presumably built in the 10th century. Some time after Theravada Buddhism took hold in Cambodia, changes were made to adapt the structure for use as a Theravada Buddhist temple.

Layout

Changes included facing the original laterite platform with sandstone, rebuilding the central shrine, adding two towers, one on each side of the central one, adding a sandstone terrace at the east and altering some of the decoration.

The rebuilding of the central shrine incorporated the use of 10th-century features, such as a pink-coloured sandstone for the doorframe, colonettes and lintels. The colour is similar to that used for Banteay Srei, a 10th-century temple. The central shrine has doors opening to all four cardinal directions. Hindu themes adorn the pediments and include (east) Shiva on his mount Nandi and (north) Indra on his elephant.

Standing images of the Buddha are carved on the exterior walls of the north shrine (collapsed). Reconstructed pediments and a few sculptures stand on the grounds around the temple. Notable ones include: a huge head of the mythical monster, *kala*; the Buddha seated under the *bodhi* tree, a popular motif in Theravada Buddhism; an image of the Buddha seated in the gesture of 'calling the earth to witness' is also present. The leaf-shaped boundary stones seen on the temple grounds were used to demark sacred space and are characteristic of Theravada Buddhism. Fragments of glazed roof tiles are scattered amongst the ruins.

Left: *The majestic Bayon temple with surrounding moat.*

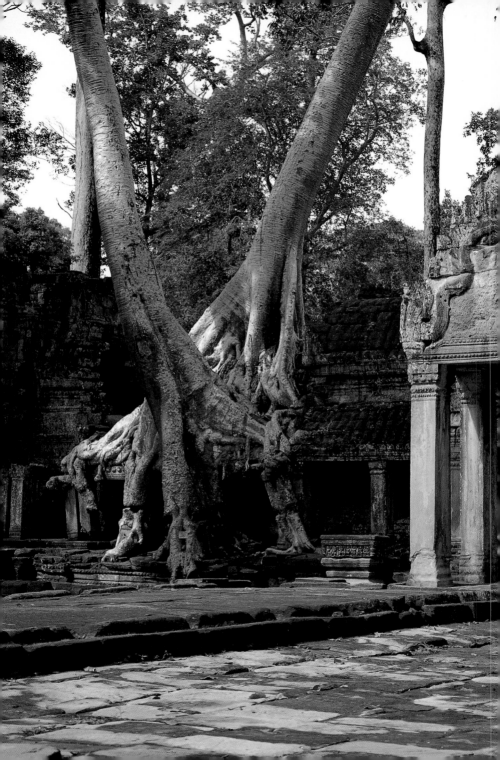

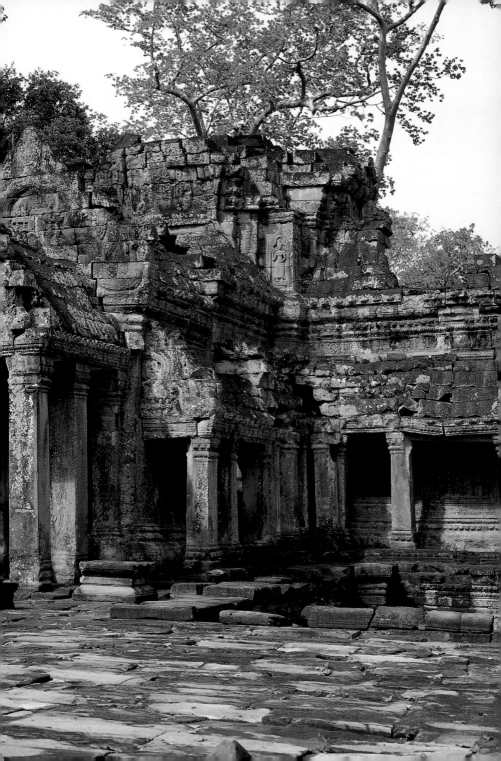

GROUP 3
PREAH KHAN: THE 'SACRED SWORD'

Preah Khan, the Beguiler, the Romancer, and the artist...it is an entrancing mystery deep in the jungle, soft and alluring in the twilight made by heavy verdure, accessible only to the ardent lover of past days who is gifted with agility.... They may have been courtyards where high priests gathered and guardians slept, but now they are walled bowers over which the trees extend to heaven's blue.... It all seems a wondrous mass of beauty tossed together in superb confusion.[53]

Location: two kilometres (1.2 miles) northeast of Angkor Thom.

Access: the best way to visit Preah Khan is from the east. Follow the road around the complex and take a right turn along the west levee of Jayatataka Baray. This will lead you to the East Entrance.

Tip: arrange for your transport to drop you at the East Entrance and drive back to the West Entrance to collect you, this will enable you to see the temple in the correct sequence and also to visit the Visitor Centre at the end of your tour

Date: second half of the 12th century (1191)

King: Jayavarman VII (reigned 1181–1220)

Religion: Buddhist (dedicated to the father of the king)

Art Style: Bayon

BACKGROUND

Preah Khan, an extensive 56-hectare (138 acres) Buddhist complex, was built in 1191 as a monastery and centre for learning by the Khmer king Jayavarman VII and dedicated to his father Dharanindravarman. The temple, which is located a few kilometres to the northeast of the north gate of Angkor Thom, served as the nucleus of a group that includes the temples of Neak Pean and Ta Som, located along the four kilometres (2.4 miles) long Jayatataka Baray—the last of the great reservoirs to be built at Angkor. This group constitutes one of Angkor's principal axial plans and hydrological systems.

Previous pages: *Preah Khan, east entrance.*
Right: *The eastern gopura, Preah Khan.*

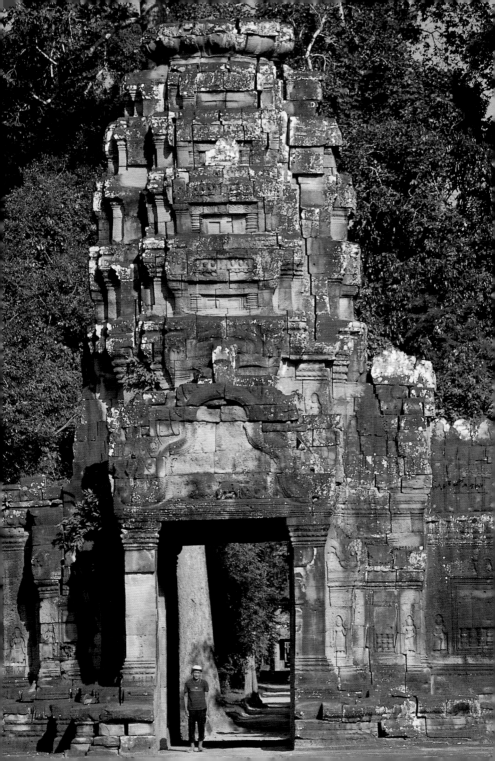

GARUDAS AT PREAH KHAN

As you are about to enter the East *Gopura* or main entrance to Preah Khan, you are passing through the outer enclosure wall built of yellow laterite stone probably excavated from the nearby moat. These walls support the magnificent sandstone sculptures of the giant *garudas* which are the guardians and protectors of Preah Khan. Each Garuda clasps in either hand the tails of three-headed *nagas*, its traditional mortal enemy. There are 72 of these giant five-metre-high *garudas*, set apart at intervals of about 45 metres—each a master work in itself.

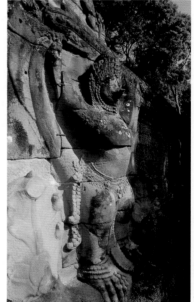

Unlike laterite, the sandstone for the *garudas* and indeed for all the temple was transported from the stone quarries in the Kulen Hills over 35 kilometres (22 miles) to the north of Angkor. In Hindu mythlogy the half man half bird image is the mount of Vishnu. In the case of Preah Khan, Buddhist mythology has combined *naga* and *garuda* to protect the ground and water (*naga*) and the heavens (*garuda*) encompassing Preah Khan. The *garudas* with their hands raised above their heads do indeed appear to be holding the temple in the sky.

These *garudas* are the symbol of Preah Khan and indeed their new responsibility as guardians is to help raise funds to continue the World Monuments Fund's (WMF) programme to conserve and present Preah Khan as a partial ruin. WMF has set up an Adopt a *Garuda* Programme so that these unique mythical beasts can be brought back to life and the ongoing conservation work and training of Khmer professionals and craftsmen in Preah Khan can be continued.

At press time, 24 of the 72 *garudas* have been adopted.

Thomas Bauer

—*John Sanday, OBE*

Above: *One of the 72* garudas *that adorn the outer wall of Preah Khan.*
Right: *A rare example of pigmentation on the stone in the Temple of One Thousand Buddhas at Angkor Wat; whether or not it is original pigmentation, is much debated.*

A two-metre (6.5 feet) high stone stele inscribed on all four sides, now under the security of the WMF, gives a wealth of information about the temple and its functions. The inscription indicates that Preah Khan was built on a battle site where Jayavarman VII finally defeated the Chams. In those days it was known as Nagarajayacri which translated from Siamese means 'The City of Preah Khan' or The City of The Sacred Sword. The sacred sword has a long history in Khmer tradition.

Four concentric enclosure walls subdivide Preah Khan. The outer or fourth wall, which is encircled by a wide moat, today encloses a large tract of jungle, formerly the living quarters of the monks, students and attendants of Preah Khan. The second enclosure wall delineates the principal religious compound of about four hectares (9.8 acres) within which there is a dense concentration of temples and shrines.

The central complex is Buddhist. The northern and western sectors are dedicated to Hindu sects of Vishnu (west) and Shiva (north), whilst the southern sector is a place of ancestor worship. The eastern sector forms the grand entrance to the central shrine.

Today Preah Khan can best be described as a partial ruin set deep in a jungle which, over the years, has taken its toll on the structures. As in Ta Prohm, magnificent trees have assumed a major responsibility for the destruction and/or support of the structures. The coexistence of these archaeological masterpieces in an unplanned natural setting has given Preah Khan special character in addition to the original splendour it must have possessed. Some of the temples and shrines were probably in use until the 17th century. However, it was only at the end of the 19th century that Preah Khan, like many other Angkor sites, was rediscovered. Since the 1920s, the EFEO has undertaken several consolidation and reconstruction projects in Preah Khan, all of which have been carefully documented. These archives are now available and will greatly assist the WMF team in its conservation activities in Preah Khan.

Andrew Dembina

LAYOUT

The principal entrance, and indeed the best way to start a tour of Preah Khan, is from the East. Bordering Jayatataka Baray is a small jetty, which WMF recently exposed. The jetty was a simple structure, probably built of rubble from other structures. Post holes are visible, signifying a wooden pavilion with a pitched tile roof on a stone base.

A flight of steps leads down to an imposing Processional Way, defined by rows of stone lanterns standing sentinel. In the 13th century, images of Buddha carved in the niches of the lanterns were crudely removed as part of a determined effort to transform the Buddhist complex into a Hindu temple. Similarly thousands of Buddha images were defaced throughout Preah Khan.

The Processional Way, which leads onto a wide stone-paved causeway across the temple's moat, is lined with divinities and demons carrying the giant *naga*, or snake. This great balustrade directs the visitor to the outer *gopura* or gateway. A similar entrance can be found on the west and lesser examples to the south and north (without processional ways) which lead to less grand *gopuras*. These two principal axial routes meet and cross at Preah Khan's central tower.

Before entering the temple complex, study the beautiful sandstone *garuda* images—the mythical Hindu bird and mount of Vishnu—on either side of the *gopura*. The *garudas*, along with the *nagas* they hold, are symbolic protectors of the air and water and 72 of them placed approximately 45 metres (147 feet) apart around the outer enclosure wall serve as the mythical guardians of Preah Khan.

Passing along the eastern axial path through dense jungle, you will find a single structure known as the *dharmasala* on your right. Although classified a rest house for pilgrims it was more likely to have been a temple to house the sacred flame. This structure was cleared from the surrounding jungle and demonstrated most of the problems relating to structural collapse. WMF completed a major renovation programme for its stabilisation in 2002.

Following the path you approach a grandiose elevated platform which was formerly enclosed by a *naga* balustrade. From here you can admire the spectacular architectural composition of the third east *gopura* and its five entrances—the approach to the temple precinct (2). The third east *gopura* is an imposing structure with its large former central tower, serving as a royal entrance to the temple proper. Most of the *gopura's* external wall surfaces are adorned with bas-reliefs, mouldings, and false windows all of which were carved 'in situ' following the placement of rough cut sandstone blocks. Take note of one of Preah Khan's famous trees, a species nicknamed *fromager* by the French for its similarity to ripened brie cheese.

Preah Khan

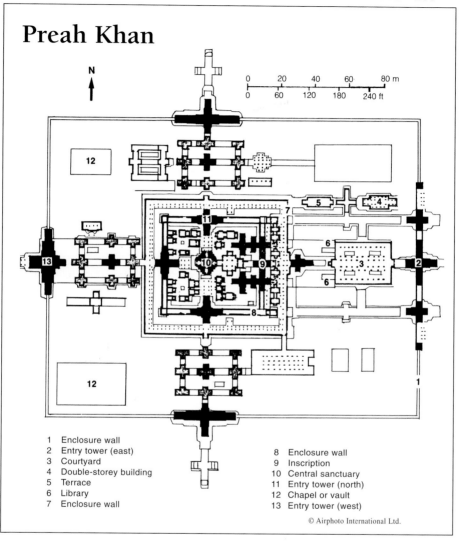

N

0 20 40 60· 80 m
0 60 120 180 240 ft

1 Enclosure wall
2 Entry tower (east)
3 Courtyard
4 Double-storey building
5 Terrace
6 Library
7 Enclosure wall

8 Enclosure wall
9 Inscription
10 Central sanctuary
11 Entry tower (north)
12 Chapel or vault
13 Entry tower (west)

© Airphoto International Ltd.

Passing through the central doorway, over thresholds clearly delineating the architectural spaces, you next enter the imposing Hall of Dancers, a large and airy structure which derives its name from the magnificent carved lintels depicting the *apsaras*, celestial dancers (3). Formerly eight of these exquisite *apsara* lintels adorned the finely proportioned performance state. However, three lintels have collapsed due to structural failure as they spanned some of the largest openings found

in Khmer buildings at that time. As this ornate hall is close to the principal entrance of the temple, it may have been the place where worshippers presented offerings of food, gifts and dances to the king and the Preah Khan divinities.

At the crossing in the Hall of Dancers, turn right (north) to see the unique two-storey pavilion, which is strangely reminiscent of classical western architecture (4). The pavilion is set in an open area where causeways enclose small patios, which may have served as reflecting pools. The pavilion is unique because of its large round drum columns. Legend claims that it once housed the Preah Khan or sacred sword, which preceded the king in processions. To the west, a more recent raised platform faces the pavilion on which a wooden temple structure was probably built (5). The post holes of the structure are still clearly visible in the laterite plinth.

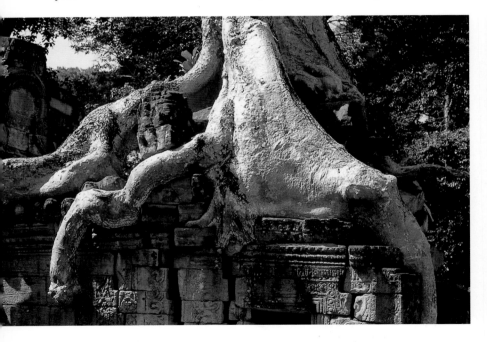

Follow the causeways and turn left back onto the main axial route. You pass through two enclosure walls in quick succession, which encircle the principal Buddhist sanctuary. Speculation points to an early expansion of this inner sanctum forcing the

Above: The tree, Tetrameles Nudiflora, is called fromager by the French—for its visual similarity to ripened brie, Ta Prohm. Right: The Preah Khan Hall of Dancers.

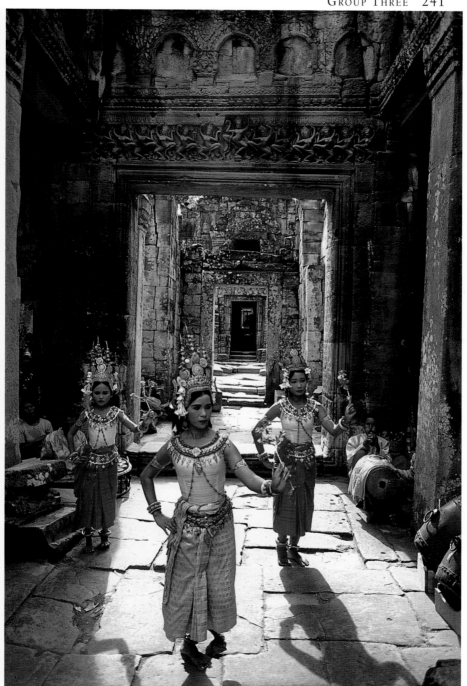

builders to speedily construct, in laterite, a secondary wall to enclose the votive shrines. Directly inside the outer of the two walls is an unusual vaulted cloister, which formerly encircled the Buddhist sanctuary. Today, structural failure and large tree growths block this cloister. The second, less clearly defined, enclosure wall is breached by the additional shrines but its location is evident from the carved *dvarapalas*, or guardians, which stand sentinel to its entrance.

The next large cruciform shrine you enter is referred to thus because of its original shape as a perfect Greek cross. Additions were made to the temple subsequently and the eastern entrance of the shrine was expanded twice, making it longer than the other entrances. Although the exact function of this shrine is unknown, it is believed that it was originally dedicated to Jayavarman VII's predecessor, Tribhuvana—a fact confirmed by an inscription on the door jamb. The west portico of this structure formerly housed the celebrated stone stele describing the foundation of the monastery at Preah Khan. This priceless stele provides precise records of the monastery's dedication as well as descriptions of its 515 divinities represented in statues, of the 139 annual festival days and the monastery's mission as a centre of learning. The walls of first east *gopura* I are finely engraved, heralding your proximity to the central shrine.

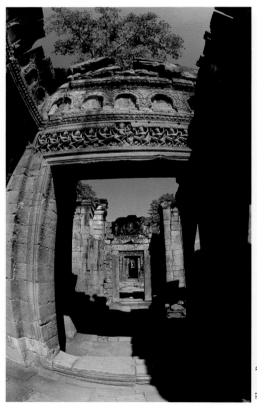

Thomas Bauer

Approaching the central Buddhist sanctuary, notice the pockmarked stonework with regular dowel holes formerly used to fix bronze panelling—

The Hall of Dancers, a large and airy structure which derives its name from the magnificent carved lintels depicting the apsaras, seen here through a fish-eye lens.

a feature which continues inside the central tower itself. The sanctuary tower is plain and unadorned considering its religious significance (10). Closer inspection of the exterior reveals stucco remains, which suggest that, in accordance with the inscription, the tower could have been ornately decorated with a gilded stuccowork. The interiors were also probably lined and decorated with embossed gilded bronze panels set on timber frames dowelled into the stone surface. Within this shrine is a 16th century stupa which replaced a beautiful statue of Lokeshvara, the bodhisattva, sculpted in the image of Jayavarman VII's father. This shrine still has special significance for local Buddhist worshippers who believe that wishes made here will come true.

Standing at the centre of the Buddhist complex within the enclosure wall, look east, back along the axis of the grandiose entrance; look west, through temple shrines dedicated to Vishnu, and north to those dedicated to Shiva—both principal Hindu divinities. WMF has cleared only the path leading to the southern *gopura* III of the southern sector dedicated to ancestor worship, most of which is undisturbed, still deep in jungle. You will notice that the land rises to the centre, reflecting the concept of Mount Meru as the centre of the universe. However, these axial vistas were never originally intended, as each shrine was worshipped individually by the monks or temple attendants behind closed doors. If you raise your eyes to the corbelled ceilings above, you will also notice the remarkable crude stone vaulting—the arch was never introduced to the Angkor civilisation. Originally, a coffered timber panelled ceiling would have been laid at cornice level, hiding the vaults and changing the proportions of these spaces.

From the central tower there are two exit routes. Should you choose to leave through the north exit, you will pass through temples dedicated to Shiva, the Hindu god of destruction and regeneration and one of the most important deities worshipped during the Angkor dynasty. In an open courtyard in the eastern part of the complex is a fronton depicting Vishnu lying on an aquatic animal in a primeval ocean, conjuring up the perfect world. His consort massages his legs.

Continuing along the western axis towards the west *gopura*, you will pass through the Vishnu complex. You will become aware that the scale and proportions of the structures diminish as you pass through a series of small shrines dedicated to various incarnations of Vishnu. Notice the inscriptions on the decorated door gives the names of former divinities that occupied the shrines, as well as their donors. This complex also contains some of the only remains of painted stucco in the Angkor region. At one point there are two striking stone frontons facing one another. The eastern fronton depicts Krishna holding up Mount Govardhana to shelter his

villagers from the wrath of Indra and the western one the image of Brahma. After royal patronage abandoned Angkor in the 15th century, it is likely that this Vishnu Temple continued as a place of active worship. A recent discovery of decorative wall painting in the central shrine—the only example of its kind in Angkor—is indicative of its later use. Reassembled stones in the open courtyard are probably remnants also of a later façade.

As you pass through the third west *gopura* III glance back at the fronton which has undergone major repairs. Originally the supporting beams and lintels were broken into two and three parts. Conservation technology developed by the WMF team has made it possible to repair this structure and to remove former unsightly concrete beams placed to support this massive stone structure.

Continuing west, the path out through the jungle will lead you to the World Monuments Fund Information Centre, which is full of interesting drawings and before and after photographs.

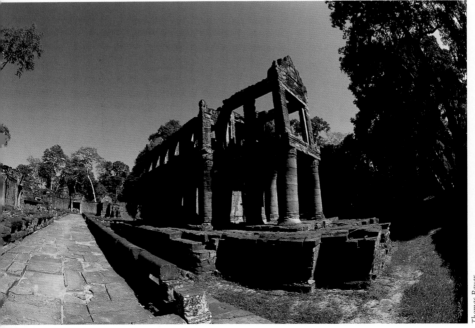

Thomas Bauer

Above: *Wide-angle lens captures, and distorts, some of Preah Khan's remarkable architecture.*
Right: Garuda, *northeast side, Preah Khan. (Thomas Bauer)*

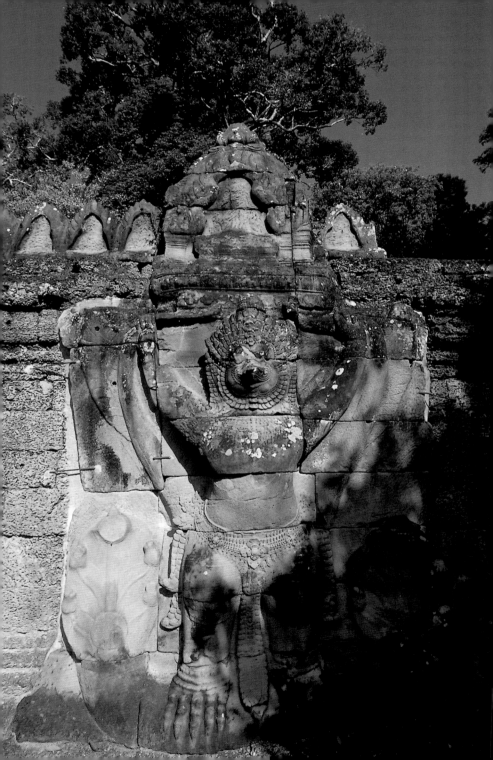

NEAK PEAN: THE 'COILED SERPENTS'

'On an artificial island in the centre (of the Jayatataka Baray or "Pool of Jayavarman"), was the little temple of Rajasri, now known as Neak Pean, one of the most unique and beautiful designs of all Khmer architecture. A little temple, only four metres square, with four lotus stories and a little crown. This little gem of a sanctuary rose out of a sacred lotus, which seemed to float on the surface of the basin'.[54]

Location: east of Preah Khan; 300 metres (984 feet) from the road
Access: enter and leave from the north
Date: second half of the 12th century
King: Jayavarman VII (reigned 1181–1220)
Religion: Buddhist
Art style: Bayon

BACKGROUND

Neak Pean is located in the centre of the Jayatataka or Northern Baray and placed on the same axis as Preah Khan. A levee was built across the baray from the Grand Circuit by the French to provide access, and cuts directly through the north jetty and embankment of the island. Originally, it could only be reached by boat. It is a small, somewhat out-of-the-way temple with a unique layout, decoration and symbolism. The temple seems to have served as a place where pilgrims could go and take the waters, both physically and symbolically—the Khmer equivalent of a spa.

The central pond may be a replica of Lake Anavatapta in the Himalayas, situated at the top of the universe, which gives birth to the four great rivers of the earth. These rivers are represented at Neak Pean by sculpted gargoyles corresponding to the four cardinal points. Lake Anavatapta was fed by hot springs and venerated in India for the curative powers of its waters. Neak Pean was probably consecrated to the Buddha coming to the glory of enlightenment. The shrine in the middle of the central pond was engulfed by a tree until 1935, when it was destroyed by a storm.

LAYOUT

The temple of Neak Pean is set in a large, square, manmade pond (70 metres, 230 feet each side), bordered by steps and surrounded by four smaller square ponds. A small circular island, with a stepped base of seven laterite tiers, is in the centre of the large square pond, and forms the base for the shrine dedicated to Avalokiteshvara. Small elephants sculpted in the round originally stood on the four corners of the pond.

Khmer women came to Neak Pean to take the waters,
which symbolised Lake Anavatapta in India.

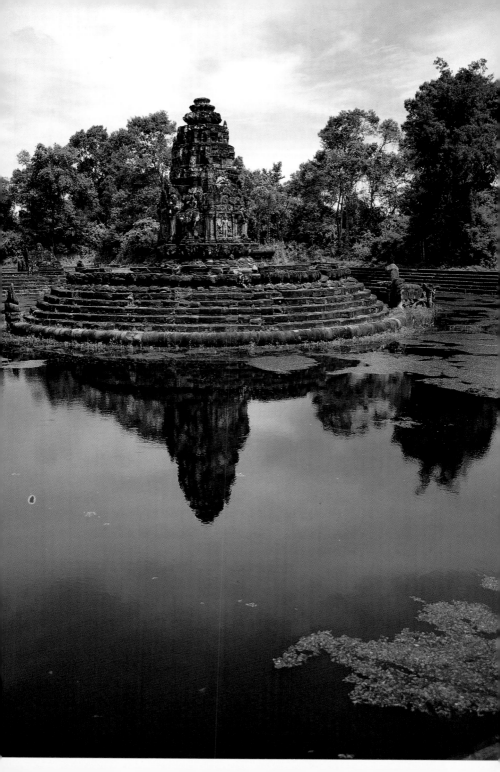

KROL KO: 'PARK OF THE OXEN'

Location: north of Neak Pean, 100 metres (328 feet) from the road
Access: enter and leave from the east
Tip: the turn-off from the main road for this site is marked with a sign in English
Date: late 12th–early 13th century
King: Jayavarman VII (reigned 1181–1220)
Religion: Buddhist (probably dedicated to Lokeshvara)
Art Style: Bayon

BACKGROUND

The main interest at Krol Ko is the pediments on the ground, which depict a bodhisattva Avalokiteshvara standing on a lotus, flanked by devotees, and Krishna raising Mount Govardhana to shelter the shepherds and their flocks.

LAYOUT

Krol Ko is a single tower surrounded by two laterite enclosure walls with a sandstone *gopura* at the east and moat enclosing with steps leading down to the water. A library built of laterite and sandstone is at the south of the interior courtyard. It opens to the west with a false door at the east. The central sanctuary with porches stands on a cruciform terrace.

TA SOM: 'THE ANCESTOR SOM'

Location: east of Neak Pean
Access: enter and leave from the west
Date: end of the 12th century
King: Jayavarman VII (reigned 1181–1220)
Religion: Buddhist
Art style: Bayon

BACKGROUND

Ta Som today has a beauty and charm that few other temples in Angkor possess. Part of this is due to its remote, natural setting and its semi-ruinous state. Ta Som is small and compact and on a more human scale than most temples bearing its builder King Jayavarman VII's distinctive feature—the enigmatic faces found on the Bayon. The Ta Som Joint Conservation Project is managed and funded by the World Monuments Fund (WMF) in association with APSARA. A programme for the sabilisation and presentation of the complex was started in March 2001, and is being masterminded entirely by WMF's Cambodian team using the skills the architects, archaeologists and workforce acquired at WMF's Preah Khan Conservation Project.

LAYOUT

The Ta Som complex follows the typical layout of its larger counterparts at Preah Khan and Ta Prohm. It is a small Buddhist monastic complex built by Jayavarman VII in the late 12th century and is typical of the temples following the period of the 'Bayon' style. It is thought that King Indravarman II enlarged Ta Som in the 13th century by building the outer enclosure wall. Located at the east end of the four-kilometre-long (2.5 miles) northern or Jayatataka *Baray* (reservoir), Ta Som's simple plan covers an area of about 4.5 hectares (11 acres). Three concentric laterite walls delineate the complex and the outer wall has sandstone *gopuras* or gateways giving access from the the east and west. East *gopura* III is engulfed in the roots of a large and picturesque ficus tree which has led to great structural damage (1). The main tower (6) is cruciform shaped with four porches.

To see the inner courtyard, it is now possible to enter it through either the east, west or southern *gopuras,* which were previously blocked by termite mounds and fallen stones. The inner sanctuary where the original Mucalinda Buddha was found buried, consists of the central tower surrounded by four courtyards which now house the fallen frontons that have been pieced together and assembled as part of the WMF conservation

Left: *West entrance, Ta Som.*

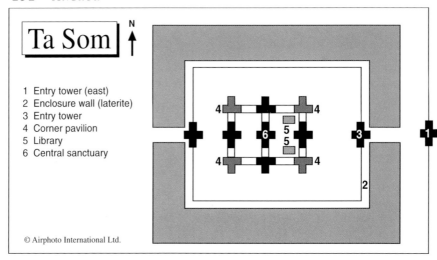

Ta Som

N

1 Entry tower (east)
2 Enclosure wall (laterite)
3 Entry tower
4 Corner pavilion
5 Library
6 Central sanctuary

© Airphoto International Ltd.

project, providing the visitor with the chance to study closely these exquisite sculptures. Ta Som also features many beautiful female *devatas* adorning its walls—a total of 172 different images can be found in this small temple complex. A unique sculptural feature is the use of the entwined *naga* tails framing the head of some of the female figures. Some are even depicted holding small birds in the cupped palms of their hands. Once you have explored the inner courtyards, continue in an easterly direction through east *gopura* II towards east *gopura* III which bisects the outer wall; go through it and turn back to see three roots entwined in the fronton and its tower. Retrace your steps and exit through the west, this time walking around the main building in a clockwise direction, viewing the female divinities adorning the outer walls.

Thomas Bauer

PRASAT PREI: 'FOREST SANCTUARY'

Location: from Siem Reap, follow the main road past Preah Khan; continue 750 metres (2,460 feet) to a dirt road on the left; turn onto the road and continue 100 metres (328 feet); the temple is on the west side

Access: enter and exit from the east

Tip: the turn off the main road is marked by a sign to Banteay Prei; this is another little visited temple that offers a pleasant jungle setting and a small, yet attractive, site

Date: late 12th–early 13th century

King: Jayavarman VII (reigned 1181–1220)

Religion: Buddhist

Art style: Bayon

LAYOUT

The temple is enclosed by a laterite wall (20 x 24 metres; 65.6 x 78.7 feet), of which only traces remain. There is one *gopura* of laterite but all that remains is a door frame and a sandstone window jamb. The cruciform sanctuary opens to the east with false doors on the other three sides. It has a long vestibule on the east that leads to a square porch. Small blind vestibules on the other three sides project from the tower and are adorned with false doors. The porch is topped by a tower of four receding tiers and the vestibules have corbelled vaults.

The decoration is typical of the period: *devatas* standing in niches, windows with balusters and blinds, *apsaras* and an abundance of foliage and geometric patterns as background motifs.

A laterite and sandstone 'library' in the southeast corner of the enclosure opens to the west.

Left: *World Monument Fund reconstruction around east* gopura, *at Ta Som.*

BANTEAY PREI: 'CITADEL OF THE FOREST'

Location:	from Siem Reap, follow the main road past Preah Khan; continue 750 metres (2,460 feet) to a dirt road on the left; turn onto the road and continue 150 metres (492 feet) past Prasat Prei to Banteay Prei
Access:	enter and leave from the east
Tip:	the turn-off to Banteay Prei is marked by a sign in English; a pleasant, rarely visited site—off the beaten track
Date:	late 12th–early 13th century
King:	Jayavarman VII (reigned 1181–1220)
Religion:	Buddhist
Art style:	Bayon

BACKGROUND

The architecture and decoration of this temple are typical of the period and consist of sandstone cruciform-shaped *gopuras* with walls adorned by female divinities standing in niches; windows with balusters and lowered blinds; and the central towers crowned with a blooming lotus.

LAYOUT

From the east entrance and walking west you see remains of a laterite enclosure wall with a sandstone ridge and niches that once contained Buddha images and remains of the east *gopura*, preceded by a small cruciform terrace with a *naga* balustrade. A laterite-paved moat surrounded this enclosure. A narrow sandstone gallery with pillars and a stone-tiled roof forms a further enclosure (30 x 24 metres; 98 x 78 feet). There is a pavilion at each cardinal point of the gallery.

The central shrine is cruciform shaped with four porches and entrances at the four cardinal points; the superstructure originally had four tiers. The false windows have balusters but no blinds. The decoration is typical of the period with *devatas* standing in niches and pediments with a *naga* lobed frame terminating in multiple heads; rows of kneeling devotees and *apsaras* above. Traces of a laterite enclosure wall are visible at the west.

GROUP 4
BENG MEALEA: 'THE LOTUS POOL'

A trip to Beng Mealea, which in itself demands an entire day, can be combined with a hunting party, since the region is rich in both small and large game and wild animals: tigers, panthers and elephants, herds of oxen and wild buffalo inhabit the forest as far as Prah Khan of Kompong Svay in the east...' (Maurice Glaize, The Monuments of the Angkor Group, *p.219 in trans. from fourth edition, published in 1963).*

Location: some 40 kilometres (24.85 miles) northeast of the Bayon and seven kilometres (4.34 miles) southeast of Phnom Kulen; depart from Siem Reap; pass the ticket checkpoint and follow the road towards the east gate of Angkor Wat; take the right turn to Banteay Srei, through the village of Pradak. Continue along the pitch road until just short of Banteay Srei village. Take the right fork towards the Kulen Hills along a gravel road to a major crossroads where you turn right along another gravel road at the foot of the Kulen Hills. Follow this road for approximately 45 minutes past a gravel quarry and at the next crossroads turn left. The entrance to Beng Mealea is a further 15 minutes away.

Access: enter and exit at the south

Tip: before you depart for Beng Mealea, ask your local guide to estimate the travel time based on the condition of the roads, which varies throughout the year; as of August 2003 the local villagers charge visitors US$2 per person; a wooden ramp enables access to parts of the interior; it is recommended that you begin your visit by walking around the enclosure wall and then entering from the south to see the interior and leaving at the north.

Caution: do not leave the paths as the area is only partially de-mined

Date: c. late 11th–early 12th century

King: probably Suryavarman II (reigned 1113–1150)

Religion: Hindu, possibly dedicated to Vishnu

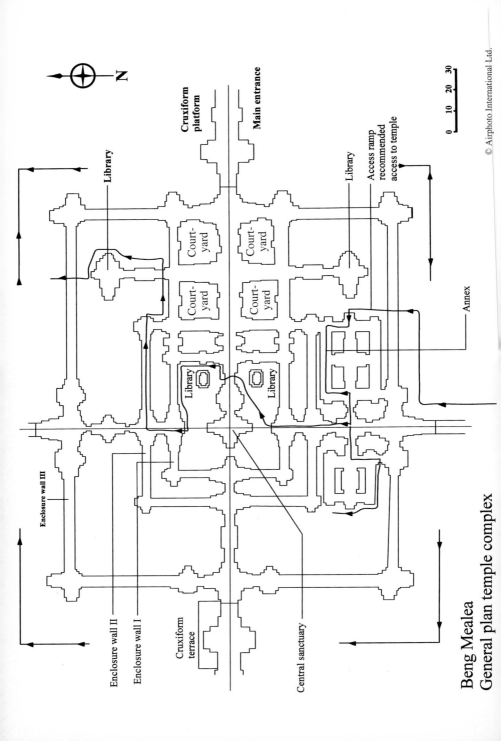

N

Library

Cruxiform platform

Main entrance

Court-yard

Court-yard

Court-yard

Court-yard

Library

Library

Access ramp recommended access to temple

Library

Enclosure wall III

Annex

Enclosure wall II

Enclosure wall I

Cruxiform terrace

Central sanctuary

0 10 20 30

© Airphoto International Ltd.

Beng Mealea
General plan temple complex

BACKGROUND

Beng Mealea is another enormous complex with an area of 108 hectares (266.86 acres). Although the precise date of the temple is not known as no inscription found so far has mentioned it, the art and architecture are stylistically similar to that of Angkor Wat and the workmanship and composition are of the same fine quality. Beng Mealea is in poor condition because of natural elements, the lack of maintenance and vandalism, so visiting this site is an experience. But nearly everyone who makes the effort to ply his or her way through the maze of Beng Mealea emerges with a sense of wonder at the accomplishments of the Khmers in constructing this earthly microcosm of the heavenly macrocosm.

LAYOUT

The layout combines the temple-mountain theme of the early and middle periods of Khmer art with the ground level plan adopted in the 13th century by connecting the

The north library on the second level at Angkor Wat.

two architectural concepts with covered galleries, corbelled vaulting, cruciform passages, raised walkways and shrines. Whichever way you perceive the developing plan, as you wander amongst the ruins, keep in mind that you are progressing from the world of man to that of the gods and moving to an increasingly more spiritual plane.

The dimensions of the outer enclosure wall of the Beng Mealea complex are 181 x 152 metres (594 x 599 feet). A pair of majestic lions stands on each side of the entrance of the causeway (once paved with sandstone) and as you walk to the south you see remains of multi-headed *nagas* and parts of a balustrade that once lined both sides of the causeway (the decoration on the crest of the multi-headed *nagas* is finely carved and so detailed that it looks like embroidery). A moat surrounds the temple. Next you approach a cruciform terrace supported by round, undecorated columns and the first of three enclosure galleries, each with a *gopura* in the middle of all sides and a tower in the four corners.

The east, or main, entrance, is preceded by a vast 'depression' that may have been a *baray*. A terrace with a laterite base and sandstone paving marks the entrance and sandstone-lined ponds flank the east causeway. Parts of a *naga*-balustrade and short pillars that supported it litter the ground on both sides of the causeway.

Enter the central complex to the east (right) side of the south *gopura* and walk along the wooden ramp to get an amazing bird's eye view of the inner area. Recognisable forms are: (south) between the 1st and 2nd enclosures, there are two sandstone structures with small, rectangular windows and balusters; a 'library' on the north and south side of the east entrance, which are connected by a 'cloister'; (east) four courtyards at the east are surrounded by narrow, vaulted galleries; the central sanctuary (now collapsed) was linked to the enclosure wall at the east by a narrow, covered gallery.

Look for the following narrative scenes in the central complex: **lintels:** Indra on his mount, the three-headed elephant; Lakshmi, Vishnu's consort, seated between two elephants with raised trunks holding a lotus; Vishnu reclining on a serpent with a lotus in full bloom springing from his navel and Brahma (four heads; only three are visible) heads emerging from the blooming lotus; the Churning of the Ocean with gods on one side and demons on the other holding the body of a serpent with a tortoise as the support for the churning pole in the centre; **pediments:** Shiva and Parvati, his consort, sitting on his mount, Nandi, the bull; Krishna with his left arm stretched upward supporting Mount Govardhana to protect the shepherds from a torrential storm brought about by Indra; Krishna wrestling with the demon Bana; Shiva dancing the cosmic dance with Ganesha on one side and Parvati, his consort, on the other.

KAPILAPURA

Location: northeast of Angkor Wat; drive to the dirt road that leads to the
east entrance of Angkor Wat; walk north along the path that
parallels the moat; at the northeast corner of the moat turn north
and follow the path through the jungle for about 150 metres (492 feet)
Access: enter and leave from the west
Tip: although little remains of the temple, the walk along the moat and
through the jungle is very pleasant
Date: 968
King: Rajendravarman (reigned 944–968) or Jayavarman V (reigned
968–1001)
Religion: Hindu (dedicated to Vishnu)

BACKGROUND

This site is interesting historically because it is one of the few known pre-Angkor sites
in the area. Fragments of an inscription on a pillar identify 968 as the date of the
foundation of the temple.

Kapilapura, which is a non-significant site today with little to see, made international
news in 1998 when the remains of some temples pre-dating the Angkor Period were
identified near the northeast edge of Angkor Wat through images produced by an
airborne radar system developed at Jet Propulsion Laboratory in the United States.
Kapilapura is one of these sites. This discovery suggests that Angkor was occupied
over 200 years earlier than previously believed. If so, it may change the entire
chronology of Angkor.

LAYOUT

The poor condition of the site makes it difficult to determine the original layout. As
you enter there are foundations of two rectangular structures (one of brick and the
other of sandstone). The central area comprises a laterite foundation with a brick
central tower. Part of a window frame with five balusters and remains of a *yoni* lie on
the grounds.

KABAL SPEAN: THE 'HEAD OF THE BRIDGE', ALSO CALLED 'RIVER OF A THOUSAND *LINGAS*'

Location: northeast of Angkor Thom; 12 kilometres (7.45 miles) east of Banteay Srei

Access: the carvings are clustered in three areas; it is recommended that you climb to the northernmost point to begin your exploration of the site

Tip: the climb up the hill follows a path that is steep in parts and uneven in others; hire a local villager to show you the easiest way up and down the hill and to point out the locations of the carvings; presently, there is no set fee for this service. It is up to you to determine what to pay when you complete your visit. Despite the heat and humidity at all times of the year, the walk through the jungle is pleasant with monolithic rocks affording rest stops along the way; walking slowly, but steadily, the climb, including rest stops, is about 45 minutes

Caution: do not wander off the path as the area is not de-mined

Date: c. mid-11th century

Religion: Hindu (dedicated to the cult of the *devaraja*)

BACKGROUND

Kabal Spean, on the western promontory of Phnom Kulen, is popularly known as the 'River of One Thousand *Lingas*.' The river is the Ruisey ('Bamboo'), which has its source on Phnom Kulen and flows southward towards Angkor and the Tonle Sap. The name, Kabal Spean, refers to a natural sandstone bridge, which you can walk over. Images of Hindu gods and their consorts and some 1,000 *lingas* are carved in the bedrock and on the banks of the Siem Reap River. Because of the location of the carvings, how clearly defined the images are when you visit depends on the seasonal flow of water; in the rainy season (late May to late October), the carvings are less visible but the site is more dramatic because of the volume of water; in the dry season (November to May), you can see the carvings more clearly but you miss the thrill of water gushing over the stones. Regardless, Kabal Spean is a sensational site.

Even though the carvings are cut in relief in the riverbed at the top of a steep hill, it has not deterred thieves from removing heads and torsos of deities. As recently as April 2003, a large image of Vishnu was savagely hacked out, leaving an irreparable, gaping hole at the heart of this sacred site.

Kabal Spean was discovered in the mid-1960s and then it was off-limits until the late 1990s because of mines. Thus, the site has never been studied and little is known about it. An inscription states that Suryavarman I (reigned 1001–1050) donated 1,000 *lingas* in 1054, but whether some date to an earlier or later period is unknown.

The ancient Khmers conducted animistic rituals to propitiate the spirits that control the waters and adorned their religious structures with water symbols to ensure fertility and prosperity. The placement of powerful images associated with creation and fertility such as sacred *lingas* (representative of Shiva's creative energy force) in *yoni* (the female principle of creation) and the gods of the Hindu trinity—Brahma, the creator, Vishnu, the preserver and Shiva, the destroyer—near the head of the river symbolically purifies and blesses the water. Therefore, it is sacred water that descends to fertilise the soil of the Angkorean plain.

LAYOUT

The carvings extend over an area of about 35 metres (114 feet). The highlights, from north to south are: near the edge of the east side of the river, there is a large carving of the four-headed god Brahma seated with legs crossed (he faces south). From this point southwards, the most frequently occurring narrative theme is the birth of Brahma (Vishnu reclines on the cosmic ocean; a lotus stem emerges from his navel; and, as it blooms, at the top of the stem, Brahma appears; Vishnu's consort, Lakshmi, kneels at his feet as if she is massaging them). There are also scenes of Shiva and his consort, Uma, sitting on his mount, Nandi. Groups of *lingas* appear amongst the carvings at all stages. You see all of these themes as you walk south—first, before the stone bridge and, later, before the waterfall.

The *lingas* are laid out in a grid and, if you look carefully, you will notice that in some a *yoni* with a spout pointing north frames the grid. The *lingas* are roughly the same size and each one is approximately 25 centimetres (9.8 inches) in diameter. They only project a few centimetres above the bedrock, so rather than the more familiar tall *linga* you see what looks like groups of round bumps projecting from the bedrock.

Walk across the stone bridge and on your left (south) there are some more carvings with the same themes. Ask your guide to point out the inscription that gives the information listed above.

Further south, you will come to a very large grid of *lingas* in a *yoni*—one of the most remarkable carvings at Kabal Spean. A group of eight *lingas* centred around one larger one and contained in a *yoni*, thus creating a mandala form. Throughout the area, carvings of animals, such as a frog and a crocodile, mingle with the gods.

PHNOM BOK: 'OX-HUMP MOUNTAIN'

Location: about 10 kilometres (six miles) from Angkor Wat; follow the main road from Angkor Thom east; pass Srah Srang and Pre Rup; turn east (right) at the first road; pass through Pradak village and continue straight on the road to Banteay Samre; continue to Phum Tchrey village (four kilometres; 2.5 miles); turn north (left) on a small a road that takes you to the south-east base of Phnom Bok

Access: climb 630 steps to reach the temple at the top of the hill; pass by a modern temple to get to the ancient site; enter and leave at the east

Caution: before undertaking the ascent and descent to Phnom Bok, keep in mind the number of steps and the steepness of the hill; concrete steps and a sturdy railing are in place; make the climb early in the morning before it gets too hot

Tip: the views of the Angkor plain below from all heights are spectacular

Date: late ninth–early 10th century

King: Yasovarman I (reigned 889-910)

Religion: Hindu (dedicated to the Hindu trinity—Shiva, Vishnu and Brahma)

Art style: Bakheng

BACKGROUND

Phnom Bok is the second highest hill in the Angkor region (height: 235 metres; 770 feet). Soon after Yasovarman I moved the capital from Roluos to Angkor he built majestic sandstone temples on the only three hills in the region—Phnom Bok, Phnom Krom and Phnom Bakheng. Even today, these sites, built over 1,000 years ago, stand out for their majestic positions and for their incredible achievement in transporting enormous blocks of sandstone through dense jungle and up the rocky slopes of the hills.

The three temples are similar in plan, architecture and decoration. No inscription related to Phnom Bok has been found but stylistically it seems to belong to the period of Yasovarman I. Etienne Aymonier, a Frenchman writing in 1901, described Phnom Bok as 'the mountain of the ink pot,' perhaps because of the shape of the mountain, which is conical. Phnom Bok has never been restored but it was partially cleared in 1939. Today it is in poor condition but the towers and the carving have not suffered from the elements as much as those on Phnom Krom.

LAYOUT

The temple of Phnom Bok, situated at the top of the hill, is square in plan and consists of three sandstone towers of equal size oriented north to south and standing in a row on a low, rectangular platform with three stairways on both the east and west sides. The central shrine is dedicated to Shiva, the northern one to Vishnu and the southern one to Brahma. The superstructure of the towers originally comprised four recessed stages. The shrines open to the east and west with false doors on the north and south.

The temple complex included two small, square buildings (the ones on the ends are built of brick with sandstone doors and the middle ones are entirely of sandstone) aligned north to south on each side of the eastern entrance to the temple. The buildings open to the west and the walls and the recessed superstructure are pierced with lozenge-shaped holes in a square formation of five by five. These features suggest they may have been used as crematoriums. A laterite enclosure wall (length: 35 metres; 115 feet, width: 45 metres; 145 feet) intersected by cruciform *gopuras* surrounded the complex and was parallelled by an interior laterite (width: three metres; nine feet) cloister. Two stone lions mark the entrance at the east.

The three central towers have sandstone octagonal colonettes on each side of the doorway. Miniature replicas of the towers originally adorned each corner of the recessed tiers on the superstructures. Some are in place but many more can be seen on the ground amongst the ruins. The decoration on the north and south towers is unfinished. Vertical bands of intricate decoration on the walls of the shrines are filled with small figures and circular floral scrolls. Lively dwarf figures—lions standing on their haunches and dancing figures—can be seen at the base of these panels.

Devatas stand in narrow niches on the walls of the three shrines. The faces of these females are beautiful and with their full breasts and narrow waists they show a voluptuousness rarely seen in Khmer art. They wear a long, pleated skirt of two layers folded at the waist and held in place by a jewelled belt with elegant pendants and rows of bangles on their arms. They hold a staff in the right hand; the left arm is close to the body and the wrist bends gracefully with fingers pointing outwards. Other decorative elements that once adorned the towers can be seen on fragments of pediments, lintels and stones that litter the ground.

A unique feature of this temple stands some 150 metres (492 feet) to the north-east of the enclosure wall. Follow the path until you reach a tall, square (12 metres; 39 feet each side) laterite platform with a height of two metres (6.5 feet). Climb the steps to the top where there is a large well (depth: three metres; 9.8 feet) with an enormous sandstone *linga* (now fallen and lying on its side), which is square at the base (symbolising Brahma), octagonal in the middle (representing Vishnu) and round at the top (symbolising Shiva). This *linga* is one of the largest in Cambodia. Its length is four metres (13 feet) and the diameter 1.20 metres (3.93 feet), and the weight is estimated to be at least 10 tonnes.

PHNOM KULEN: 'MOUNTAIN OF THE LYCHEES'

Location: 48 kilometres (29 miles) northeast of Siem Reap; 15 kilometres (nine miles) east of Banteay Srei

Access: there are several roads to Phnom Kulen from the Banteay Srei area; ask your local guide for information about which one is in the best condition and for an estimate of the travel time

Tip: Phnom Kulen is outside the jurisdiction of Angkor and, therefore, the ticket for the temples is not valid. To visit Phnom Kulen you must pay a fee of US$20 per person. An additional fee for a car or motorbike may also be charged.

Caution: do not go off the paths on Phnom Kulen as the area is not de-mined

BACKGROUND

Phnom Kulen is a long mountain range extending north to south on the east side of the Angkor plain. The size of the mountain is imposing. It stretches nearly 12.8 kilometres (eight miles) and is the highest mountain in the area (height: 450 metres; 1,476 feet) with a wide plateau across the top. The north-western part of the Kulen plateau is the source of the Siem Reap River.

Phnom Kulen is important historically as it is the birthplace of the Angkor Period and, thus, modern Cambodians consider it a sacred place. Jayavarman II consolidated the existing states in the region at the beginning of the ninth century. To legitimise his power he organised a ceremony in 802, installing the cult of the *devaraja* and pronouncing himself king, which took place on Mount Mahendrapura the 'mountain of the great Indra,' known today as Phnom Kulen. He erected a temple, Rong Chen, to house his royal *linga*, at the centre of his capital, called Mahendraparvata, on the mountain. It was a pyramid built of brick and an earthly representation of Mount Meru, the abode of the gods.

Surveys conducted early last century identified ruins of some 30 temples spread over a space of 12–14 square kilometres (around five square miles) on the southeast end of the Kulen plateau. Even then, many of the sites were no more than mounds of brick; others were in ruins. Remains of some temples on Kulen are still standing but, presently, they are difficult to get to because of the lack of roads and because they are located in areas of the mountain that have not been demined. It you want to try to see these sites ask at the Khmer Tourist Information Office in Siem Reap (across from the Grand Hotel) for a guide who knows the Kulen area well.

A steep, graded road near the northwest end of Phnom Kulen takes you to the top where you can see a huge reclining Buddha sculpted in the rocks that dates from the post-Angkor period when Theravada Buddhism took hold in Cambodia. The image is enclosed in a modern shrine accessed by steps. The views from the top are spectacular.

A nearby waterfall affords a refreshing break where you can swim. Food and drinks are available. It is a popular picnic site for Cambodians on the weekends. Images of Hindu divinities and *lingas* are carved in the bedrock just before the waterfall. A footbridge takes you across the river and on your right is a small sandstone shrine of an unknown date.

Nature seems to dominate many of Angkor's sites.

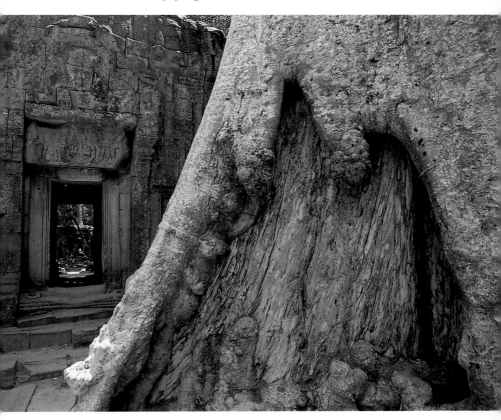

GROUP 5
ROLUOS

Three temples of Preah Ko, Bakong and Lolei are clustered together near the modern village of Roluos, and extend over an area of three kilometres (almost two miles) at the northeast end of the Tonle Sap. The three temples belonging to the Roluos group date from the late ninth century and have similar characteristics of architecture, decoration, materials and construction methods, which combine to reveal the beginning of the classic period of Khmer art. The brick structures are decorated with magnificent sandstone deities in niches and lintels, some of which are in remarkably good condition.

To reach Roluos take the road leading to Psar Leu (New Market) from Siem Reap town and continue for about ten kilometres (6.2 miles). Continue eastward for about 35 minutes—the temples are signposted down a small road on the right, which will take you to the ancestral temples of Preah Ko (on your right). This small group of six towers is exceptional in its setting, architecture and decoration.

Return to the road, turn right and continue until you come to the temple-mountain of Bakong—the temple is directly in front of you. Follow the road in a clockwise direction to the east entrance. Have your transport wait for you on the west side. Walk across the causeway which spans a moat, admiring the earliest example of a *naga* balustrade at Angkor. Enter the temple at the east and walk around it on ground level before climbing to the top. The lintels and false doors of the towers on the ground level are exceptionally beautifully decorated.

Leave the temple at the west and continue round the temple back to the access road. Once you reach the main road turn right and look for a small road on the left; follow it to Lolei (on your left). Like the East Mebon, Lolei is situated in the middle of the Indratataka Baray (a reservoir). Today, it is part of a modern temple complex. Some consider the decoration of Lolei the finest of the Roluos group. Return to the main road, turn right and follow the main road back to Siem Reap.

Two temples, previously inaccessible, in the Roluos area with great historical interest warrant a visit for those keen to gain an understanding of the formative period of the great Khmer civilisation and see remains of some exquisite art. **Prasat Prei Monti** and **Prasat Trapeang Phong** are both located south of Bakong, between two and four kilometres (1.2 and 2.5 miles) to the west of the secondary road that passes by the southeast enclosure wall of Bakong, and continues south to the Tonle Sap. These two sites, which may be the earliest ones yet known in the area, could

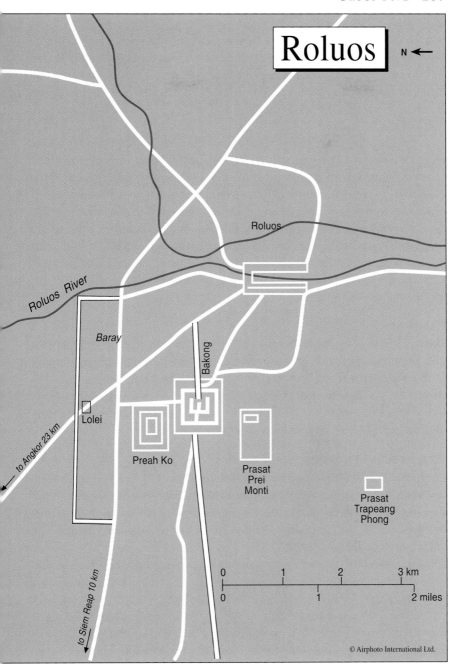

Roluos

N ←

Roluos

Roluos River

Baray

Bakong

to Angkor 23 km

Lolei

Preah Ko

Prasat Prei Monti

Prasat Trapeang Phong

to Siem Reap 10 km

| 0 | | 1 | | 2 | | 3 km |

| 0 | | | 1 | | | 2 miles |

© Airphoto International Ltd.

possibly date to the late Zhenla period (around the end of the eighth century) or the beginning of the ninth century. The latter may have been the capital of Jayavarman II (reigned 802–c. 835), either before or after he inaugurated the Angkor Period and built his capital, Mahendraprarvata, on Phnom Kulen. The former, Prasat Prei Monti, may have been capital of Jayavarman III (reigned c. 842–877) or his successor Indravarman I (reigned 877–889).

Stylistically, they can be looked at together as they share similar characteristics of art and architecture. The remains at Prasat Trapaeng Phong are more numerous and consists of four sanctuaries arranged in a square. The following characteristics of late 8th century to early 9th century architecture can be seen at both sites: a square brick tower with receding tiers and set on a platform with moulding; the shrine opens to the east with false doors on the other three sides; sandstone doorframes, columns and lintels with beautifully carved floral garlands extending above and below a horizontal band with mythical creatures at each end. The ubiquitous beast, a *kala*, occupies centre position on the lintel. Graceful *devatas* stand in niches. Remains testify that they were originally covered in stucco.

BACKGROUND

Roluos is the site of an ancient centre of Khmer civilisation known as Hariharalaya ('Abode of Hari-Hara'). Some 70 years after Jayavarman II established his capital on Mount Kulen in 802 inaugurating the Angkor Period, he moved the capital to Hariharalaya, perhaps for a better source of food or for defence purposes. Jayavarman II died at Roluos in 850. It is generally believed that his successors remained there until the capital was moved to Bakheng in 905.

ARCHITECTURE

The buildings of the Roluos group are distinguished by tall, square-shaped, brick towers on low pedestals. They open to the east, with false doors on the other three sides. As is typical of this period, the towers were built of brick with stucco facing; columns, lintels and decorative niches were of carved sandstone as were the sculptures set in them.

An enclosure wall originally surrounded the temples although only traces remain today. It was intersected on two or more sides by a *gopura*, an innovation of about this period (or perhaps slightly earlier). The early examples of *gopura* were square in plan with a tiered upper portion. The library also made its appearance at Roluos. It is a rectangular building with a vaulted roof and frontons. A temple often has two libraries, one on each side of the *gopura* preceding the central sanctuary.

DECORATION

The characteristic decorative features of the Roluos group are: a *kala* (monster head), the Hindu god Vishnu on his mount, *garuda*, female figures with abundant jewellery; and a preponderance of guardians and *apsaras*. Columns are generally octagonal and intricately adorned with delicate leaves. Decoration on the lintels at Roluos is, according to some art historians, the most beautiful of all Khmer art.

Andrew Dembina

APSARA research staff taking a rubbing of an inscription at Preah Ko temple.

PREAH KO: THE 'SACRED BULL'

Location: between Bakong and Lolei; on the western side of the road to Bakong
Access: enter and leave from the east
Date: late ninth century (879)
King: Indravarman I (reigned 877–889)
Religion: Hindu (dedicated to Shiva); funerary temple built for the king's parents, maternal grandparents, and a previous king, Jayavarman II and his wife
Art style: Preah Ko

LAYOUT

The tranquil setting and exquisite decoration of the Preah Ko towers warrant an unhurried visit. Originally square in plan and surrounded by three enclosure walls with *gopuras*, the complex seems small today because of the dilapidated state of the enclosures. The outer enclosure is 400 by 500 metres (1,312 by 1,640 feet) square with *gopuras* on the east and west sides. A small terrace (largely destroyed) (1) precedes the laterite *gopura* at the east. The sandstone pillars and windows of this *gopura* with thick balusters carved with rings, which give the appearance of being turned like wood, are still in place. The east and west wings lead to a laterite causeway that once stood at the axis of a moat.

Pass through the remains of the *gopura* and continue walking westward. Long halls or galleries parallel the middle enclosure wall, two each at the east and west, and one each at the northeast and southeast. Bases of these galleries are visible at the east. Straight ahead on the north and south sides of the walkway there are galleries with a porch opening to the east (mostly ruined) (5). An unusual, square, brick building stands between the long hall and the gallery at the south (6). It has a tiered upper portion and a porch opening to the west and is readily distinguished by a five-square grid of diamond-shaped holes (perhaps for ventilation) and a row of figures of ascetics in niches above the holes on the upper portion of the building. The function of this building is unknown, but one theory is that it was used as a crematorium.

Continuing along the walkway in an eastward direction and you come to a brick enclosure wall (7), which has two *gopuras* at the east and directly opposite on the west (8). They are simple in design with columns and lintels depicting Vishnu on a *garuda*. A step at the entrance in the shape of a moonstone is noteworthy for its graceful form. An important inscription describing the temple foundations was

Preah Ko

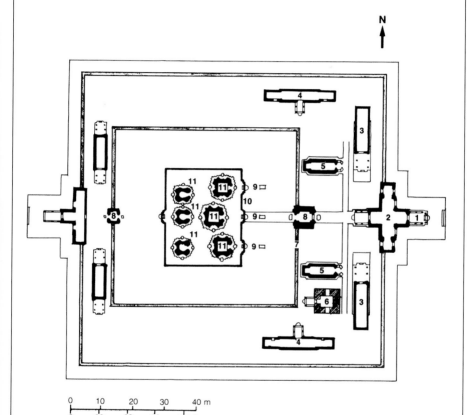

N

0 10 20 30 40 m
0 30 60 90 120 ft

1 Terrace
2 Entry tower
3 Base of gallery
4 Hall
5 Gallery
6 Square brick building
7 Building (sandstone)
8 Sanctuary tower
9 Building (gallery, porch)
10 Central sanctuary base
11 Central sanctuary

© Airphoto International Ltd.

found in the east *gopura,* which is in a dilapidated state leading through the inner enclosure wall.

As you approach the central area at the east you see the remains of three images of Nandi, the 'Happy One', a white bull and the mount of Shiva (9). Although only portions of the bulls remain you can discern their original position facing the temple and their crouching stance.

■ CENTRAL AREA

The central area consists of brick towers set towards the east in two rows on a low platform. The shrines of Preah Ko are built near ground level—a typical feature of Khmer temples that are dedicated to ancestors. A curious aspect of these towers is that they are not evenly spaced. In the back row, the north tower is closer to the central tower than the south one. One theory for this unusual arrangement suggests the two ancestors had a close relationship in their earthly lives.

Another deviation from symmetry is that the three towers at the east are larger than those at the west; the central one in the east is the largest and set slightly back from the other two. The central tower dominates the eastern row and the northwest tower stands out in the western row. All six towers have four recessed levels at the base.

Each tower contained an image or symbol of a Hindu god with whom the deceased was united. The three at the east honoured paternal ancestors of King Indravarman I and are identified by male guardians flanking the doorways, whereas the three at the west honoured his maternal ancestors and have female divinities on each side of the doorways. Three stairways at the east leading onto the raised temple platform are guarded by pairs of sandstone lions. The only other access to the central level is a single stairway on the west side.

The central towers are square in plan with a porch in each of the cardinal directions (11). Each of the six towers of the central group was covered with elaborate stucco. Large areas of the original material are still to be found on the towers. Each door frame is of a simple design and cut in four parts with mitred corners, similar to a typical carpentry joint. The decoration on the western towers is of inferior quality to those in the front row. A curious feature of the centre tower in the back row is that the false door is brick and coated with stucco, whereas the other false doors are of sandstone.

The carved decoration on the false, sandstone doors, lintels and columns of these towers is superb. As you approach the central area, pause to study the overall façades of the three shrines at the east, so beautifully united in design, yet different in decoration. The carving on the eastern towers is of better quality than that on the western ones.

The beautiful swags of hanging garlands, seen on the lower register of many lintels, are characteristic of the Preah Ko art style. Mythical monsters, such as the kala spewing garlands, are also typical. The *kala* is a recurring theme in the decoration at Preah Ko. Identified by a monster-like head without a lower jaw, the *kala* spews foliage from its mouth which extends to the north and south sides of the lintel, where it is held by a *makara,* another mythical monster. Some outstanding carving includes: the *garuda,* surmounted by a row of small heads, on the lintels of the central tower at the west; small horsemen and figures mounted on serpents above the doors of the northeast tower.

The columns are intricately decorated with designs combining leaf, floral and geometric elements and divided into registers by carved rings. The superb male guardians and female divinities standing in niches are finely carved and the colour of the grey sandstone contrasts dramatically with the surrounding coloured plaster and red brick background.

Above: *Relief, second level, southeast gallery, Bayon.*
Following pages: *Three of the six towers at Preah Ko, dedicated to ancestors of the king.*

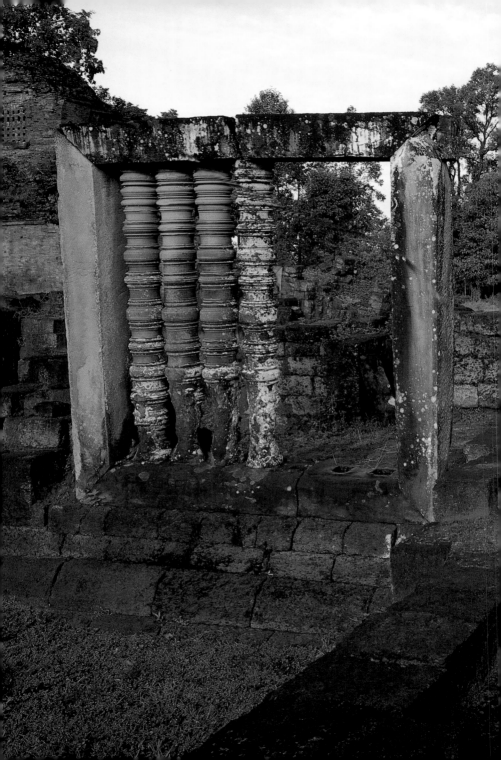

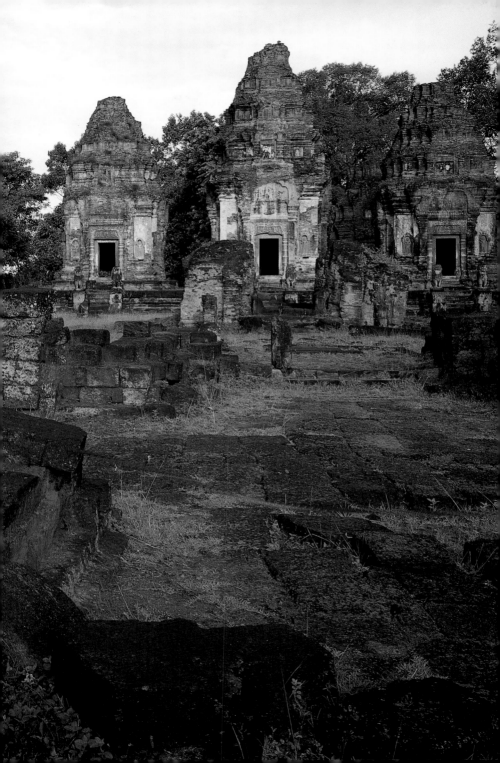

BAKONG

Location: south of Preah Ko
Access: enter and leave at the east, a modern Buddhist temple occupies the
 northeast section of the complex
Date: late ninth century (881)
King: Indravarman I (reigned 877–889)
Religion: Hindu (dedicated to Shiva)
Art style: Preah Ko

BACKGROUND

Bakong was the centre of the town of Hariharalaya, a name derived from the god Hari-Hara, a synthesis of Shiva and Vishnu. It is a temple-mountain symbolising the cosmic Mount Meru. Four levels leading to the central sanctuary extend the symbolism, and correspond to the worlds of mythical beings (*nagas, garudas, rakashas* and *yakshas*). The fifth and topmost level is reserved for the gods—the levels represent the five cosmic levels of Mount Meru. Bakong was probably the state temple of Indravarman I.

LAYOUT

The temple of Bakong is built as the first temple mountain on an artificial mound and is enclosed within two separate enclosure walls. The outer enclosure wall (not on the plan) measures 900 by 700 metres (2,953 by 2,297 feet). It surrounds a moat, and there are causeways on four sides, which are bordered by low *naga* balustrades. The inner and smaller enclosure wall (1) has a *gopura* (2) of sandstone and laterite in the centre of each side of the wall. After passing through the *gopura* at the east, follow the processional way (3) towards the central complex.

 Long halls (4) on each side lie parallel to the eastern wall. They were probably rest houses for visitors. Pairs of square-shaped, brick buildings at the northeast and southeast (5) corners are identified by rows of circular holes and a porch opening to the west. The vents in the chimneys suggest these buildings served as crematoriums. Originally, there were also buildings of this type, at the northwest and southwest corners, but today they are completely ruined. On each side of the processional way, just beyond the halls, there are two square structures with four doors (6). The inscription of the temple was found in the northern building.

Bakong was at the centre of the ancient settlement of Hariharalaya. (John Sanday)

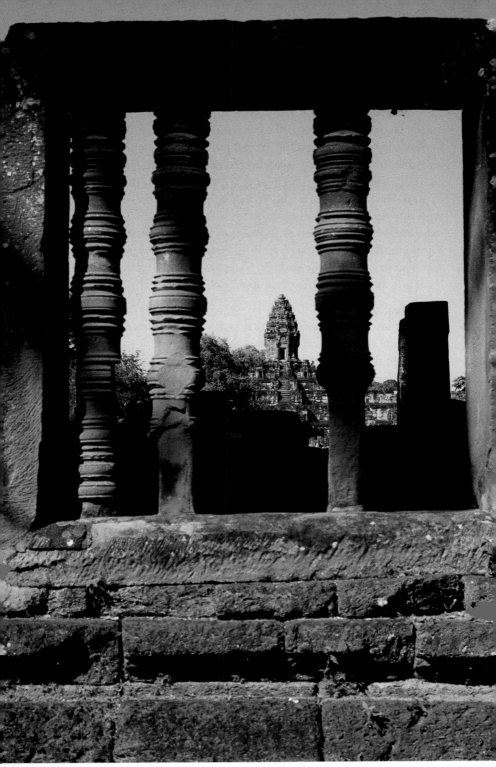

LOLEI

Location: north of the main road in the centre of the *baray*, close to a modern Buddhist temple

Access: a levee cuts across the now disused *baray* to the eastern landing platform. Enter and leave the temple by the stairs at the east

Date: end of the ninth century

King: Yasovarman I (reigned 889–910)

Religion: Hindu (dedicated to Shiva); in memory of the king's father

Art style: transitional between Preah Ko and Bakheng

BACKGROUND

Even though Lolei is in poor condition, the remaining carvings are exquisite and the inscriptions are some of the finest in the Roluos group. To appreciate the setting of this temple you must imagine that it was originally located in the centre of a great *baray*, the Indratataka and accessed by boat. According to an inscription found at the temple, the water in this *baray* was for use at the capital of Hariharalaya and for irrigating the plains in the area.

LAYOUT

The layout consists of a double platform rising originally from the *baray* surrounded by a laterite enclosure wall on all four sides. Lions on the landings of the stairways guard the temple. The four towers are set on a smaller brick platform. A sandstone cruciform channel situated at the centre of the four towers is an unusual feature. The channels extend to the cardinal directions from a square pedestal for a *linga*. It is speculated that holy water poured over the *linga* flowed in the channels.

■ CENTRAL TOWERS

The four brick towers appear randomly placed on a raised brick platform. As the two north towers are aligned on the east–west axis, it is possible that the original plan was for six towers which probably shared a common base like that at Preah Ko. Niches in the corners of the towers on the east shelter male guardians holding tridents and those of the west with female divinities wearing a beautiful long pleated garment and holding fly whisks. They are sculpted in sandstone. The panels of the false doors have multiple figures. The inscriptions on the door jambs of these towers are exceptionally fine.

The tiered upper potion of a brick tower at Lolei.

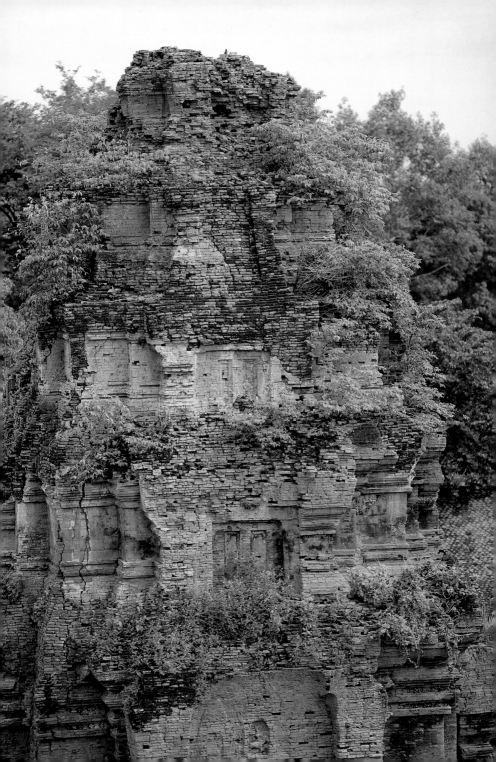

GROUP 6
PRASAT KRAVAN: THE 'CARDAMON SANCTUARY'

Location: east of Angkor Wat and south of Banteay Kdei
Access: drive off the road to the east and follow round to the east side
 Enter and leave the east
Date: first half of the tenth century (921)
King: completed during the reign of Harshavarman I (c 910–923);
 it may have been built by high court officials
Religion: Hindu (dedicated to Vishnu)
Art style: transitional from Bakheng to Koh Ker

BACKGROUND

The exceptional feature of this temple is remarkable carvings on the interior walls which stand alone as unique examples in Khmer art. The interiors of two of the five towers have carvings depicting Vishnu and his consort, Lakshmi; the scene in the central tower is the most impressive one, but both of them are exceptional in stature and quality of workmanship. This temple was reconstructed by the EFEO and given a new foundation, interior walls and drains. Much of the external brickwork was replaced with carefully made reproductions which are marked with the letters CA (Conservation d'Angkor).

LAYOUT

Prasat Kravan consists of five brick towers in a row on one platform, which are decorated with carved, sandstone lintels and octagonal columns. All of the towers open to the east.

■ CENTRAL TOWER

This is the only tower with intact recessed tiers, which are visible on the interior. This tower encloses a *linga* on a pedestal. An inscription on the door frame gives the date 921 for the erection of the statue of Vishnu on the interior. The east decoration on the exterior of the central tower is sculpted with male guardians in shallow niches and chevrons and framed figures on the pilasters. A frieze of small heads adorns the lintel.

The interior decoration of this tower depicts, on the south wall (to the left of the entrance), Vishnu standing below a beautiful arched frame depicting the legend of the dwarf who grows into a giant and takes three steps to span the universe and to assure the gods of the possession of the world. In his four arms he holds a disc, a ball,

a conch and a club. His left foot rests on a pedestal, whereas a lotus held by a female divinity emerging from the ocean (three wavy lines) supports his right foot . On the north wall (to the right of the entrance), Vishnu, holding the same four symbols, rides on the shoulders of his mount, *garuda*. They stand under a richly carved arched and are flanked by two seated praying figures. On the west wall (facing the entrance), Vishnu (with eight arms) and six tiers of attendants and an enormous reptile (perhaps a crocodile or lizard) across the top (difficult to distinguish).

■ NORTH TOWER

This tower was dedicated to Lakshmi, wife of Vishnu. On the south wall (to the left of the entrance). She is standing and holds in her four hands symbols of power—a discus, trident, elephant hook and a lotus; a praying figure kneels on each side of Lakshmi; the niche, with multiple lobes is extravagantly decorated with tassels and floral swags.

■ SOUTH TOWER

The walls on the interior have no decoration. A skilfully modelled lintel on the exterior depicts with Vishnu on his mount, a *garuda*.

Aerial view of Prasat Kravan. (Khin Po-Thai)

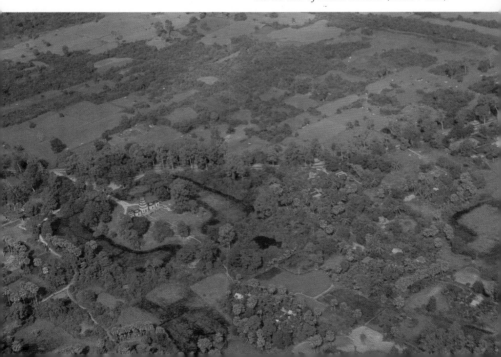

SRAH SRANG: 'ROYAL BATH'

It was, perhaps, a chapel to Kama, god of love. The spot would suit the temper of the strange power, terribly strong and yet terribly tender, of that passion which carries away kingdoms, empires, whole worlds, and inhabits also the humblest dwellings.... Love could occupy this quiet nest embedded in water...gave the impression that love had come one day and had left there, when he went away, a part of his spirit.[56]

Location: across the road from the east entrance of Banteay Kdei
Access: visit Srah Srang, east of the road
Date: end of the 12th century
King: Jayavarman VII (reigned 1181–1220)
Religion: Buddhist
Art style: Bayon

BACKGROUND

Srah Srang is a large tank (700 by 300 metres, 2,297 by 984 feet) with an elegant landing terrace of superb proportion and scale. It is a pleasant spot to sit and look out over the surrounding plain. Facing east, straight ahead, you can see the towers of Preah Rup. Srah Srang always has water

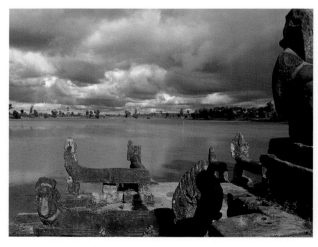

The elegant terrace with stairs at Srah Srang (The Royal Bath).

and is surrounded by greenery. According to one French archaeologist, it 'offers at the last rays of the day one of the most beautiful points to view the Park of Angkor'.

Right: *Worshippers still make offerings at many of Angkor's sites, such as this shrine at Prasat Kravan.*

LAYOUT

A majestic platform ('landing stage') with stairs leads to the pond. It is built of laterite with sandstone mouldings. The platform is of cruciform shape with serpent balustrades flanked by two lions. At the front there is an enormous garuda riding a three-headed serpent. At the back there is a mythical creature comprising a three-headed serpent, the lower portion of a *garuda* and a stylised tail decorated with small serpent heads. The body of the serpent rests on a dais supported by mythical monsters.

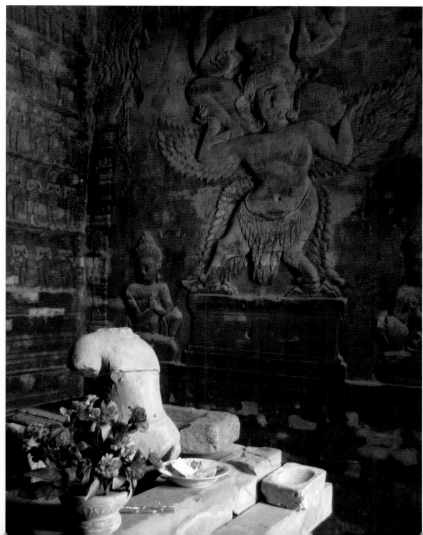

Andrew Dembina

BAT CHUM

Location: take the road south from Srah Srang for 500 metres (1,640 feet); turn left (east) onto a dirt road and continue for 750 metres (2,460 feet)
Access: enter and leave from the east
Date: mid-tenth century
Tip: this temple is beautiful in the morning when the sun shines on the east facade
King: Rajendravarman (reigned 944–968)
Religion: Buddhist
Art style: Pre Rup

BACKGROUND

Bat Chum is one of the earliest Buddhist monuments in Cambodia, although the layout is nearly identical to known Hindu temples. An inscription on the doorjamb of each of the three towers gives the date of dedication (960) and praises the builder. Interestingly, the name of the architect of the temple is given. An inscription also refers to a 'holy place', which is probably a rectangular reservoir located 300 metres (984 feet) from the east entrance of the temple.

LAYOUT

The ground plan comprises three square brick towers standing on a low platform with a stairway at the centre on the east. Superb seated stone lions flank the stairs. An enclosure wall with a *gopura* at the east and a moat surround the temple. The towers open to the east and each one has three false doors on the other sides.

The central tower (height: eight metres; 26 feet) has a sandstone doorframe and octagonal colonettes with bands and floral elements. The sandstone lintels at the east are decorated with the Hindu god, Indra, on his mount, the three-headed elephant flanked by two lions with their backs facing each other and a row of praying figures; another one a *kala*-like monster devouring an elephant holding a garland in its trunk;

The north tower has a well-preserved false door and a lintel with a complete plant-stem decoration ending in volutes 'ridden' by small figures.

BANTEAY KDEI: 'CITADEL OF THE CELLS'

In the ruin and confusion of Banteay Kdei the carvings take one's interest.
They are piquant, exquisite, not too frequent...they seem meant...to make
adorable a human habitation.[57]

Location: southeast of Ta Prohm
Access: enter and leave from the east
Date: middle of the 12th century to the beginning of the 13th century
King: Jayavarman VII (reigned 1181–1220)
Religion: Buddhist
Art style: at least two different art periods—Angkor Wat and Bayon—
are discernible

BACKGROUND

Banteay Kdei was built as a Buddhist monastic complex by Jayavarman VII and was undoubtedly an important temple. Today, however, it is difficult to perceive what Banteay Kdei might have looked like because of its dilapidated condition, due largely to faulty construction and the use of poor quality sandstone which has a tendency to crumble. Changes and additions carried out after the initial construction of the temple also account for its confused and unbalanced present-day layout.

Nevertheless, it is worth a visit as it has some good carving and is less crowded than other monuments of the same period. The temple is similar in art and architecture to Ta Prohm, but it is smaller and less complex. It is also not as overtaken by nature as Ta Prohm because it was occupied by monks over the centuries, except in the 1960s when it was inaccessible because it was inhabited by a herd of dangerous wild deer. It is unknown to whom this temple was dedicated as the inscription stone has never been found.

The Japanese Institute of Asian Cultures conservation team discovered 274 Buddha images in 2002, probably buried at the time of Hindu iconoclasm.

LAYOUT

According to archaeologists, the original basic plan of Banteay Kdei included a central sanctuary (5), a surrounding gallery (6) and a passageway connected to another gallery. A moat enclosed the temple. The outer enclosure (700 by 500 metres; 2,297 by 1,640 feet) is made of laterite (1) and has four *gopuras* in the Bayon style, each with four faces looking in the cardinal directions, and *garudas* placed at

the corners of each *gopura*, a favourite design of Jayavarman VII. These *gopuras* are of the same style as those at Ta Prohm.

A path leads from the east *gopura* to a grand rectangular terrace that is known as the Hall of the Dancing Girls, a name derived from the decoration, which includes a frieze of dancers (2). From this terrace you can see the moat that enclosed the temple. Walk across the terrace and continue westward. On the north side of the walkway you will see remains of large, thick pillars, which probably supported a building of wood. The pillars are similar although not round like those at Preah Khan.

The *gopura* of the second enclosure (3) is cruciform with three passages; the two on either end are connected to the laterite wall of the enclosure (4). The inner walls of the enclosure are decorated with scrolls of figures and female divinities in niches. In the interior court there is a frieze of Buddhas.

Continuing westward you reach the central area, which appears confused because many parts have collapsed and some of the halls and galleries are later additions. The central area is approached through a large entrance that was originally a tower, but has now collapsed. The tower was connected to a gallery with rows of pillars on each side. This arrangement of a tower with a gallery enclosed yet another gallery with four towers, one in each corner, the central sanctuary and a courtyard in a cruciform-shaped plan. Traces of carving are still visible in the central shrine.

The walls of the central sanctuary were probably covered, perhaps with metal. Two small sanctuaries, sometimes called libraries (7), open to the west in the courtyards on the left and right of the causeway.

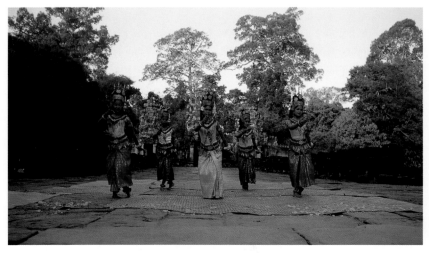

Dancers recreate the movements of mythical apsaras

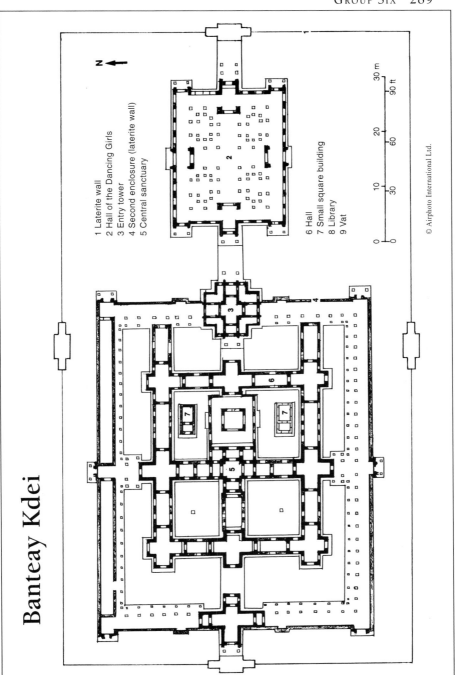

Banteay Kdei

N

1 Laterite wall
2 Hall of the Dancing Girls
3 Entry tower
4 Second enclosure (laterite wall)
5 Central sanctuary

6 Hall
7 Small square building
8 Library
9 Vat

0 10 20 30 m
0 30 60 90 ft

© Airphoto International Ltd.

KUTISVARA

Location: across the main road near the *gopura* of the north enclosure wall
at Banteay Kdei; walk 200 metres (656 feet) north, across several
rice fields

Access: enter and leave from the north

Date: early ninth–tenth century

King: Jayavarman II (reigned 802–850); Rajendravarman II
(reigned 944–968)

Religion: Hindu (dedicated to Shiva)

Art style: Preah Ko (central tower); Pre Rup (other two towers)

BACKGROUND

Kutisvara is the site of Kuti. It is mentioned in the Sdok Kok Thom stele (although
written at a later date) in connection with Jayavarman II, who reigned in the ninth
century. Another inscription on a stone found at the nearby temple of Banteay Kdei
mentions it in a tenth century context and the reign of Rajendravarman.

LAYOUT

Three sanctuary brick towers (broken) are aligned north and south and open to the
east. They stand on a small hill that was probably surrounded by a moat. The
doorframes, octagonal colonettes and lintels are of sandstone. The central tower is
raised on a laterite and brick platform preceded by a double stairway. It is approximately
3 metres (10 feet) square. A pedestal for a *linga* was found in the central tower. The
other two towers are slightly later in style and set on a laterite base. The lintels have
a small frieze across the top, scrolls of foliage and small figures. Brahma (four heads)
appears on the east lintel of the central tower. A lintel on the ground, which belongs
to the north tower, depicts the Churning of the Ocean of Milk.

PRE RUP: 'TURN' OR 'CHANGE, THE BODY'

'A work of great style and impeccable proportions,' wrote Maurice Glaize in his guidebook of 1963

Location: northeast of Srah Srang and 500 metres (1,640 feet) south of the East Baray

Access: enter and leave from the east

Tip: because the temple is built entirely of brick and laterite, the warm tones of these materials are best seen early in the morning or when the sun is setting. Two views from the top terrace are outstanding: first, looking east towards Phnom Bok and Phnom Kulen; and second, looking west, where the towers of Angkor Wat can be distinguished on the far horizon

Date: second half of the tenth century (961)

King: Rajendravarman II (reigned 944–968)

Religion: Hindu (dedicated to Shiva)

Art style: Pre Rup

BACKGROUND

Pre Rup was called the 'City of the East' by Philippe Stern, assistant curator at the Musée Guimet in Paris. The boldness of the architectural design is superb and gives the temple fine balance, scale and proportion. The temple is close in style to the East Mebon, although it was built several years later. It is a temple-mountain, symbolising Mount Meru.

The Cambodians have always regarded this temple as having funerary associations, but its true function is uncertain. Nevertheless, the name Pre Rup recalls one of the rituals of cremation, in which the silhouette of the body of the deceased, outlined with its ashes, is successively represented according to different orientations. Some archaeologists believe that the large vat located at the base of the east stairway to the central area (**9**) was used at cremations.

LAYOUT

Pre Rup dominates the vast plain which the East Baray irrigated. Constructed on an artificial mountain in laterite with brick towers, the plan is square and comprises two enclosure walls (**1** and **2**) with *gopuras* placed centrally in each wall. A platform of three narrow tiers (**3**) serves as a pedestal for five towers, which are set out in a quincunx—one in each corner and one in the centre (**4**). The outer enclosure wall is 127 by 116 metres (417 by 380 feet).

Pre Rup

N

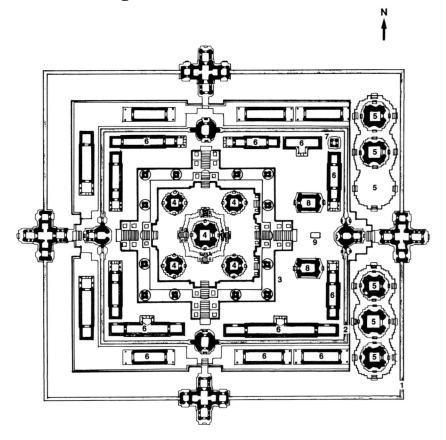

```
0    10    20    30    40 m
0    30    60    90   120 ft
```

1 Enclosure wall (laterite)
2 Enclosure wall (laterite)
3 Base with three tiers
4 Tower on upper platform
5 Group of three towers
6 Hall
7 Small square building
8 Library
9 Vat

© Airphoto International Ltd.

Within the outer laterite enclosure wall there are two groups of three towers on each side of the entrance (5); the groups share a common base. The middle tower in each of the two groups dominates and is more developed than the others. It appears that the first tower on the right of the entrance was never built or, if it was, its bricks were reused elsewhere. The most complete lintel is on the southernmost tower (east face) and it depicts Vishnu in his *avatara* form a man-lion.

The second enclosure wall (2), also built of laterite, has four small *gopuras*, one on each side. Long halls are placed between the two enclosure walls (6). The walls of these halls, which have sandstone porches, are built of laterite. In the courtyard, there are vestiges of long halls probably for use by pilgrims. They have sandstone pillars in the east and laterite walls and windows with balusters in the west. In the northeast corner there is a curious small square building (7) built of large blocks of laterite and open on all four sides. The inscription describing the foundation of the temple was found near this building.

■ LIBRARIES

On the left and right sides of the east *gopura* of the second enclosure there are libraries (8) with high towers. They sheltered carved stones with motifs of the nine planets and the seven ascetics. In the centre there is a vat (9) between two rows of sandstone pillars. Glaize suggested, as the temple was dedicated to Shiva, that rather than being a dias for a coffin this platform, it was more likely to have a been a base for a wooden structure or a platform for Shiva's mount Nandi.

■ CENTRAL AREA

The three-tiered platform (3, 4) can be approached by a stairway on all four sides. Pedestals flanking the stairways are adorned with seated lions. The first two tiers are built of laterite and have simple supporting walls with moulded bases and cornices. The third tier is built of sandstone, and there are two additional stairways on the east side guarded by lions. At the first level, 12 small shrines originally containing *linga* and opening to the east are evenly spaced around the platform.

The five central towers on the top platform are open to the east. All remaining doors are false and exquisitely carved in sandstone with figures and plant motifs. In the southwest tower there is a depiction of Brahmi, the consort of Brahma with four heads and four arms. On the west elevation of this tower there is a carving of a divinity with a boar's head. It is Varahi, the female counterpart of Varaha or Vishnu in his *avatara* form of a boar. Figures in the niches are surrounded by flying *apsaras*. The figures in the two west towers are female while those at the east and central towers are male.

PRASAT LEAK NEANG: 'TOWER OF THE HIDDEN MAIDEN'

Location: east of the northeast corner of Pre Rup
Access: walk along the path east of the main road for 100 metres (328 metres)
Date: 960
King: Rajendravarman II (reigned 944–968)
Religion: Hindu (dedicated to Shiva)
Art style: Pre Rup

BACKGROUND
Inscriptions on the doorjambs of the tower describe donations and identify the date of the temple as AD 960.

LAYOUT
A single square (4.5 metres; 14.8 feet each side) brick tower (leaning) with simple, yet elegant, moulding. It opens to the east with a sandstone doorframe and octagonal, decorated pillars and false doors in brick on the other three sides. The superstructure is composed of graduated tiers. Indra on a three-headed elephant is the central figure on the sandstone lintel above the east entrance; a row of small praying figures frames the upper edge of the lintel.

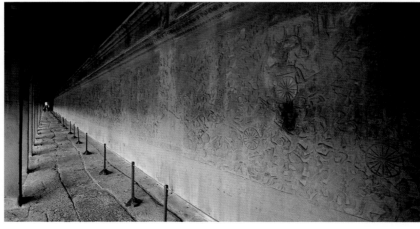

Galleries of intricately carved bas-reliefs encircle Angkor Wat.

Thomas Bauer

EAST MEBON

The lovely temple of Mebon, a pyramid of receding terraces on which are placed many detached edifices, the most effective being the five towers which crown the top. Could any conception be lovelier, a vast expanse of sky-tinted water as wetting for a perfectly ordered temple.[58]

Location: 500 metres (1,640 feet) northeast of Pre Rup
Access: enter and leave from the east
Date: second half of the tenth century (952)
King: Rajendravarman II (reigned 944–968)
Religion: Hindu (dedicated to Shiva); an ancestor temple in memory of the parents of the king
Art style: Preah Rup

BACKGROUND

The East Mebon and its neighbour Pre Rup were built by the same king, just nine years apart, and are similar in plan, construction and decoration. A major difference, however, is that the East Mebon once stood on a small island in the middle of the Eastern Baray, which was a large body of water (two by seven kilometres; 1.2 by 4.3 miles) fed by the Siem Reap River. The only access was by boat to one of the four landing-platforms, situated at the mid-points on each of the four sides of the temple.

Today, the *baray*, once a source of water for irrigation, is a plain of rice fields and the visitor is left to imagine the original majesty of this temple in the middle of a large lake. You can get some idea of what the view must have been like from walking around the top level. Archaeologists have estimated that the original *baray* was three metres (9.84 feet) deep with a volume of 40 million cubic metres of water. The decoration on the lintels at the Mebon is superior in quality of workmanship and composition to that of Pre Rup. The motifs on the false doors, with small mythical figures frolicking amongst foliage, are particularly fine.

LAYOUT

The East Mebon is a temple-mountain symbolising Mount Meru with five towers in quincunx atop a platform of three diminishing tiers. The whole is surrounded by three enclosure walls. Construction work in this temple complex utilises all the durable building materials known to the Khmers—laterite, brick, stucco and sandstone.

East Mebon

N

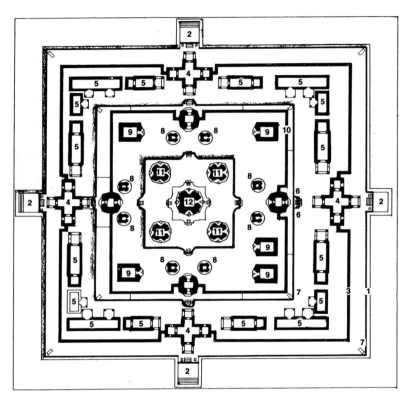

1 Outer enclosure wall
2 Terraced landing
3 Enclosure wall
4 Entry tower
5 Gallery
6 Lions
7 Elephants
8 Tower (brick)
9 Rectangular building (laterite)
10 Wall (sandstone)
11 Tower (upper terrace)
12 Central sanctuary

0 10 20 30 40 m
0 30 60 90 120 ft

© Airphoto International Ltd.

The outer enclosure wall (1) is identified by a terraced landing built of laterite with pairs of lions on all four sides (2). The interior of this wall is marked by a footpath. The middle enclosure wall has centrally placed cruciform *gopuras,* on all four sides (4). They have two doors with porches and are made of laterite and sandstone.

An inscription was found to the right of the east tower. A series of galleries built in laterite surround the interior of this enclosure wall (5). They were originally roofed in timber rafters but today only vestiges remain. These galleries probably served as halls for meditation. The stairways of the tiered base are flanked by lions (6). Beautifully sculpted two-metre (6.5 feet) high, monolithic elephants stand majestically at the corners of the first and second tiers (7). They are very realistic with details of their harnesses and other decoration. **Tip:** the elephant in the northwest corner is in the best condition.

■ GOPURAS

Lintels on the west *gopura* (4) depict Vishnu in his *avatara* form of Narasingha, half-man, half-lion, where he is disposing of the king of the demons by renting him apart (east face). The lintels of the northeast *gopura* show Lakshmi between two elephants which, with raised trunks, are sprinkling her with lustral water.

■ INNER COURTYARD

The large inner courtyard contains eight small brick towers (8)—two on each side —opening to the east. Each one has octagonal columns and finely worked lintels with figures amongst leaf decorations. On the east side of the courtyard there are three windowless, rectangular, laterite buildings (9) opening to the west. Vestiges of bricks above the cornices suggest they were vaulted. The two on the left of the entrance are decorated either with scenes of the stories of the nine planets or with the seven ascetics. Two more buildings, without windows, of similar form stand at the northwest and southwest (9) corners of the courtyard.

■ UPPER TERRACE

The terrace with the five towers isenclosed by a sandstone wall with moulding and decorated bases (10). Lions guard four steep flights of stairways to the top platform.

■ CENTRAL TOWERS

The five towers on the upper terrace were built of brick and open to the east; the remaining false doors on each of the towers are made of sandstone (11 and 12). Male guardians on the corners are finely modelled. Circular holes pierced in the brick, for the attachment of stucco, are visible. The false doors of the towers have fine decoration with an overall background pattern of interlacing small figures on a plant background.

■ **CENTRAL SANCTUARY: LINTELS ON THE TOWERS OF THE UPPER LEVEL**
East side: Indra on his mount, a three-headed elephant, with small horsemen on a branch; scrolls with mythical beasts spewing figures under a small frieze of worshippers; west side: Skanda, god of war, rides his peacock; south side: Shiva rides his sacred bull, Nandi.

■ **NORTHWEST CORNER TOWER**
East side: Ganesha is curiously riding his trunk, which is transformed into a mount.

■ **SOUTHEAST CORNER TOWER**
North side: the head of a monster is eating an elephant.

Below: *A view from the north of the west entrance of Ta Prohm.*
Right: *The west gopura, Ta Prohm.*

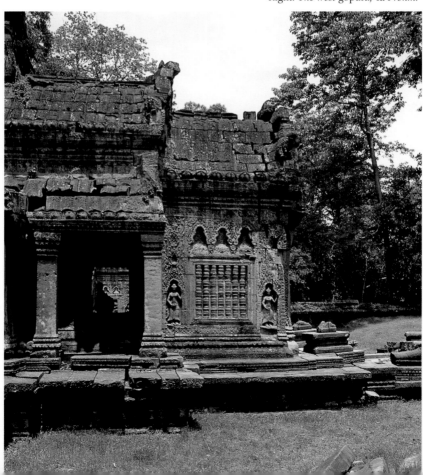

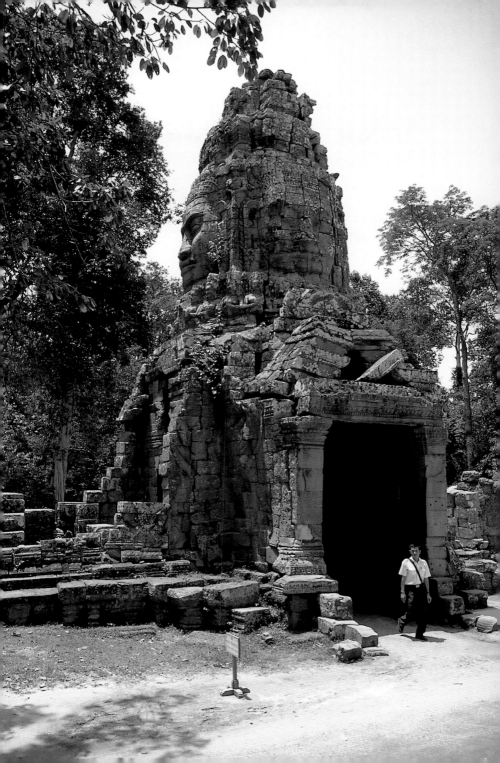

GROUP 7
TA PROHM: THE 'ANCESTOR BRAHMA'

Ta Prohm's state of ruin is a state of beauty which is investigated with delight and left with regret. But one can always come again. And one always does.[59]

Location: is located southeast of Ta Keo and east of Angkor Thom. Its outer enclosure wall is close to the northwest corner of Banteay Kdei

Access: arrange for your transport to take you to the east entrance of Ta Prohm and walk through the complex in sequence. Have your transport wait for you at the west entrance. As you leave the temple, you will pass the more popular west entrance, where refreshment stalls are located, as well as scores of children selling handicrafts

Date: mid-12th century to early 13th century (1186)

King: Jayavarman VII (reigned 1181–1220)

Religion: Buddhist (dedicated to the mother of the king)

Art style: Bayon

BACKGROUND

Ta Prohm was left untouched by archaeologists, except for the clearing of a path for visitors and structural strengthening to stave off further deterioration. Because of its natural state, it is possible to experience at this temple some of the wonder of the early explorers, when they came upon these monuments in the mid-19th century. Shrouded in jungle, the temple of Ta Prohm is ethereal in aspect and conjures a romantic aura. Fig, banyan and *kapok* trees twist and spread their gigantic roots over, under and in between the stones, probing walls and terraces apart, as their branches and leaves intertwine to form a roof above the structures.

'Everywhere around you, you see Nature in its dual role of destroyer and consoler; strangling on the one hand, and healing on the other; no sooner splitting the carved stones asunder than she dresses their wounds with cool, velvety mosses, and binds them with her most delicate tendrils; a conflict of moods so contradictory and feminine as to prove once more—if proof were needed—how well "Dame" Nature merits her feminine title!'[60]

Ta Prohm remains much the same as when the Europeans saw it in the late 19th century.

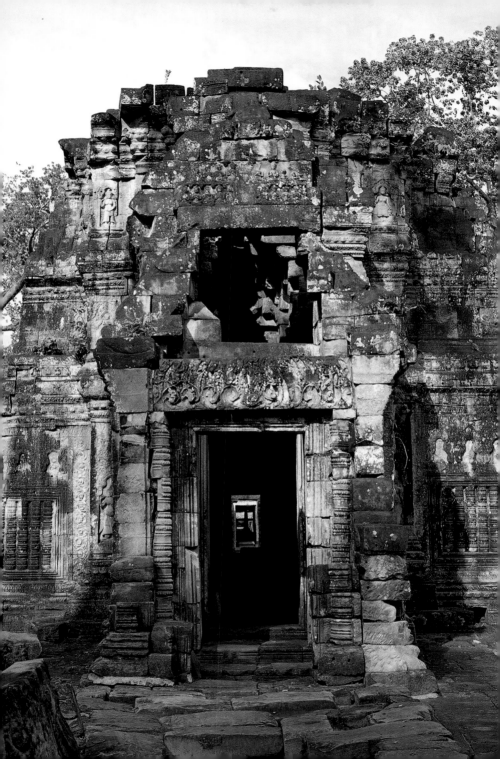

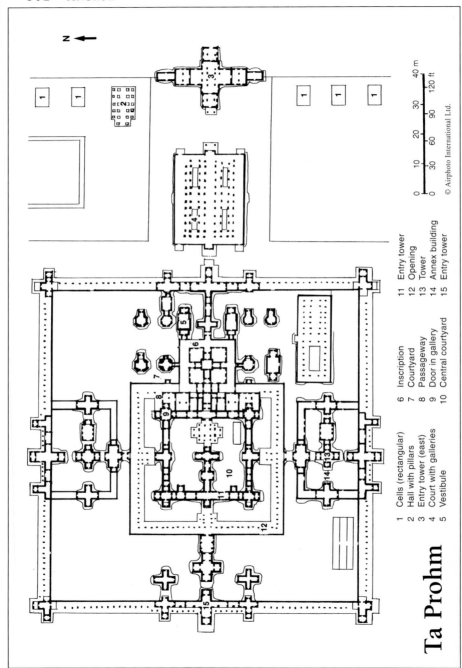

Ta Prohm

1 Cells (rectangular)
2 Hall with pillars
3 Entry tower (east)
4 Court with galleries
5 Vestibule

6 Inscription
7 Courtyard
8 Passageway
9 Door in gallery
10 Central courtyard

11 Entry tower
12 Opening
13 Tower
14 Annex building
15 Entry tower

© Airphoto International Ltd.

The monastic complex of Ta Prohm is one of the largest sites at Angkor. A Sanskrit inscription on stone, now removed to the Conservation d'Angkor, tells us something about its size and function. Ta Prohm owned 3,140 villages. It took 79,365 people to maintain the temple, including 18 high priests, 2,740 officials, 2,202 assistants and 615 dancers. Among the property belonging to the temple was a set of golden dishes weighing more than 500 kilograms (1,100 pounds), 35 diamonds, 40,620 pearls, 4,540 precious stones, 876 veils from China, 512 silk beds and 523 parasols.[61] Even considering that these numbers were probably exaggerated to glorify the king, Ta Prohm must have been an important and impressive monument.

LAYOUT

The monastic complex of Ta Prohm is a series of long, low buildings standing on one level connected with passages and concentric galleries framing the main sanctuary. A rectangular, laterite wall (700 by 1,000 metres, 2,297 by 3,281 feet) encloses the entire complex. While this is the layout determined by archaeologists it is not seen clearly today because of the poor condition of the temple and the invasion of the jungle. While this temple was originally built according to the symmetrical, repetitive plan that is a hallmark of Khmer architecture, Ta Prohm seems haphazard and some areas of the temple are impassable; others are accessible only by narrow covered passages and, of course, much of the temple's fascination lies in this disarray.

The east entrance is signalled by a *gopura* in the outer enclosure wall of the temple. Pass through it and follow the path from the east entrance walking westward. You come to a grand terrace paved in sandstone and slightly elevated, which precedes the east *gopura* of the enclosure wall which surrounds the temple proper (3). Pass through the *gopura* on the north side of the terrace but, before you enter, pause to look at the superb carving on the wall (to the left of the entrance) depicting an episode from the life of the Buddha when the Earth Goddess rises from underground. She wrings the water from her long black hair and it drowns the demon Mara and his army. Walk through the *gopura* and inside are rectangular cells paralleling the enclosure wall; and just north of the *gopura* is a sandstone hall, known as the Hall of the Dancers, distinguished by large square pillars (4).

Continue walking towards the west. In the central area you see a series of galleries and shrines, some of which are very close together. Female divinities stand gracefully in niches, often entwined with roots; and Buddhist scenes, sometimes hastily and other times finely carved, decorate the facades and frontons. A fine example of the

Following pages: Little has been done to restore Ta Prohm, except structural strengthening to stave off further deteoriation.

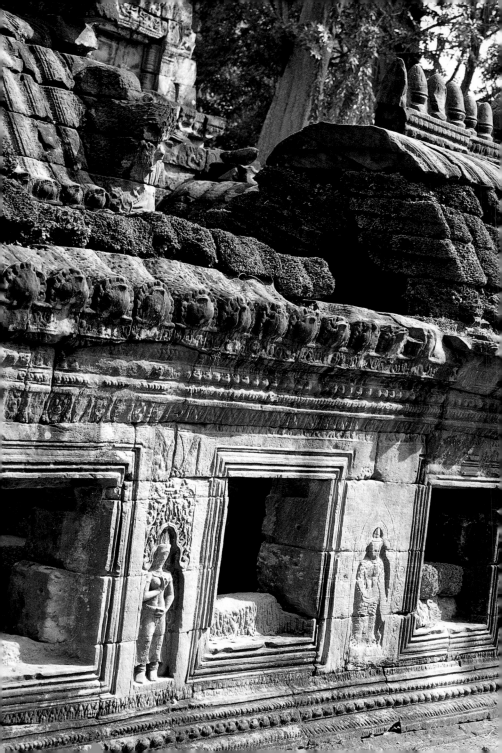

apsara motif is on the library in the north and south of the central galleries. A memorable aspect of this central courtyard is the many openings filled with foliage and framed by stone doorways or windows.

The central sanctuary itself is easy to miss and stands out because of its absence of decoration. The stone has been hammered, possibly to prepare it for covering with stucco and gilding, which has since fallen off. This accounts for the plainness of the walls of this important shrine. Evenly spaced holes on the inner walls of the central sanctuary suggest they were originally covered with metal sheets.

From this point, visiting Ta Prohm is really going wherever your instincts lead you, to enjoy the wonder of making new discoveries, of finding hidden passages or obstructed reliefs, of climbing over fallen stones, and of experiencing the harmony between man and nature. There are many pleasant spots to simply sit and enjoy the tranquil surroundings.

Continue walking westward and pass through a central cruciform-shaped gopura in the first enclosure wall. Next is a terrace with remains of stone sculpture scattered in the area, which must have been imposing figures when they were in place. A walkway flanked by a serpent balustrade leads to the west *gopura* providing access through the first enclosure wall surrounding the temple. The walk westward towards your transport is along a delightful shaded path through the jungle. The large cruciform-shaped east *gopura*, recognisable by a tower with four faces, looking towards each of the cardinal points marks the west entrance to Ta Prohm and leads you through the outer enclosure wall.

'So the temple is held in a stranglehold of trees. Stone and wood clasp each other in grim hostility; yet all is silent and still, without any visible movement to indicate their struggle—as if they were wrestlers suddenly petrifed, struck motionless in the middle of a fight. The rounds in this battle were not measured by minutes, but by centuries'.[62]

A porch at Ta Prohm.

LAYOUT

Ta Keo is a replica of Mount Meru with a rectangular plan and five square towers arranged in a quincunx, standing majestically on a finely moulded three-tiered pedestal that is 12 metres (39 feet) high. Two enclosure walls (1 and 2) with sandstone *gopuras* on four sides enclose the temple. Inscriptions on the pilasters of the east *gopura* describe the temple's foundation (3). The first two platforms are enclosed by a wall (lower platform) and by a narrow gallery (upper platform).

The east entrance to Ta Keo is marked by a causeway over a moat that is preceded by a pair of lions and a row of small lanterns defining the east processional way. The east *gopura* has a central opening with a tower that is flanked by two smaller gates. Long rectangular halls (4 and 6) on both levels probably sheltered pilgrims. Access to the halls was under a second terrace. It is enclosed completely by a sandstone gallery with inward facing windows. Two libraries on the east side of the platform open to the west.

■ CENTRAL AREA

The upper platform is square and stands on three diminishing tiers with stairways on each side. Most of the space on the upper level is occupied by the five towers, all unfinished, opening to the four cardinal points. The central sanctuary (8) dominates the layout. It is raised above the other towers and is given further importance by the development of porches. The interior of the central tower is undecorated, but this draws your attention to the size of the sandstone blocks raised to such a height. It overwhelms you as you wonder how the Khmers managed to manoeuvre these enormous stones into position.

The only temple without decoration at Angkor, having never been completed, Ta Keo.

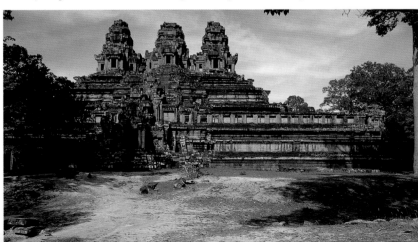

TA NEI

Location: north of Ta Keo; leave Angkor Thom from the Victory Gate and turn left (north) on the first dirt road (unmarked) after Ta Keo; turn on the first road; go to the end of the road where you will find the temple on the right of the road, approximately 800 metres (2,624 feet) away

Access: enter and leave from the southwest corner

Date: late 12th century

King: Jayavarmn VII (reigned 1181–1220) with additions by Indravarman II (reigned 1220–1243)

Religion: Buddhist

Art style: Bayon

BACKGROUND

Inscriptions on the door jambs name the founders of the temple. APSARA, the governing body for the monuments at Angkor, has built a field office to the west of this site and some conservation measures are being tested at Ta Nei.

LAYOUT

Ta Nei consists of three enclosure walls, a central sanctuary, annexes and basins to the north and south of the temple. A laterite enclosure wall with three sandstone *gopuras* at the east that is part of an enclosed gallery is the main entrance, although there were originally three enclosures. The eastern pediment of the central *gopura* depicts Lokeshvara standing on a lotus with *apsaras* around him. Above, unusual kneeling images with distended stomachs; perhaps they are praying to be cured.

Long, narrow basins (length: 123 metres; 403 feet) along the north and south sides inside lie between two of these walls. The *gopuras* in the other directions were additions made by Jayavarman VII's successor, Indravarman II. Cruciform sandstone towers with two upper tiers stand at the four corners of the laterite gallery with sandstone ridges.

The inner court consists of a central, cruciform sanctuary with a porch in each cardinal direction standing on a sandstone base; a library of brick and sandstone opening to the west (collapsed) and situated at the south. Motifs on the walls of the central tower are typical of the period with *devatas* standing in niches and windows with balusters carved into them.

CHAPEL OF THE HOSPITAL

Location: west of Ta Keo
Access: follow the footpath a few metres off the main road to the west;
enter and leave from the east
Date: end of the 12th century
King: Jayavarman VII (reigned 1181–1220)
Religion: Buddhist
Art style: Bayon

BACKGROUND

An inscription found in the area identifies this site as one of the chapels of the 102 hospitals built by the king.

LAYOUT

Traces of a cruciform-shaped *gopura* of sandstone and laterite situated at the east remain. A short walkway precedes the single tower. The central sanctuary is cruciform-shaped opening to the east with false door on the other three sides. Female divinities adorn the exterior and a scroll surrounds the base of the tower. The pediments are decorated with images of the Buddha.

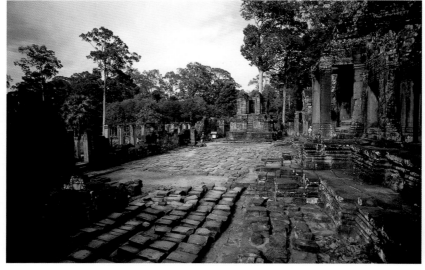

Thomas Bauer

Northeast courtyard and northern library, Bayon.

SPEAN THMA: 'BRIDGE OF STONE'

Location: 100 metres (330 feet) west of Ta Keo
Access: located in a bend of the Siem Reap River on the west side of the
bridge on the road between Thommanon and Ta Keo; walk from
the side of the road and down the path to the bank of the Siem
Reap River.

BACKGROUND

Spean Thma is a bridge constructed of reused blocks of sandstone of varying shapes
and sizes, which suggests it was built to replace an earlier bridge. The orientation of
the bridge seems odd today because the course of the river has changed, probably due
to the erosion of the river bed. The river has meandered to the east (parallel to the
old bridge) and, then, turns sharply to the south again. Notice the great difference
in the former and present levels of the river bed. This is probably one of the reasons
for the dry *barays,* as the Siem Reap River was one of several to provide water to the
irrigation system. The river now flows along the right side of the bridge instead of
under its arches.

LAYOUT

The bridge is supported on massive pillars, the openings between them spanned by
narrow corbelled arches.

A pond at Banteay Srei.

CHAU SAY TEVODA

Location: east of the Gate of Victory of Angkor Thom, a short distance across the road south from Thommanon

Access: enter and leave by the north

Date: end of the 11th–first half of the 12th century

King: Suryavarman II (reigned 1113–1150)

Religion: Hindu

Art style: Angkor Wat

BACKGROUND

Chau Say Tevoda and Thommanon are two small monuments framed by the jungle, that stand across the road from each other and are similar in plan. Although the exact dates of these monuments are unknown, they belong stylistically to the period of classic art (12th century) and represent two variations of a single theme of composition.

LAYOUT

Rectangular in plan, Chau Say Tevoda, with a central sanctuary opening to the east and an enclosure wall with four *gopuras*, originally provided central access points through the walls. Two libraries open to the west occupy spaces in the northeast and southeast corners. Walking towards the temple you can see traces of a moat and vestiges of the laterite enclosure wall.

Chau Say Tevoda during major restoration by a team from China.

Andrew Dembina

■ GOPURAS

Traces of their platforms and stairways of the gopuras remain. A raised causeway at the east (3) on three rows of octagonal supports (added at a later date) and a terrace link the east *gopura* to the nearby Siem Reap River.

■ CENTRAL SANCTUARY

Walk around the central sanctuary and notice the detailed carving on the exterior and the finely carved female divinities in the corner niches. A rectangular room with a porch (4) precedes the central sanctuary (5) and connects it with the east *gopura* by a passage raised on three rows of columns. The exterior wall of this long room is covered with a floral pattern inscribed in squares and sculpted with stone flowers similar to those at Banteay Srei and the Baphuon. The three false doors of the central sanctuary are decorated with foliage, while the columns have floral diamond-shaped patterns; human figures accentuate some of the bands of foliage on the columns.

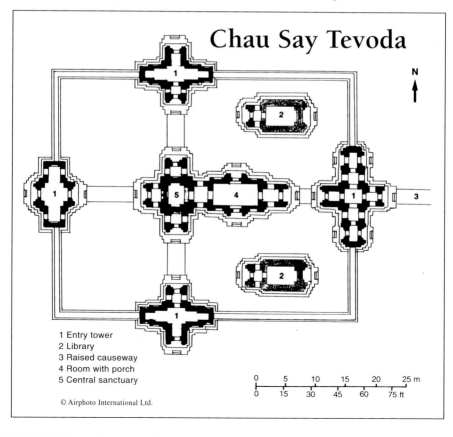

Chau Say Tevoda

N

1 Entry tower
2 Library
3 Raised causeway
4 Room with porch
5 Central sanctuary

© Airphoto International Ltd.

0 5 10 15 20 25 m
0 15 30 45 60 75 ft

THOMMANON

Location: east of the Gate of Victory of Angkor Thom, a short distance
(north) across the road from Chau Say Tevoda
Access: enter and leave at the south.
Date: end of the 11th–first half of the 12th century
King: Suryavarman II (reigned 1113–1150)
Religion: Hindu
Art style: Angkor Wat

BACKGROUND

In the 1960s, an extensive programme of anastylosis was undertaken at Thommanon by the EFEO, hence its sound condition today.

LAYOUT

Thommanon is rectangular in plan with a sanctuary (1) opening to the east, a moat and an enclosure wall with two *gopuras*, one on the east and another on the west (2), and one library (3) near the southeast side of the wall. Only traces of a laterite base of the wall remain.

■ CENTRAL SANCTUARY

The base of the tower is finely modelled and decorated; the foliage of the middle band has raised figures. There are four porches, one on each side of the central tower. The decoration on the three false doors of these porches is exceptionally delicate. Also notice the highly stylised, yet exquisite, female divinities. The east lintel depicts Vishnu on *garuda*. A porch with tiers on the east *gopura* connects with a long hall (4). The fronton above the south door is in poor condition, but it depicts Ravana (with multiple heads and arms) shaking the mountain where Shiva is enthroned. Over the doorway towards the adjoining vestibule, a fronton depicts the death of Vali after his battle against Sugriva.

■ EAST GOPURA

This *gopura* is linked by a common platform to the long hall. The entrance has three openings and bays that have been walled up. The centre has four porches, and at the west is a portico in front of a porch. Cylindrical vaulting can be seen on one recessed level. The north fronton depicts Vishnu felling two of his enemies, one of whom he holds by the hair.

■ LIBRARY

The library has elongated windows with balusters that have been walled up. The interior is paved with laterite. The library opens to the west with a small porch and two windows; there is a false door on the east side.

■ WEST GOPURA

The *gopura* has a central gate and is flanked by two wings with windows. The building shows absolute purity of lines in its architecture, and great care has been taken with the decoration. The west fronton depicts Vishnu on *garuda* battling against the demons. The columns and the base are ornamented with human figures; the false tiles on the end of the vaults represent lions.

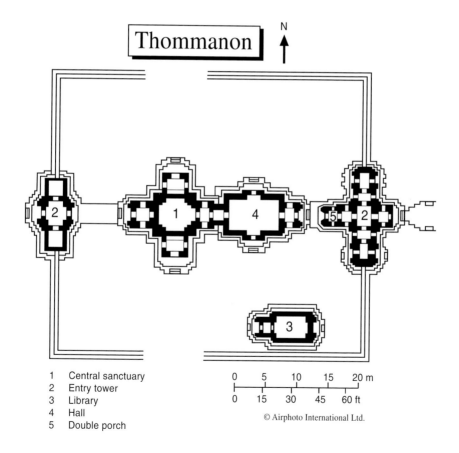

Thommanon N ↑

1	Central sanctuary
2	Entry tower
3	Library
4	Hall
5	Double porch

0 5 10 15 20 m
0 15 30 45 60 ft

© Airphoto International Ltd.

BAKSEI CHAMKRONG:
THE 'BIRD WHO SHELTERS UNDER ITS WINGS'

This little temple with its four square tiers of laterite, crowned by a brick sanctuary, might serve for a model in miniature of some of its giant neighbours, and is almost as perfect as the day it was built...[64]

Location: north of Phnom Bakheng, and on the west of the road leading to the south gate of Angkor Thom

Access: a visit to Baksei Chamkrong can be combined with a stop at the south gate of Angkor Thom. Enter and leave the temple from the east entrance.

Tip: the architecture and decoration of this temple can be viewed by walking around it (in a clockwise direction). The stairs are in poor condition; if you want to climb to the top use either the north or south stairway

Date: mid-10th century (947)

King: perhaps begun by Harshavarman I (reigned 910–944) and completed by Rajendravarman II (reigned 944–968)

Religion: Hindu (dedicated to Shiva); may have been a funerary temple for the parents of the king

Art style: transitional between Bakheng and Koh Ker

BACKGROUND

The name of the temple derives from a legend in which the king fled during an attack on Angkor and was saved from being caught by the enemy when a large bird swooped down and spread its wings to shelter him. Baksei Chamkrong was the first temple-mountain at Angkor built entirely of durable materials—brick and laterite with sandstone decoration. It is situated near the foot of Phnom Bakheng, but it need not be overshadowed by that great temple-mountain because, even though it is small, the balanced proportions and scale of this monument are noteworthy and elevate it to masterpiece status. An inscription on the doorjamb reveals the date of the temple and mention a golden image of Shiva and the mythical founders of the Khmer civilisation.

LAYOUT

Baksei Chamkrong is a simple plan with a single tower on top of a square, four-tiered laterite platform(1–4) of diminishing sizes (27 metres, 89 feet, a side at the base, and 12 metres, 39 feet, high). Three levels of the base are undecorated, but the top platform has horizontal mouldings around it that sets off the sanctuary. Steep staircases on each side lead to the sanctuary. Originally, a brick enclosure wall (5) with a *gopura* to the east enclosed the temple. Some vestiges are still visible on the east side of the temple.

Baksei Chamkrong

1 First tier of the base
2 Second tier
3 Third tier
4 Fourth tier

5 Wall (brick)
6 Entry tower
7 Central sanctuary

© Airphoto International Ltd.

■ **CENTRAL SANCTUARY (7)**
The square, central brick tower stands on a sandstone base. The fine jointing of the brickwork is noteworthy. It has one door opening to the east with three false doors on the other sides, which are in remarkably good condition. A vertical panel in the centre of each false door contains motifs of foliage on stems. As is typical of tenth-century Khmer architecture, the columns and lintels are made of sandstone and decorated in a motif that imitates wood carving. An outline of female divinities can be seen in the bricks at the corners of the tower.

Unfortunately, the stucco that once adorned this temple has disappeared, although the holes where it would have been attached are visible. Most of the lintels are in poor condition, but, on the east, Indra riding a three-headed elephant is still recognisable and is finely carved. The interior of the tower has a sunken floor and a corbelled vault.

PRASAT BEI: THE 'THREE TOWERS'

Location: northwest of Baksei Chamkrong; on the west side of the main road leading to the south gate of Angkor Thom; 300 metres (984 feet) to the west along a footpath

Access: enter and leave from the east

Tip: after visiting Baksei Chamkrong, walk through the jungle towards the north to see Prasat Bei and Thma Bay Kaek; then follow the path that parallels the moat of the Royal City of Angkor Thom, admiring the causeway leading to the South Gate

Date: tenth century

King: Yasovarman I (reigned 889–910)

Religion: Hindu (dedicated to Shiva)

Art style: Bakheng

BACKGROUND

Prasat Bei was built by the king who moved the capital from Harihalaya (Roluos) to Angkor and built Bakheng as his state temple and constructed the East Baray. The temple was never completed and some restoration was carried out by the EFEO in the 1960s.

LAYOUT

Three brick towers aligned north-south and open to the east stand on a laterite and sandstone platform (24 x 10 metres; 78 x 32 feet). The northern tower was never finished and the superstructure of the southern tower is missing.

The central tower is square with a height of ten metres (33 feet) and opens to the east with a sandstone doorframe and two octagonal pillars decorated with rings and foliage. The other three sides are sandstone false doors with pilasters. Indra on his mount, the three-headed elephant, is the central figure on the east lintel.

THMA BAY KAEK: 'CROW'S RICE STONE'

Location: Located between the south moat of Angkor Thom and Baksei
Chamkrong, to the north of this last monument; 125 metres (410
feet) west of the road
Access: enter and exit from the east
Date: tenth century
King: Yasovarman I (reigned 893–c. 900)
Religion: Hindu, dedicated to Shiva
Art style: Bakheng

BACKGROUND

Little remains of this site, but the area is pleasant to stroll in and a visit can be
combined with Prasat Bei. A sacred deposit of five gold leaves was found under the
paving of the central sanctuary. The larger central leaf was engraved with the outline
of a standing bull, the mount of Shiva.

LAYOUT

Originally, Thma Bay Kaek was a single square brick tower oriented to the east and
preceded at the east by a tiered laterite terrace probably covered with a thin sandstone
paving. Today only the sandstone doorframe and lintel with a *garuda* and ornamental
branches remain. A *yoni* with sandstone *linga* is on the platform.

Sandstone blocks lie waiting to be put back into place during restoration, Baphuon.

Thomas Bauer

PHNOM BAKHENG

It is a testimony to the love of symmetry and balance which evolved its style...in pure simplicity of rectangles its beauty is achieved. It is a pyramid mounting in terraces, five of them....Below Bak-Keng lies all the world of mystery, the world of the Khmer, more mysterious than ever under its cover of impenetrable verdure.[65]

Location: 1,300 metres (4,265 feet) northwest of Angkor Wat and 400 metres (1,312 feet) south of Angkor Thom

Access: in the 1960s this summit was approached by elephant and, according to one French visitor, the ascent was 'a classic promenade and very agreeable'. Following this route, a shaded path that winds its way up the hill, is the easiest way to the top and takes approximately 15 to 20 minutes. You can also hire an elephant and *mouhot* to ride along this path up the hill. Alternatively, you can climb the hill by a steep path with some steps on the east side of the monument (height 67 metres, 220 feet)

Tip: the best times to visit are in the morning or at sunset. On a clear day from the upper platform of Bakheng it is possible to see: the five towers of Angkor Wat, Phnom Krom to the southwest near the Great Lake, Phnom Bok in the northeast, Phnom Kulen in the east, and the West Baray. This view should not be missed.

Date: late ninth to early tenth century

King: Yasovarman I (reigned 889–910)

Religion: Hindu (dedicated to Shiva)

Art style: Bakheng

BACKGROUND

Soon after Yasovarman became king in 889 AD, he decided to move the capital northwest from Roluos, where his predecessor reigned, to the area known today as Angkor. He named his new capital Yasodharapura, and built Bakheng as his state temple. Thus, Bakheng is sometimes called the 'first Angkor'. The original city, which is barely distinguishable to visitors today, was vast, even larger than Angkor Thom. A square wall, each side of which is four kilometres (2.5 miles) long, surrounded the city, enclosing an area of some 16 square kilometres (six square miles). A natural hill in the centre distinguished the site.

'It is difficult to believe, at first, that the steep stone cliff ahead of you is, for once, a natural feature of the landscape, and not one of those mountains of masonry to which Angkor so soon accustoms you...the feat of building a flight of wide stone steps up each of its four sides, and a huge temple on the top, is a feat superhuman enough to tax the credulity of the ordinary mortal.'[66]

The temple of Bakheng was cut from the rock that formed the natural hill and faced with sandstone. Traces of this method are visible in the northeast and southeast

Phnom Bakheng

1 First tier of the base
2 Second tier
3 Third tier
4 Fourth tier
5 Fifth tier

6–9 Towers on the top level
10 Central sanctuary
11 Tower (brick)
12 Tower around base

```
0    10   20   30   40 m
|----|----|----|----|
0    30   60   90  120 ft
```

N

© Airphoto International Ltd.

corners, reflecting improved construction techniques and the use of more durable materials. This temple is the earliest example of the quincunx plan with five sandstone sanctuaries built on the top level of a tiered base, which became popular later. It is also the first appearance of secondary shrines on different platform levels.

SYMBOLISM

Bakheng was a replica of Mount Meru and the number of towers suggests a cosmic symbolism. The seven levels (ground, five tiers, upper terrace) of the monument represent the seven heavens of Indra in Hindu mythology. The temple must have been a spectacular site in its entirety because originally 108 towers were evenly spaced around the tiers with yet another one, the central sanctuary, at the apex of them all. Today, however, most of these towers have collapsed. Besides the central sanctuary, there were four towers on the upper terrace, 12 on each of the five levels of the platform, and another 44 towers around the base (12). The brick towers on the different levels represent the 12-year cycle of the animal zodiac. It is also possible that the numerology of the 108 towers symbolises the four lunar phases with 27 days in each phase. The arrangement allows for only 33 of the towers to be seen from each side, a figure that corresponds with the number of Hindu deities.

LAYOUT

'Every haunted corner of Angkor shares in the general mystery of the Khmers. And here the shadows seem to lie a little deeper, for this hill is like nothing else in the district.'[67] At the top of the hill, Phnom Bakheng is set on a tiered platform of five levels. The temple consisting of five towers in quincunx is located on the top most platform. The platform is square and each side measures 76 metres (249 feet) long and its total height is 13 metres (43 feet). There are stairways of a very steep gradient on all four sides. Seated lions flank the steps at each of the five levels.

There are vestiges of a laterite enclosure wall with *gopuras* surrounding the complex. Beyond there is a small building to the north with sandstone pillars in which there are two *lingas*. Continuing towards the top, you come to a modern footprint of the Buddha in the centre of the path. This is enclosed in a cement basin and covered with a wooden roof. Closer to the top, remains of a *gopura* in the enclosure wall around the temple complex are visible. Two libraries opening only to the west on either side of the path are identified by rows of diamond-shaped holes in the walls; the doors on the east are modern additions.

■ TOP LEVEL

When Henri Mouhot stood at this point in 1859, he wrote in his diary: 'Steps...lead to the top of the mountain, whence is to be enjoyed a view so beautiful and extensive, that it is not surprising that these people, who have shown so much taste in their buildings, should have chosen it for a site.'[68] Five towers are arranged in quincunx. The central tower once contained the linga to which the temple was dedicated. There are openings to all four cardinal points. The remaining four sanctuaries also sheltered lingas on pedestals and are open on two sides.

The central sanctuary (**10**) is decorated with female divinities set in niches at the corners of the temple which have delicately carved bands of foliage above; the pilasters are finely worked and have raised interlacings of figurines. The *makaras* on the tympanums are lively and strongly executed. The decoration above the doors is well-preserved showing a panel of foliated cusps with the heads of 33 gods. An inscription is visible on the west side of the north door of the central sanctuary. The evenly spaced holes in the paving near the east side of the central sanctuary probably held wooden posts which supported a roof.

Dancers emulate mythical apsaras *at Preah Khan.*

GROUP 8
BANTEAY SREI: 'CITADEL OF THE WOMEN'

Banteai Srei...is an exquisite miniature; a fairy palace in the heart of an immense and mysterious forest; the very thing that Grimm delighted to imagine, and that every child's heart has yearned after, but which maturer years has sadly proved too lovely to be true. And here it is, in the Cambodian forest at Banteai Srei, carved not out of the stuff that dreams are made of, but of solid sandstone.[69]

Location: 25 kilometres (15.5 miles) northeast of East Mebon

Access: this site warrants as much time as your schedule allows. The roads have been recently repaired and it takes 30–45 minutes from Siem Reap to get to the temple. To reach Banteay Srei, follow the main road north out of Siem Reap, turn right at the south side of the moat at Angkor Wat; follow the road to Srah Srang and Pre Rup; turn right at the road before the East Mebon; pass through the village of Phoum Pradak, where there is a junction (if you continue straight, after about five minutes, you will reach Banteay Samre). Turn right and continue on the road north until you come to a fork; take the road on the left and follow it to Banteay Srei which you will reach shortly after crossing a river—on your left-hand side; enter and leave at the east

Date: second half of the 10th century (967)

King: Rajendravarman II (reigned 944–968) and Jayavarman V (reigned 968–1001)

Religion: Hindu (dedicated to Shiva)

Art style: Banteay Srei

BACKGROUND

The enchanting temple of Banteay Srei is nearly everyone's favourite site. The special charm of this temple lies in its remarkable state of preservation, small size and excellence of intricate decoration. The unanimous opinion amongst French archaeologists who worked at Angkor is that Banteay Srei is a 'precious gem' and a 'jewel in Khmer art'. Banteay Srei, as it is known by locals, was originally called Isvarapura, according to inscriptions. It was built by a brahmin of royal descent who

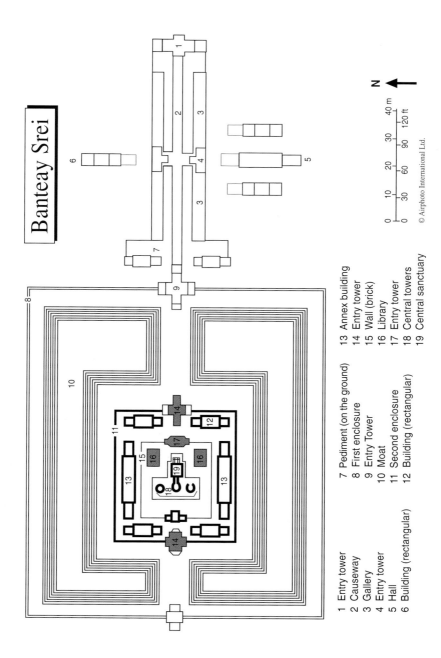

Banteay Srei

N

0 10 20 30 40 m
0 30 60 90 120 ft

© Airphoto International Ltd.

1 Entry tower
2 Causeway
3 Gallery
4 Entry tower
5 Hall
6 Building (rectangular)
7 Pediment (on the ground)
8 First enclosure
9 Entry Tower
10 Moat
11 Second enclosure
12 Building (rectangular)
13 Annex building
14 Entry tower
15 Wall (brick)
16 Library
17 Entry tower
18 Central towers
19 Central sanctuary

was spiritual teacher to Jayavarman V. Some describe it as being closer in architecture and decoration to Indian models than any other temple at Angkor. A special feature of the exquisite decoration was the use of a hard pink sandstone (quartz arenite) which enabled the 'technique of sandalwood carving with even an Indian scent to it'.

Architectural and decorative features of Banteay Srei are unique and exceptionally fine. A tapestry-like background of foliage covers the walls of the structures in the central group as if a deliberate attempt had been made to leave no space undecorated. The architecture is distinguished by triple superimposed frontons with relief narrative scenes carved in the tympanums, terminal motifs on the frames of the arches, and standing figures in the niches. Panels are decorated with scenes inspired by Indian epics, especially the *Ramayana* and its execution has a liveliness not seen in the more formal decoration of earlier temples.

The temple was discovered by the French in 1914, but the site was not cleared until 1924. The theft of several important pieces of sculpture and lintels by a European expedition, meticulously planned by the young Frenchman, Malraux, caused a great scandal in 1923, but hastened the archaeological work. The thieves were held under house arrest in Phnom Penh and only released after the return of the stolen pieces.

Banteay Srei is the first temple at Angkor to have been completely restored by the process of anastylosis, after the EFEO studied this method at Borobudur on the island of Java in Indonesia. Compared to the rest of Angkor this temple is in miniature. The doors of the central towers are narrow and barely one-and-a-half metres (five feet) in height. The quality of architecture and decoration make up for any shortcomings in size. As Maurice Glaize wrote, Banteay Srei is 'a sort of "caprice" where the detail, of an abundance and incomparable prettiness, sweeps away the mass'.[70] The inscription relating to the foundation of Banteay Srei was discovered in 1936 in the easternmost *gopura* of the outer enclosure wall.

LAYOUT

Banteay Srei is rectangular in plan and enclosed by three enclosure walls and a moat. Only two of the enclosure walls are visible. Enter the temple from the east and walk through the cruciform laterite *gopura* on the principle east-west axis of the temple at the axis of the enclosure wall (1). The sandstone pillars and a fronton depicting Indra on a three-headed elephant on the east porch of the *gopura* give a hint of the warm colour of the stone and the exquisite decoration to come.

> *Banteay Srei's pink sandstone was carved with some of the finest decorative work at Angkor. (John Sanday)*

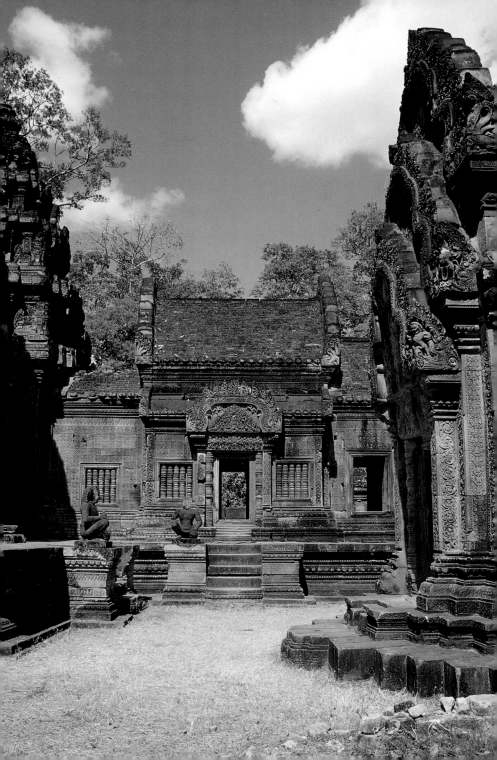

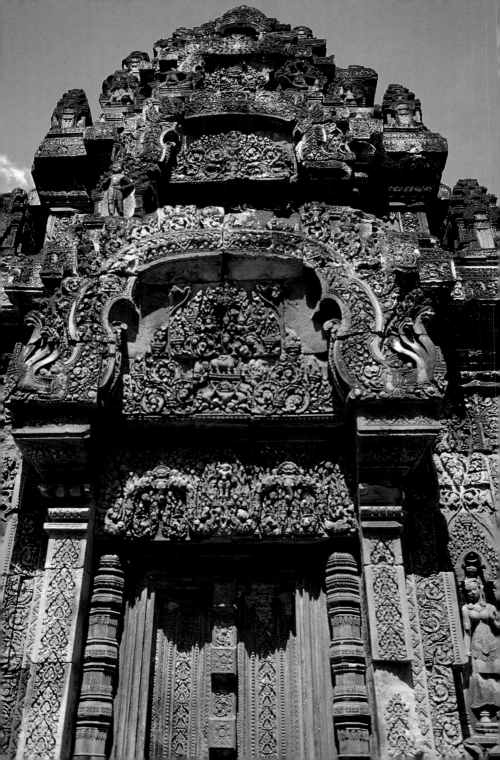

After walking through the east *gopura* you will be on the processional way (2) with decorative sandstone markers. Long pillared galleries overlook the processional way. They are built with laterite walls and sandstone pillars, in the middle of which are small *gopuras* (4). Behind the galleries to the south are three long, parallel halls, which are oriented north to south (5). On the north side there is a single building ((6) with a superb fronton of Vishnu in his *avatara* form as a man-lion. Be sure to walk through the *gopura* to see this fronton. Immediately opposite, on the south side, the fronton depicts Shiva and his wife Uma riding the bull Nandi.

Continue walking westward and at the end of the causeway to the south is a fronton set at the ground (7), depicting the abduction by the demon. Viradha, of Sita, wife of Rama. Take the opportunity to study the carving close up and at eye level, as it is a fine example of the workmanship to be found at Banteay Srei.

Walk through the east *gopura* (9) leading you to the middle enclosure, and as you pass through pause to see the beautiful inscriptions on the door jambs. Once through the *gopura* you will be looking towards the central enclosure across a moat lined with laterite. Walking westwards you will pass through and enter the temple complex encircled by a laterite, enclosure wall. The *gopura* has two porches and triangular-shaped frontons reminiscent of wooden architecture, and framed with large terminal scrolls. Inscriptions can be seen on the door jambs of this tower. Inside the central complex area are six annex buildings built of laterite (12, 13), which may have served as rest houses for meditation.

■ CENTRAL GROUP

You have now reached the central area of the temple, which is the most important and the most beautiful. It is surrounded by a brick enclosure wall that has almost entirely collapsed (15). However, there are remnants on either side of the east *gopura*. Walk through the *gopura* (17) and in the central courtyard you will see two libraries on each side of the walkway (16). They both open to the west and have laterite and sandstone walls with an unusual corbelled vault in brick.

Look straight ahead, and you will see three shrines arranged side by side in a north to south line standing on a common, low platform and opening to the east (18). The principal shrine in the centre contained the *linga* of Shiva; the shrine on the south was also dedicated to Shiva, whereas the one on the north honours Vishnu. All three central shrines are of a simple form with a superstructure comprising four tiers, decorated with miniature replicas of the main shrine which symbolise the dwelling of the gods. The shrines are guarded by sculptures of mythical figures with human

Cosmic symbolism and mythology are depicted throughout Banteay Srei. (John Sanday)

torsos and animal heads kneeling at the base of the stairs leading to the entrances. Most of these figures are copies; the originals have been removed for safekeeping.

Take time to study the overall appearance of the central complex before looking at the details. The buildings are a veritable assemblage of architectural, sculptural and decorative triumph. Hardly any space is left uncarved and the whole is covered with intricate and delicate motifs. Foliage designs abound, but so do geometric patterns and they are intertwined to produce work of extraordinary beauty.

Now begin to explore the elements of this total composition. Access to the central complex is not permitted

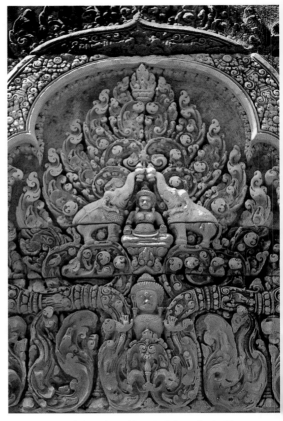

The Hindu goddess, Lakshmi, flanked by elephants on a fronton at Banteay Srei.

but it is suggested that you try to start your tour of the central area by walking around it twice—first, to get a perspective of the size and an understanding of the orientation of the buildings, and, second, to look at the elements in more detail following the order of this guide. There are many more things to see at this temple besides the highlights mentioned below, so allow time to make your own discoveries.

Divinities on the central towers: the figures of male and female divinities standing in recessed niches at the corners are perfect in proportion, balance and artistic style. The females have plaited hair or a bun tied at the side, in a style characteristic of Banteay Srei, and simply dressed with loosely draped skirts. They wear exquisite jewellery, including heavy earrings that weigh down their elongated ear lobes, garlands of pearls hanging from their belts, bracelets, arm and ankle bands, and elaborate necklaces. Notice the row of graceful *hamsas* on the base below their feet.

The males are equally as appealing and stand guard holding a lance, a lotus or other emblem. Their dress is even more simple that the female, and consists of a loin cloth that imitates a pocket fold on the thigh. The face is sublimely noble and the hair intricately plaited and pulled up into a cylindrical chignon. The niche around the figures emulates decorated pillars on each side and a beautiful lobed arch with a flame-like design. The whole is supported by monkey-faced mythical figures.

Library on the left (south): on the east fronton is a scene from the Ramayana. Ravana, king of the demons of Lanka (Sri Lanka) and the enemy of Rama, goes to Mount Kailasa, home of Shiva and his wife, Parvati, where he tries to enter, but is forbidden access. He is furious and shouts at the monkey-headed guardian, who yells back saying that Ravana's power will be destroyed by the monkeys. Ravana (multiple heads and arms) is so angry he raises the base of Mount Kailasa (represented by a pyramid on a background of stylised forest) and shakes it with all his might trying to lift up the mountain.

Meanwhile, Shiva sits on his throne at the summit of the mountain while his terrified wife, Parvati, hovers near his left knee, clinging to his shoulder. Shiva retaliates and prepares to bring the whole weight of the mountain upon Ravana with his toe. The mountain falls on Ravana and crushes him under its mass. Ravana acknowledges Shiva's power and sings his praises for 1,000 years. As a reward, Shiva sets him free and gives him a sword. Other figures in the scene include creatures, hermits and animals living on the mountain who express their terror and flee to the jungle. On the first step the monkey-faced guardian of the mountain raises his hand, perhaps to warn Ravana that one day he will be destroyed by the monkeys.

On the west fronton: Shiva is in the Himalayas meditating and living the life of an ascetic. Parvati tries to attract his attention, but fails and is disappointed that he does not notice her. The gods ask Kama, god of love, to assist Parvati and help her distract Shiva from his meditation. Kama shoots one of his flowery arrows into Shiva's heart. The latter is angry and shoots a fiery ray from his frontal eye, reducing Kama to ashes. Shiva casts his eyes on Parvati and is enamoured by her beauty. He marries her and Shiva brings Kama back to life. A group of ascetics below Shiva, as well as figures with human bodies and animal heads, complete the scene.

North Library: on the east fronton (from the top), Indra, god of the sky, riding in a chariot drawn by his mount, a three-headed elephant, is creating rain to put out a terrible forest fire started by Agni, god of fire, in order to kill a naga who lived in the forest. Indra asks Krishna and his brother, Balarama, to help keep the animals from fleeing, so they stand on the edges of the forest and shoot arrows to stop the rain.

Below, Krishna and Balarama (holding the shaft of a plough) appear again, as children and, are surrounded by animals in the forest.

On the west fronton the scene takes place in a palace and the theme concerns Krishna, who murders his cruel uncle, King Kamsa, because he tried to kill him when he was a child. Krishna approaches the dais, clutches Kamsa by the hair, and throws him off his throne. The two-storied palace is supported by columns, and is a fine example of the architecture of the period. Garlands decorate the first floor and the profile of the palace is a series of recessed stages. The two main figures in the scene are indicated by their size. The women wear expressions of shock and confusion over the murder. Below, Krishna and his brother kill wrestlers. On each side, helpers stand in chariots drawn by animals.

Central Sanctuary (**19**): the male guardians in the corners of the central tower are magnificent specimens of Khmer sculpture. Their hair is swept up in a cylindrical chignon and they hold a lotus in one hand and a lance in the other. The lintels on the central sanctuary are finely carved. The themes are: (north) a battle between the monkeys, Vali and Sugriva; (west) the abduction of Sita; (south) a wild boar.

One of many souvenir stands in the Angkor area. (Thomas Bauer)

BANTEAY SAMRE: 'CITADEL OF THE SAMRE'

Location: 4.2 kilometres (2.6 miles) east of the East Mebon
Access: enter and leave at the north or east
Date: middle of the 12th century
King: Suryavarman II (reigned 1113–1150)
Religion: Hindu (dedicated to Vishnu)
Art style: Angkor Wat

BACKGROUND

Banteay Samre is one of the most complete complexes at Angkor due to restoration using the method of anastylosis. Unfortunately, the absence of maintenance over the past 20 years is evident and theft has mutilated many of the temple's treasures. The name Samre refers to an ethnic group of mountain people, who inhabited the region at the base of Phnom Kulen and were probably related to the Khmers. No inscription has been found for this temple but the style of most of the architecture is of the classic art of the middle period similar to Angkor Wat. The monument most likely dates from the same period, or, perhaps, slightly later, although there are additions attributed to the Bayon style. The proportions of Banteay Samre are splendid. A unique feature is an interior moat with laterite paving, which when filled with water must have given an ethereal atmosphere to the temple. All of the buildings around the moat are on a raised base with horizontal mouldings, decorated in some areas with figures framed by lotus buds.

LAYOUT

The plan of Banteay Samre is roughly square and consists of a laterite enclosure wall with four *gopuras*. Behind the wall, overlooking the enclosed moat, are *gopuras* on each side. The central courtyard contains the main sanctuary, which has four wings and is approached by a long hall with libraries on each side. Begin your visit to this temple from the east, and walk along the laterite, paved causeway (length 200 metres, 656 feet), which leads to the east *gopura* providing access through the outer enclosure wall of the monument.

The causeway, on two levels (not shown on the plan), is bordered on each side by serpent balustrades in the style of Angkor Wat, of which only vestiges remain. The end of the causeway leads to a stairway flanked by crouching lions on short columns. This long and dramatic causeway was probably covered with a wooden roof.

■ LIBRARIES

The cramped placement of the libraries (14) in the northeast and southeast sections of the central sanctuary suggests a change in the original plan. The libraries have slender proportions with exposed corbelled vaulting, false aisles, pierced with long windows and frontons. The decoration on the false doors is remarkably fine. The door on the south library is the best preserved.

A particularly fine depiction of the birth of Brahma is seen on the fronton of the northeast library, west face. In this cosmic myth, Vishnu reclines on his side on the serpent, Ananta, and floats on the ocean. His upper torso rests on his elbow. A golden lotus emerges from the navel of Vishnu signifying the beginning of a new cosmic period. The lotus opens and Brahma appears to preside over the new creation.

West gopura at Preah Khan. (Thomas Bauer)

ESPYING THE ETHEREAL CITY OF NAKHON WAT

'I had already been in Siam several months before I could carry out the project which had originally taken me to that country. My plan was to cross overland into Cambodia, and there photograph the ruined temples and examine the antiquities which have been left behind by the monarchs of a once powerful empire. Mr H G Kennedy, of HBM's consular service, consented to accompany me on this expedition, and we got away together on January 27, 1866.

. . . The Chow Muang of Nakhon Siamrap received us with great courtesy, placing a house at our disposal for two or three days, until a Laos chief, who had come with a considerable escort on a pilgrimage to Nakhon Wat, should have started on his homeward journey, and left room for our accommodation. The old town of Siamrap is in a very ruinous state—the result, as was explained to us, of the last invasion of Cambodia—but the high stone walls which encircle it are still in excellent condition. Outside these fortifications a clear stream flows downwards into the great lake some fifteen miles away, and this stream, during the rainy season, contains a navigable channel. On the third morning of our stay we mounted our ponies, and passed out of the city gates on the road for Nakhon Wat, and the ancient capital of the Cambodian empire. One hour's gentle canter through a grand old forest brought us to the vicinity of the temple, and here we found our progress materially arrested by huge blocks of freestone, which were now half buried in the soil. A few minutes more, and we came upon a broad flight of stone steps, guarded by colossal stone lions, one of which had been overthrown, and lay among the débris. My pony cleared this obstacle, and then with a series of scrambling leaps brought me to the long cruciform terrace which is carried on arches across the moat. This moat is a wide one, and has been banked with strong retaining walls of iron-conglomerate. The view from the stone platform far surpassed my expectations. The vast proportions of the temple filled me with a feeling of profound awe, such as I experienced some years afterwards when sailing beneath the shade of the gigantic precipices of the Upper Yang-tsze.

. . . I believe that a richer field for research has never been laid open to those who take an interest in the great building races of the East than that revealed by the discovery of the magnificent remains which the ancient Cambodians have left behind

them. Their stone cities lie buried in malarious forests and jungles, and though many of them have been examined, not a few are still wholly unexplored; and indeed it is impossible for anyone who has not visited the spot to form a true estimate of the wealth and resources of the ancient Cambodians, or of the howling wilderness to which their country has been reduced by the ravages of war, the destructive encroachments of tropical jungle, . . . The disappearance of this once splendid civilisation, and the relapse of the people into a primitiveness bordering, in some quarters, on the condition of the lower animals, seems to prove that man is a retrogressive as well as a progressive being, and that he may probably relapse into the simple forms of organic life from which he is supposed by some to have originally sprung.

. . . We spent several days at the ruined city of Nakhon, on the verge of the native jungle, and amidst a forest of magnificent trees. Here we were surrounded on every side by ruins as multitudinous as they were gigantic; one building alone covered an area of vast extent, and was crowned with 51 stone towers. Each tower was sculptured to represent a four-faced Buddha, or Brahma, and thus 204 colossal sphinx-like countenances gazed benignly towards the cardinal points—all full of that expression of purity and repose which Buddhists so love to portray, and all wearing diadems of the most chaste design above their unruffled stony brows. At the outer gate of this city, I experienced a sort of modern 'battle of the apes'. Reared high above the gateway stood a series of subordinate towers, having a single larger one in their centre, whose apex again displayed to us the four benign faces of the ancient god. The image was partly concealed beneath parasitic plants, which twined their clustering fibres in a rude garland around the now neglected head. When I attempted to photograph this object, a tribe of black apes, wearing white beards, came hooting along the branches of the overhanging tree, swinging and shaking the boughs, so as to render my success impossible. A party of French sailors, who were assisting the late Captain de Lagrée in his researches into the Cambodian ruins, came up opportunely, and sent a volley among my mischievous opponents; whereupon they disappeared with what haste they might, and fled away till their monkey jargon was lost in the recesses of the forest.'

John Thomson, The Straits of Malacca, Indo-China, and China;
or, Ten Years' Travels, Adventures, and Residence Abroad, 1875

GROUP 9
WEST BARAY

This half-day tour provides a break from looking at ruins of temples and enables you to take a pleasant boat trip on the West Baray, the largest man-made body of water at Angkor. You can hire a boat to take you to the island in the middle where the temple of the West Mebon once stood. Today, only traces of it remain. But the island is a pleasant spot for a picnic or just walking around when the water level is low. Alternatively, you can go for a refreshing swim.

To reach the West Baray, leave Siem Reap on the airport road to the northwest. Continue past the turning-off to the airport and just prior to crossing a large canal turn to the right (north) down a road running parallel to the canal and follow it until you reach the levee around the south bank of the *baray*.

The West Baray is a vast man-made lake, surrounded by an earthen levee which forms a dyke. According to legend, the young daughter of a ruler of Angkor was grabbed by an enormous crocodile, which made a large opening in the south dyke of the West Baray that can still be seen today. The crocodile was captured and killed. The princess, still living in its stomach, was rescued.

As the temple in the middle is in the same style as the Baphuon, the *baray* was probably constructed in the 11th century. The east dyke leads to the temple of Bakheng. Some historians believe the West Baray could have been a mooring place for the royal barges as well as a reservoir and a place for breeding fish.

View from Hall of the Dancers, looking east, Preah Khan.

Thomas Bauer

WEST MEBON

Location: access to the south levee is 11 kilometres northwest of Siem Reap
Access: the south dyke of the West Baray; take a boat to the island in the centre of the *baray*; walk to the east entrance of the temple
Date: second half of the 11th century
King: Suryavarman I (reigned 1002–1050)
Religion: Hindu (dedicated to Vishnu)
Art style: Baphuon

BACKGROUND

The West Mebon is situated at the centre of the West Baray on an island. Inscriptions relating to this baray have not been found, so it cannot be dated exactly. But based on the architecture and decoration of the temple it probably dates to the second half of the 11th century. It was from here that the magnificent, over-lifesize bronze of Vishnu was found, now on display in the National Museum in Phnom Penh.

LAYOUT

The West Mebon was originally surrounded by a square enclosure wall with three square, sandstone *gopuras* and a sanctuary on one level crowned with a lotus. Most towers have collapsed, but the three on the east side are reasonably intact. A sandstone platform at the centre is linked to a causeway of laterite and sandstone that leads to the east dyke. The sides of the towers are carved with lively animals set in small squares, a type of decoration found also at the Baphuon. **Tip:** at certain times of the year when the water level is low enough, it is possible to walk along the shore line and look back at the island to see heaps of stones from the collapsed areas.

AK YOM: THE 'CRYING BIRD'

Location: from Siem Reap, take Route No. 6 west (towards Sisophon) for 7.5 kilometres (4.6 miles); turn onto the road going north to the West Baray; at the south bank of the *baray*, turn west and follow the road for 350 metres (1,148 feet); the temple is on the south side of the road

Date: seventh to ninth century

Religion: Hindu (dedicated to Shiva)

BACKGROUND

Although Ak Yom is a rarely visited site, it is of historical importance. An inscription on a re-used door jamb of the central shrine is dated 674, which makes Ak Yom the oldest known temple at Angkor. When the West Baray was constructed in the second half of the 11th century, the temple of Ak Yom was partially buried by the south levee of the *baray*. and it was not rediscovered until 1932. Archaeologists suggest that even the remains visible today may be built over an earlier site. According to an inscription, the temple was dedicated to the god Gambhiresvara (a name for Shiva in his form of an extreme ascetic).

LAYOUT

Originally, Ak Yom consisted of a square, brick central shrine on a pyramid of three tiers accessed by steps on each side; an enclosure wall with brick towers in each of the four corners and a further six brick towers in pairs on the north, south and west sides around the central shrine (vestiges remain). The central sanctuary opened to the east with false doors on the other three sides. Traces of niches visible on the walls probably contained standing figures. Fragments of sandstone lintels decorated with arches intercepted by medallions and hanging leaf motifs and columns with rings lie on the grounds of the temple. Post holes are still visible and were probably used to support a wooden framework for the monument.

On the upper level there is a curious square block of sandstone (broken) with a groove and a cylindrical hole that leads to a deep, brick-paved chamber below (depth: 12.25 metres; 400 feet). Two gold leaves engraved with elephant images were found in this chamber so, perhaps, it once contained sacred offerings buried at the centre of the temple.

GROUP 10
TONLE SAP

A boat trip on the Tonle Sap is a pleasant outing and gives you a chance to see a fishing village. It is recommended you make this tour in the morning, so you can combine it with a trip to the hilltop temple of Phnom Krom, which is best to visit before the midday heat. Leave Siem Reap on the main road leading south, and continue until you come to a village and a slight turn on the road angling to the left. You are at the base of the hill on which stands the early tenth century sandstone temple of Phnom Krom. The setting is magnificent and the view of the lake from the top is unsurpassable. At the top of the hill, walk through the grounds of the modern temple, veering left and up a short flight of wooden steps to the temple itself.

Return to your transport at the bottom of the hill and continue along the road in a southerly direction until you come to a fishing village. Here you can hire a boat to take you to the edge of the lake. Along the way you will see the fishermen and their families who live on the water and form the so-called 'floating villages'.

The Tonle Sap is the largest permanent freshwater lake in southeast Asia. As the main source of fishing and agriculture to people living on the surrounding plain, it has played an important role in Angkor throughout history. The lake which is connected to the Mekong River by the Tonle Sap River, joins the Mekong River at Phnom Penh. From this point, the Mekong flows south into the South China Sea, and provides the means of external waterway communication for Angkor. The hydrological process that causes the lake to increase in size during the monsoon rains, and then recede, is believed to be of importance in maintaining the ecological system of the lake, which includes various species of fish and birds.

Tonle Sap possesses the world's largest pelican colony. (Frédéric Goes)

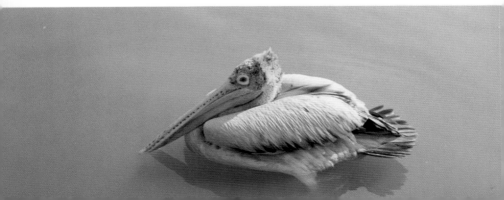

TONLE SAP—MASTERPIECE OF NATURE AND CORNERSTONE OF ANGKORIAN CIVILISATION

Tonle Sap Great Lake is often referred to as the "heart" of Cambodia. This huge body of water is a fascinating but threatened natural treasure, brimming with fish and aquatic life and providing over three million Cambodians with their daily source of protein. Its unique freshwater swamp forest habitat and wildlife make the lake an exceptional wetland for biodiversity conservation. The Tonle Sap dominates the landscape of northwestern Cambodia and was a key element in the establishment and development of the ancient Angkorian civilisation.

When searching for a place to establish their capital, the first Angkorian kings looked for a landscape that reflected the Hindu mythological representation of the world, i.e. Mount Meru (the home of the gods) surrounded by the Cosmic Ocean. Phnom (Mount) Kulen and adjacent Tonle Sap Great Lake to the south fitted this symbolic vision perfectly, and in 802 Jayavarman II was crowned on Phnom Kulen as the first *devaraja* or god-king, founding Angkorian civilisation. The fertile plains between the mountain range and the floodplain of the lake were settled rapidly, and Angkor reached its apogee with the magnificent architectural monuments that visitors come to admire today.

The mythological symbolism alone, however, could not have shaped such a successful civilisation without the presence of a strong economic base to support the spiritual power—a base that was provided mostly by the extraordinary richness of Tonle Sap. The vital role that the lake played in sustaining the Angkorian empire is magnificently illustrated in the density and variety of aquatic life represented on the bas-reliefs of the Bayon temple in Angkor Thom: sometimes the creatures are spread across all three tiers of the gallery walls, swimming past submerged trees. Angkor now had all the attributes for success: the spirit and the body, the mind and the strength.

Today the Angkorian splendours are jungle-covered ruins, but Tonle Sap continues to thrive, full of life, activity and beauty. According to recent geological surveys, the lake was formed around 15,000 years ago. At that time, it was a large, isolated inland lake. About 5,000 years ago, after the last ice age,

rising sea levels created a connection between the lake and the Mekong River. This resulted in a unique hydrological system in which every year, the Tonle Sap River, which drains the lake, reverses its flow under the pressure of the Mekong flood. From June to October, the lake is filled by the overflow from the Mekong, absorbing huge quantities of water, quadrupling its surface area, multiplying its volume by a factor of 70 and rising from one metre to ten metres deep. Seventy per cent of the lake's water originates from the Mekong, hence it is an integral part of the Mekong River system. During the monsoon, the unique floodplain habitat surrounding the lake is progressively swallowed by the flood, so that it becomes what the French called the "inundated forest". By September, it is a vast inland sea of 12,000 square kilometres (4,633 square miles), only the crowns of the larger tree emerging as lonely islands. All the plants under water then lose their leaves, a most unusual phenomenon for a tropical deciduous

forest. During this period, vast numbers of fish migrate from the Mekong to feed and grow in the submerged vegetation. These "white fish", which require highly oxygenated water, join the lake's resident "black fish". The latter are able to withstand the difficult conditions of the dry season, burying themselves in the mud, breathing air and even waddling across dry land in search of water.

The fish spread through the flooded forest and probably eat tree seeds and fruits. During this period

A large flock of Asian openbills feeds on mudflats as waters recede.

fisher families go out into the forest to cut stocks of firewood, spear fish, catch turtles, and dip gill-nets into the aquatic vegetation to harvest water snakes, that are sold as snacks for crocodiles in the crocodile farms that have mushroomed around the lake since the early 1990s. The annual harvest is estimated at over a million water snakes, making it the largest-known snake harvest from any site in the world. Among these harmless aquatic snakes is the endemic Tonle Sap water snake, found nowhere else on the planet.

In November, as the water starts to recede, the fish move slowly out of the forest. The fishermen use this opportunity to channel them into huge enclosures. Kilometre-long

The lesser adjutant roosts around the lake in December and January.

bamboo fences ending in arrow-shaped traps are set up to line the lake shore; this industrial-scale fishing technique uses only bamboo stakes, wooden poles and nets, and has probably been practised unchanged since Angkorian times, although it cannot be clearly identified in the iconography. The annual fish catch from the Tonle Sap is estimated at 300,000 tonnes, making it one of the world's top freshwater fisheries: hectare for hectare, the lake is ten times more productive than the North Atlantic Ocean. The lake contributes 70 per cent of the national fish catch, and fish products represent 70 per cent of the protein intake of Cambodians.

As the fish concentrate in an ever-shrinking body of water, large water birds move from their wet-season feeding areas throughout the country—and beyond—to nest in the pristine swamp forest of Prek Toal, in the northwestern corner of the lake. This site is the last breeding stronghold in southeast Asia for seven species of endangered water bird. From October to May, thousands of pairs of darters, storks, pelicans and ibises breed here in huge mixed-species colonies, feeding their offspring on the bounty of the lake. However, large-scale egg and

chick collection for the local food market threatened to extirpate these remaining colonies until, in 2001, a tight protection programme was initiated that involved local villagers. Now, the endangered species are showing signs of recovery and the site has become one of Cambodia's prime ecotourism destinations. The water bird spectacle at Prek Toal is an enduring testimony to the resilience of this living treasure, the Tonle Sap, recalling early accounts by French naturalists, who described it as a paradise for water birds.

All Cambodians are aware and proud of Angkor, their cultural masterpiece, but most do not realise that Angkor could not have blossomed without the aid of its nearby natural masterpiece: the Tonle Sap Great Lake. Today, this priceless heritage is under threat from a number of sources: dam construction on the Upper Mekong River in China will irreversibly alter the hydrological regime of the lake; each year flooded-forest habitat is lost to agriculture and fires are deliberately set; and fish stocks show signs of over-exploitation. The preservation of the Tonle Sap and the sustainable use of its riches are critical, not only for the food security of over three million people but also to ensure that the heart of the Kingdom continues to beat for future generations of Angkorian descendants.

At the heart of the country, the Tonle Sap Great Lake is an exceptional gift of nature to Cambodia. The lake's unique hydrology, ecology and biological diversity as

Darter colony in Prek Taol Sanctuary.

well as its cultural significance were recognized in its listing as a UNESCO Biosphere Reserve in 1997. Over 200 species of plant, 200 fish species, 30 reptiles, 200 birds and 20 mammals have been documented from the lake. The Tonle Sap can boast five superlatives, echoing the number of towers at Angkor Wat:

1. It is the largest freshwater lake in southeast Asia (2,500 square kilometres expanding to 12,000 square kilometres; from 965 square miles to 4,633 square miles at maximum flood).

2. It is the largest seasonally flooded freshwater swamp forest habitat in southeast Asia (300,000 hectares).

Water snakes and their eggs for sale at Siem Reap market during the snake harvest.

3. It is one the world's top freshwater fisheries (300,000 tonnes per year).

4. It hosts the largest colonies of endangered water birds in Southeast Asia; and

5. It yields the world's largest snake harvest.

To be initiated into the fascinating ecological and human aspects of the Tonle Sap, nothing replaces a full-day tour with Osmose. Osmose is a non-profit organisation implementing an integrated conservation-education-ecotourism project in Prek Toal in partnership with the Wildlife Conservation Society. Small groups (four to seven persons) are guided by a specialist of the area for a morning of birding and an afternoon visit to the floating village. For more information visit www.osmosetonlesap.org or e-mail osmose@online.com.kh or call 063 963 710) or visit the Sam Veasna Centre for Wildlife Conservation (100 metres past the Angkor Village Hotel). Booking two weeks in advance is highly recommended.

Text and pictures—Frédéric Goes, Wildlife Conservation Society,
Tonle Sap, Siem Reap.

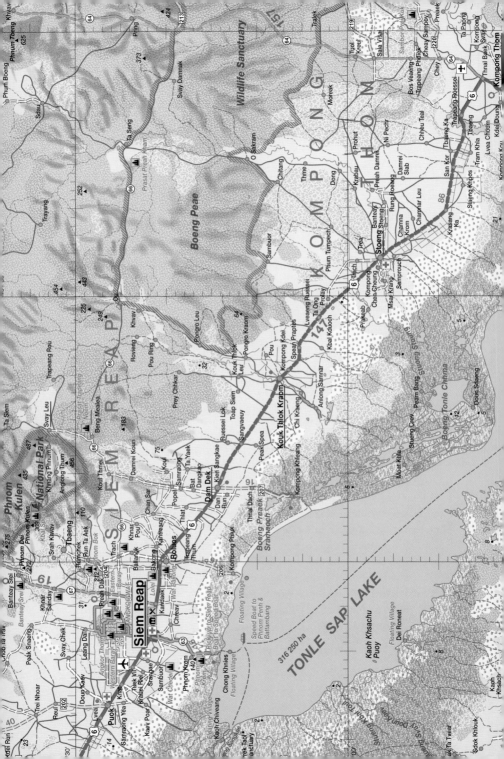

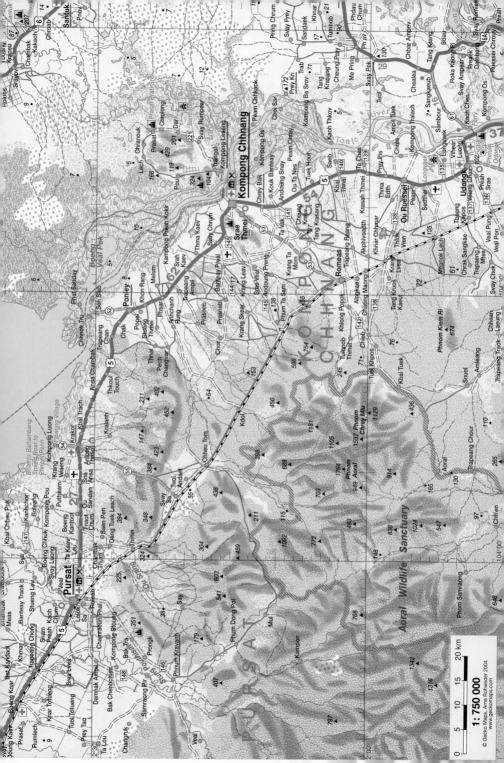

WAT ATVEA

Location: take the road south from Siem Reap towards Tonle Sap for seven kilometres (4.3 miles); turn right, follow a path 500 metres (1,640 feet); the ancient site is located behind the main building of a modern pagoda
Access: enter and leave at the east
Date: 12th century or later
Religion: Hindu

BACKGROUND

Etienne Aymonier, who saw this temple in the late 19th century, suggested that it might not have been completed. At that time, he saw several blocks of stone that appeared as if they had never been put in place. In other parts of the temple, he saw evidence where the carving was begun, but not finished. Other early French observers commented on the enormous size of the blocks of stone used in the building of this small temple.

LAYOUT

A laterite enclosure wall with four *gopuras* enclosed the temple. The *gopura* at the west is larger than the others and has three chambers. From there, a walkway leads to cruciform sandstone central shrine with a porch in each cardinal direction and a lotus bud tower, all of which is typical of 12th century architecture. The shrine is raised on a platform and opens, unusually, to the west. A small laterite pavilion (unfinished) is on the south. Four sandstone shrines with corbelled vaulting stand in the corners of the complex. *Devatas* standing in niches are unfinished, which allows you to see the process of carving. The site is in relatively good condition, however, as with some other sites, the absence of inscriptions makes precise dating impossible at the present time.

PREAH EINKOSEI

Location: in Siem Reap town; go north along the road that parallels the eastern bank of the Siem Reap River; it is the third pagoda on the right, on the oppodite bank to the Angkor Conservation office.
Access: enter and leave the ancient temple from the northwest
Date: mid-10th century
King: Rajendravarman (reigned 944–968)
Religion: Hindu

BACKGROUND
The door jambs have two inscriptions written in Khmer and a stele found at the site also provides information about this temple.

LAYOUT
One central brick tower and a smaller one are oriented north to south, stand on a raised and moulded laterite base, which opens to the east. The main tower has a sandstone doorframe with columns and a tiered superstructure. The remains of a laterite wall with a sandstone *gopura* flanked by two seated lions are found at the east.

Carvings on the east face of the central shrine depict: Indra mounted on his elephant flanked by two lions standing with their backs facing each other and holding a horizontal swag; the Churning of the Ocean of Milk, rather crudely executed but in good condition.

The tip of one of Prasat Suor Prat's 12 towers.

GROUP 11
PREAH PITHU

Location: northeast of the Terrace of the Leper King
Access: enter and leave east of the main road
Date: first half of the 12th century (parts of the 13th century)
King: Suryavarman II (reigned 1113–1150)
Religion: Hindu (dedicated to Shiva)
Art style: Angkor Wat

BACKGROUND

The complex of Preah Pithu is a delightful area to wander in and experience the pleasure of finding hidden stones, unseen carvings and obscure alcoves. And the proportions and decoration of the terraces are amongst the finest in Khmer art. Most of the structures are in poor condition, but their bases remain and, from the evidence, the buildings of Preah Pithu were of excellent quality in design, workmanship and decoration.

LAYOUT

The Preah Pithu group consists of two cruciform terraces and five sanctuaries, situated in seemingly random order amongst enclosure walls, moats and basins. All shrines are square with false doors, stand on a raised platform and are oriented to the east. Starting from the main road, the first temple is approached by a cruciform terrace with columns and a *naga* balustrade. Beyond is an enclosure wall with *gopuras* on the east and west sides. The sanctuary with four staircases stands on a plinth. Female divinities in niches are seen in the corners. Notice the floral motif on their skirts. A second shrine lies on the same axis and is similar in plan and decoration to the previous one.

A third temple is situated behind the other two and to the north. The sanctuary stands on a square terrace four metres (13 feet) high and 40 metres (131 feet) long on each side. Four axial stairways guarded by lions give access to the sanctuary. Although the shrine has windows with balustrades it is undecorated. Fragments of frontons and lintels provide evidence that it was later used as a Buddhist sanctuary.

Continuing towards the east there is a pond where two sculpted elephants stand on each side of a staircase. This is a particularly serene and pleasant spot. Retrace your steps and you will find remains of a fourth shrine on your left (south). The decoration on the pilasters of this shrine clearly belong to the Angkor Wat period. The fifth shrine of the Preah Pithu group is further north and comprises two buildings decorated with scenes from the *Ramayana*.

THE KLEANGS: 'STOREHOUSES'

Location: behind the 12 towers of Prasat Suor Prat and facing the Terraces of the Elephants and the Leper King
Access: enter and leave from the west; walk past the Suor Prat towers towards the east
Date: end of the tenth–beginning of the 11th century
King: Jayavarman V (reigned 968–1001) or Suryavarman I (1002–1050)
Religion: Hindu
Art style: Kleang

BACKGROUND

The Kleangs consist of a pair of large sandstone façades that look quite grand against a jungle background. They are similar in time, layout, style and decoration, although inscriptions suggest that the South Kleang was built slightly later than the north one. Some scholars believe the name 'storehouse' is inappropriate for such buildings as these and suggest they may have been reception halls for receiving foreign dignitaries.

LAYOUT

Both buildings are long rectangular structures with cruciform porches placed centrally on the west and east facades. Windows with balusters are evenly spaced across the elevation on either side of the porches. The decoration is restrained, but thoughtful in its design and execution. The faceted columns of the doorways support lintels decorated with foliate scrolls.

North Kleang: the workmanship of the architecture and decoration is more carefully executed than that of the South Kleang. To the rear of the North Kleang there is a laterite wall with high level horizontal windows which encloses smaller halls in a courtyard.

South Kleang: the long rectangular building is unfinished, but it stands on a moulded platform. The interior decoration is limited to a frieze under the cornice.

Following pages: The kleangs ('storehouses').

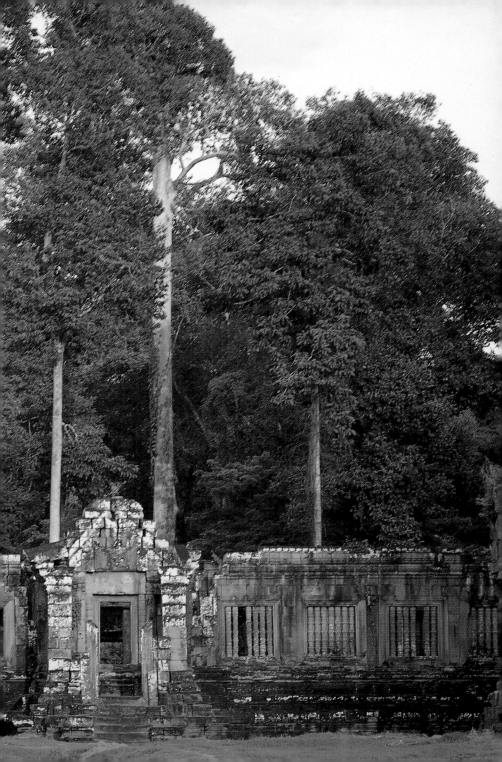

PRASAT SUOR PRAT:
THE 'TOWERS OF THE CORD DANCERS'

Location: at the beginning of the road leading to the Gate of Victory of
Angkor Thom; 1,200 metres (3,937 feet) in front of Phimeanakas

Access: enter and leave the towers from the road

Date: end of the 12th century

King: Jayavarman VII (reigned 1181–1220)

Religion: Buddhist

Art style: Bayon

BACKGROUND

The purpose of these 12 towers is a source of some controversy. According to a
Cambodian legend, the towers served as anchoring places for ropes which stretched
from one to another for acrobats who performed at festivals; the king observed the
performances from the terraces. The activity is reflected in the name of the towers.

Zhou Daguan wrote about an entirely different purpose of the towers in describing
a method of settling disputes between men. 'Twelve little stone towers stand in front
of the royal palace. Each of the contestants is forced to be seated in one of the towers,
with his relatives standing guard over him. They remain imprisoned two, three, or
four days. When allowed to emerge, one of them will be found to be suffering some
illness—ulcers, or catarrh or malignant fever. The other man will be in perfect health.
Thus is right or wrong determined by what is called "celestial judgement" '.[71]

Henri Mouhot wrote that the towers were 'said to have been the royal treasure...It
served, they say, as a depository for the crown jewels'.[72] Another theory is that they
may have served as an altar for each province on the occasion of taking the oath of
loyalty to the king.

LAYOUT

Prasat Suor Prat is a row of 12 square laterite and sandstone towers, six on either side
of the road leading to the Victory Gate, parallel to the front of the terraces. The two
towers closest to the road are set back slightly from the others. The towers have an
unusual feature of windows with balusters on three sides. Entrance porches open
toward the west onto the parade ground. These features support the theory that these
towers were used as some sort of viewing area, reserved for princes or dignitaries,
opening on to the large parade ground in front of the Royal Palace. The interior of
each tower has two levels and on the upper one there is a cylindrical vault with two
frontons. The frames, bays and lintels were made of sandstone.

TEP PRANAM: THE 'WORSHIPPING GOD'

Location: 100 metres (328 feet) northwest of the Terrace of the Leper King
Access: a path to the west from the main road leads to Tep Pranam
Date: parts of the temple were built at different times ranging from the end of the ninth century to the 13th century
King: Yasovarman (reigned 889–910)
Religion: Buddhist

BACKGROUND AND LAYOUT

The presence of Buddhist monks and nuns at this temple give it a feeling of an active place of worship. The site was originally a Buddhist monastery associated with Yasovarman at the end of the ninth centry. The entrance to Tep Pranam is marked by a laterite causeway bordered by double boundary stones at the corners and a cruciform terrace. The sandstone walls of the base of the terrace have a moulded edging. Two lions precede the walls and are in 13th century art style. The *naga* balustrades are probably 12th century, whereas the two lions preceding the terrace at the east are Bayon style.

BUDDHA

The large stone Buddha is seated on a lotus pedestal with a moulded base. He is in the position of 'calling the earth to witness'. The body of the Buddha has been reassembled from numerous reused stones.

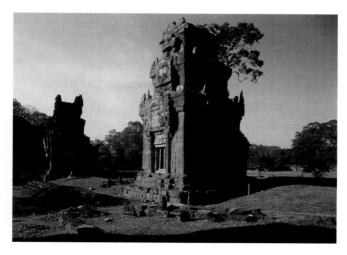

Towers at Prasat Suor Prat.

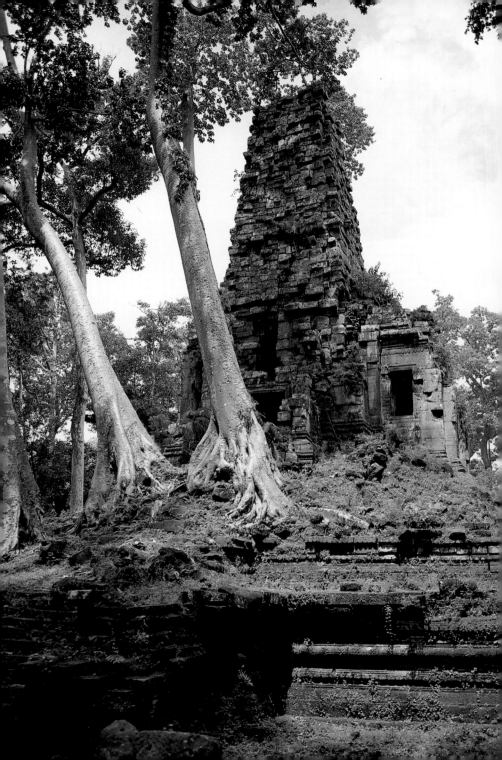

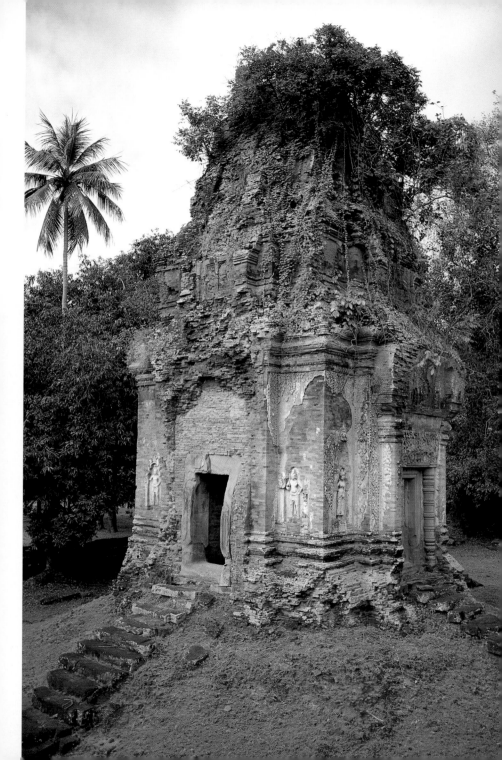

PREAH PALILAY

Location: north of Phimeanakas; follow the footpath through the jungle west of the enclosure wall of the Royal Palace or beyond Tep Pranam

Access: enter and leave at the east

Tip: this is one of the most serene areas of Angkor. Take time to enjoy it

Date: first half of the 12th century (central sanctuary)–late 12th-early 13th century (*gopura*)

Religion: Buddhist

Art style: Angkor Wat and Bayon

BACKGROUND

Lintels and frontons lying on the ground afford an opportunity to study the details of the carvings at eye level. Many depict Buddhist scenes with Hindu divinities.

LAYOUT

A large seated Buddha in front of the temple of Preah Palilay is of a recent date. A cruciform terrace precedes the temple and stands as an elegant example of the classic period of Khmer art. Serpent balustrades terminating with a crest of seven heads frame the terrace. A causeway joins the terrace to the east *gopura*, which is set in the laterite enclosure wall of which only parts remain. Enter through the cruciform east *gopura* with three openings and a vaulted roof with double frontons. The principal feature of interest at this temple is the Buddhist scenes on the frontons. They are some of the few that escaped defacement in the 15th century. The scenes depicted are: east, a reclining Buddha; south, a seated Buddha, which is especially beautiful in the mid-morning sun; north, a standing Buddha with his hand resting on an elephant.

CENTRAL SANCTUARY

Only the central sanctuary of Preah Palilay remains intact. The sandstone tower opens on four sides, each one with a porch. The tower stands on a base with three tiers intercepted by stairs on each side. The upper portion is collapsed and a truncated pyramid forms a cone which is filled with reused stones.

Previous pages. Left: *A precarious tower at Preah Palilay.*
Right: *Brick tower at southwest corner of Bakong.*

GROUP 12
BEYOND ANGKOR

Four exceptional Khmer temples of the Angkor Period—**Banteay Chhmar, Koh Ker, Preah Khan of Kompong Svay, Preah Vihear**—that were previously off-limits and inaccessible are now open to visitors. Each one is large in scale, remotely located and spectacular in a special way. Until recently, they were simply sites you read about and saw sculptures from them in museums. The temples are vast ruins—parts of towers, doorways and galleries stand above heaps of fallen sandstone blocks, broken lintels, pediments and the jungle encroaches everywhere—with hardly even any paths to follow (except Preah Vihear, which is in better condition). To see the temples in such a setting is part of the appeal and their ruined state doesn't detract from the pleasure of visiting these remarkable sites.

Access is possible by four-wheel-drive vehicle in almost all conditions. However, trips are easiest by helicopter, especially for visitors with time constraints, as bad roads slow the vehicle access. Banteay Chhmar can be reached by land but the road conditions are variable and at times parts are impassable. Getting to Preah Vihear is possible with a four-wheel-drive vehicle but be prepared for a slow ascent as you climb a 600-metre- (1,968-feet-) high mountain. The other two sites, Koh Ker and Preah Khan of Kompong Svay, are equally hard to reach by land because of the long distances and poor roads.

The condition of the sites makes it difficult to perceive the layout of the temples. To help you better understand the layouts, a plan for each one is included. Likewise, it is not practical to describe the temple in detail. General overviews of the layout of the temples are included to give you an idea of the placement of structures as you probe the ruins and climb over fallen stones. Scenes depicted on carvings that you may encounter are identified and their mythological meaning is explained to increase your knowledge and to enhance your appreciation of the wonder and glory of these temples.

When visiting these four sites it is recommended that you hire a local villager to lead you through the ruins and to assist you while climbing, if necessary. They know the easiest paths along which to manoeuvre and the locations of the best carvings. Presently, there is no set fee for this service. It is recommended that you reward them with moderate tips, as you see fit.

> *Caution: do not wander beyond the confines of the temple and never go past the areas marked off by wooden stakes painted white with red tips. They are NOT de-mined.*

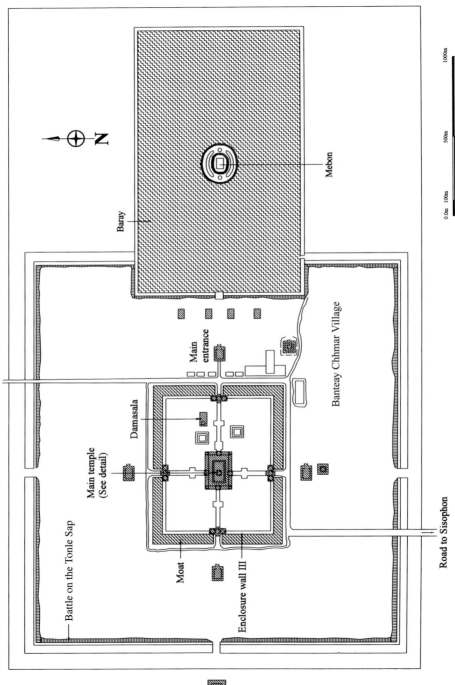

Banteay Chhmar

General site plan

N

Baray

Mebon

Main entrance

Damasala

Main temple
(See detail)

Battle on the Tonle Sap

Moat

Enclosure wall III

Banteay Chhmar Village

Road to Sisophon

0.0m 100m 500m 1000m

(Not to scale)

Banteay Chhmar: the 'Citadel of the Cat'

Even as recently as 1956 when Christopher Pym visited the temple, nearby villagers were unaware of its existence: *'The schoolmaster who had come with me from Thmar Pouok was full of wonder for this vast Khmer temple, so seldom visited even by the Khmers themselves. Most of his fellow-countrymen, he said, thought that Angkor was the only place where such marvels could be seen. He had not realised that the ancient Khmer kings built on this enormous scale in other parts of Cambodia as well.'* (Mistapim in Cambodia, London, The Travel Book Club, 1960, p. 101).

Location: northwest Cambodia, near the border of Thailand; 102 kilometres (63.38 miles) from Siem Reap to Sisophon; 70 kilometres (44 miles) north of Sisophon on Route 69

Access: enter and leave from the east

Tip: This temple is accessible from Siem Reap by car or motorcycle but the road conditions are variable and at times parts are impassable; by car, journey time one-way in mid-2003 was four hours; the temple can also be reached by road from Thailand and crossing the border (visa required) into Cambodia at Poipet; however, the road conditions in this direction vary.

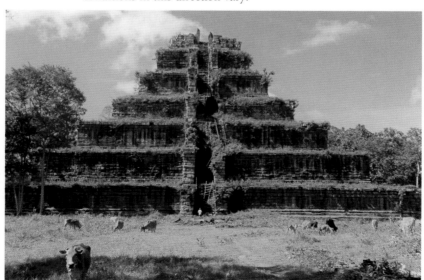

Khin Po-Thai

Prasat Thom at Koh Ker.

It is recommended that you begin by walking around the enclosure wall to see the carvings on the exterior; return to the east and enter the inner complex from the east, exit at the west and return to your starting point by the footpath around the exterior of the enclosure wall

Date: late 12th–early 13th century
King: Jayavarman VII (reigned 1181–1220)
Religion: Buddhist (dedicated to Crown Prince Indravarman, son of the king, and to four military officers who gave their lives to save the Crown Prince in a battle with the enemy)
Art style: Bayon

BACKGROUND

Banteay Chhmar is a little-known and rarely visited site situated at the foot of the Dangrek mountains. It is vast and comparable in size to other large monastic complexes such as Preah Khan of Angkor and the Royal City of Angkor Thom. But, unlike the latter, Banteay Chhmar has never been restored and, today, it is a confused mass of fallen walls, collapsed galleries, broken sandstone blocks—all entwined with jungle. It covers an area of nine hectares (22.23 acres). The outer enclosure wall is 2,000 x 2,500 metres (6,5050 x 8,202 feet). Georges Groslier estimated that it took about 20,000 labourers between 27 and 30 years to complete Banteay Chhmar.

The temple made international news in 1998 through an organised theft in which carvings were cut away from a large section (length: 11 metres; 36 feet) of the wall of the temple. They were transported across the border but Thai police intercepted the truck and eventually the irreplaceable treasures were returned to Cambodia. The wall is now reconstructed from some 118 pieces and stands in the northeast courtyard at the National Museum of Phnom Penh.

LAYOUT

The plan of the temple combined a variety of Khmer architectural forms and features using sandstone and laterite. It included enclosure walls with covered galleries and square columns, pavilions, moats between two of the walls, a cruciform terrace, an inner rectangular area with a central sanctuary, towers, 'libraries' and basins. A majestic causeway with a *naga* balustrade supported by gods on the left and demons on the right is at the east along with a sandstone *dharmasala* or pilgrim's rest house; also there was a large *baray* (700 x 1,500 metres; 2,296 x 4,921 feet) at the east, which, originally, had a shrine in the middle that is believed to have resembled the one at Neak Pean in Angkor. At the centre of each side of the enclosure wall is a *gopura* with

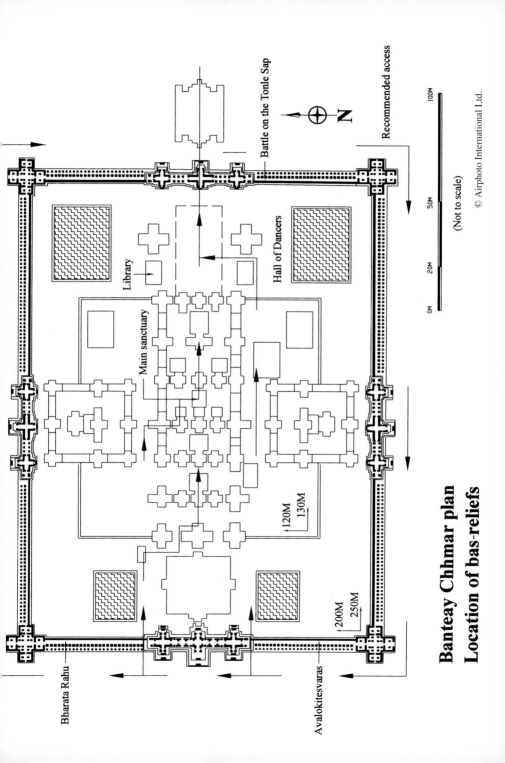

**Banteay Chhmar plan
Location of bas-reliefs**

Battle on the Tonle Sap

Recommended access

N

(Not to scale)

© Airphoto International Ltd.

0M 20M 50M 100M

Library

Hall of Dancers

Main sanctuary

120M
130M

200M
250M

Bharata Rahu

Avalokitesvaras

three chambers that was crowned by towers with four gigantic faces, one in each cardinal direction, like those at Angkor Thom.

Besides the wonderful, remote jungle setting of Banteay Chhmar, the bas-reliefs are exceptional both in quality and content. Many, though, are unidentifiable because either they have not been studied, are too weathered to see them clearly or are too damaged from vandalism and theft. Some highlights that can be seen on the second enclosure wall (shown on the plan) are:

East wall, south side: an action-packed battle scene on the Tonle Sap between the Chams (wearing a helmet that looks like a flower turned upside down) from central Vietnam and the Khmers (in boats with their hair tied back).

South wall, east & west sides: a historical scene of the battle in 1177 when the Chams (wearing the ubiquitous helmet and a short-sleeved, printed jacket) made a surprise attack on Angkor; generals mounted on caparisoned elephants and chariots drawn by horses and mythical beasts lead processions of Khmer foot soldiers (wearing plain, round-collared jackets) armed with bows and arrows, or lances and shields ready for hand-to-hand combat; high-ranking officials can be seen surrounded by royal regalia—umbrellas, fly whisks, fans and peacock feathers; (west side, near the *gopura*) the heads of two decapitated men show the fierceness of the battle.

West wall, south side: originally a series of eight standing, multi-armed cosmic Lokeshvaras with a single head, a rare form of the bodhisattva in Khmer art; they depict different aspects of the cosmic figures and thus they have differing numbers of arms; the typical attributes held in the hands are a book, prayer beads and a nectar flask; a small Buddha seated in meditation appears in the cylindrical headdress of the figure; praying figures, celestial beings, tropical foliage and lotus surround the central figure. The theft described above occurred on this wall.

West wall, north side: the Churning of the Ocean of Milk, the Hindu myth of creation appears near the corner tower; a gigantic mythical beast, Rahu, appears twice; on the upper tier, he fights with a warrior; on the lower tier, he devours a cart and a four-legged animal.

North wall, east side: a grand procession of females carried in palanquins on the shoulders of bearers, rows of devotees carrying offerings.

Central area: You can climb over the stones, in and out of doorways and galleries of the central complex. The shape was a long rectangular complex (121 x 40 metres; 400 x 130 feet) with three sanctuaries connected to one another with covered galleries and small, free standing buildings; there is a basin in each corner of the inner complex. Amongst the ruins you may find carvings of *apsaras, garudas* and gigantic faces on what were probably sandstone towers.

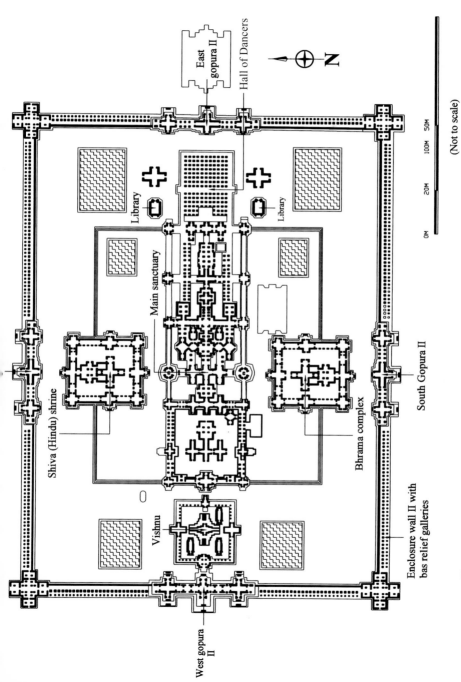

East gopura II

Hall of Dancers

N

© Airphoto International Ltd.

0M 20M 100M 50M

(Not to scale)

Library

Library

Main sanctuary

Shiva (Hindu) shrine

South Gopura II

Bhrama complex

Enclosure wall II with
bas relief galleries

Vishmu

West gopura
II

Banteay Chhmar plan

KOH KER

King Jayavarman IV 'founded by his own power, a city which was the seat of the prosperities of the universe.'—from an inscription in Lawrence Briggs' The Ancient Khmer Empire, reprint, Bangkok, White Lotus, 1999, p. 117.

Location: 80 kilometres (49.71 miles) northeast of Angkor
Access: by road or from wherever the helicopter is able to land; the temple is oriented to the east
Date: first half of the tenth century
King: Jayavarman IV (reigned 928-941)
Religion: Hindu (dedicated to Shiva)
Art style: Koh Ker

BACKGROUND

Some five years before he became king, the future Jayavarman IV, whose uncle reigned at Yashodharapura, the capital of Angkor, left the area and settled in Chok Gargyar ('Island of Glory'), the present-day site known as Koh Ker, northeast of Angkor, and called Lingapura in inscriptions. Despite the meaning of the early name, Koh Ker is certainly not an island. It is located inland in a remote part of Cambodia east of the southern tip of Phnom Kulen, which, today, is one of the poorest regions of the country. Whether or not Jayavarman IV was a usurper is uncertain, but he divided the kingdom by establishing a new capital in the remote location of Koh Ker. To accomplish this, he must have wielded considerable power as a military leader. Inscriptions state that he ruled over the territories of Battambang, Siemreap, Kampong Thom, Kampong Cham and Ta Kev. He died at Koh Ker around 941. His son, Harshavarman II, who succeeded him, reigned briefly until 944. The cause of his death at a young age is uncertain. His successor moved the capital from Koh Ker back to Angkor.

Jayavarman IV's 'royal ceremonial complex' of Koh Ker was built on a grand scale and some of the largest and most extraordinary sculpture ever created by the Khmers was made during this period. Koh Ker images are renowned, not only for their colossal size and powerful musculature, but also for portraying action and movement previously unknown in Khmer sculpture. Two enormous Koh Ker sculptures in the National Museum in Phnom Penh represent this period admirably (both are carved

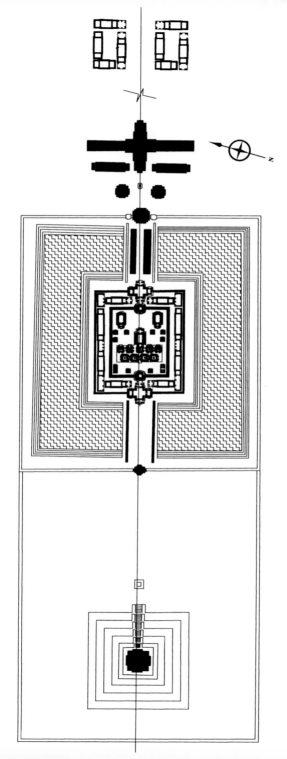

Koh Ker
Site plan of main temple complex

from a single piece of stone): an image of Garuda, the king of birds and mythical mount of the Hindu god, Vishnu, standing inside the entrance of the museum; and two monkeys Sugriva and Bali, engaged in a fierce fight enacting an episode from the Ramayana.

LAYOUT

The capital of Koh Ker occupied a rectangular area of approximately five by seven kilometres (3.10 x 4.34 miles), of which all are not accessible. The monuments of Koh Ker can be divided into three groups by their location: (1) the Prasat Thom complex with a *baray*; (2) the northern group and (3) the southern group. The structures in all three groups were built primarily of brick with the increasing use of laterite and sandstone.

Group 1: a long, processional way (length: 182 metres; 600 feet) at the east flanked by so-called 'palaces' marks the entrance to the Prasat Thom complex (this eastern entrance is difficult to get to presently). Each so-called 'palace' is an unusual configuration of four rectangular galleries, each divided into three rooms. The galleries, which have angular roofs, square columns and windows with balusters, form a rectangle around a small courtyard. Another odd feature of the 'palaces' is that they are not symmetrical. The galleries at the east have porches facing each other, whereas the ones at the south have porches at both ends; and those on the north and west have no porches (see plan). The function of the 'palaces' is unknown. Perhaps they were accommodations for honoured guests or maybe the king used them for religious retreats.

After the 'palaces' and going westward, you come to a large cruciform *gopura* with two galleries; close by, two long, rectangular buildings parallel the *gopura* followed by two small shrines; then you come to the rectangular, laterite enclosure wall, marked at the east by an imposing brick building, **Prasat Kraham**. Next, two balustrades with combined *naga* and *garuda* motifs line the reservoir. The avenue along the dyke is lined with two rows of porticoes. Two successive enclosure walls (one of laterite and one of sandstone), each with cruciform *gopuras* at the east and west, follow. A continuous row of long, laterite buildings with porticoes and windows with balusters stand between the two enclosure walls.

Central area: you have reached the central area; there are 'libraries' on the east and west sides; going west, you come to a terrace with nine brick shrines of unequal size and placement but roughly aligned in two rows east to west (five in the front row and four in the back) and the central sanctuary. A pavilion and a portico precede the

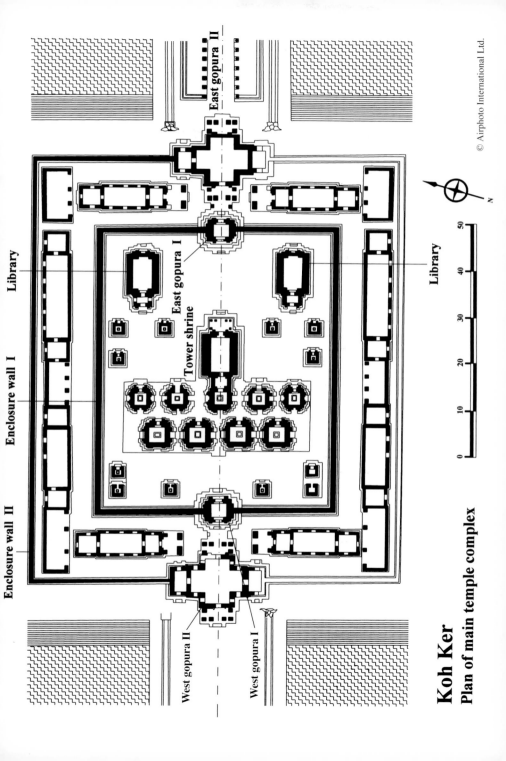

Koh Ker
Plan of main temple complex

© Airphoto International Ltd.

East gopura II

East gopura I

Tower shrine

Library

Library

Enclosure wall I

Enclosure wall II

West gopura II

West gopura I

N

0 10 20 30 40 50

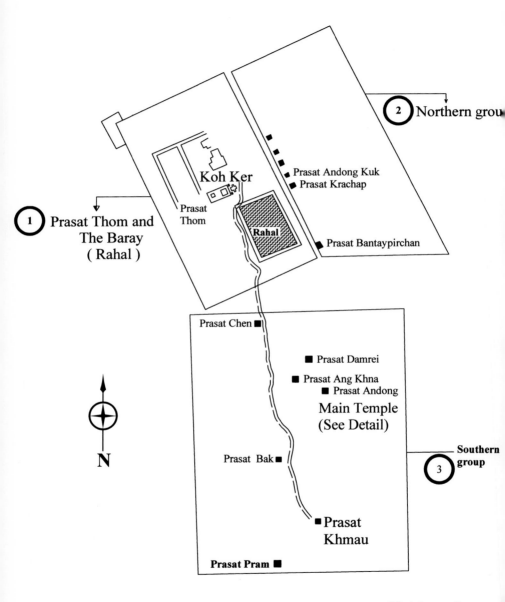

2 Northern grou

Prasat Andong Kuk
Prasat Krachap

Koh Ker

Prasat
Thom

Rahal

1 Prasat Thom and
The Baray
(Rahal)

Prasat Bantaypirchan

Prasat Chen ■

■ Prasat Damrei

■ Prasat Ang Khna
■ Prasat Andong

Main Temple
(See Detail)

Southern
group

3

Prasat Bak ■

N

■ Prasat
Khmau

Prasat Pram ■

Not to scale

Koh Ker

© Airphoto International Ltd.

central shrine, giving it a rectangular shape. Twelve small towers are arranged in clusters of three on ground level around the terrace. In total, there were originally 21 shrines in the central area.

Continuing west, you leave the central area by passing through a *gopura* of the enclosure wall that connects to yet another *gopura* of a second enclosure wall. Then you cross a reservoir with a *naga* and *garuda* balustrade and you will see the spectacular seven-tiered pyramid of Prasat Thom straight ahead. It is located outside the inner enclosure at the western end of a rectangular outer enclosure wall. Oriented to the east, the base is 55 metres (180 feet) square. The pyramid has only one access located at the east. At its apex, according to inscriptions, a *linga* was 'raised to the height of 35 metres [114 feet] [including the pyramid] as an unparalleled wonder.' Henri Parmentier, a French archaeologist, estimated that the *linga* was 4.6 metres (15 feet) high and weighed 24 tonnes. The undecorated tiers of the pyramid forced the eye up to its apex, which once housed the extraordinary *linga*.

Tip: Access up the pyramid is a steep climb by a wooden ladder with a railing but the ladder does not extend to the top; the remainder of the climb is on narrow, unevenly spaced stones. The top level of the pyramid is small but reaching it rewards the climber with panoramic views of the surrounding area and the chance to see remains of what must have been gigantic lions supporting the base for the *linga* mentioned in the inscriptions.

A *baray* called the 'Rahal' located to the south and slightly east of the outer enclosure wall. The enormous *baray* (1,188 x 548 metres; 3,900 x 1,800 feet) may have provided a supply of water for irrigation.

The northern group: a row of square sandstone towers are located northeast of the *baray* and aligned north to south, parallelling the Stun Sen River. At least three of these sanctuaries are easily accessible today by a pleasantly shaded path through the jungle; each sanctuary contains a large *linga* (average height: 2.35 metres; 7.70 feet) that symbolises the union of the three divinities of the Hindu trinity: Brahma by the square base, Vishnu by the octagonal mid-section and Shiva by the hemispherical top. The *lingas* are set in majestic, terraced sandstone pedestals with detailed carving and moulding.

The southern group: a royal highway ran from the northwest corner of the Rahal, south to Beng Mealea and west to Angkor. Square brick sanctuaries (either single or in groups of three) were situated on both sides of this road. They are however, at present, inaccessible.

South palace

North palace

Koh Ker

PREAH KHAN—KOMPONG SVAY

'Grass was head high. We continued our way southwards along a narrow path, which led to the inner gate of Prah Khan. The central courtyard beyond lay behind a huge heap of fallen masonry tangled with jungle plants. The temple of Prah Khan is still a total ruin, and has not, like Angkor, been restored by the French.'

Christopher Pym visited the temple in 1957 and wrote about it in *The Road to Angkor*, London, The Travel Book Club, 1959, p. 157.

Location: Kompong Thom Province; 96.5 kilometres (60 miles) east of Beng Mealea; about 20 minutes from Beng Mealea by helicopter. It is also accessible by four-wheel drive vehicle but this requires a stay somewhere in the vicinity.

Access: from wherever the helicopter is able to land

Date: c. 11th century with additions into the late 12th century

King: probably built by Suryavarman I (reigned 1001–1050) with additions made in the early 12th century by Suryavarman II (1113–1150) and in the late 12th century by Jayavarman VII (reigned 1181–1220)

Religion: Buddhist

BACKGROUND

Preah Khan of Kompong Svay (the name of the district in which it is located) is also known as Preah Khan of Kompong Thom (the name of the province in which it is located, which should not be confused with Preah Khan of Angkor). Preah Khan of Kompong Svay was a vast monastic complex with an exterior enclosure of nearly five square kilometers (1.9 square miles), which is the most extensive site yet found in Cambodia. French scholars place the building of this temple around the 11th century, perhaps during the reign of king Suryavarman I. Preah Khan may have served as his capital. Suryavarman II may have added other parts to the temple in the 12th century.

Magnificent sculpture originally graced the buildings of the great temple of Preah Khan of Kompong Svay. Louis Delaporte, a Frenchman, who was originally a member of the Mekong Exploration Commission, had a mission in Cambodia to take Khmer

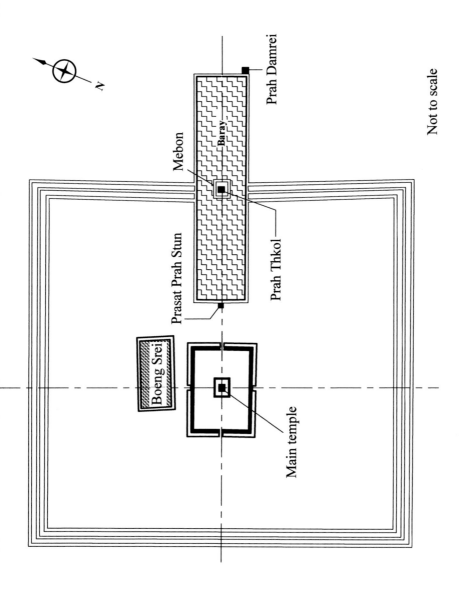

N

Mebon

Baray

Prah Damrei

Prasat Prah Stun

Prah Thkol

Boeng Srei

Main temple

Not to scale

© Airphoto International Ltd.

Preah Khan Kompong Svay

statuary to France to form the first official collection of Khmer art. Delaporte and his team of workers removed many major works of art from this site and others in the late 19th century. The famous stone head believed to be a portrait of Jayavarman VII in his prime was removed from Preah Khan of Kompong Svay and is now in the National Museum of Cambodia, Phnom Penh.

LAYOUT

It comprises a central sanctuary, four enclosure walls, numerous buildings, basins and moats. The exterior enclosure wall is five kilometres square (1.93 miles square), making Preah Khan of Kompong Svay the largest enclosure in Cambodia. A *baray* (2,987 x 518 metres; 9,800 x 1,700 feet) with a shrine in the middle (Preah Thkol) and two 'libraries' was situated at the east. Preah Thkol must have been a spectacular sight with its four chambers and tapering tower, all adorned with sculpted elephants and pediments of faces of the Lokeshvara. Preah Damrei, a square pyramid with a height of 15 metres (50 feet) stood at the southeast bank of the *baray*, whereas Prasat Prah Stun was located on the west bank. The latter was built of sandstone with three porticoes, four corner chambers that formed a cruciform shrine with corbelled vaulting and a gigantic face of the Lokeshvara in each cardinal direction, an architectural theme that was fully developed during the reign of Jayavarman VII in the late 12th to early 13th century. Two cruciform terraces supported by sacred geese precede Prasat Preah Stun.

An eastern causeway leads to another enclosure wall, built of laterite (701 x 1,097 metres; 2,300 x 3,600 feet) with four *gopuras* and surrounded by a moat. Passing through one more enclosure wall takes you to the central, cruciform sandstone sanctuary (collapsed), which stands on a two-tiered platform and has doors in all four cardinal directions. A gallery vaulted in stone with windows opening towards the interior and supporting pillars surrounds it. The central sanctuary is cruciform and oriented to the east standing on an elevated base with two tiers. Two 'libraries' also stand within the complex.

PREAH VIHEAR:
'MOUNTAIN OF THE SACRED MONASTERY'

Location: 100 kilometres (62 miles) northeast of Siem Reap; Si Sa Ket Province, Thailand

Access: from Cambodia by four-wheel-drive vehicle up a steep road that follows a ridge; also possible to access by helicopter from wherever the helicopter lands. Access from Thailand is possible on a smooth road. The temple description here is from east (starting at the entrance in Thailand) to west

Tip: Spectacular views of Cambodia and Thailand from the Dangrek Mountains

Date: construction probably began in the late ninth to early tenth centuries and continued in the mid-12th century

King: begun by Yasovarman I (reigned 889–910); additions made by Suryavarman I (1001–1050) and completed by Suryavarman II (1113–1150)

Religion: Hindu (dedicated to Shiva)

BACKGROUND

Preah Vihear is an imposing temple situated on a promontory of the Dangrek Mountain range (length: 152 metres; 500 feet) and (width: 160 metres; 525 feet) at a height of 657 metres (2,155 feet) above sea level and 547 metres (1,794 feet) from the top to the flatland of Cambodia. Preah Vihear is arguably the most spectacular location of any Khmer site. The natural topography is ideal for an earthly representation of the heavenly cosmos, which the Khmers strove to build and worthy of a temple dedicated to Shiva, the 'supreme being of the mountain'. The temple is unusually oriented to the north, away from Cambodia. Based on the styles of architecture, Preah Vihear was built over a period of some 300 years by various kings.

Following a treaty in 1907 between France (who then administered Cambodia) and Thailand, the temple of Preah Vihear was in Thai territory. Cambodia protested citing that the decision was based on a map in which the borders were incorrectly drawn. The International Court of Justice in the Hague settled the case in 1962 and allocated the temple to Cambodia. The only access, however, (until recently) was from Thailand. And it was only open sporadically for nearly three decades due to the civil war in Cambodia. Today, though, it is open to visitors and accessible by helicopter or in a four-wheel-drive vehicle from Siem Reap and over land. Very basic

These numbers refers to
those in the text

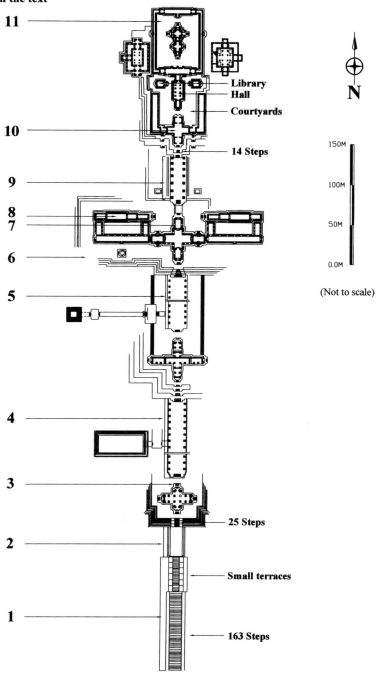

11

Library
Hall
Courtyards

10

14 Steps

9

8
7

6

5

4

3

25 Steps

2

Small terraces

1

163 Steps

150M

100M

50M

0.0M

N

(Not to scale)

Preah Vihear plan A

Entrance

© Airphoto International Ltd.

accommodation is available, such as camping out overnight at an army base, along the way.

You can also reach Preah Vihear from Thailand; it is known as Khao Phra Viharn in Thai.

LAYOUT

Preah Vihear is a long, axial layout extending from south to north and comprises a *baray*, four enclosure walls of progressively increasing height with *gopuras* linked by causeways on the first and second levels; palace buildings on the third level and the main sanctuary on the fourth level. The total length of the ascent from the entrance of the stairway at the north to the central shrine is 800 metres (2,625 feet). Starting at the main entrance at the north and walking to the south, the sites are:

[1] a grand stone stairway that is eight metres (26 feet) wide (at the entrance) and 78 metres (255 feet) long with 163 rather steep steps cut directly into the rock; towards the last third of the stairway the steps narrow with small terraces (and originally lion sculptures) on each side.

[2] a sloping stone-paved platform with low walls on each side (width: 30 metres; 100 feet) and two multi-headed (7) *nagas*; followed by a stairway of 25 steps leading to the *gopura* of the first level.

[3] *gopura*: (in poor condition) cruciform shape built on a high base with four porches and stairways with lions.

[4] a few steps lead to a causeway (ten metres, 32 feet wide; 275 metres, 902 feet long) flanked by 67 square stone pillars (two metres, 6.5 feet high) with stylised lotus-bud capitals; a rectangular reservoir (18 metres, 59 feet wide; 37 metres, 121 feet long) with steps descending to the water lies to the east of the causeway.

[5] a cruciform *gopura* of the second level built on a high base; in the form of a gallery with pillars on the north side and small chambers on all four sides; **pediment, south door:** depicts the Churning of the Ocean of Milk with Mount Mandara as the churning stick and Vishnu in his descent as a turtle at the base; on either side, gods and demons holding the body of the serpent, Vasuki, churn the ocean to obtain the elixir of immortality; a so-called 'lion head' stone-paved reservoir with steps lies to the east at a distance of approximately 50 metres; 164 feet; a stone-paved causeway flanked by 41 pairs of pillars and 29 steep steps flanked by platforms lead to the *gopura* of the third level.

[6] small sandstone tower opening to the east and west (perhaps a later construction).

[7] the cruciform *gopura* of the third level is the largest and most elaborately decorated; it extends to the east and west for a total length of 35 metres (114 feet);

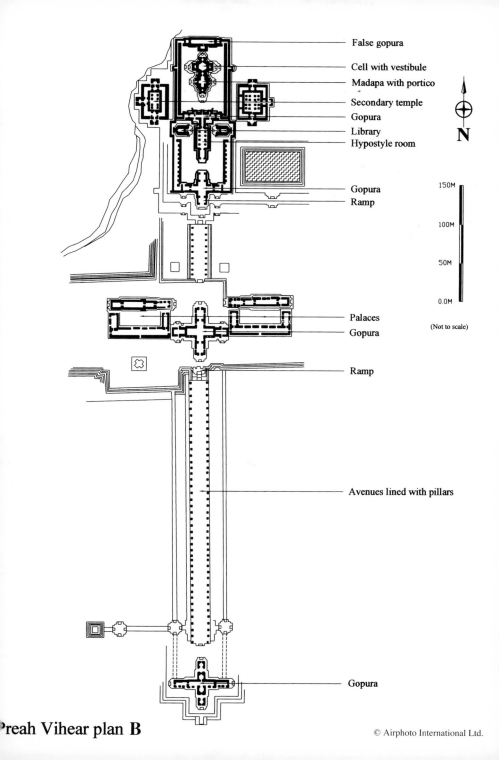

False gopura

Cell with vestibule
Madapa with portico
Secondary temple
Gopura
Library
Hypostyle room

Gopura
Ramp

150M
100M
50M
0.0M

Palaces
Gopura

(Not to scale)

Ramp

Avenues lined with pillars

Gopura

N

Preah Vihear plan **B**

© Airphoto International Ltd.

five structures on a high base make up the *gopura,* which is built of large, thick sandstone blocks and has 12 windows with balusters'; **pediments** (some highlights): [8] the two annex halls are so-called 'palaces' (in poor condition) built on a high base accessed by a steep stairway; each one is oriented east to west and consists of a long room and a smaller one on both ends.

[9] seven steps lead to yet another causeway flanked by a *naga* balustrade and nine boundary-posts on each side.

[10] the cruciform *gopura* of the fourth level has a long extension (originally with pillars) on the east and west sides that runs in a north to south direction; the whole forms an 'L' shape and encloses a courtyard with a hall and a superb rectangular 'library' on each side.

[11] **central courtyard:** the rectangular central courtyard is defined by a surrounding gallery with a *gopura* on the north and south sides; the gallery has a high, corbelled vault with undecorated walls and large windows without balusters; unusually, the gallery has no doors and to get to the courtyard you have to climb through the windows. The central sanctuary is cruciform with a porch preceding it at the morth, a vestibule and a cell with porticoes; gracefully lobed triangular pediments carved with narrative scenes and floral motifs are characteristic of this temple.

Aerial view of Preah Vihear. (Khin Po-Thai)

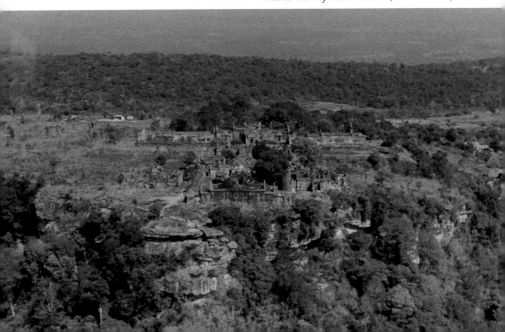

GROUP 13
SITES NORTH OF PHNOM PENH
SAMBOR PREI KUK

Location: Kompong Thom Province; depart from Phnom Penh and go north on National Highway 6 to Kompong Thom (168 kilometres; 104 miles). The temple complex is 35 kilometres (22 miles) northeast of Kompong Thom; 146 kilometres (90 miles) southeast of Siem Reap; the road leading to the site is clearly marked in English on one side and with a billboard-size map on the other side.

Access: the entrance is on the main road at the northeast side of the northern group; have your transport wait for you at the west side of the southern group

Date: first half of the seventh century

King: Isanavarman I (reigned c. 616–635)

Religion: Hindu (dedicated to Shiva)

Art Style: Sambor Prei Kuk

BACKGROUND

The remarkable site of Sambor Prei Kuk (Isanapura 'city of Isana' in inscriptions) affords an opportunity to explore art and architecture at its finest. 'Isana' is a name of the Hindu god Shiva and also of King Isanavarman I. Sambor Prei Kuk, located in the fertile valley of the Stung Sen River, a tributary of the Tonle Sap, was built by Isanavarman I as his capital in the seventh century and dedicated to the Hindu god Shiva. Chinese records identify Sambor Prei Kuk with the ancient capital of Zhenla, a pre-Angkor state dating between the sixth and eighth centuries. Inscriptions testify to the importance of Sambor Prei Kuk or Isanapura, which was one of the largest capitals in the region. Although the site was cleared in the 1960s, jungle rapidly re-engulfed it. Closed for decades, Sambor Prei Kuk is once again cleared and displays intriguing early-period Khmer art. The isolated site is in a beautiful and peaceful jungle setting. Take time to view these captivating ruins.

LAYOUT

An enormous earthen enclosure wall and a moat surrounded the ancient capital and, to the east, are remains of brick temples clustered in three groups—northern, central and southern—that give an impression of this once magnificent and prosperous early centre. Both the architecture and the decoration reflect a strong Indian influence.

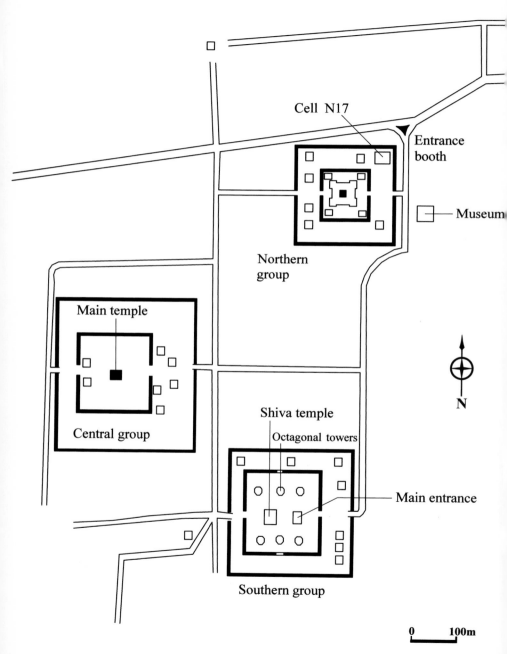

Sambor Prei Kuk

© Airphoto International Ltd.

The structures stand on high platforms and vary in shape. Many are square or rectangular and, others are octagonal, which is the least common form. Each shrine opens at the east and has false doors on the other sides. A typical superstructure consists of recessed tiers with replicas of the tower itself in the centre on each side. On the interior of the towers, there is often corbelled vaulting and indentations that once held timber beams for a ceiling.

The shrines are adorned with doorframes, round columns and finely carved lintels of sandstone and framed by brick pilasters. A decorative lintel rests on the columns, whereas the functional lintel rests on the pilasters. A frieze of garlands with floral pendants around a turban-like form, reminiscent of Indian architecture, adorns the capitals of the columns. Pediments at Sambor Prei Kuk are mainly horseshoe-shaped.

The joints between the bricks are hardly visible and, according to French archaeologists, they were rubbed together until a perfect fit was achieved and adhered with a vegetable-based glue. Then the bricks were carved and a 'coating' was often applied to enable finely detailed decoration.

Bas-reliefs with narrative scenes are an innovation of Sambor Prei Kuk and they were executed in brick, a technique requiring great skill. The decoration reflects an earlier woodcarving tradition and includes so-called 'flying palaces' on the exterior walls of some of the buildings. The name 'flying' palace or pavilion derives from the idea that whenever a god needed to go somewhere to use his power in balancing the good and evil forces of the universe he would travel in a structure that could fly.

Another fine example of carving in brick is seen on the medallions filled with narrative scenes on the interior of the west enclosure wall of the southern group. The scenes are difficult to identify but the naturalistic depictions of human figures and animals, such as monkeys, are unmistakable and they are probably episodes from the great Hindu epic, the Ramayana.

The composition of the lintels is typically a horizontal swag with four arches and three medallions, often containing mythical animals or deities. Indra riding an elephant or a *garuda*, often occupies the centre of the lintel with divinities on horseback on the sides. Mythical sea monsters spewing garlands appear on several shrines, a composition that later became one of the most popular decorative themes for lintels in Khmer art. Festoons of garlands across the lintels are exceptionally delicate.

Before entering the northern group, follow the path to the north of the entrance booth a short distance to see the oldest building of the Sambor Prei Kuk complex, which stands alone both in location and architecture. This unusual structure is small and square with walls made of stone slabs, a flat roof and a single horizontal slab of stone at the foundation. It stands on a moulded base. It is windowless and has one

opening at the west, which is accessed by three steps. A row of carved balusters around the base is both decorative and functional as it allows for ventilation. Four small horseshoe-shaped arches filled with faces are evenly space around the cornice of the building. A similar motif surrounds the base. The architecture and the decoration are derived from Indian woodworking techniques. The function of this building is uncertain although it shares a few similarities with a building of the pre-Angkor period presently located in Ta Keo Province that has been identified as an *ashram*, so perhaps it was used as a hermitage for ascetics.

Following the path a bit further to the north, you will come to a brick shrine that is almost entirely engulfed by the roots of an enormous tree. It is worth seeing just for the harmonious interplay between nature and man.

Northern Group Remains of ten or so buildings in this group are recognisable and construction on them undoubtedly began in the seventh century, but successive kings, after Isanavarman, completed them and made additions. The largest and most impressive part of this group is five shrines elevated on a sandstone base with elegant moulding, The shrines are laid out in a quincunx with one in the centre and one in each of the four corners.

Central Group The structures in this group were probably the last to be built and thus date to the end of the seventh century. Remains of only a single, rectangular building in this group are visible today. Nevertheless, it is an impressive, rather large brick structure (eight by six metres; 26 x 20 feet) standing on a raised base with two entrance staircases flanked by fierce-looking stone lions (restored) on the buttresses of the staircase perched on their haunches with full manes and gaping mouths, who serve as guardians of the temple and also signify the power of the king. Because of the presence of these lions, locals call this shrine 'The Lion Temple'.

Southern Group This group is believed to have been the ancient city of Isanapura, where King Isanavarman established his capital. Two enclosure walls surround the southern group of structures. The entrance to this group is through an elaborate *gopura* with a sandstone canopy of Indian inspiration. Inscriptions mention a golden statue of Shiva with a silver image of his mount, Nandi, the bull, was probably placed under this canopy. The main temple is rectangular with a corbelled vault and faces east. The doorframe and columns are of sandstone, which are, in turn, framed by brick pilasters. This group contains five octagonal shrines inside the first enclosure and eight in the second one. The brick carving on the exterior of these buildings is a fine example of the so-called 'flying palaces', which were used by the gods when they moved from place to place.

Spean Praptos (Praptos 'Bridge')

Location: continue north from Kompong Thom on National Highway 6 to Kompong Kdei; the bridge borders the town of Kompong Kdei; Siem Reap is 60 kilometres (37 miles) further north

Access: you cross the bridge en route to or from Siem Reap

Tip: when you reach the bridge, stop and walk along the path following the bank of the river to the left or right side of the bridge to admire its construction, which was admirably restored by the French in 1964; the drive between Phnom Penh and Siem Reap offers a firsthand view of the countryside and its villages, a lifestyle that is probably similar to daily life in the Angkor Period

Date: late 12th–early 13th century

King: Jayavarman VII (reigned 1181–1220)

Religion: Buddhist

A giant tree, sprouting at The Terrace of the Elephants at Angkor Thom

BACKGROUND

An extensive public works programme initiated by Jayavarman VII included linking Angkor, the administrative, religious and political centre of the Khmer Empire, to the outlying areas of his kingdom. To accomplish this he built a series of raised laterite roads, or so-called highways; spanned the intervening rivers by constructing monumental bridges ornamented with fabulous *naga* (King of the Waters) balustrades; and built rest houses, or stopping places, every 15 kilometres (nine miles) along the roads. These roads and rest houses provided a way for Mahayana Buddhists to make pilgrimages to the great temples, such as Preah Khan of Kompong Svay and Beng Mealea. They were built of sandstone and placed parallel to the road. Examples can be seen today at Banteay Chmar and Preah Khan of Angkor. Each royal road began at one of the five *gopuras* of the enclosure wall of the Royal City of Angkor.

The royal road that includes Spean Praptos began at the south gate of Angkor Thom; proceeded along the western moat of Angkor Wat to the modern town of Siem Reap; then to the north end of the Tonle Sap; parallelled the lake southwards to the modern town of Kompong Kdei. The bridge spans the Chikreng River , which bisects the town. Spean Praptos is the best preserved (though restored) of the bridges built by Jayavarman VII. To cross this bridge and to stop on it and marvel at its construction is one of the highlights of travelling by road between the two destinations.

According to the French savant, Georges Coedes, this royal road made a circuit that extended south of Phnom Penh all the way to Phnom Chisor and then returned to Angkor—for a total distance of 933 kilometres (580 miles).

LAYOUT

The massive bridge is over 87 metres (285 feet) long and 17 metres (55 feet) wide, and it has 21 arches spanning the Chikreng River. Since the corbel arch was the only method of closing a space known to the Khmers, it was also how they built their bridges. The banks of the river near the bridge were faced with stone. This facing extended for 130 metres (426 feet). *Naga* railings flank the sides and multi-headed serpents mark the ends of the bridge. A row of gods on one side and demons on the other hold the scaly body of a serpent.

WAT NOKOR 'PAGODA OF THE CITY'

Location: northeast of Phnom Penh; five kilometres (three miles) from the modern town of Kompong Cham on the west bank of the Mekong River

Access: enter and leave from the east

Tip: the scenes on the pediments depict episodes from the life of the historical Buddha while he was still a prince; as they are not presented chronologically, it is recommended that you familiarise yourself with the story by reading the summary on pages 111–113 before you walk around the temple

Date: late 12th–early 13th century

King: Jayavarman VII (reigned 1181–1220)

Religion: Buddhist

BACKGROUND

Wat Nokor is also known as Phnom Bachey and Preah Chei Preah Ar. An interesting feature of this temple is how the art and architecture have been assimilated and altered to adapt to its use as a Theravada Buddhist temple. It was built in the late 12th or early 13th century and dedicated to Mahayana Buddhism, but sometime after the capital of Angkor moved to Phnom Penh, in the mid-15th century, parts of Wat Nokor were altered to make it more suitable as a Theravada Buddhist temple. The original superstructure of the central sanctuary, which was most likely tall, square and tapered to a lotus shape, was converted to look like a *stupa*, the signature architectural form of Theravada Buddhism.

LAYOUT

The central area of Wat Nokor comprises a square, sandstone sanctuary with porches on all four sides and oriented to the east, and two libraries and narrow galleries of laterite with very large, sandstone *gopuras* at the east and west. The complex included a gallery supported with two rows of square pillars with an enormous *gopura* at the east with three chambers that are separated by two large rectangular halls supported by two rows of square columns; and two laterite, rectangular walls. The temple originally included a basin at the east outside the complex.

Today, a large *vihara*, or area for gatherings of lay people, precedes the original temple at the east. It is a flat, rectangular space built on ground level and supported by round columns. Both the floor and the columns are brightly painted with geometric designs and narrative scenes.

The sandstone pediment on the original central sanctuary at the east is difficult to see because of the *vihara* in front of it and because it has been painted and covered with gold leaf. Narrative scenes while walking clockwise around the temple follow. South pediment—top register: Prince Siddhartha arrives at a river bank in a forest, removes his princely clothes and jewellery to put on the simple robes of a monk and cuts his long, black hair; middle register: he releases his loyal horse and instructs his faithful groom to return to the palace; bottom register: a row of devotees, kneeling with hands together in a gesture of praise and adoration for the future Buddha. West pediment—he is preparing to leave the palace secretly late at night. A grand feast has just finished and before he leaves he looks in on his sleeping wife and son one last time; and—bottom register—he also sees the court ladies and dancers in disarray, having completed their duties and exhausted from the event. North pediment— Prince Siddhartha leaves the palace with his horse and groom (holding the horse's tail); the gods have provided four celestial beings to assist the prince's secret departure by each one holding a foot of the horse to prevent any untoward noise.

Above: *Temple-mountain of Ta Keo.*
Right: *The gardens of the National Museum in Phnom Penh.*

evidence suggests that Angkor Borei was occupied between at least the second century BC and the fourth century AD and may have been the flourishing inland capital of the state of 'Funan' mentioned in Chinese records. A joint archaeological project between the University of Hawaii and the Royal University of Fine Arts in Phnom Penh was launched in 1993 with the objectives of establishing the site's history and determining patterns of land use. A city wall and remains of shrines have been identified but there is not much to see at the actual site but a small museum in the nearby town of Angkor Borei is worth a visit. Architectural finds, sculpture (although many are copies) and pottery from the site are displayed and supported by informative descriptions.

In the dry season, the sites can be reached by road but during the rainy season the delta floods and Angkor Borei and the museum located in the town of the same name and Phnom Da are accessible by boat from Ta Keo town, which is a pleasant ride with fine views of the delta.

Phnom Da, 20 kilometres (12 miles) east of Angkor Borei, is a majestic brick and sandstone temple situated on the slope of a hill. Although the existing temple dates to the mid-11th century, the interior core suggests that it was originally built in the seventh or eighth century. The temple was Hindu and dedicated to Vishnu. The large sanctuary is square with redented corners and opens to the east with false doors on the other three sides. The walls and false doors are of laterite with a brick superstructure. Small projecting porches are also of brick with corbelled vaulting. The doorframes, octagonal columns and pediments are of sandstone. Fine moulding can be seen around the base and upper part of the sanctuary. A remarkable schist sculpture of Vishnu flanked by smaller images of Rama and his brother, Balarama, (now in the National Museum of Cambodia) was found at this site.

Ashram Maharosei ('Monastery of the Great Hermit') is a unique stone sanctuary on the slope of Phnom Da that French conservators have dated to the fifth or sixth century. It is built of basalt stone. The architecture of the ashram is an interesting blend of external influences, derived from temples on the Dieng Plateau in Java and from those in southern India fused with Khmer aesthetic preferences.

The small square structure opens to the east with three receding tiers and a lotus bud finial. The walls are intercepted with windows and a baluster on each side. Fine round columns flank the door with a 'U'-shaped pediment (unfinished) above the entrance. An unusual feature is a high stone wall on the interior of the building.

Inscription on door jamb, east gopura, Banteay Srei.

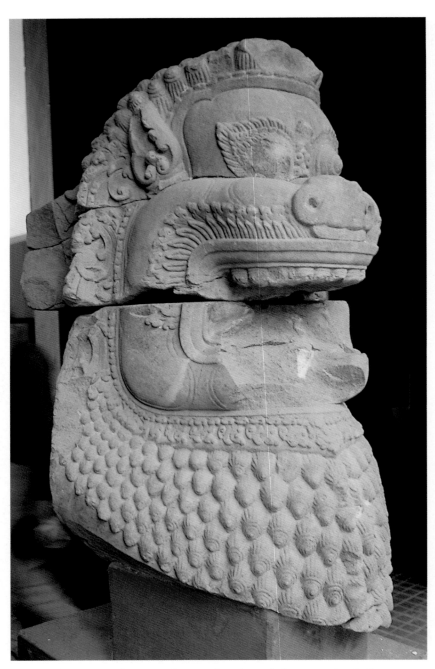

Above: *National Museum, Phnom Penh.* Right: *Hall of Dancers at Preah Khan.*

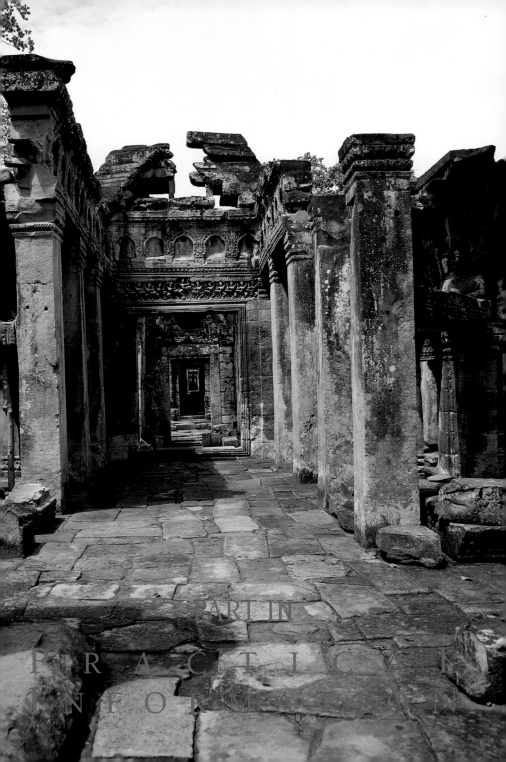

The following practical information is as up-to-date as it could be at press time and was compiled by the publisher.

GENERAL INFORMATION

Cambodia is a constitutional monarchy with His Majesty Preah Bat Samdech Preah Norodom Sihamoni as its head of state. Population is around 12 million, of which some 90 per cent is ethnic Khmer and largely Theravada Buddhist. Khmer is the official language.

CLIMATE

Cambodia is suitable to visit most of the year round and lies in a tropical zone. The best time to visit Angkor is during the cooler months between October and February. From late May or June to late October or early November rain can be expected. Seldom, however, is a complete day ruined by constant rain. It makes going around the Angkor temples somewhat difficult because of muddy paths and slippery stones, but the sandstone monuments are truly beautiful after a rain storm. For those not used to heat and humidity, it should be remembered that Cambodia is in the tropics and even during the cooler months it will still feel very hot. Early mornings in any season, however, are comfortably cool and as sites around Angkor open at dawn, this is a great way to avoid crowds of vistors.

CLOTHING

Lightweight, loose-fitting cotton clothing is recommended and long-sleeved items should be included for protection from mosquitoes and the sun. It is not appropriate to wear very short shorts, nor for men to take off their shirts. Sturdy shoes with good support are recommended for visiting the temples. Hats are also essential protection against the sun.

CURRENCY

The national unit of currency is the riel but the US dollar is widely used throughout Cambodia; small change, however, is usually given in riel. It is forbidden to take riels out of the country. Gold is also circulated in the markets.

There are no restrictions on the amount of foreign currency you can bring in to Cambodia, but any amount over US$10,000 must be declared. The most readily converted currencies are the: US dollar, Thai baht, Japanese yen, Euro and British pound. The value fluctuates slightly, but recent rates have held around 4,200 riels to US$1.

The daily bustle along Sisowath Quay, Phnom Penh.

Payment for domestic air tickets and many hotels and restaurants are often preferred in cash. However, payment with major credit cards is becoming more widely accepted, though a surcharge of two to three per cent is often levied. Most banks will give cash advances from a credit card, and so will several money-changers. Traveller's cheques are not widely accepted, but they can be exchanged in most banks for a two per cent service charge.

CAMBODIAN FESTIVALS & PUBLIC HOLIDAYS

January 1: International New Year's Day. Public holiday.

January 7: Makara Day. Public holiday. Victory Day on Khmer Rouge's regime of genocide in 1979.

February 23: Meak Bochea celebrates the enlightenment of Bhudda with large processions of nuns and monks. Public holiday.

March 8: International Women's Day. Public holiday.

April 13–15: Bonn Choul Chhnam Thmey ('Entering New Year' festival) and Maha Sangran Days (The Great opening of New Year and new god). Cambodian New Year. Public holiday.

May 1: International Labour Day. Public holiday.

May** Bonn Visakha Buchea. Birthday of the Buddha. Public holiday.

May** (on the 4th day after Visakha day) Bonn Chroat Preah Nongkoal. Royal Ploughing Ceremony. Public holiday.

June 18: Commemoration of former Queen Norodom Monineath Sihanouk's birthday. Public holiday.

September 24: Constitution Day. Public holiday.

Late September and Beginning of October ** Bonn Pchum Ben. Ancestral Spirit Re-commemoration Day. On this day people believe their ancestral spirits come to forgive their sins and to receive offerings from families. People make offering to them at *wats* during a 15-day lead-up to Ben Thom (meaning 'Big Offerings'). Buddhist ceremony and public holiday.

October 23: Paris Peace Accord. Public holiday.

October 31: King Norodom Sihanouk (retired) birthday.

November 9: Independence Day. Public holiday.

November** Water and Moon Festival. Public holiday.

December 10: United Nation's Human Rights Day. Public holiday.

**** Please note that the date of this festival depends on the Lunar Calendar**

Low–rise colonial buildings line the muddy Siem Reap River.

USEFUL WEBSITES

A selection of recommended websites by correspondants based in Siem Reap follows:

GENERAL

www.canbypublications.com

Useful sight-seeing and events information by the publishers of free *Visitors Guide* magazines that cover Siem Reap, Phnom Penh and Sihanoukville.

www.dccam.org

Documentation Center of Cambodia puts Cambodian facts and stats at your fingertips.

www.norodomsihanouk.info

The retired Cambodian King's site gives insight on diverse cultural matters as well as on the royal family itself.

www.phnompenhpost.com

Official Website of the country's highly-rated English-language fortnightly magazine.

www.lonelyplanet.com

The backpackers' 'bibles' are augmented by up-to-the-minute news and travel tips on destinations that include Cambodia.

CULTURAL, CONSERVATION AND HIGHER EDUCATION

www.autoriteapsara.org

APSARA (Authority for the Protection and Management of Angkor and the Region of Siem Reap) website tracks its conseravtion efforts—largely of Angkor temple sites, including details on projects undertaken by other international groups.

www.efeo.fr

Cultural findings from the École Française d'Extrême Orient—in French.

www.khmerstudies.org

Site of a Siem Reap-based organisation that promotes the study of Cambodian culture and offers fellowships for research projects.

PERSONAL WEBSITES

andybrouwer.co.uk/home.html

British Andy Brouwer writes the best of the personal sites, packed with tales from his annual travels in the kingdom. A comprehensive links page that includes some travelogues (andybrouwer.co.uk/links.html); Brouwer puts in as much info on temples as contributors submit (which includes Dawn Rooney, the author of this book).

jinja.apsara.org/blog
Cambodia-based Web log by a Web designer. Social and cultural insights are paired with selective events listings.

www.khmerconnection.com
The USA is home to the largest number of Cambodians outside the kingdom. Check out this community's events and concerns on this site.

www.talesofasia.com
Tales of Asia offers recent blogs (website journals) as well as its own useful guide on Cambodia, among other Asian destinations.

USEFUL TOURIST PUBLICATIONS
Cambodia-based Canby Publications publishes three useful quarterly magazines for Phnom Penh, Siem Reap and Sihanoukville. Each has useful practical content on sight-seeing, accommodation, transportation, restaurants and bars and more, as well as excellent localised maps.

TRAVEL TO CAMBODIA
Following Cambodia's adoption of an 'open air' policy in 2000, it is now possible to reach Siem Reap directly from many cities in the region using several different airlines. For example, there are now direct international flights on Bangkok Airways and its subsidiary, Siem Reap Airways, from Bangkok to Siem Reap several times daily, a very easy journey making Angkor a convenient weekend destination from Bangkok. Silk Air flies a round trip via both Siem Reap and Phnom Penh from Singapore. It is possible to fly from Ho Chi Minh City to Siem Reap on Vietnam Airlines; Lao Aviation and Royal Phnom Penh Airways fly from Vientiane. President Airlines also flies daily between Bangkok and Phnom Penh, and twice daily from Siem Reap to Phnom Penh.

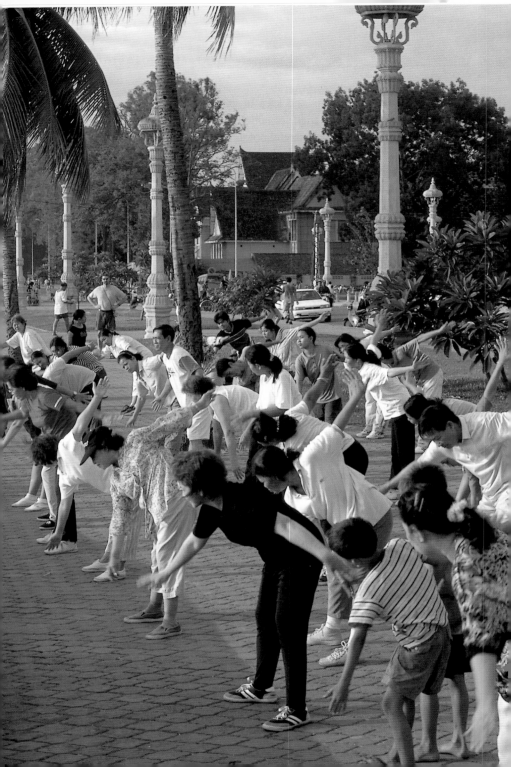

INTRODUCTION TO PHNOM PENH

It was in November 1989 that I made my first trip to Phnom Penh as team leader of the first group of specialists to visit Angkor after the war. I remember arriving in a city that was grey and lifeless; nowhere to stay but a scruffy windowless room in a seedy hotel. As we returned after dinner on our first night, tracer bullets flew over our rickshaws as a reminder that we were in a war-torn country.

The following morning we thought our first outing was to the National Museum; having heard of its famous collection of Khmer sculpture, it was with a sense of excitement we set off in one of the few cars running in Phnom Penh down dusty streets where the stench of garbage and sewage was rife. It was a shock to find that our Government hosts had decided to take us to the Museum of Genocide, Toul Sleng, rather than the National Museum as our first introduction to Cambodia. It brought Cambodia's immediate past history into focus and over the following 12 years these memories have been the driving force behind my work in Angkor.

Over the years, I have had a chance to discover the true Phnom Penh and as the city has been restored and resuscitated and as it has expanded, my image of Phnom Penh today has shifted from a devastated and abandoned city to a city of magnificent colonial buildings, both public and domestic. I marvel, too, at some of the remarkable later architectural masterpieces, such as Central Market, a unique art deco structure completed in 1937, which symobolises the centre of Phnom Penh. But I lament the city's modern sterilisation, as a result of hideous modern Thai-facade architecture and billboards that hide or destroy a unique and relatively unknown city of the East.

As a visitor to Phnom Penh for the first time, there are standard things to do, such as to visit the reminders of the horrors past: Choeung Ek—the Killing Fields Memorial, and Tuol Sleng—the Genocide Museum. The Royal Palace and the Silver Pagoda are great monuments to the recent Khmer monarchy and it is essential to pay respects to Wat Phnom on the hill overlooking the city. However, there are other aspects of Phnom Penh, which I will help you discover.

Starting with Cambodia's recent history; Choeung Ek is a 15-kilometre (nine-mile) drive to the northwest of Phnom Penh. This is a monument to those slain during the Pol Pot regime and is located at one of the many "killing fields" throughout the country. Choeung Ek, formerly a Chinese graveyard, became the site for the brutal executions of those who had endured torture and deprivation in Tuol Sleng. The memorial was erected in 1988.

Working out on the waterfront, Phnom Penh.

Strolling the river banks in central Phnom Penh.

My early memories of Tuol Sleng Museum, formerly Tuol Svay Prei High School that was converted by the Khmer Rouge into S21 Prison, are of a young widow whose husband had been an inmate in the prison. She recalled, with tears streaming down her face, how her husband and the 17,000 other inmates had lived and died under the Khmer Rouge regime. Visiting Tuol Sleng is a profound and depressing experience—its former use as a school and its simplicity as a makeshift prison accentuate the brutality committed. When I visited there was a large map of Cambodia made up of skulls, using thighbones to represent rivers, filling one wall— a gruesome memory which has now been removed.

In strong contrast, the Royal Palace complex has a wonderful mixture of grandeur and trivia. The compound consists of many buildings, the most notable of which is the Silver Pagoda, where wealth in the form of precious objects and cultural treasures are on view. Of particular note is the Emerald Buddha made of Baccarat crystal set on a high gilded pedestal, in front of which stands a life-sized gold Buddha weighing, it is claimed, 90 kilograms. The image, which is studded with over 9,500 diamonds, was made in the palace workshop in 1906 and is a fine example of the skills of Khmer

craftsmen at the turn of the 20th century. If possible seek out the great bull Nandin; it is kept in a small shrine called the Library, which also contains an important collection of Buddhist texts and is close to the entrance. This amazing piece of sculpture, which is over one metre long, was excavated from a field in Kandal Province in November 1983 and is said to be of the Angkorian Period and is 80 per cent silver and 20 per cent bronze alloy. It is truly a remarkable work of art and much revered by the local community. Enclosing the Silver Pagoda compound is a gallery which contains wall paintings depicting the *Ramayana*, painted around 1900. These paintings have suffered from the effects of humidity and some restoration work has been undertaken by a Polish atelier to prevent rising damp by inserting a lead damp-proof course into the wall. The paintings, although damaged, are of very fine quality and worth a closer study.

Legend has it that in 1372 Yea Penh fished a floating log from the river and discovered four images of the Buddha inside it. These images were placed on the *phnom* or hill and thus the city was founded. After the royal family moved from Angkor in the mid-15th century they relocated at Lovek and Udong. It was only in 1866 that the capital was moved to Phnom Penh. Today the *phnom* and its *wat* are a great attraction to both locals and foreign visitors: the locals believe their wishes will come true if requests are made to the Buddhist images here, whether for exams, business or love. If a wish is granted the recipient returns to make offerings of flowers and bananas, favourites of the local spirits. There is also a practice to liberate caged birds that are 'captured' by locals and sold to those wishing to liberate a spirit or requesting a wish; I am convinced the birds once released are trained to return each night to roost in their original cages.

The National Museum is one of my favourite museums in Asia. Not only does it have an extensive and significant collection of Khmer sculpture, but the building itself adds a special low-key charm to the experience of viewing the very fine collection of Khmer sculpture. The Museum was built in 1919, to the design of Georges Groslier, the father of Bernard Philippe Groslier who was the last of the French curators at the Conservation d'Angkor in Siem Reap. Until recently, the museum was a home to millions of bats and many people will recall their dusk exodus, like smoke from a burning house, to cull the mosquitoes of Phnom Penh. We are informed they have taken up new residence in caves in the Cardamom Mountains to the west of Phnom Penh.

The role water plays in Cambodia is difficult to understand without a boat trip on the rivers of Phnom Penh. As with Angkor, Phnom Penh was settled because of its proximity to water—three rivers influence the city. An unusual natural phenomenon

'TS DE

que je t' ai
:nne.
ant des
est

e qui

sans

:ommis à
s non

. il est

ordres,
:

chea

:ssus, vous
ectrique
s

uets,

THE SECURITY OF REGULATION

1- You must answer accordingly to my question-Don't turn them away .

2- Don't try to hide the facts by making pretexts this and that

. . You are strictly prohibited to contest me .

3- Don't be a fool for you are a chap who dare to thwart the revolution .

4- You must immediately answer my questions without wasting time to reflect .

5- Don't tell me either about your immoralities or the essence of the revolution.

6- While getting lashes or electrification you must not cry at all.

7- Do nothing, sit still and wait for my orders . If there is no order , keep quiet . When I ask you to do something , you must do it right away without protesting

8- Don't make pretext about Kampuchea Krom in order to hide your secret or traitor.

9- if you don't follow all the above rules , you shall get many many lashes of electric wire .

10- if you disobey any point of my regulations you shall get either ten lashes or five shocks of electric discharge .

English translation of prisoner regulations at the site of former Khmer Rouge prison at Tuol Sleng.

takes place at the point where the Mekong, the Sap and the Bassak rivers all meet (see The Mekong River, p.25). When the flow reverses—sometime in November, the flood waters in the Sap River rush past the Royal Palace embankment, and provide the backdrop to an amazing cultural spectacle of traditional boat races with crews of up to 36 oarsmen riding the river's current.

At the end of a day, it makes ideal relaxation to take a boat trip and to circle the point of confluence to see the three rivers and experience their power as the sun sinks, usually in a fiery ball behind the palace; and to watch the local community seek their evening catch by casting their nets in the ebbing tide. Their stilted houses form small clusters along the river bank and, from these stilts, you can measure the enormous rise and fall of these rivers (see Cambodian Water Festival, p.27).

The shopping experience in Phnom Penh is a must for those who enjoy bargain-hunting. Prime locations are the many different markets or *phsars*. The Russian Market, *Phsar Toul Tom Poung*, so-named because it was the traditional haunt of the greatest bargain hunters—the Russians—is the most popular. The deeper you penetrate this rabbit warren of small stalls the more you find. Everything from an amazing collection of Khmer and Chinese crafts silks, to pirated CDs and DVDs and all kinds of brand-name clothing. You can kit yourself out with a complete wardrobe for under US$20.

Other than the Independence Monument—designed by highly respected Khmer architect Vann Molyvann, the doyen of the architectural movement in Cambodia, who was later to be the first to campaign for the safeguarding of Angkor—the other great monument of the art deco movement in Phnom Penh is Central Market. Just to walk in and experience this vast cathedral-like open space buzzing with activity will be a lasting souvenir of Phnom Penh. One day, hopefully the clutter of little stalls clogging the entrances will be removed to reveal the building in all its former glory.

There are only a few *quartiers* left that typify the original French Colonial ambience. Many of the remaining old buildings have been turned into fine restaurants. Along Sisowath Quay, which in former days was a squatters' paradise, the embankment has been cleared and turned back into a promenade. Old colonial buildings can still be found, in contrast to modern development, and several have been converted into bars or restaurants. The most notable hostelry is the Foreign Correspondents Club of Cambodia (FCCC) located in an airy upper-floor space overlooking the Sap River (an ideal spot to view the boat races). There is always a bustling crowd of people there enjoying the food and drinks, all of which are very reasonably priced.

Remnants of colonial architecture survive in and around the Royal Palace and the Royal University of Fine Arts. Again, many small cafés and bars have squeezed into

the ground and first floors of former dwellings providing an intimate atmosphere with good food and wine as well. Try The Shop for lunch and indulge in its wonderful Belgian *gâteaux* and *chocolat* or the upper-storey Tamarind Restaurant close by, an elegant hideaway with excellent fare. As you drive along spacious Norodom Boulevard, you will see many stately colonial mansions that have been restored; and in the maze of streets leading south towards the river are the remnants of shop fronts and domestic terraces that have become shops or bars.

If you revel in nostalgia, stay at, or at least visit, the Hotel Royal, carefully refurbished by the Raffles Group to its original elegant colonial style. Its hotel rooms radiate low-key luxury and the Elephant Bar, the haunt of the media during the Khmer Rouge time, has many ghosts both good and bad and a well-stocked bar.

Do not, like so many visitors do, bypass Phnom Penh because there are direct flights to Siem Reap from Bangkok, Hong Kong, Shanghai or Singapore. Spend at least a day or two there, inhaling the feel of Cambodia and learning her culture. Experience a trip on the rivers and get a sense of their importance to the development of the Khmer empire and spend a half day studying the sculptures of Angkor at the National Museum, so when you reach the temples you can begin to place these wonderful works of art in context remembering, not too many decades ago, most of them were in their original location or buried close by.

—*John Sanday, OBE*

Below: *Royal Palace, Phnom Penh.*
Right: *A typical street in Phnom Penh today, which blends the past with the present.*

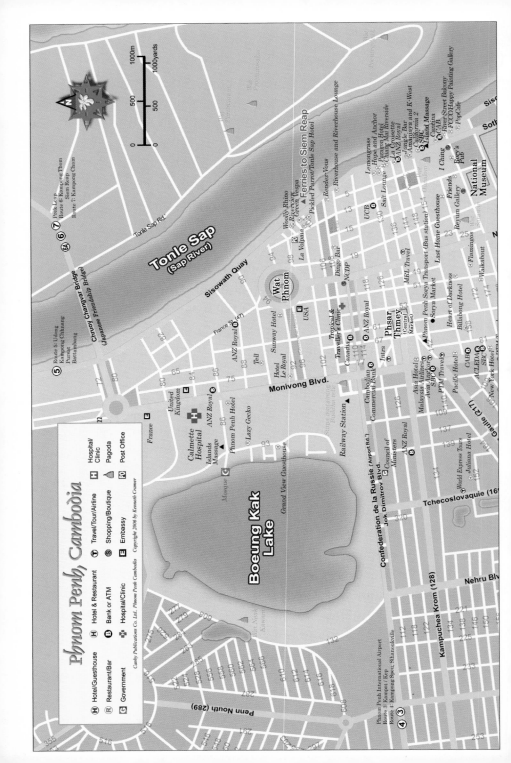

Phnom Penh, Cambodia

Legend:
- Ⓗ Hotel/Guesthouse
- Ⓡ Restaurant/Bar
- Ⓖ Government
- Ⓗ Hotel & Restaurant
- Ⓑ Bank or ATM
- ✚ Hospital/Clinic
- Ⓣ Travel/Tour/Airline
- Ⓢ Shopping/Boutique
- Ⓔ Embassy
- ✚ Hospital/Clinic
- ⚑ Pagoda
- Ⓟ Post Office

Canby Publications Co. Ltd. Phnom Penh Cambodia Copyright 2006 by Kenneth Cramer

1000m / 1000yards
500
0

Tonle Sap (Sap River)

Boeung Kak Lake

Wat Phnom

Sisowath Quay

Monivong Blvd.

Confederation de la Russie (Airport Rd.)
Jok Dimitrov Blvd.

Kampuchea Krom (128)

Nehru Blvd

Tchecoslovaquie (16)

Gaulle (211)

Penn Nouth (289)

Tonle Sap Rd.

Chruoy Changvar Bridge (Japanese Friendship Bridge)

Calmette Hospital

Phnom Penh Hotel

United Kingdom

France

Grand View Guesthouse

Islands Massage

Lazy Gecko

Mosque

Railway Station

Council of Ministers

Cambodian Commercial Bank

Sunway Hotel

Hotel Le Royal

Tropical & Traveller's Clinic

Canadia

USA

Dingo Bar

NCDP

Intra

Phsar Thmey (Central Market)

Woolly Rhino
Riverview
Green Vespa
Pickled Parrot/Tonle Sap Hotel
Rendez-Vous

Ferries to Siem Reap
Riverhouse and Riverhouse Lounge

Lemongrass
Hope and Anchor
Paragon Hotel
Salt Lounge
Chang Mai Riverside
La Volpaia
La Croisette
AZ Royal
Jungle Bar
Amanjaya and K-West
California 2
Cantina

Sand Massage
CAB
FCCC/Happy Painting Gallery
PopCafe
River-Street Balony

UCB

MRL Travel

Last Home Guesthouse
Reyum Gallery
Friends
I Ching
Rory's Pub

National Museum

Walkabout
Flamingos

Heart of Darkness
Billabong Hotel

Phnom Penh Sorya Transport (Bus station)
Sorya Market

ACLEDA
SBC
CAB

Asia Hotel
Malaysia Airlines
Avia Aigle Azur
PTM Travel
Pacific Hotel

New York Hotel

World Express Tours
Juliana Hotel

Phnom Penh International Airport
Route 3: Kampot / Kep
Route 4: Kampong Speu, Sihanoukville

Route 5: Udong, Kampong Chhnang, Pursat, Battambang
Route 6: Kampong Thom, Siem Reap
Route 7: Kampong Cham
Prek Leap

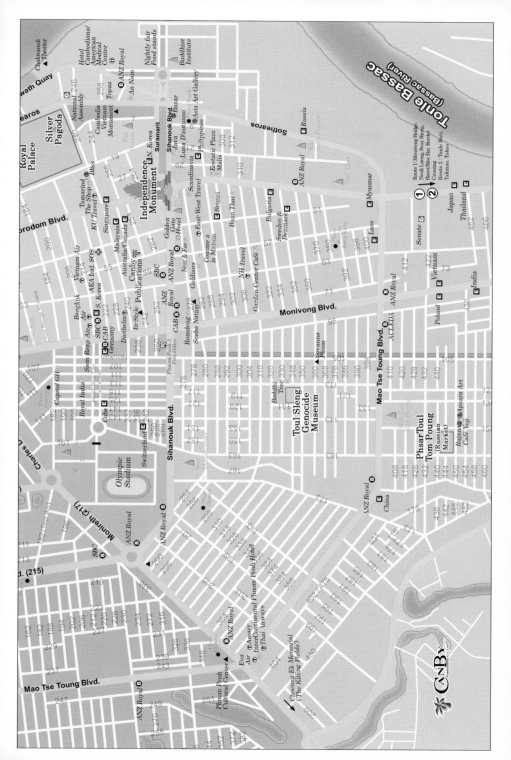

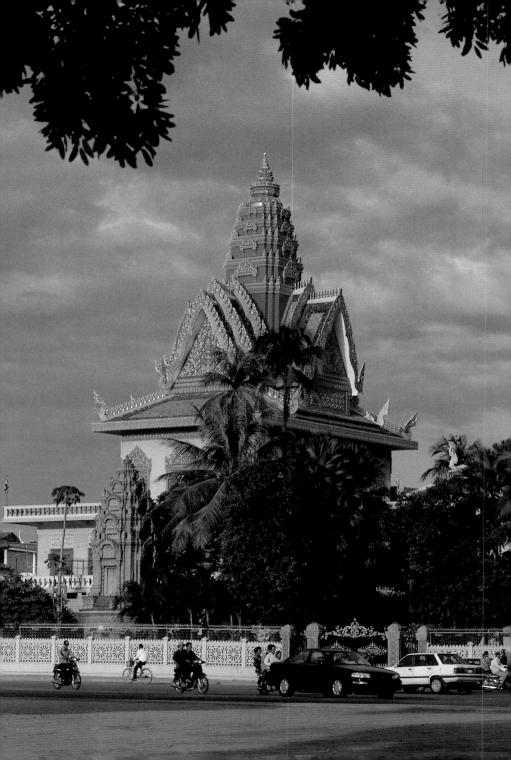

PHNOM PENH

It is recommended you stay at least one night in Phnom Penh as it has several points of interest. The main one for those going to Angkor is the National Museum, which houses the most extensive and finest collection of Khmer art on public display anywhere in the world. The Cambodian capital has a population of some 1.2 million, is very much a city in transition and it gives a visible historical insight into the country's past.

HOTELS

The following is a selection of Phnom Penh hotels. We have listed a predominantly four- and five-star selection here. For the independent-minded, view further options at these websites: www.smarttravel.com, www.asiahotels.com, www.orientaltravel.com, www.zuji.com.hk.

LUXURY

The upper end of the hotel market in Phnom Penh is limited but improving.

Intercontinental Regency Square 296 Mao Tse Tung Boulevard. Tel: (023) 424 888; Fax: (023) 424 885. Phnom Penh's newest and smartest hotel with a sprawling pool terrace. Its clean-lined architecture is interspersed with replicas of ancient Khmer art. Prices range from US$170–US$1,500.

Raffles International Le Royal 92 Street, off Monivong Boulevard. Tel: (023) 981 888; Fax: (023) 981 168. Completely refurbished to its original celebrated French colonial style with all the amenities of a luxury hotel. Rooms range from around US$260–US$2,000.

Himawari Hotel Apartments 313 Sisowath Quay. Tel: (023) 214 555. Originally called Mi Casa, it is ideally situated right on the banks of the Mekong River, only 10 kilometres from the International airport and within five minutes walk to the Royal Palace and the National Museum. Popular with visiting long-stay consultants. Rooms range from US$115 upwards.

UPSCALE

Amanjaya Pancam Hotel 1 Street 154 Sisowath Quay. Tel: (023) 214 747; Fax: (023) 219 545. Email: amanjaya@online.com. Website: www.amanjaya.com. Surrounded by the city's best cultural and historic sites, this boutique hotel with river-view balconies, has 21 exquisitely decorated suites and rooms with hardwood floors that contain Cambodian rosewood furniture and silk fabrics. Prices range from US$95–US$215.

Imperial Garden Villa and Hotel 315 Sisowath Quay. Tel: (023) 219 991; Fax: (023) 219 992. Superior rooms and villa's overlooking the river. Swimming

Wat Qunalom in Phnom Penh.

pool, tennis, health club. Prices range from US$70–US$400.

Phnom Penh Hotel 53 Monivong Boulevard. Tel: (023) 991 868; Fax: (023) 991 818. Email: vannak@phnompenhhotel.com. Website: www.phnompenhhotel.com

Sheraton Cambodia 47 Street. Tel: (023) 426 773; Fax: (023) 426 858. Relatively new property with swimming pool, business centre and nightclub. US$100–US$130.

Sofitel Cambodiana 313 Sisowath Quay, Tel: (023) 426 288; Fax: (023) 426 392. The first of the new era of modern hotels overlooking the river confluence, with international facilities. US$120–US$400.

Sunway Hotel 192 Street (near Wat Phnom). Tel: (023) 430 333; Fax: (023) 430 339. US$160–US$240. Popular, well-equipped hotel with business centre.

LOW–MID–PRICE
There is an abundance of places to stay in this bracket.

Bougainvillier Hotel & Restaurant 277G Sisowath Quay. Conveniently situated on the Quay and a short distance by foot to the National Museum and the Royal Palace. The rooms in this small hotel are delightfully decorated and contain all conveniences. Restaurant serves Khmer and French dishes. Friendly staff.
Tel: (023) 220 528; Fax: (023) 220 529. Price range US$35–US$60.
Email:bougainvillierhotel@bougainvillierhotel.com

Diamond 172–184 Monivong Boulevard. Tel: (023) 217 326; Fax: (023) 216 637. US$40–US$60. One of the better establishments in this range.

Goldiana 10 282 Street. Tel: (023) 219 558. US$20–US$25.

Golden Gate Hotel 9 Street 278 (just off Street 51). Tel: (023) 721 161. Fax: (023) 427 618. US$15–US$40. Loyal following, clean and safe.

New Lapaillote Hotel No. 234 Street 130, Phsar Thmey3, Daun Penh. Tel: (023) 992 038. US$25. Accepts VISA and MC credit cards. Email: newlapaillote@yahoo.com.

Paragon Hotel, 219B Sisowath Quay. Nice waterfront location, from US$15. Tel: (023) 222 607. Email: info_paragonhotel@yahoo.com.

Paris I 154 Street, Tel: (023) 426 724. US$40–US$50.

River-Star Hotel Restaurant & Tours 185 Corner Sisowath & Street 118. Tel: (023) 990 501–3. Email: reservation@riverstarhotel.com. Website: www.riverstarhotel.com. US$18–US$29. With attractive balconies on the top floor.

Renakse 40 Sothearos Boulevard, opposite the Royal Palace. Tel: (023) 422 464; Fax: (023) 426 492. US$10–US$50.

Singapore Monivong Boulevard. Tel: (023) 425 552; Fax: (023) 426 570. US$15–US$20.

Star Royal Hotel 383 Sisowath Quay. Tel: (023) 219 443; Fax: (023) 218 476. US$35–US$60.

BUDGET

There are scores of budget priced accommodations in the capital, particularly near the independence monument, Central Market, the river and Boeung Kak Lake.
Boddhi Tree Guesthouse 50 Street 113. Tel: (023) 865 445. US$6–US$12. Good restaurant with fresh healthy food.
California 2 Hotel 317 Sisowath Quay. Tel: (023) 982 182. US$15–US$17. With a restaurant specialising in Baja-style burgers, tacos and Khmer food.
Capitol Guesthouse 14, Street 182. Tel: (023) 724 104; Fax: (023) 214 104. US$2–US$12. The original backpacker guesthouse with tourist information and a restaurant.
Golden Bridge and **Golden Sun** (both have varying price, from US$15–US$40; are safe, quiet and inexpensive), near Wat Lanka. Tel: (023) 721 396.
Grandview Guesthouse On Boeung Kak Lake, left at the mosque. Tel: (023) 430 766.
L'Imprevu Six kilometres past Monivong Bridge, Route 1. Tel: (023) 360 405. US$8–US$15. Bungalows with good facilities, especially for children.

RESTAURANTS

There is a reasonable variety of Cambodian and international cuisines available, most at affordable prices. Sisowath Quay is the main restaurant area.
An Nam 18 Sothearos Boulevard next to the Hong Kong Centre. Well presented central Vietnamese cuisine. Open 8.30am–11pm. Tel: (023) 212 460.
Baan Thai South of the independence monument, set in a garden, Thai-house style. Open 11.30am–2pm. 2 Street 306. Tel: (023) 362 991.
Bamboo House On 46 Sihanouk Boulevard, near Psah Kapko. Long established Filipino restaurant, also serving international cuisine. Open 9am–11pm. Tel: (012) 841 302.
Comme a la Maison French restaurant serving a la carte and specials. There is a shop selling baked goods and a charcuterie, as well as a take-away service. An online menu allows orders to be phoned in before you arrive. 13 Street 57. Tel: (023) 360 801. Website: www.commealamaison–delicatessen.com.
East India Curry Good, popular Indian food, indoor seating with aircon. Open 11am–2pm and 5.30pm–10.30pm. 9 Street 114. Tel (023) 305 151.
Foreign Correspondents' Club of Cambodia (FCCC) 363 Sisowath Quay. Open to non-members, with a bar and restaurant overlooking the Tonle Sap-Mekong confluence, this is one of Cambodia's most popular places to eat International cuisine and drink. Open 7am–12am. Tel: (023) 724 014. Website: www.fcccambodia.com.
Freebird American-style restaurant grill and bar that won a Phnom Penh 'restaurant of the year' award for 2005. It also provides laptop hook-ups and a mini-mart. Open 7am–Midnight. 69 Street 240. Tel: (023) 224 712.

Friends This non-profit tapas restaurant is run by street youth-in-training with all profits made going into the Friends charity. Open 8am–8pm. Located 215 Street 13. Tel: (023) 426 748. Website: www.streetfriends.org.

Garden Bar Corner of Street 148 and Sisowath Quay. Curbside setting overlooking river with draft beer and international fare.

Garden Center Café Long established restaurant doubling as a café in a garden setting. It serves very good Western and Asian dishes and guests can eat while listening to the soothing sound of running fountains. Open from 7am–9pm; closed Mondays. 23 Street 57. Tel: (023) 363 002. Website: www.gardencentercafe.com.

Hope & Anchor Guesthouse and Riverside Bar, 213 Sisowath Quay—at the corner of Street 136. Tel: (023) 261 167. Website: hopeandanchor-cambodia.com.

Le Duo Restaurant and Pizzeria Excellent Italian restaurant with an ever-popular wood fired pizza oven. It has a menu with everything you could ask for, including French specialties and an extravagant dessert menu which provides a perfect climax to a delicious meal. Open 11.45am–2.15pm and 6.15pm–10.15pm (closed Wednesday lunchtime but open evening). 41 Street 322. Tel: (023) 991 906.

Mex Mexican eatery next to the Independence monument on Norodom Boulevard. No telephone.

Pacharan Tapas and Bodega This restaurant and bar produces some of the tastiest Spanish food in Phnom Penh, situated in a uniquely decorated bar and restaurant on an upper floor, overlooking the river. There is a full bar serving draft beer and an assortment of spirits. Located on the corner of Sisowath Quay and Street 184 (entrance on Street 184). Tel: (023) 224 394. Email: pacharan@fcccambodia.com.

Paragon Hotel, 219B Sisowath Quay. Tel: (023) 222 607. Email: info_paragonhotel@ yahoo.com.

Ponlok Seafood Popular Chinese establishment at 319 Sisowath Quay. Tel: (023) 212 025.

The Shop Service and its fresh daily breads and pastries available in this stylish deli are impressive. The Shop provides an excellent home and office delivery service, which also includes special cake orders. Open 7am–7pm. 39 Street 240. Tel: (023) 986 964. Website: www.theshopcambodia.com.

Red Hibiscus Steak House & Grill, 277C Sisowath Quay, Reasonably priced guest rooms at the small hotel upstairs. Tel: (023) 990 691. Website: www.redhibiscus.biz.

The River House International Delicious Middle Eastern dishes in this popular restaurant located on the quay. Thai-owned and managed. 6E Street 110 & Sisowath Quay. Tel: (012) 821 259.

Tamarind Restaurant and Bar A special hideaway with delicious food, ranging from, classical French fare to Tapas and North African specialities, served in a delightful French colonial atmosphere. 31 Street 240. Tel: (012) 830 139.

NIGHTLIFE

Warning: A night on the town in Phnom Penh can lead you to some rather questionable places, so it is always wise to be very aware of what you are getting your self into because in Phnom Penh there is everything from the posh to the sleaze and an ability to cater for everyone's need. Although many good times can be had within the city's nightlife, it is important to keep your wits about you. Many travellers have had problems by becoming involved with the 'girls of the night' or even the young Khmer elite who are heavily connected with the most popular night spots.

Over the years Cambodia has rightly so received a lot of bad press relating to the sex trade. This sex trade has mostly originated as a result of poor provincial families who have kept their sons working on their farms while sending there daughters to the big city to make some money. Often, these poor girls are sold off to prostitute traffickers and they end up in neighbouring countries. In Cambodia the combination of "taxi girls", as they are known here, and excessive drinking can lead to explosive situations, which can spell disaster.

The overwhelming difference between the nightspots in Siem Reap and Phnom Penh is the intermixing between locals and tourists in the latter. Phnom Penh has a lot more wealthy young Khmers from moneyed army and political families, who are not to be trifled with. Nevertheless, there are plenty of fun and reputable places where you can have a good time, full of the diversities to be expected in the capital city of a fast developing economy; and with new found oil reserves off the Cambodian coast, things are likely to keep rocking.

BARS/CLUBS

Dingo Bar Aussie bar with a casual and relaxed atmosphere. There are live sports on TV and good pub grub, US$1 Beer and US$2 spirit mixers; a great place to watch a good game. Open 4pm–2am. 34 Street 148. Tel: 012 303531. Website: www.dingobar.com.
Elephant Bar A very elegant and sophisticated bar located in the Raffles Hotel Le Royal. It is a must-see place on account of the elephant-theme décor and the combination of a billiards table and two drinks for the price of one during happy hour (4pm–9pm). Open 12pm–12am. Street 92 inside the Hotel Le Royal. Tel: (023) 981 888.
Foreign Correspondents' Club of Cambodia (FCCC) Phnom Penh One of the original river-front bar and restaurants that always has a crowd of tourists, so is a

great place to meet like-minded people. The FCCC also showcases many photo and art exhibitions, that are always worth checking out. See restaurant listings. Open 7am–Midnight (happy hour 5pm–7pm). 363 Sisowath Quay. Tel: (023) 724 014.

Freebird See restaurant listings. Open 7am–Midnight. Located 69 Street 240. Tel: (023) 224 712.

Green Vespa Popular little Irish bar has a regular following because of generously-sized food portions and wide selection of music, beer and sprits—the key ingredients for a good bar. Friday happy hour features a unique "pour your own shot" concept. Open 6am–Late. 95 Sisowath Quay. Tel: (012) 887 228.

Heart of Darkness One of the most popular nightspots in Phnom Penh. Recently reopened after extensive renovations, it is now bigger and better than ever. International DJs feature every Saturday night, and play a wide range of dance genres. The Heart and the other nearby nightspots are very popular among the elite Khmer crowd and taxi girls. It is important to exercise caution in such places. Open 8pm till late. Located 38 Street 51.

The Martini Another well-established night spot with more of a disco atmosphere and a popular beer garden. It also provides big TV screens and three pool tables, along with international DJs every Friday and Saturday night. Open 7pm–3am. Located 45 Street 95. Website: www.martini–cambodia.com.

Shanghai Bar With its half-price drinks between 4pm and 7pm, you can understand why this is so popular. But the Shanghai is also a late-night haunt with a friendly atmosphere, pool table, big-screen TV and garden terrace with a new tapas menu. Open 4pm–Late. Located on the corner of street 51 and 172. Tel: (012) 804 836. Website: www.shanghaibarcambodia.com.

BANKS

Most banks are open between 8am and 3.30pm, Monday to Friday. Some are open on Saturday mornings until 11.30am. Money-changers can be found in abundance around Sisowath Quay and across the city. The ANZ bank has opened several ATM facilities—one can be found on Sihanouk Boulevard.

TRANSPORT

Taxis, motos (motorbike taxis) and rickshaws are available outside many of the capital's hotels and tourist spots.

Reputable Personal Drivers Mr Oum Sam Ol, 2E, Street 360, Sangkat Boeung Keng III, Khan Chankarmon. Tel: (012) 845 541. Email: mr-samol@yahoo.com.

Mr Sothon of the Taxi Association of Phnom Penh. 8 Russian Boulevard, Sangkat Kakap, Khan Dangor. Tel: (012) 846 507.

Mekong Express This is the best of the bus services that can take you to destinations outside of Phnom Penh. Two services run every day to Siem Reap taking between five and six hours and cost US$9. Tel: (023) 427 518/(012) 787 839. Located on Sisowath Quay.

USEFUL ADDRESSES

EMBASSIES

Australia Villa 11, Street 254. Tel: (023) 213 470.

Belgium 6 Street 306. Tel: (023) 367 404.

Bulgaria 227 Norodom Boulevard. Tel: (023) 723 182.

Canada Villa 11, Street 254. Tel: (023) 213 470.

China 256 Mao Tse Tung Boulevard. Tel: (023) 720 922.

Cuba 98 Street 214. Tel: (023) 368 610.

Denmark 8 Street 352 (023) 987 629.

France 1 Monivong Boulevard. Tel: (023) 216 381.

Germany 76–78 Street 214. Tel: (023) 216 381.

India 777 Monivong Boulevard. Tel: (023) 210 912/ 210 913.

Indonesia 90 Norodom Boulevard. Tel: (023) 216 148.

Japan 75 Norodom Boulevard. Tel: (023) 217 161/ 217 164.

Laos 15–17 Mao Tse Toung Boulevard. Tel: (023) 983 632.

Malaysia 5 Street 242. Tel: (023) 216 176/ 216 177.

Malta 10 Street 370. Tel: (023) 368 184.

Myanmar 181 Norodom Boulevard. Tel: (023) 223 761.

North Korea 39 Suramarit Boulevard. Tel: (023) 217 013.

Philippines 33 Street 294. Tel: (023) 215 145.

Poland 767 Monivong Boulevard. Tel: (023) 217 782/ 217 783.

Russia 213 Sothearos Boulevard. Tel: (023) 210 931.

Singapore 92 Norodom Boulevard. Tel: (023) 360 855.

South Korea 64 Street 214. Tel: (023) 211 901.

Sweden 8 Street 352. Tel: (023) 212 259.

Switzerland 53D Street 242. Tel: (023) 219 045.

Thailand 196 Norodom Boulevard. Tel: (023) 363 870.

UK 27–29 Street 75. Tel: (023) 427 124.

USA 27 Street 240. Tel: (023) 216 436.

Vietnam 426 Monivong Boulevard. Tel: (023) 362 531.

The National Museum of Cambodia

The National Museum of Cambodia houses the largest collection of Khmer art in the world and is internationally renowned for its stone and bronze sculpture. The stately, courtyard building is located in the heart of Phnom Penh near the Royal Palace and looking towards the Tonle Sap River. The building, designed by Georges Groslier and experts from the Cambodian School of Arts, was inaugurated in 1920 by His Majesty King Sisowath of Cambodia and named the Albert Sarraut Museum in honour of the French Governor-General of Indochina. French curators managed the museum until 1951, when it was turned over to the Cambodian government and in 1966 the name was changed to the National Museum of Cambodia.

The architecture blends Eastern and Western styles. The imposing red façade, carved gables, tiered roofs and graceful finials replicate Khmer style, whereas the interior of the museum is reminiscent of southern Europe with an abundance of natural light created by galleries surrounded by a colonnade that opens onto a courtyard with four lotus ponds. Access to the museum is by a central staircase, flanked at the base by a pair of stone lions. The main monumental teak wood doors are decorated with tenth century designs inspired by the 'jewel-like' temple of Banteay Srei and skilfully carved by instructors and students of the Faculty of Fine Arts. Major alterations to the museum in 1969 added additional space for offices, a library and underground storage.

During the civil war, the director of the museum was killed and the staff forced to leave the city along with the rest of the population when Phnom Penh was evacuated in April 1975. The Khmer Rouge did not destroy the building but it remained unattended until the end of their regime in 1979 and during that time the collection suffered from damage and neglect, jewellery was stolen and textiles disintegrated. The building's roof, and electricity deteriorated; flooding in the storage area threatened the artifacts, many of which were taken from provincial museums to Phnom Penh for safekeeping; and bat dung seeped through the ceiling, eroding the surface of stone pieces. Nevertheless, rudimentary measures put the museum in order soon after the liberation of Phnom Penh and it reopened during Cambodian New Year in April 1979. However, the lack of finances and technical expertise precluded undertaking necessary repairs and little progress was made in the next decade.

Several factors in the 1990s helped the National Museum of Cambodia regain its reputation as the world's leading repository of the artistic heritage of the Khmer culture. A settlement amongst rival factions in Cambodia in 1991, followed by the arrival of a United Nations peacekeeping force and a democratic election stabilised the country politically. Tourism resumed and accelerated the need for a museum of international standards. Angkor was added to UNESCO's World Heritage List, which ensured international co-operation and assistance. With Australian support the museum roof was repaired and re-tiled. The french Government has set up a successful conservation laboratory, which has trained a group of skilled conservators in the processes of repair, conserving and cleaning stone objects. Measures were undertaken to repair and restore the building, to establish an inventory of the collection, to photograph the objects and to set up a conservation laboratory. Cambodia joined the Association of Southeast Asian Nations (ASEAN) in 1999 and it is hopeful that member countries will assist the museum in developing technology and human resources for the preservation of Cambodia's cultural heritage.

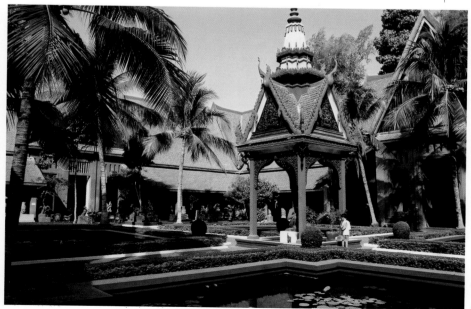

The National Museum of Cambodia, Phnom Penh.

Dawn Rooney

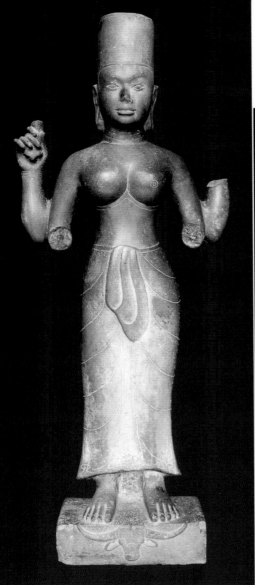

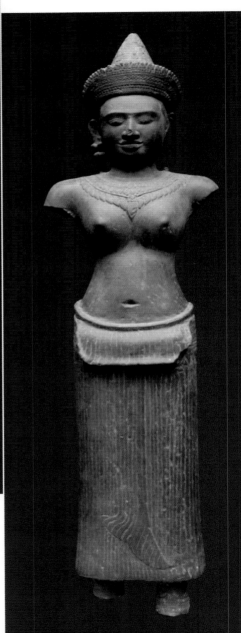

The goddess Durga with four arms; early eighth century.

Phnom Penh National Museum

An exquisitely proportioned Khmer female divinity wearing a long skirt with central pleats and an elaborate necklace; 12th century.

Phnom Penh National Museum

Khmer art from the National Museum of Cambodia was seen in the West in two unprecedented exhibitions held in the 1990s, which contributed towards developing a greater awareness of Cambodia's artistic legacy. Lavishly illustrated catalogues with informative texts accompanied both exhibitions and continue to serve as permanent records of the National Museum's treasures. In 1992, *The Age of Angkor*, an exhibition at the Australian National Gallery in Canberra displayed 35 stone and bronze masterpieces from the museum in Phnom Penh. *Sculpture of Angkor and Ancient Cambodia, Millennium of Glory*, an exhibition of over 100 sculptures from the collections of the National Museum of Cambodia and the Musée Guimet (Musée National des Arts Asiatiques) in Paris, travelled between France, United States and Japan—between 1997 and 1998. It began in Paris at the Grand Palais; then went to Washington DC at the National Gallery of Art; and to Tokyo at the Metropolitan Art Museum and, finally, to Osaka at the Municipal Museum of Fine Art.

THE COLLECTION

The formation of the museum collection began with objects retrieved from archaeological excavations conducted by the École Française d'Extrême Orient (EFEO—the French School of Far Eastern Studies) and pieces that were found in Cambodia or donated to the museum. Additions were made and by the early 1970s the collection contained several thousand objects. Although the number is fewer today in the aftermath of civil war, the holdings are still extensive and include a broader range than previously. A visitor to the museum today can follow the evolution of Khmer art chronologically, which spans nearly 2,000 years, from prehistory to present day, and view the masterpieces of the collection. The holdings of the museum continue to grow with discoveries of new sites facilitated by international expertise and a burgeoning group of Cambodian graduates of the Department of Archaeology at the Royal University of Fine Arts (RUFA), which reopened in 1989.

The objects in the collection are grouped by material and fit into four general periods of art classification: the Formation of Khmer Art (first to fifth century); Pre-Angkor (sixth to eighth century); Angkor (ninth to 13th or 14th century); and post-Angkor (14th or 15th to 20th century).

VISITING THE GALLERIES

The layout of the museum is divided into four galleries. Upon entering the museum, you come face-to-face with a colossal sandstone sculpture of Garuda (half-human, half-bird), the king of birds and the mythical mount of the Hindu

god Vishnu. The size and movement displayed in this piece are characteristic of the early-10th century Koh Ker art style and give the visitor an introductory taste of the grandeur of Khmer art.

East Gallery: includes the Hall of Bronzes, which extends to the left and right of the Garuda; the Hall of Post-Angkor Buddha images at the north end; and the Hall of Prehistory artifacts at the south end.

South Gallery: displays stone sculpture from the sixth to the 11th century.

West Gallery: continues the chronology of stone sculpture with pieces dating from the 12th to the 13th centuries.

North Gallery: includes ethnographic material in the northwest part of the gallery and ceramics in the northeast section.

The south, west and north sides of the colonnade are filled with stone lintels, pediments and other stone inscriptions, which are worth viewing for those who have a special interest in Khmer art. One major advantage of the pieces in this area is that you can view them at eye level, rather than from a distance in their original locations at the top of doorways and elsewhere. At the northeast corner, 25 metres of a sandstone wall, stolen in the late 1990s from Banteay Chmar, a late 12th century temple located in a remote area of northwest Cambodia near the border of Thailand, is on display. It was recovered by Thai police en route to Bangkok and returned to Cambodia. The wall consists of more than one hundred sandstone blocks carved with a large, standing, multiple armed Avalokitesvara, a bodhisattva who emanates compassion. The highlight at the centre of the courtyard is a stone sculpture of Yama, the original image of the so-called Leper King (late-12th to early-13th century)—encased in a Khmer-style pavilion.

Practical Information: The museum is open daily from 8am until 5pm. The ticket booth is located at the northeast corner of the building and the entrance fee is US$3 per person. Photographs are not allowed inside the museum. Large bags and cameras must be checked upon entering the building. Guide services are available in Khmer, French, English and Japanese languages. A souvenir counter selling postcards, books and reproductions of sculpture is located near the entrance.

A new and highly recommended guidebook to the National Museum of Cambodia written by the Director, Khun Samen, is on sale at the souvenir counter, entitled *The New Guide to the National Museum: Phnom Penh* (1st ed, The Department of Museums, Ministry of Culture and Fine Arts, Phnom Penh, 2002).

—*Dawn F. Rooney*

MISCELLANEOUS

ARMITA Performing Arts, founded by American Fred Frumberg, stages eight-week festivals two or three times a year. Performances include a variety of Cambodian forms such as circus, classical ballet, drama, puppetry and many more. Telephone or email for schedule. 241, Street 63. Tel: (023) 220 424; Fax: (023) 220 425. Email: ffrumberg@aol.com. Website: www.amritaperformingarts.org.

National Library 92 Street.

DHL Worldwide Express 28 Monivong Boulevard. Tel: (023) 427 726.

Monument Books 111 Norodom Boulevard. Tel: (023) 217 617. Email: info@monument-books.com. Monument has a second Phnom Penh store at the International Airport. Tel: (023) 890 563. Both branches have excellent sections covering Indochina and East Asia, and a comprehensive range of international titles.

PLACES OF INTEREST

Royal Palace It is a surprise to many visitors to learn that this is a largely a 20th century structure, with several buildings dating back to the 19th century. The Chan Chhaya Pavilion, the Throne Hall of Prasat Tevea Vinichhay, the Napoleonic cast-iron framed pavilion and the Silver Pagoda are some of the most important buildings.

National Museum Pre-Angkorian and Angkorian period sculpture are the main attractions, making a visit here before and after journeying to Siem Reap an excellent idea. Most of the sculptures have been skillfully conserved and are beautifully presented in this remarkable museum. Located close to the Royal Palace at the junction of 113 Street and 350 Street (see pages 432–437).

Wat Phnom Phnom Penh's oldest temple is said to hold the ashes of Ponhea Yat, the first king of the post-Angkor period of Cambodian history. Many of the capital's citizens come here to pray for protection before journeys, success in examinations and to help heal illness. Situated at the junction of Tou Samuth Boulevard and 47 Street in the northeast of the city.

Colonial Architecture Phnom Penh's most attractive colonial-style architecture is located between Norodom Boulevard and the river.

The Killing Fields The Choeng Ek extermination camp is located approximately 18 kilometres southwest of the capital. The English name originates from the famous Hollywood film, which highlighted the Khmer Rouge massacres. A Perspex stupa has been erected there to commemorate the more that 17,000 people who were executed.

Tuol Sleng This is where the Khmer Rouge interrogated and tortured its prisoners in Phnom Penh. The thousands of pictures on the walls of the victims are, perhaps, a much more stark revelation of the atrocities between 1975 and 1979 than Choeng Ek. Located west of Achar Mean Boulevard.

SIEM REAP

Capital of the province of the same name, this small, French colonial-influenced town is situated picturesquely along the banks of the Siem Reap River approximately seven kilometres (4.3 miles) from its national and international airport. It will be considerably more picturesque when the authorities complete their much-discussed plans to clean up the river.

HOTELS

Given its small size, Siem Reap has an astonishing variety of accommodation from super deluxe to the humblest dormitory. There's a style for almost every taste, including the ubiquitous spa resort. In fact, there is serious concern among members of the local and international travel industry that the large number of planned new

Siem Reap's new era of luxury resorts is led by the likes of Le Meridien.

hotels, resorts and guesthouses that will be opening over the coming years will grossly overtax available water resources and encourage unsustainable numbers of visitors. Meantime, the visitor can benefit from the glut of accommodation; prices are, for the most part, competitive, except at the peak of the high season. Our modest selection below is based, for the most part, on personal experience or reliable recommendation.

LUXURY

Le Meridien Angkor Standing very close to Angkor Wat, this hotel (pictured above) combines the intricate designs and magnificence of Khmer-themed architecture with all the luxury and comfort of modern amenities in a resort-like atmosphere. A lush garden

with green-tiled pool, a spa and a reflexology 'sanctuary' offer complete relaxation and rejuvenation after a day walking around the sites. Price: US$150 upwards.
Tel: (063) 963 900; Fax: (063) 963 915. Website: www.angkor.lemeridien.com.
Amansara This property, part of the luxurious Aman chain, has just added a further 12 exclusive suites with private swimming pools to its original 12 rooms. Services and high standards generally are as expected of the Aman group. Located on the road to Angkor, near Grand Hotel D'Angkor. Price range: US$675 plus.
Tel: (063) 760 333; Fax: (063) 760 335. Email: amansara@amanresorts.com.
Grand Hotel D'Angkor This hotel has been running since the end of 1998, following extensive and meticulous renovation. Its wonderful gardens surround a beautiful swimming pool. There are tennis courts, a fully equipped gym with sauna and steam baths. There are two restaurants with excellent Southeast Asian cuisine and well-stocked bars. It provides both comfort as well as an insight into the wonders of Angkor. It has 131 deluxe rooms and special luxury suites as well as a full range of international standard facilities. Located in the centre of town. Price Range: US$310–US$900, full board.
Tel: (063) 963 888; Fax: (063) 963 168. Email: raffles.grand@bigpond.kh.
Hotel de la Paix This new art-deco-inspired hotel, with its specialty suites that include duplexes and gardens, offers portable iPod music systems with each room. It has a rooftop swimming pool and a beautiful garden. It is prominently located on Sivutha Boulevard, 15 minutes from Siem Reap International airport. Price range is US$300–US$750. Tel: (063) 966 000. Website: www.hoteldelapaixangkor.com.
La Residence d'Angkor A deluxe boutique hotel, located near the Old Market and on the Siem Reap River, this hotel has 55 rooms arranged around a swimming pool. Small, yet spacious, this hotel is superbly decorated using oiled teakwood and natural materials throughout. A jewel in the heart of the town. Price Range: $200–US$350.
Tel: (063) 963 390; Fax: (063) 963 123.
Email: Angkor@pansea.com.
Website: www.pansea.com.
Hotel Sofitel Royal Angkor Modern resort-style deluxe accommodation in Siem Reap, with an excellent French restaurant. On the road to Angkor Wat.
Price Range: US$280–US$1,500.
Tel: (063) 964 600; Fax: (063) 964 610.
Email: sofitel@sofitel–royal–angkor.com.

Vintage cars create old world flavour at Siem Reap hotels—this one belongs to the Sofitel Royal Angkor.

Victoria Angkor Resort & Spa. French colonial-style hotel. Price Range: US130–US$440. Central Park area. Tel: (063) 760 428; Fax: (063) 760 350. Email: resa.angkor@victoriahotels–asia.com. Website: www.victoriahotels–asia.com.

UPSCALE

Angkor Century This large resort with its own spa has a wide choice of restaurants and bars. Good souvenir shops here too. Price Range: US$100–US$210. Tel: (063) 963 777; Fax: (063) 963 123. Email: enquiry@angkorcentury.com.

Angkor Hotel On the Siem Reap end of the Airport Road. Price Range: US$100–US$210. Tel: (063) 964 301; Fax: (063) 964 302. Email: angkor@bigpond.kh.

Angkor Village This hotel is made up of unique wooden houses with all amenities located in a lush well-kept garden with restaurant and swimming pool. Angkor Village provides a nightly classical dance performance at the APSARA theatre. Rooms range from US$80–US$170. Situated on the east side of the river in the Wat Bo area. Tel: (063) 963 561. There is also a new Angkor Village, a resort in the same mould, in the newly designated hotel zone on the east of the main road leading to Angkor.

Foreign Correspondents' Club of Cambodia, Angkor Looking more like a clean-lined Californian spa than the journalists' hang-out that its name implies; accommodation was launched in December 2004, alongside this popular upscale Western riverside restaurant and bar, next to the post office. Price range: US$144–US$160. Tel: (063) 760 280. Website: www.fcccambodia.com.

Shinta Mani This hotel has 18 clean, simply-appointed rooms. It is also a free training institute for 25 Cambodians who spend six months learning all aspects of the hotel industry. Twenty per cent of the room fee goes to the school. Price range: US$144–US$160. Oum Khun Street and 14th Street, Mondul 2, Svay Dangkum Commune. Tel: (063) 761 998; Fax: (063) 761 999. Email: shintamani@sanctuaryresorts.com. Website: www.sanctuaryresorts.com/shintamani.

LOW–MID–PRICE

Angkoriana Villa Pleasant villa-style hotel, formerly a well-run guesthouse located on the road to the monuments. Price Range: US$50–US$150. Tel: (016) 630 096; Fax: (063) 964 349. Email: angkorianahotel@everyday.com.kh.

Auberge Mont Royal D'Angkor Charming family-style hotel with bathtubs and a terrace restaurant. Located 100 metres behind Sivatha. Price Range: US$25–US$55. Tel/Fax: (063) 964 044.

Bopha Angkor Hotel Modern but traditional-style hotel with tastefully decorated rooms. Its restaurant is set in beautiful tropical gardens.
Price Range: US$35–US$45. Tel: (063) 964 928; Fax: (063) 964 446.
Email: hba@rep.forum.org.kh.
Borann, l'Auberge des Temples Quiet and relaxed lush garden with swimming pool is the backdrop for 20 nice rooms with their own verandahs. Behind Sawasdee restaurant.
Price Range: US$36–US$48. Tel: (063) 964 740. Email: borann@bigfoot.com.
Day Inn Angkor Resort Opposite the Shinta Mani on Oum Khun Street, Mondul 1 Svay Dankum. US$80–US$90. Tel: (063)760 500; Fax: (063) 760 503.
Email: gm@dayinnangkor.com. Website: www.dayinnangkor.com.
Freedom Hotel On Route 6, close to the New Market out of town. A popular hotel with travellers, it has wide-ranging facilities. Price Range: US$15–US$30. Tel: (063) 963 473; Fax: (063) 964 274.
Golden Angkor Hotel Near the centre of town, just off the airport road. With cable TV and hot water. Price Range: US$10–US$30. Tel/Fax: (063) 964 039.
La Noria Guest House Modelled after a traditional-style house with additional French flair. Rooms with verandas and a good French restaurant.
Price Range: US$29–US$39. Tel: (063) 963 639. Email: info@mysteres–angkor.com.
Mandalay Inn Located in the heart of Siem Reap, this comfortable hotel has a restaurant that serves good, well-prepared food. Burmese managed.
Price Range: $15–US$30. 148, Sivatha Road. Tel: (063)963 920; Fax: (016) 904 012.
Email: maungmmt@yahoo.com. Website: www.geocities.com/mandalayinn.
Mekong Angkor Palace Small hotel in the centre of town with a good atmosphere and garden setting. Price Range: US$15–US$40. Tel: (063) 963 636.
Molly Malones Nice clean rooms with wooden furniture, A/C, hot water, cable TV and a fridge along with a very authentic Irish Bar and restaurant. Free WiFi internet is also offered. It is centrally located in the South West area of the old market.
Price Range: US$20–US$40. Tel: (063) 963 533.
Mysteres D'Angkor Fifteen pavilion-style rooms with private gardens in landscaped setting. Quiet area, north of Route 6, behind Wat Por Lanka.
Price Range: US$25–US$35. Tel: (063) 963 636.
Pavillion Indochine Traditional Khmer wooden house and bungalows, set in lush tropical gardens with restaurant and bar. Wat Thmei area.
Price Range: US$25–US$35. Tel: (012) 804 303. Email: FACG@online.com.kh.
Website: www.pavillionindochine.com.
Royal Crown Hotel Excellent value; it is within walking distance to the Phsa Chas (Old Market) and is highly rated for cleanliness, spacious and well-appointed rooms,

friendly staff, and pleasant dining area. Price Range: US$25–US$55. 7 Makara Street, Wat Bo Village, Salakamreuk Commune. Tel: (063) 760 316; Fax: (63) 760 317. Email: rch@online.com.kh. Website: www.royalcrownhotel.com.kh.

Hotel Ta Prohm Riverside hotel centrally located near the Old Market. One of the first new hotels to be built in Siem Reap, now a little dated.
Price Range: US$70–US$110. Tel: (063) 380 117; Fax: (063) 380 116.
Email: taphrom@lotus–temple.com.

Yaklom Angkor Lodge Very clean bungalows in garden setting with exceptionally helpful staff; extremely good value. Good Thai and international restaurant (See Sawasdee Food Garden in restaurant section). Located on the second street on the left after crossing the bridge on Route 6. Price Range: US$25–US$35. Tel: (063) 964 456. Email: yaklom@rep.forum.org.kh.

BUDGET

Dead Fish Tower Inn Provides both A/C and Fan room in a hybrid mid-range backpacker-friendly atmosphere. Rooms range from US$5–US$20. Located next to the Dead Fish Tower Restaurant on Sivatha Boulevard. Tel: (012) 630 377.

Earthwalkers Located off Route 6 towards the airport. This Western-managed guesthouse is an oasis that is clean and friendly in a garden setting.
Price Range: $5–US$15. Tel: (012) 967 901; (063) 760 107.
Email: mail@earthwalkers.no. Website: www.earthwalkers.no.

Golden Banana Very clean air-con and fan bungalow-style rooms in garden setting. Quiet and friendly atmosphere; close to Wat Damnak. Price Range: US$8–US$20. Tel: (012) 885 366. Email: info@angkorvillage.com. Website: www.golden–banana.com.

Green Bamboo Guesthouse Traditional wooden house, family run, clean and friendly. Located on Wat Bo Road. Price Range: US$5–US$8. Tel: (063) 834 152. Email: senangkor@yahoo.com.

Ivy Guesthouse has the same friendly atmosphere as the Ivy Bar and Restaurant with a very central location in the Old Market area which is very convenient for shopping and restaurants. Rooms from US$15–US$20. Tel: (012) 800 860.
Email: ivyasia@hotmail.com.

Mahogany Guesthouse In Wat Bo Street; one of the best–known budget guesthouses. Friendly atmosphere. Price Range: US$5–US$8. Tel: (063) 963 417; Fax: (063) 380 025.

Red Piano Guesthouse Not just a good place to eat and drink but it also has comfortable and clean rooms that are air-conditioned and nicely finished with wooden furniture. Family rooms are also available. Rooms from US$16–US$28. The Red Piano is located close to the Bar and has a very nice rooftop terrace with views

towards Phnom Krom. It is located just West of Sivatha Boulevard in the old market area. Tel (063) 963 240.

Smiley's Guesthouse Off Sivatha Boulevard. Well-known on the travel circuit. Cheap, communal and friendly. Price Range: US$1–US$6. Tel: (063) 852 955.

Sunway Guest House In Wat Bo Street. Popular with backpackers. Family atmosphere Price Range: US$2–US$12. Tel: (063) 964 432. Email: sunway_guesthouse@yahoo.com.

RESTAURANTS

Most hotels have eating facilities, some are excellent but there are also good small local and foreign-owned restaurants. 'Bar Street' and the Old Market area is considered the pulse of Siem Reap for most tourists and expatriates, containing everything that one could need from spas and massages to places where you can have a good night out.

By day the market area is a bustling area of local activity. Bar Street is where many people head both day and night because it has the widest selection of bars and restaurants in one area. With its obvious need for expansion, some of the small back lanes running adjacent to Bar street—such as Walking Lane—are beginning to bustle too but they are often easily missed by newcomers because they are quite hidden, making it all the more worthwhile to go and check them out, to discover lesser-visited establishments.

Abacus Newly opened restaurant/bar, with fantastic barbecue dishes and a lavish dessert selection in a renovated wooden Khmer-style house, set in a large garden. Good wine list catering for any price level. Bookings recommended. Located Oum Khun Street (opposite the New York School, just off north end of Sivatha Boulevard). Open 11am till late; closed Sundays. Tel: (012) 644 286.

Amok Seek out this lovely little restaurant in a small lane way, parallel to 'Bar Street' in town. A very reasonably priced set menu, of which the main course is a choice of various types of *amok*, a coconut-based traditional Khmer dish that everyone must try. Has, possibly, the best chocolate mousse in town. Tel: (012) 800 309.

Angkor Cafe International and Khmer cuisine; across the moat from Angkor Wat. It has comfortable A/C dining and garden patio seating. Open 7am–7pm. Tel: (063) 380 300.

Banteay Srei Restaurant Khmer; on Airport Road, good breakfast, local food and plenty of local colour. No telephone.

Bopha Angkor Restaurant Khmer; local food of high standard, served in tropical garden setting. On east side of the river (see hotel listings).

Barrio French Restaurant and Bar in nicely renovated open aired building, good food and reasonably priced. 7 Sivutha Street. Tel: (012) 756 448.

Blue Pumpkin International; serves delicious food, baked goods and ice cream. Favourite breakfast spot for expats and with the new addition of WiFi you can surf the

net on your laptop while enjoying the unique couch lounge seating upstairs. Opposite the old market. 365 Mondol 1, Svay Dang Kum. Tel: (012) 946 227.

Cafe Indochine A beautifully renovated traditional wooden house that now acts as a cafe and restaurant that offers very good French and Khmer food. Located on Sivutha Street, next to Mekong Bank. 44 Sivatha Street. Tel: (012) 804 952.

Carnets d'Asie Nestled in a courtyard behind a gallery and bookshop, this is a place for fine French food and Asian dishes. Recline on floor cushions in the pavilion or sit at a table in the tropical garden; either way, the smoked salmon pasta and foie gras are sublime. Delightful Carnet's beautiful gallery-cum-bookshop at its entrance is another draw. 333 Sivatha Street. Tel: (016) 746 701. Website: www.carnetsdasie–angkor.com.

Chez Sophea French; directly facing Angkor Wat, this is good spot to eat lunch when touring, with a wide range of wines. Set menu; Khmer/European dishes; moderately priced. Note: one day's notice is needed for dinner. Tel: (012) 858 003. 11am–9pm.

FCCC International Foreign Correspondents' Club of Cambodia Sister restaurant to the popular Phnom Penh branch. Beautifully refurbished classic 1960s building with an extensive international menu. Overlooking the river, near the market. A popular expat venue, with boutique-style shops downstairs and a recently opened gallery next door. Open 7am–Midnight. Tel: (063) 760 280.

Green House II Khmer/International; large selection and reasonably priced. On the Airport Road. No telephone.

Hawaii Pizza House Very good pizza and large selection of Khmer dishes. Small bar (Happy Hour 5pm–8pm) with good music and friendly staff who provide free delivery service. Located in Wat Bo area. 7am–Midnight. Tel: (012) 850 362.

Kampaccino Pizza Good Khmer/Western fare, with the best poached eggs in town. Ideally situated across from the river very close to the old market. Tel: (012) 835 762.

Karma Sutra Has the reputation of the best Indian restaurant in Siem Reap, which is about to expand in size to accommodate an ever-increasing clientele. Serving dishes from all over India with seafood daily specials and an ever-changing set menu. Also provides take away option, which makes it very popular. Its bar is a perfect place to start a night out. Open 11am–Late. Located in the Old Market area on Bar Street. Tel: (063) 761 225.

Khmer Kitchen Said to have the best local food in town, with very reasonable prices. Located on Walking Lane, which runs parallel to Bar Street. No telephone.

Little India Long-established and popular Indian, serving good food and homemade bread. Inexpensive. Near Old Market. Tel: (012) 652 398.

La Noria Restaurant Excellent French food and good wines. A covered open-air restaurant; moderately priced. Open from 6am to 10pm. Part of the guesthouse north of Route 6 on the east side of the river. Tel: (063) 963 639.

Madame Butterfly A little out of town, this restaurant is set apart by its setting in traditional wooden Khmer house. More luxurious than the average dwelling, it serves appropriately refined Khmer cooking. Airport Road. Tel: (016) 909 607.

Moloppor Tiny Japanese-owned riverside cafe with very competitive prices, and a rooftop sauna. Sit on the floor of the Bamboo gallery or in the cosy bar below. Excellent milkshakes and mini-pizzas, often crowded. East River Road. Tel: (063) 760 257.

Sala Bai Hotel School Philanthropy and greed, both accommodated in one place! An NGO-run restaurant where young Khmers are put through their paces in the kitchen providing delicious lunches. The set menu is particularly recommended. Taphul Road. Tel: (063) 963 329.

Sawasdee Food Garden Just North of Route 6 is a charming garden-style Thai restaurant with friendly staff and excellent food; moderately priced. 11am–10pm. Tel: (063) 964 456. Email: yaklom@rep.forum.org.kh.

Soup Dragon Vietnamese/international fare; three floors, airy seating, reasonably priced. Soup varieties are great value. On the corner of Bar Street and the road that runs along the side of the Old Market in the direction of the Provincial Hospital. Head for its breezy rooftop. Tel: (063) 964 933.

Tell Fine Asian/Western restaurant with some of the best German food in town. Indoor A/C and outside curbside seating. Open 11am–10pm. Located on Sivatha Boulevard. Tel: (063) 963 289.

Viroths New, modernist open-plan garden restaurant serving tasty Khmer food. Particularly good for large groups looking for stylish efficiency but check ahead to avoid tour groups. Wat Bo Road. Tel: (012) 826 346.

Viva The only bar/restaurant in town which serves specialty of Mexican drinks and meals, which include a very good selection of frozen Margaritas. Viva is also one of the only places where you can speak Spanish with the local Cambodian staff. Both dine-in and take-away open 10am–Late. Tel: (092) 209 154.

BARS

Abacus Fabulous new bar and restaurant that is very popular with tourists and mainly French expats. The bar area is an open ground floor of and old renovated Khmer wooden building and has a good exhibition area. It provides some of the best wines and cocktails in the area. Open 11am till late and is closed Sundays. Tel: (012) 644 286.

Angkor What? Very popular late night bar, attracting young expats and travellers. Wide selection of good music and drinks making it the last place to close on most nights. Located in the Old Market. Tel: (012) 482 764.

Banana Leaf Curbside open–air cocktail bar which serves a good selection of ice cream, finger food and Khmer dishes as well as great coffee; paninis are a strong point. Very centrally located on Bar Street. A favourite with expats and tourists alike. It is the perfect spot for a nightcap and people-watching. Corner of Bar Street and Old Market Road. Open 9am–Late. No telephone.

Barrio French bar in pleasant renovated building. Serves very good food and wine by the glass. On Sivatha Boulevard. No telephone.

Boom Boom Room A new but already very popular café that serves pots of hot tea and coffee along with a light snack menu while patrons listen and browse through audio libraries and a funky clothing and merchandise range. Located next to the Le Grand Café in the old market area. No telephone.

Dead Fish Tower Unique architecture with multiple levels and open-air platforms which really need to be seen to be believed. Friendly atmosphere with good Khmer and Thai food. Located at the South end of Sivatha Boulevard. 7am–late. Tel: (063)963060/ (012) 630 377.

The Elephant Bar In the basement of the Grand Hotel D'Angkor. A fine place for a sundowner. Popular among expats during its happy hour. Great service and friendly staff. Try one of Jackie Kennedy's favourite cocktails or a legendary gin sling. There is even popcorn made on the spot here. 11am to 11pm. Tel: (063) 963 888.

FCCC The newest outpost of the Foreign Correspondents' Club of Cambodia is already thought of as a colonial classic. Sip gin and tonic at the zinc bar or lounge on the riverside balcony in enormous armchairs. Competent international fare available, outdoor movie screenings. Pokambor Avenue. Tel: (063) 760 280.

The Funky Monkey Located in the Old Market area overlooking the river, this bar and restaurant was recently opened by fun expat owners with friendly local staff. It has a unique combination of lighting, seating and décor, which gives it its 'funky' feeling. Thursday night is quiz night, with all money raised going to worthy charities. An extensive menu includes a weekly Sunday Roast best booked the Friday before due to popularity. No telephone.

In Touch New open-plan Thai bar and restaurant for those craving oriental chic. Excellent bar and tasty Thai food, but it's the decor and people-watching that make it a must. Beware long waits for big groups with multiple orders. Corner of Bar Street, Old Market area. Tel: (016) 939 111.

Ivy Bar South of the old market. Unpretentious quiet watering hole for expats and tourists at budget prices with free pool table and unique display of photographs. Also serves all-day breakfasts. 7am to late. Tel: (012) 800 860.

Bars and cafés abound in Siem Reap.

Laundry Bar A popular late-night spot for tourists and expats, where you can actually dance. Great music and party atmosphere, sometimes featuring well-known DJs, similar atmosphere to that of the Heart of Darkness in Phnom Penh. 5pm–late. Old market area. Tel: (016) 962 026.

Le Grand Café International bar/restaurant serving a good selection of Asian and French meals along with a full bar. Balcony and curbside seating overlooking the old market. 6.30pm–Late. Tel: (063) 965 330.

Linga Bar Straight-friendly gay bar, packed with anyone passing through town who appreciates excellent cocktails at great prices in funky surroundings. Good music; tasty snacks include tapas and charcuterie. Walking Lane (parallel to Bar Street), old market area. Tel: (012) 246 912.

Molly Malones Bar/restaurant gives you the complete Irish experience with its large predominately wooden interior that has an authentic Irish pub ambiance aided, of course, by the ability to buy a Guinness and Irish whiskeys. If you happen to be in town for Saint Patrick's Day, the beer turns green and as do the clients. Very good Irish and international fare. 7.30am–2am; located in the old market area. Tel: (063) 963 533.

The Red Piano Attractive bar serving the Tomb Raider cocktail and unpretentious food that features the best Belgium fries in Siem Reap. The Red Piano is located on one of the corners of Bar Street and with its double storey and corner location it provides a great place from which to view the goings-on of the surrounding area. Provides a variety of different types of seating. Draft beer is available served by friendly staff; very popular spot for travellers and expats alike. Tel (063) 963 240.

Le Tigre du Papier Popular French-run bar, with a coffee shop and menu. It also operates a book exchange service. You can swap one of your books for a different read which is a great idea for people who are travelling light. Located next to the Angkor What? bar. No telephone.

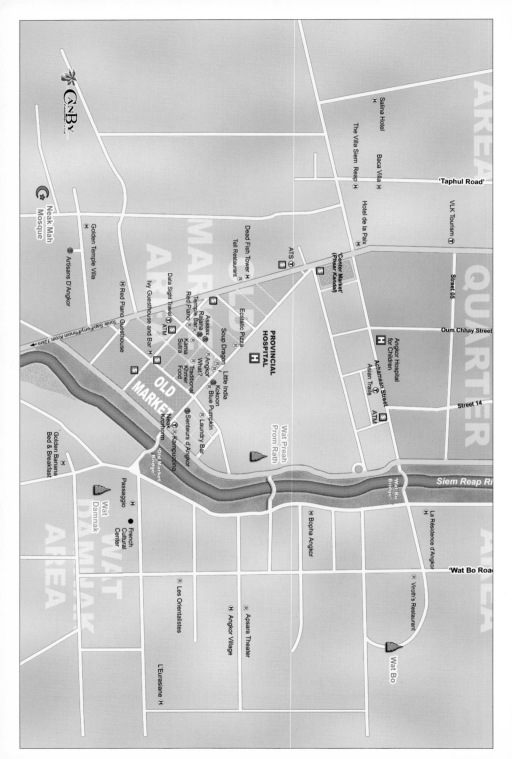

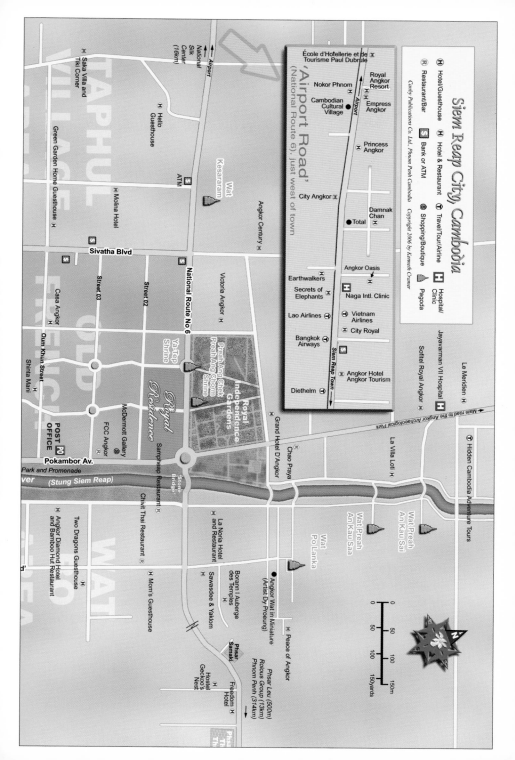

The Warehouse The only indie rock bar in Siem Reap and one of the newest bars to open in the old market area. The Warehouse has a small but good varied menu, a large drinks list and a large archive of rock/indie music. Located on a corner near the Laundry Bar towards the Old Market. Open 10.30am–3am. No telephone.

Zanzi Bar South end of Sivatha Boulevard. Nightspot with a bit of a bar-girl reputation. 7pm to late. No telephone and was 'temporarily' closed at press-date.

SPAS AND MASSAGE

Body Tune a very swish spa and massage parlour with reflexology, aromatic oil and traditional Thai massages. Located on Pokambor Ave, overlooking the river next door to the Funky Monkey. Open 10am–10pm daily. Tel (063) 764 141. www.bodytune.co.th.

USEFUL ADRESSES

Business to Business Destination Asia (Cambodia) Ltd is a Destination Management Company, looking after Travel Companies, Incentive Houses, Corporate Meetings, Conferences, Cruise ships and specialised travel requirements. Villa 18 Salakanseng Svaydangkum, Siem Reap. Tel: (063) 963 271. Fax: (063) 963 553. Email: david@destination–asia.com. Website: www.destination–asia.com.

Center for Khmer Studies An NGO, promoting research and teaching of arts and humanities, as they apply to Cambodia. PO Box 9380 Wat Damnak. Tel: (063) 964 385. In the US: 210 East 86th Street, New York, NY 10028. Tel: +1 (212) 517 2624. Email: center@khmerstudies.org. Website: www.khmerstudies.org.

Kantha Bopha Center Conference centre and recital hall, where every Saturday night, at 7.15pm, Dr Beat Richner gives a cello recital in aid of the Kantha Bopha Foundation, a children-focused charity. Jayavarman VII Hospital, Email: kbcenter@online.com.kh. Website; www.beatocello.com.

Monument Books Monument Books 278, Phsar Chas Market. Tel: (063) 963 228.

Neak Krorhorm Travel and Tours is a reliable travel agent, located on the north side of old market. Tel: (063) 762 333.

World Monuments Fund gift shop On the site at Preah Khan in Angkor, a small shop and exhibition area supports WMF's ongoing conservation and training activities. Open from around 7.30am to 4.30pm daily. Telephone inquiries should be directed to the Siem Reap WMF office: (063) 963 542.

Wildlife: Khin Po-Thai is a Siem Reap-based guide, with particular interest in conservation issues, Tonle Sap and the ornithology of these parts of Cambodia. 560 Wat Bo, Salakomererk. Tel: (012) 309 007. Email: kpthai_angkor@mobitel.com.kh.

Banks

There are several banks in Siem Reap where it is possible to change money and advance cash dollars on credit cards. It is also possible to change money and travellers checks with local moneychangers, who may offer a better rate. Alternatively, ATM machines are finally available.

ANZ has opened a new branch in Siem Reap that operates a few ATM machines. The main branch is located at 566–570 Tep Vong Street (near Psar Kandal) and one of its ATMs is located in the Old Market area near the Red Piano end of Bar Street. For enquires call (023) 726 900 or visit www.anzroyal.com.

Transport

The best way of seeing the monuments is to hire a private car or a *moto* (motorcycle with driver). A car and driver can be hired for US$20–US$30 per day. A moto costs US$5–US$8, and most drivers double as basic guides. Motorbike drawn tuk-tuks are a great way to tour the temples, comfortably fit two people and can be hired for around US$10–US$15 per day. Banteay Srei is no longer considered a security risk area and is very much open to visitors; it should be noted, though, that cars, motos and tour buses still require a surcharge per journey there.

Site Passes

A pass to visit the temples is required and can be purchased only at the drive-in ticket counter and checkpoint located on the main road to the monuments just before you enter the forested area. Passes are available for a single day, for three days or for one week. The passes are valid for all the sites within the Angkor area, including Roluos, Banteay Srei and Kbal Spean. You will be asked to pay a separate admission charge of US$5 per person to enter Beng Melea, and a US$20 charge is levied by a private company should you wish to visit the Kulen Hills.

The prices for passes to the main sites are: one day, US$20; three days, US$40; and one week, US$60 (children under 12 are admitted free). All except one-day passes, need to have a passport photograph of the purchaser, which can be obtained free of charge at the ticket counter. Passes are for sale from 5am to 5.30pm. Those bought after 5pm allow visits for the whole of the next day too. Note that from 5.30pm free entry is allowed; dusk falls at around this time every day and from 6pm to 7pm, known locally as the magical hour, brings a great experience for hues and colours in the jungles and monuments.

Visitors should carry their passes at all times as they are checked at the entrance to all temples. Anyone found without their pass is liable to a fine of US$30.

APPENDIX I
COMPARATIVE CHRONOLOGY OF THE KHMER AND OTHER CIVILISATIONS

BC
c 5000–0

CAM: early society
WEST: Stonehenge (2200–1700); Parthenon (447–433)

AD
0–100

SEA: Indianisation
IND: Sanchi stupa; Amaravati stupa
CH: end of Western Han dynasty
WEST: birth of Christ; Ptolemy's *Geography*; Colosseum (Rome) (72–80)

200

CAM: Funan
SEA: early state of Champa–Vietnam–(200); Pyu kingdom–Burma–(250)
IND: Pallava dynasty

300

SEA: Oc–Eo (Vietnam)
IND: Gupta dynasty (320–600)
CH: Dunhuang Caves (336)

400

IND: wall–paintings at Ajanta; wall–paintings at Sigiriya (Sri Lanka)

500

CAM: Zhenla
IND: Ellora Caves
WEST: Hagia Sophia–Constantinople–(532–7)

600

CAM: Sambor Prei Kuk; Isanavarman I; Jayavarman I (645–81)
SEA: Dvaravati kingdom; Srivijaya dynasty (c 680–1287)
IND: Mamallapuram temples (625–75)
CH: Tang dynasty (618–906)

700

CAM: Upper and Lower Zhenla
SEA: Sailendras dynasty (750); Borobudur (Java)
IND: Pala dynasty

800

CAM: Jayavarman II (802–50); Jayavarman III (850–77);
 Indravarman I (877–89); Yasovarman I (893–c 900)
SEA: Pegu (880)
IND: temple of Kailasa at Ellora (800)
WEST: Charlemagne, Emperor of the West (800); beginning of the
 Norman invasions; first cathedral at Cologne (Germany) (873);
 siege of Paris by the Normans (885)

900

CAM: Harshavarman (c 900–22); Isanavarman II (922–7); Jayavarman IV
 (921–41); Harshavarman II (941–4); Rajendravarman (944–68);
 Jayavarman V (968–1001)
IND: Chola Empire (900–1170);
CH: the Five Dynasties (907–60); Northern Song dynasty (960–1125)

1000

CAM: Udayadityavarman I (1001–2); Jayaviravarman (1002–11);
 Suryavarman I (1002–50); Udayadityavarman II (1050–66);
 Jayavarman VI (1080–1107)

WEST: conquest of Sicily by knights of Normandy (1010); St. Mark's,
 Venice (1042–85); Westminster Abbey (1052–65); Norman
 conquest of England (1066); Winchester Cathedral (1079);
 Durham Cathedral (1096)

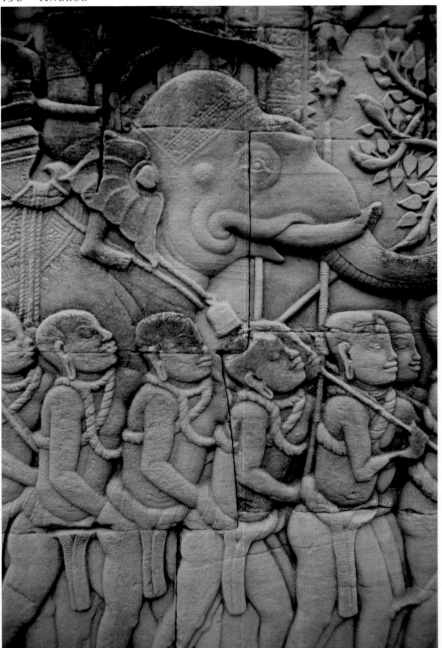

*Relief depicting Khmer soldiers taken prisoner
by the Chams (southern Vietnamese) in the battle of 1177.*

1100

CAM: Dharanindravarman I (1107–13); Suryavarman II (1113–c 1150);
Yasovarman II (1150–65); Tribhuvanadityavarman (1165–77);
Jayavarman VII (1181–c 1219)

SEA: Chams seize Angkor (1177)

IND: conquest of Northern India by Mongols (1192–6)

CH: Southern Song dynasty (1127–1276)

WEST: Notre Dame de Paris (1163–1235); Oxford University (1167)

1200

CAM: Indravarman II (1220–43); Jayavarman VIII (c 1243–95)

SEA: Sukhothai kingdom (Thailand); Lan Na kingdom (Thailand)

CH: Yuan dynasty (1270–1368); Mongol conquest of China;
Zhou Daguan at Angkor (1296–7)

WEST: Magna Carta (1215); the Great Interregnum (1250–73);
Marco Polo to the court of Kublai Khan (1271–95)

1300

CAM: Srindravarman (1300–7); Jayavarmadiparamesvara (c 1327)

SEA: Ayutthaya kingdom (1350–1767)

CH: Ming dynasty (1368–1644)

WEST: beginning of the Hundred Years' War (1337)

1400

CAM: Thais attack Angkor (1431)

CH: Imperial Palace and Temple of Heaven at Beijing (1421)

Abbreviations

CAM: Cambodia
WEST: Europe and the Middle East
SEA: Southeast Asia
IND: Indian Sub–continent
CH: China

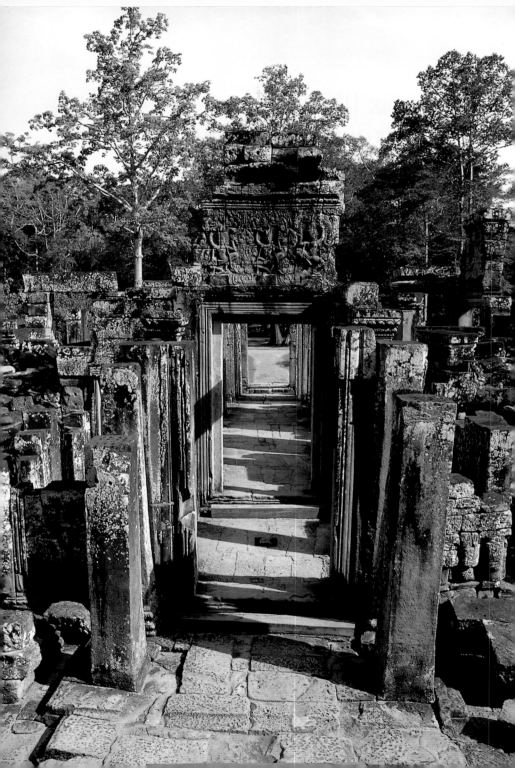

| 1181–1220 | Jayavarman VII | Mahaparamasangata | Ta Prohm, Banteay Kdei, Neak Pean, Ta Som, Srah Srang, Angkor Thom, Bayon, Terrace of the Elephants, Terrace of the Leper King, Krol Ko, Preah Palilay Preah Khan, Prasat Suor Prat |

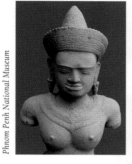

Phnom Penh National Museum

A Khmer female divinity—perfect in form and detail, 12th century; at the National Museum.

1220–1243	Indravarman II		
1243–1295	Jayavarman VIII (abdicated)	Paramesvarapada	
1295–1308	Indravarman III		
1300–c 1307	Srindravarman (abdicated)		
1308–1327	Indrajayavarman		
1330–1353	Paramathakemaraja		
c 1371	Hou–eul–na		
1404	Samtac Pra Phaya		
1405	Samtac Chao Phaya Phing–ya		
1405–1409	Nippean–bat		
1409–1416	Lampong or Lampang Paramaja		
1416–1425	Sorijovong, Sorijong, or Lambang		
1425–1429	Barom Racha, or Gamkhat Ramadhapati		
1429–1431	Thommo–Soccorach, or Dharmasoka		
c 1432	Ponha Yat, or Gam Yat		

Gallery at the Bayon.

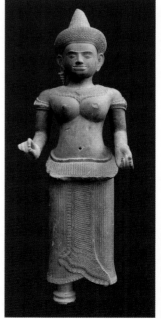

Phnom Penh National Museum

Khmer 12th–century divinity.

Detail of carved pilaster, Banteay Srei.

FURTHER READING

GENERAL BACKGROUND, MODERN AND HISTORICAL

Many of our readers use the Internet to find books they want to read in preparation for a trip to Angkor. Readers may not be aware, however, that in different countries books are often published by different publishing houses. As a result, a title's ISBN (International Standard Book Number) listed below will be a starting point in your search.

Briggs, Lawrence, *'The Ancient Khmer Empire'*, *Transactions of the American Philosophical Society*, Vol 41, Pt 1 (1951), reprint White Lotus Press, Bangkok, Thailand, 1999, ISBN: 974 8434 93 1.

Bizot, Francois, *The Gate*, Knopf (US publisher)/ Harvill Press (UK publisher), 2003 ISBN: 1 84343 056 8

Chandler, David, *A History of Cambodia*, 3rd rev ed, Westview Press, Boulder, Colorado, 1983, ISBN 0 300 057 520; Silkworm Books, Chiang Mai, Thailand, 2003.

Colet, John & Eliot, Joshua, *Cambodia Handbook*, Footprint, 3rd ed., 2002, ISBN: 1 903 471 401.

Higham, Charles, *The Archaeology of Mainland Southeast Asia, From 10,000 BC to the Fall of Angkor*, Cambridge University Press, Cambridge, UK, 1989, ISBN: 0 521 27525 3.

Higham, Charles, *The Civilization of Angkor*, Weidenfeld & Nicolson, London, 2001, ISBN: 0 297 82457 0.

Kamm, Henry, *Cambodia: Report from a Stricken Land*, Arcade Publishing, New York, 1998, ISBN: 1 66970 433 0.

Mabbett, Ian and David Chandler, *The Khmers*, Blackwell, Oxford UK & Cambridge, USA, 1995, ISBN: 0 631 17582 2.

Rooney, Dawn, *Angkor Observed*, 2nd ed, Orchid Press, Bangkok, 2001. ISBN: 974 8304 79 5

Shawcross, William. *Sideshow: Kissinger, Nixon and the Destruction of Cambodia*, Cooper Square Press, 2002, ISBN: 081 54 1224 X.

Snellgrove, David, *Khmer Civilization and Angkor*, Orchid Press, Bangkok, 2001. ISBN: 974 8304 95 7.

Swain, Jon, *River of Time*, Minerva, 1996, UK ISBN: 0 749 32020 6.

Zhou Daguan (Chou Ta–Kuan) *The Customs of Cambodia*, Michael Smithies, ed; newly translated from the French; & Finot, Louis, *The Temple of Angkor Wat*, Editions G. Van Oest, Paris, 1929; Michael Smithies, trans, The Siam Society, Bangkok, 2001, ISBN: 974 8298 51 5.

Following page: *A view down the steep steps of the southwest tower of Angkor Wat* .

The Art of the Khmers

Albanese, Marilia, *Angkor: Splendors of the Khmer Civilization*, White Star, Vercelli, Italy 2002, ISBN: 88 8095 839 9.

Albanese, Marilia, *The Treasures of Angkor*, Cultural Travel Guides, White Star Publishers, Vercelli, Italy, 2006, ISBN: 88 544 0117 X.

Bonheur, Albert le, *Of Gods, Kings, and Men: Bas-reliefs of Angkor Wat and Bayon*, Serindia Publications, London, 1995, ISBN: 0 906026 37 7.

Bunker, Emma C. & Douglas Latchford, *Adoration and Glory: The Golden Age of Khmer Art*, Art Media Resources, Chicago, 2004, ISBN: 1 58886 070 1.

Coe, Michael D., *Angkor, and the Khmer Civilization*, Thames & Hudson, New York, 2003, ISBN: 0 500 02117 1.

Dagens, Bruno, *Angkor: Heart of an Asian Empire*, English translation, Harry N. Abrams, New York, 1995, ISBN: 0 8109 2801 9.

Dalsheimer, Nadine, *Les collections du musee national de Phnom Penh*, Ecole francaise d'Extreme-Orient, Paris, 2001, ISBN: 2 914330 17 0.

Dieulefils, P., Photo-Editor, Text by Louis Finot, *Ruins of Angkor: Cambodia in 1909*, Facsimile edition by River Books, Bangkok, 2001, ISBN: 974 8225 80 1.

Dumarçay, Jacques, *Architecture and its Models in South-East Asia*, Michael Smithies, trans and ed, Orchid Press, Bangkok, 2003, ISBN: 974 524 027 3.

Dumarçay, Jacques, *The Site of Angkor*, Michael Smithies, ed. & trans, Oxford University Press, Kuala Lumpur, 1998, ISBN: 983 56 0040 6.

Dumarçay, Jacques and Michael Smithies, *Cultural Sites of Burma, Thailand, and Cambodia*, Oxford University Press, Kuala Lumpur, 1995, ISBN: 967 65 3070 0.

Dumarçay, Jacques & Pascal Royere, Michael Smithies, trans & ed, *HdO: Cambodian Architecture, Eighth to Thirteenth Centuries*, Brill, Leiden, The Netherlands, 2001, ISBN: 90 04 11346 0.

Finot, Louis, Henri Parmentier & Victor Goloubew, *A Guide to the Temple of Banteay Srei at Angkor*, originally published in French, 1926; reprint in English, White Lotus, Bangkok, 2000, ISBN: 974 7534 22 3.

Freeman, Michael, *A Golden Souvenir of Angkor*, reprint, Asia Books, Bangkok, 2001, ISBN: 974 8303 09 8.

Freeman, Michael, *Khmer Temples in Thailand & Laos*, River Books, Bangkok, 1996, ISBN: 974 89007 6 2. Includes Banteay Chhmar & Preah Viharn

Freeman, Michael, *Angkor: Icon*, River Books, Bangkok, 2003, ISBN: 974 8225 90 9.

Freeman, Michael & Claude Jacques, *Anc ent Angkor*, rev ed, River Books, Bangkok, 2003, ISBN: 974 8225 27 5.

Giteau, Madeleine & Danielle Gueret, *Art and style: Khmer Art: The Civilizations of Angkor*, ASA Editions, 1997, ISBN: 2 911 589 21 1.

Jacques, Claude, *Angkor: Cities & Temples*, Tom White, trans, Asia Books, Bangkok, 1997, ISBN: 974 8225 15 1.

Jeldres, Julio A. & Somkid Chaijitvanit, *The Royal Palace of Phnom Penh and Cambodian Royal Life*, Post Publishing, Bangkok, 1999, ISBN: 974 202 047 7.

Jeldres, Julio A., *The Royal House of Cambodia*, Monument Books, Phnom Penh, 2003, ISBN: 974 90881 0 8.

Jessup, Helen Ibbitson, *Art & Architecture of Cambodia*, Thames & Hudson (World of Art), London, 2004, ISBN: 0 500 20375 X.

Jessup, Helen & Thierry Zephir, eds., *Sculpture of Angkor and Ancient Cambodia: Millennium of Glory*, National Gallery of Art Washington, Reunion des Musées Nationaux, Paris, Thames and Hudson, 1997, ISBN: 0 500 23738 7.

Laur, Jean, *Angkor: An Illustrated Guide to the Monuments*, Flammarion, English edition, Paris, 2002, ISBN: 2 0801 0723 2.

Mannikka, Eleanor, *Angkor Wat: Time, Space, and Kingship*, pb, University of Hawaii Press, Honolulu, 2000, ISBN: 0 8248 2353 2.

Mehta, Julie B., *Dance of Life: The Mythology, History and Politics of Cambodian Culture*, Graham Brash, Singapore, 2002, ISBN: 981 218 085 0.

Ortner, Jon. *Angkor—Celestial Temples of the Khmer Empire*, Abbeville Press, New York, no date, ISBN: 0 7892 0705 2.

Phim, Toni Samantha and Ashley Thompson, *Dance in Cambodia*, Oxford University Press, Selangor Darul Ehsan, Malaysia, 1999, ISBN: 983 56 0059 7.

Roveda, Vittorio, *Images of the Gods: Khmer mythology in Cambodia, Laos & Thailand*, River Books, Bangkok, 2005, ISBN: 974 9863 03 8.

Roveda, Vittorio, *Khmer Mythology: Secrets of Angkor*, 4th ed, River Books, Bangkok, 2003, ISBN: 974 8255 37 2.

Roveda, Vittorio, *Preah Vihear, River Books Guides*, River Books, Bangkok, 2000, ISBN: 974 8225 25 9.

Roveda, Vittorio, *Sacred Angkor: The Carved Reliefs of Angkor Wat*, Photography by Jaro Poncar, River Books, Bangkok, n.d. ISBN: 974 8225 83 6.

Samen, Khun, *The New Guide to the National Museum: Phnom Penh*, 1st ed, The Department of Museums, Ministry of Culture and Fine Arts, Phnom Penh, 2002. No ISBN.

Snellgrove, David, *Angkor Before and After, A Cultural History of the Khmers*, Orchid Press, Bangkok, 2004, ISBN: 974 524 041 9.

Zephir, Thierry, *Angkor: A Tour of the Monuments*, Archipelago Press, Singapore, 2004, ISBN: 981 4068 73 X.

Zephir, Thierry, *Khmer: Lost Empire of Cambodia*, English translation, Thames and Hudson, London, 1998, ISBN: 0 500 30084 4.

FOOTNOTES

PREFACE

1 P Jennerat de Beerski, *Angkor, Ruins in Cambodia* (Houghton Mifflin, Boston & New York, 1924), p.20.

INTRODUCTION

2 H Churchill Candee, *Angkor, The Magnificent, The Wonder City of Ancient Cambodia* (H F & G Witherby, London, 1925), p.vii.

3 Lawrence Briggs 'The Ancient Khmer Empire', *Transactions of the American Philosophical Society*, 41, pt 1, 1951; Maurice Glaize, *Les Monuments du Groupe d'Angkor: Guide*, 3rd ed (A Maisonneuve, Paris, 1963).

GEOGRAPHICAL SETTING

4 Chou Ta–Kuan, *The Customs of Cambodia*, 2nd ed, Paul Pelliot, trans (The Siam Society, Bangkok, 1992), p.39.

5 *Ibid.*

HISTORICAL BACKGROUND

6 J P Carbonnel, 'Recent Data on the Cambodian Neolithic: The Problem of Cultural Continuity in Southern Indochina', in *Early South East Asia, Essays in Archaeology, History and Historical Geography*, R B Smith and W Watson, eds (Oxford University Press, New York and Kuala Lumpur, 1979), pp.223–6.

7 *Ibid*, pp.223–5.

8 *Ibid*, p.258.

9 Claude Jacques, ''Funan', 'Zhenla': The Reality Concealed by these Chinese Views of Indochina', in *Early South East Asia, Essays in Archaeology, History and Historical Geography*, R B Smith and W Watson, eds, pp.371–9.

10 Lawrence Palmer Briggs, 'The Ancient Khmer Empire', *idem*, pp.67–8.

11 Michael Vickery, Cambodia after Angkor: the chronicular evidence for the 14th to 16th centuries, Ann Arbor, Michigan, University Microfilms, 1977 in *The Khmers*, Ian Mabbett and David Chandler, Oxford UK and Cambridge, USA, Blackwell, 1995, p.216.

12 Hugh Clifford, *Further India, Being the Story of Exploration from the Earliest Times in Burma, Malaya, Siam, and Indo–China* (Frederick A Stokes, New York, 1904, reprinted White Lotus, Bangkok, 1990), p.154.

13 Donatella Mazzeo and Chiara Silva Antonini, *Monuments of Civilization, Ancient Cambodia* (Grosset and Dunlap, New York, 1978), p.181.

14 Clifford, pp.153–4.

15 Marcelo de Ribadeneira, 'History of the Philippines and Other Kingdoms', 17, Vol 1, Pt 2, Pacita Guevara Fernandez, trans (The Historical Conservation Society, Manila, 1970), p.441.

16 Clifford, p.154.

17 *ibid*, p.183.

18 D O King, *Travels in Siam and Cambodia,* Journal of the Royal Geographical Society, Vol 30, 1860, pp.177–182.

DAILY LIFE DURING THE KHMER EMPIRE

19 Chou Ta-Kuan, p.29.

RELIGION

20 For a detailed discussion of local spirits worshipped in Cambodia see *The Khmers*, Ian Mabbett and David Chandler, Oxford UK & Cambridge USA, Blackwell, 1995.

21 Herman Kulke, 'The Devaraja Cult', translated by IW Mabbett and JM Jacob, Ithaca, New York, Data Paper: Number 108, Southeast Asia Program, Department of Asian Studies, Cornell University, January 1978.

22 For an English translation, see *Reamker (Ramakerti)*, the Cambodian version of the *Ramayana*, translated by Judith M Jacob with the assistance of Kuoch Haksrea (Oriental Translation Fund, New Series, Vol. XLV, London: The Royal Asiatic Society), 1986.

23 *ibid*, pp.290–1.

24 G Groslier, Sculpture khmere, p 44 in 'Khmer Mythology' by C-H Marchal, p.205 in *Asiatic Mythology: A Detailed Description and Explanation of the Mythologies of All the Great Nations of Asia*, by J Hackin, Clement Huart, Raymonde Linossier H De Wilman-Grabowska, Charles-Henri Marchal, Henri Maspero, Serge Elisev, New York, Crescent Books.

KHMER ART AND ARCHITECTURE OF THE ANGKOR PERIOD

25 Chou Ta-Kuan, p.2.

INTRODUCTION TO ITINERARIES:
26 H W Ponder, *Cambodian Glory: The Mystery of the Deserted Khmer Cities and their Vanquished Splendour: and a Description of Life in Cambodia Today*, London, Thornton Butterworth, 1936, p.316.

GROUP 1: ANGKOR WAT
27 D H Dickason, *Wondrous Angkor*, (Kelly & Walsh, Shanghai, 1937), p.46.
28 H Churchill Candee, *Angkor: The Magnificent, The Wonder City of Ancient Cambodia*, p.71.
29 G Cœdés, *Angkor: An Introduction*, Emily Floyd Gardiner, trans and ed (Oxford University Press, New York and Hong Kong, 1963), p.40.
30 F Vincent, *The Land of the White Elephant: Sights and Scenes in South–East Asia 1871–1872*, (Oxford University Press, Singapore, rep, 1988), pp.209–11.
31 H Churchill Candee, *Angkor: The Magnificent, The Wonder City of Ancient Cambodia*, pp.68–9.
32 *Ibid*, p.25.
33 RJ Casey, *Four Faces of Siva: The Detective Story of a Vanished Race,* (George Harrap, London, 1929), p.200.
34 H Churchill Candee, *Angkor: The Magnificent, The Wonder City of Ancient Cambodia*, p.73.
35 Helen Churchill Candee, *Angkor: The Magnificent, The Wonder City of Ancient Cambodia*, p.68.
36 RJ Casey, *Four Faces of Siva: The Detective Story of a Vanished Race*, p.62.
37 Aymonier, trans, in *Textes Khmers*, 1878.
38 H Churchill Candee, *Angkor: The Magnificent, The Wonder City of Ancient Cambodia*, p.92.
39 O Sitwell, *Escape With Me! An Oriental Sketch–Book*, (Macmillan, London, 1940), p.91.
40 RJ Casey, *Four Faces of Siva: The Detective Story of a Vanished Race*, p.59.

GROUP 2: ANGKOR THOM
41 J Boisselier, 'The Symbolism of Angkor Thom', H H Subhadradis Diskul and V di Crocco trans, text of lecture given at the Siam Society on 17 November 1987, in Siam Society Newsletter, Vol 4, No 1, p.3.
42 Chou Ta–Kuan (Zhou Daguan), *The Customs of Cambodia*, p.2.
43 PJ de Beerski, *Angkor: Ruins in Cambodia*, p.52

GROUP 2: TERRACE OF THE ELEPHANTS

44 PJ de Beerski, *Angkor: Ruins in Cambodia*, p.147.

45 *Ibid*, p.148.

GROUP 2: TERRACE OF THE LEPER KING

46 PJ de Beerski, *Angkor: Ruins in Cambodia*, p.175.

GROUP 2: BAPHUON

47 Chou Ta–Kuan (Zhou Daguan), *The Customs of Cambodia*, p.2.

GROUP 2: BAYON

48 H Churchill Candee, *Angkor: The Magnificent, The Wonder City of Ancient Cambodia*, p.126.

49 PJ de Beerski, *Angkor: Ruins in Cambodia*, p.124.

50 PJ de Beerski, *Angkor: Ruins in Cambodia*, p.125.

51 H Churchill Candee, *Angkor: The Magnificent, The Wonder City of Ancient Cambodia*, p.139.

52 H Churchill Candee, *Angkor: The Magnificent, The Wonder City of Ancient Cambodia*, p.141.

GROUP 3: PREAH KHAN

53 H Churchill Candee, *Angkor: The Magnificent, The Wonder City of Ancient Cambodia*, (HF&G Witherby, London, 1925), pp.274–81.

GROUP 3: NEAK PEAN

54 Lawrence Palmer Briggs, The Ancient Khmer Empire, *Transactions of the American Philosophical Society*, 41, 1 (1951), pp.218–9.

55 M Glaize, *Les Monuments du Groupe d'Angkor*, p.212.

GROUP 6: SRAH SRANG

56 PJ de Beerski, *Angkor: Ruins in Cambodia*, pp.189–90.

GROUP 6: BANTEAY KDEI

57 H Churchill Candee, *Angkor: The Magnificent, The Wonder City of Ancient Cambodia*, pp 249–50.

GROUP 6: EAST MEBON

58 H Churchill Candee, *Angkor: The Magnificent, The Wonder City of Ancient Cambodia*, p.269.

GROUP 7: TA PROHM

59 H Churchill Candee, *Angkor: The Magnificent, The Wonder City of Ancient Cambodia*, p.256.

60 HW Ponder, *Cambodian Glory: The Mystery of the Deserted Khmer Cities and their Vanished Splendour*, p.305.

61 G Cœdès, *Angkor: An Introduction* (Oxford University Press, Singapore, 2nd ed, 1990) p. 96.

62 Rt Hon M MacDonald, *Angkor and the Khmers*, 4th ed, 1965, p.115.

GROUP 7: TA KEO

63 RJ Casey, *Four Faces of Siva: The Detective Story of a Vanished Race*, pp.181–2.

GROUP 7: BAKSEI CHAMKRONG

64 HW Ponder, *Cambodian Glory: The Mystery of the Deserted Khmer Cities and their Vanished Splendour*, p.62.

GROUP 7: PHNOM BAKHENG

65 H Churchill Candee, *Angkor: The Magnificent, The Wonder City of Ancient Cambodia*, pp.217–18.

66 H W Ponder, *Cambodian Glory: The Mystery of the Deserted Khmer Cities and their Vanished Splendour*, p.72.

67 RJ Casey, *Four Faces of Siva: The Detective Story of a Vanished Race* , p.129.

68 H Mouhot, *Travels in the Central Parts of Indo–China (Siam), Cambodia, and Laos, During the Years 1858, 1859 and 1860*, 2 vols (John Murrray, London, 1864), Vol 1, pp.300–1.

GROUP 8: BANTEAY SREI

69 HW Ponder, *Cambodian Glory: The Mystery of the Deserted Khmer Cities and their Vanquished Splendour*, p.254.

70 M Glaize, *Les Monuments du Groupe d'Angkor: Guide*, p.230.

GROUP 11: PRASAT SUOR PRAT

71 Chou Ta–Kuan (Zhou Daguan), *The Customs of Cambodia*, p.33.

72 Henri Mouhot, *Travels in the Central Parts of Indo–China (Siam), Cambodia and Laos*, p.8.

Hinduism The religion and social system of the Hindus; popular in Cambodia particularly from the first century to the 12th century

Kailasa A mythical mountain in the Himalayas and the abode of Shiva

kala A masklike creature with the characteristics of bulbous eyes, a human or lion's nose, two horns, clawlike hands and a grinning face

Kalkin see Vishnu

Khmer (Kh) The ancient indigenous people of Cambodia

Krishna A hero of the Hindu epic, *Mahabharata*, and one of the *avataras* of Vishnu

Laksmana The brother of Rama and a major character in the *Ramayana*

laterite A soil leeched of most of its silica abundant in Cambodia and northeastern Thailand; characterised by a porous texture and a red colour; hardens on exposure to air; used as a building material, particularly for foundations of Khmer temples

linga A representation of the male organ of generation, a symbol of Shiva and his role in creation

lintel A crossbeam resting on two upright posts. On a Khmer temple the lintel is above the door or window opening, directly below the pediment

lokapala A protector of one of the eight directions of the earth in Hindu myths

Lokeshvara ('Lord of the World') The name is often used in Asia for the compassionate bodhisattva Avalokiteshvara

Mahabharata One of the great Indian epics. It describes a civil war in north India

Mahayana Buddhism The 'Greater Vehicle'; a school of Buddhism; flourished in Cambodia, particularly in the late 12th and early 13th centuries

Mandara A mythical mountain in the Himalayas that served as a pole for the Churning of the Ocean of Milk

makara A large sea animal with the body of a reptile and a big jaw and snout that is elongated into a trunk

Meru A mythical mountain at the centre of the Universe and home of the gods; the axis of the world around which the continents and the oceans are ordered

Mucilinda The *naga* king who sheltered the Buddha while he was meditating during a storm

naga A semi-divine being and a serpent-god of the waters who lives in the underworld beneath the earth or in the water; it is generally seven or nine-headed with a scaly body

Nandi 'The Happy One'; a white bull and the vehicle of Shiva

nirvana The 'extinction' and final liberation from the cycle of rebirths; the goal of Buddhists

Pali A language derived from Vedic Sanskrit

pediment The triangular upper portion of a wall above the portico. Usually known as fronton at Angkor

phnom (Kh) 'hill' or 'mountain'

pilaster A column used on the side of an open doorway that projects slightly from the wall

preah (Kh) 'Sacred, holy'

Prasat (Kh) 'Tower'

Rahu A demon depicted with a monster's head and no body; supposedly causes eclipes by seizing and swallowing the sun and moon

rakshasa A demon who lives in Lanka (Sri) with Ravana

Rama The hero of the *Ramayana*; the seventh *avataras* of Vishnu

Ramayana An Indian epic describing the story of Rama and Sita

Ravana King of the *rakshasas* depicted with ten heads and 20 arms. His abduction of Sita and battle against Rama are the essential parts of the *Ramayana*

rishi A Sanskrit term which refers to a sage, an ascetic, or a hermit. A *rishi* in Khmer art has a goatee and sits cross-legged in meditation

sakti The energy of a feminine deity who is regarded as the consort of the god

sampot (Kh) A Cambodian garment worn as a covering for the lower body

Sesa (see Vasuki)

Sita Rama's wife and heroine of the *Ramayana*

spean (Kh) 'bridge'

srah (Kh) 'pond'

srei (Kh) 'woman'

Sugriva The monkey king in the *Ramayana*

ta (Kh) 'ancestor'

Theravada Buddhism The 'Doctrine of the Elders' representing the traditional Pali heritage of early Buddhism (see Hinayana Buddhism)

Tonle Sap (Kh) ('Sweet Water') A freshwater sea in western Cambodia that is linked with the Mekong River by the Tonle Sap River

Upanisads Ancient religious texts from India

varman (Kh) The 'protected', the victorious; the suffix is often attached to the names of Khmer kings

Vasuki The serpent upon which Vishnu reclines or sits. It also serves as a rope when the Ocean of Milk is churned by the gods and demons. It is sometimes called Ananta or Sesa

Vedas A group of hymns and prayers used by Indo-Aryans of northern India during the second millennium BC

wat 'temple'

yaksha A male nature spirit and a deity who often serves as a guardian and has the characteristics of bulging eyes, fangs and a leering grin

yoni Vulva–shaped female symbol of creation and generation

Zhenla (Chenla) An ancient Chinese name for a state in Cambodia that existed from the sixth century to the eighth century

Index